Portrait of Vincent

A VAN GOGH BIOGRAPHY

By

Lawrence & Elisabeth
Hanson

CHATTO & WINDUS
WITH SECKER & WARBURG
LONDON

PUBLISHED BY
CHATTO AND WINDUS LTD
42 WILLIAM IV STREET
LONDON WC2

*

CLARKE, IRWIN & CO LTD
TORONTO

FIRST PUBLISHED 1955
PRINTED IN GREAT BRITAIN

TO
JOOST AND ESTHER

Preface

NEARLY thirty years ago one of us, admiring the work of Van Gogh and having read his letters, began to plan and partly to write a biography, feeling that existing biographies of the man as distinct from studies of the painter were too emotional to reach any useful truth. After a time, however, and for several reasons, the work was put aside: the subject proved difficult and the biography decidedly one that could not be hurried; there were on closer examination obvious gaps in the letters (which had for the most part not been dated) and until the suppressed passages and letters were released and dated with reasonable accuracy a biography would necessarily remain incomplete; and finally, research into Van Gogh's life before he left the Netherlands was then in its infancy and biographers had to contend with a serious shortage of information.

A few years ago all these objections had been overcome or were in process of becoming so, and we both took up the work. We then hoped to publish in the centenary year, but were unable to do so because the complete edition of the letters on which all future biographies must rely had not finished publication in Amsterdam. In consequence this book appears out of order, being published after our biography of Gauguin instead of preceding it as we had intended. In all other respects the delay has been an advantage as far as we are concerned.

We have written primarily for those who like ourselves find one of their chief pleasures in the work of the painter; our object is best explained by a quotation from Sir John Rothenstein: "We can be deeply moved by a work of art of whose creator we are entirely ignorant. But are we not moved yet more deeply by the works of art which we are able to see in relation to the personalities of the artists who made them?" We have often wished that a straightforward, reliable and non-technical biography existed of painters (and indeed of all artists) whose work particularly interests us. This need we have now tried to fill for lovers of Van Gogh's work; and if a few of those who read are better able to understand his paintings, we shall consider ourselves well rewarded.

But this is not simply the biography of a painter. The life of Van Gogh will always be to many people even more remarkable than his work—it is one of the most tragic and, regarded in a certain light, most inspiring stories in the world. This book may, therefore, appeal to those interested in the story of genius no matter in what form that genius finds expression.

This is not a book of art criticism. When we consider it necessary we

have related work to the conditions under which it was made; we have also from time to time described a painting which gives us particular pleasure or which seems to us to have some significance in the development of the artist; but of art criticism as such there is nothing in the book—our descriptions are made in words that can be understood by any reader. Van Gogh said many times that any man who applies himself to a painting can obtain from it what the painter is trying to express in so far as the painter has succeeded. We have written in that belief. We should perhaps add—and we have in mind particularly the beginning and end of this book—that everything we have written is solidly based on ascertained facts. This assurance will not be necessary to previous readers; we make it only to those who may come to this as the first of our works.

We are most grateful to Ir. V. W. van Gogh for permitting us to quote from the letters. We have made free translations, our object being to give the essence of the thing said—to attempt to give the manner of the man who said it would merely lead to confusion, as we have tried to explain in our appendix. We are much indebted to Mme de Goldschmidt-Rothschild for her hospitality and her kindness in allowing us to study and use the letters to Emile Bernard and to examine her collection. We are particularly obliged to Mr and Mrs J. Baljeu for their help in translation and in many other directions. We also wish to thank Dr L. King-Lewis, whose kindness has made the writing of this book possible; our thanks for various favours are given gratefully to M. Roland de Margerie and Mme M. Perin; and we have once more to express our appreciation of the work of Miss B. Carpenter on a difficult manuscript.

For permission to reproduce paintings we are indebted to Ir. V. W. van Gogh and the Directors of the following galleries: Gemeente Musea, Amsterdam; Rijksmuseum Kröller-Müller, Otterlo; The Art Institute of Chicago; The City Art Museum, St Louis; The Museum of Fine Arts, Boston; The Museum of Modern Art, New York; The Louvre; Musée des Beaux Arts, Lille; and Musée de l'Atheneum, Helsinki. We also wish to thank the Editor of *The Sunday Times* for allowing us to quote from his paper.

L. H.
E. M. H.

Tourrettes-sur-Loup,
1955

Contents

Illustrations

PART ONE

THE SEEKER

THE BOY

1853-1864

IN the spring of the year 1851 the Rev. Theodorus van Gogh brought home a wife to the parsonage of Groot-Zundert, a Dutch village on the main road between Breda and Antwerp. He was twenty-nine, she was thirty-two. They had known each other for years (her younger sister had married his favourite brother Vincent), but he, unlike his prosperous brothers, had chosen to follow his father and his ancestors into the Dutch Reformed Church, his stipend was small and he could not afford to marry until he had been in his living for two years.

His wife, Anna Cornelia Carbentus, was the daughter of a well-known bookbinder in The Hague. She too came of an old family, but an unremarkable one of small traders. She had the broad face of a peasant, low jutting brows, deep-set eyes, wide cheekbones, was domineering, energetic, forceful, hot-tempered and highly emotional, possibly to the point of hysteria—the history of her children suggests it.

He was unlike his wife in every respect. He was the best-looking of a distinguished family—he was known in Zundert as the handsome dominie. He had much the same type of face as Newman— high broad forehead, long aquiline nose, wide eyes, strong jaw, thin lips—the face of an ascetic, which accurately expressed his nature and character, for he was gentle and kind but narrow-minded, holding inflexible views on right and wrong. In keeping with the Dutch character and the record of the Van Gogh family, he was a minority man, preaching a Calvinistic doctrine in the midst of a people predominantly Catholic. He did not preach it well, and his congregation of one hundred souls (a sixtieth part of the village) did not increase; but his charity was beyond creed —he gave freely to the poor, so freely that his small stipend suffered and the church council protested, but in vain—and in spite of his half-empty church and of his outspokenness—for he was something of a martinet in his mild way and did not hesitate to visit and openly reprove backsliders—he was widely loved; no

word of criticism has come down from the many people who spoke about him after his son had become famous.

He had a strong family feeling, was proud of the Van Gogh family and greatly attached to his parents, brothers and sisters. The name of Van Gogh had been known and respected in the Netherlands as far back as the fifteenth century; the first recorded member of the family was characteristically a Protestant theologian renowned for what were then unorthodox religious views, and he was followed by others who played a courageous and inflexible part in the rise of the Protestant movement. The first direct ancestor of the pastor at Zundert was a Vincent van Gogh baptised in The Hague in 1674 and a strict Protestant. His eldest son Johannes became a goldsmith—a craft that many Van Goghs were to follow—and another son, also Vincent, took up sculpture, a profession unique in Van Gogh history but which, as it happened, was to prove more profitable than the customary family business.

This Johannes was the great-grandfather of Theodorus. His eldest son, named after him, combined in a manner typical of the Van Goghs the craft of goldsmith and the calling of Protestant preacher, and his one grandson, Vincent, went into the Dutch Reformed Church—helped to do so by the great-uncle after whom he had been named and whose sculpting had earned him considerable wealth.

By the time of which we speak, 1851, this Vincent had settled in Breda and his children were spread over the Netherlands, all of them prospering except the youngest, Theodorus: two daughters had made notable marriages, the eldest son Johannes had become a Vice-Admiral in the navy and three sons had become successful art dealers—the first, Hendrik, worked up a prosperous business at Rotterdam, then moved to Brussels to manage a branch of Goupil, the famous Paris firm; the second, Cornelius Marinus, founded an even more successful concern at Amsterdam; the third, Vincent, after selling artists' materials in a small shop in The Hague, developed a gallery of such distinction that Goupil were glad to offer him a partnership, which he accepted, moving to Paris and handing over the Hague gallery to his manager Tersteeg; but he was delicate and by 1851 had retired to Prinsenhage, midway between his father at Breda and his favourite brother at Zundert.

THE BOY

At Zundert Theodorus had not only followed the calling of his father and ancestors, he had inherited the main Van Gogh characteristic, a fanatical sense of duty. He was not envious of his brothers' and sisters' material success, he sought neither fame nor wealth, only the good life and the power to persuade others to it. Indeed, although poor by the standard of the rest of the Van Gogh family, he was sufficiently comfortable to live without undue worry (or when not so he had only his excessive charity to blame), he had money enough for food and clothes and he had a small but comfortable parsonage to which to bring his wife. His one regret was the smallness of his congregation and his failure to increase it, but even this no doubt receded when his wife bore her first child.

This was on March 30, 1852. The child, a boy, was named Vincent—an obvious choice, being not only the most frequently used Van Gogh name but the name of his grandfather at Breda and of his uncle at Prinsenhage, who, being childless, would almost certainly make him his heir.

But the pastor and his wife, though happy together and admirably matched in temperament and character, proved to be unsuited as parents; a delicate, neurotic streak ran through the Van Gogh family and the alliance did not improve it. What Theodorus must have regarded as his greatest blessing—the children of his loved wife—was to cause him much anxiety and suffering and eventually to shorten his life.

The first blow fell quickly; the baby Vincent died a few weeks after his birth. The sorrow of his parents—and there is every sign that his mother in particular took the loss of her firstborn hardly —was allayed the next year; on March 30, 1853, exactly one year after the birth of the child, another boy was born. He was given the name of his dead brother—Vincent.

The second Vincent, the subject of this book, was in almost every respect the child of his mother; he had the Van Gogh red hair and the freckles which accompanied it and he early showed signs of the Van Gogh devotion to a narrow creed which in him was to become fanaticism, but in all else his origins must be sought in his mother: his appearance, the sunken light blue-green eyes, the sidelong suspicious glance, and his temperament, impatient, abrupt, the hot temper rising in a second to such uncontrollable fury that there must have been early indications that

he was mentally unstable—indications to be repeated in some of the brothers and sisters who followed him.

But if his parents did suspect that the Van Gogh neurosis was present to an alarming degree in their eldest living child it cannot be said that they took adequate precautions against it. On the contrary. His father appears to have lived, as one would expect, rather apart from his children, and particularly from this first boy, who must have seemed in his roughness and violence to be the very antithesis of himself. He was kind, considerate and conscientious, but with his cool temperament and his anxiety chiefly given to behaviour and the saving of an immortal soul he must often have appeared remote to a passionate child longing for positive affection rather than spiritual guidance. The father was affectionate in his way, but it was not the child's way; and even when he walked with him (as he did every day), studied with him and encouraged him (as he did regularly), the barrier between them prevented all true intimacy. It may also well be—no record exists, nor would one expect it to exist, but such happenings would be no more than normal—that his father, excessively conscious of the boy's uncouthness in comparison to his own immaculate good looks and behaviour, was driven after particular naughtinesses to comment sharply on his son's clumsiness, his penchant for covering himself with dirt, his unlikeness to the rest of the family. Small things but deadly. Yet even a spiritually minded man, given provocation enough, will descend to personalities, and jibes of this kind would leave their mark on such a one as the proud and sensitive Vincent.

None the less one must look elsewhere for the chief actor. It is the mother—the only one who could perhaps have given the child what he needed—who must bear the main responsibility for Vincent's development. For it was not long before he became what is now known as a problem child. The attitude of a mother towards her first living child is almost always ambivalent; in this case, given Mrs Van Gogh's unstable and highly emotional nature and Vincent's likeness to her, trouble was bound to follow —trouble that fell unjustly on the child. She could not rationalise her grief for the loss of the first Vincent and, as these things will if not checked, the grief became a habit to be worked off on his successor, and the living child was brought up under the shadow of his dead namesake. Every week a pilgrimage was made to the

grave to lay flowers by the headstone. Whenever he was unruly or difficult—and he grew naturally into a difficult child, stubborn, bad-tempered and rough—the first Vincent was held up to him as the model son.

Nor was this all: though small he was strong, and this physical strength, which with his temperament led him to roughness and hare-brained exploits, was often a joy to his mother; but her pride would as often change frighteningly into a coolness, almost a dislike, as though she resented the strength preserving him from the dangers that had robbed her of her firstborn. In this mood and in anger she often could not resist brandishing before him a picture of that dead brother who would have been so different—obedient, quiet, ever loving—and rebuking him for adding by his naughtiness to her suffering. Then she would repent, would dote on him, spoil him, caress him fiercely and possessively—for at times he was very precious to her, more so than any other of her living children.

This kind of love, well known to many children, is usually accepted gladly at the moment, for a child like Vincent, longing for assurance and security through love, will snatch at anything that resembles it remotely. But if a child does not at once resent as a substitute what he is offered, he will do so later; with Vincent the harm was done; as he grew older he realised that he was not in the eyes of his mother the real Vincent, he was a usurper and could not be loved as his elder brother—dead only in body—was loved. Had he a life at all, he must have wondered, with the name and birthday of another? He felt guilty and unwanted and he would dream of the ideal woman, the eternal mother, who would love him always and whom he could adore for ever; and after one of the frequent emotional scenes between him and his mother the small, heavily freckled, red-haired boy would break away and bang about the house, glaring, shouting, browbeating his sisters, commanding, quarrelling, trying as children will to force himself into attention by a display of aggression—attention of any sort seeming some sort of substitute for love and admiration. For love, of course, was what he needed, like any child, but possibly more than most children as his nature was more intense; he craved for love; to be needed—that was his great longing, but, foreshadowing the future, he had already begun to behave in such a way as to drive love away. The parsonage maid—a village girl—liked

him less than any of the other children; he had "horrible manners", she said, was rude and strange; and no doubt he was, in such moods. But children's memories are mercifully intermittent; the stigma of living in the shoes of an invisible and faultless brother was not always in his mind; and playing with his brother and sisters, devising and directing games (at which he was so good that they one day spontaneously presented him with a rosebush), or drawing and painting under his father's direction (a recreation common to most middle-class homes at that time), or sitting or walking quietly for once with his mother, he too would become quiet, self-effacing and so pleasant that visitors would exclaim in astonishment and think that they had misjudged him.

Perhaps his father's approbation was the thing he most coveted. He worshipped his father and was convinced that so good a man had never before walked the earth. To be like him! But he was not like him; he was as unlike as son could well be. It must have seemed to him impossible that a man so far above him could love him. His father loved everyone, of course, in his quiet and godly way, and loved him too, but his son's frequent violence, his untidiness, even his strength worried and, Vincent would have thought if he were not his father and a grown man, actually alarmed him. He was kind but was also outwardly cold and could be severe; and when he punished the boy, as he often did, perhaps he too was thinking of that other Vincent who would have been the gentle, obedient, godly son he desired. He was far too kind ever to say so, but he talked often of the dead child with a kind of wistful regret, and the living Vincent could think for himself.

He sought elsewhere, as children must, for love. He did not find it in his sisters. There were three: Anna, two years his junior, Elizabeth and Willemien. Anna resented his domineering ways, and the two smaller girls, delicate both, were too much afraid of his noise and roughness to feel, or at any rate to express, affection. There was left the second boy, Theo, four years younger than Vincent. He, like his younger sisters, was gentle, sickly and nervous, but unlike them he admired the strength and forcefulness of his elder brother; he began to follow him about, they slept together, and the strange couple—for they seemed outwardly to have little in common—often appeared to be inseparable. He was not a mother or a father but he was a human being, merci-

fully uncritical, and the longing Vincent alternately clung to him and bullied him but always loved him.

But Theo was, after all, only a very small boy and the comfort he could give was limited; on the whole, and increasingly as the instinct of the child in Vincent was confirmed by the reasoning of the boy, the tyranny of the dead Vincent soured much of his life in his home. Perhaps this was why he began to spend more and more time with the peasant boys he met every day at the village school—it is certainly a characteristic of the misunderstood child of good family to resort for comfort to the company of the simple and homely peasant type. Vincent was for ever off with the village boys; and when he took his daily walk with his father to the scattered parishioners, going into the dark, low-ceilinged weavers' cottages where the man sat spectre-like at his loom, looking in at the large inn parlours with their huddle of peasants grouped about the sanded floor, turning aside over the fields for a word with the shepherd, listening to his father's kindly but rather formal greetings, watching him bring almost guiltily out of a pocket the little gift of food, tobacco or money and lay it by in silence, seeing his sorrowful glances at the scanty meal of potatoes, the hollow faces and the undernourished children clustered round the fire of smouldering sticks, he was filled with a passionate wish to be like this saintly man and to help his unfortunate fellows. He was far already from saintliness; he could not sigh like his father that it was God's will that some men must suffer in this life, encourage them to look to another for comfort and try in his humble way to ease their lot—he felt furious indignation for the hardships of his friends. For his friends they had become; they were as blunt and short of speech as he, with them alone (the little Theo excepted) he felt at ease, no politeness demanded, no cleanliness, no neatness of clothes, no restraint. He looked like them, he seemed to feel like them, he believed himself to be one of them but an unworthy one.

Sometimes Theo would join him and his father for their walks, treading the white sandy paths contentedly between his two heroes. Both he and Vincent were to remember these walks and, surprisingly, without embellishments—the enormous skies, a cold blue broken by many clouds, the dark heath spreading to the far horizon, the lark spinning up above patches of corn. Those Brabant cornfields were fixed in Vincent's heart and in his eye,

from the stubbly green shoots of spring to the summer's full sheath of yellow. He walked more and more as he grew older, and often alone; he wanted to love and be loved, yet somehow he found himself solitary time after time and not uncontentedly; he walked with his peasant's plod along the white paths, across the tough, springy heather and over the ploughed fields, a stocky, dirty, unpleasing red-headed boy, never tiring physically and never tiring of what he saw—to him the flat Brabant countryside appeared afresh every day. He was not as other children, he took nothing for granted; the starlings that perched on the roof of his father's church, rose, wheeled, quarrelled and perched again, never became to him merely birds or black objects that he had seen a hundred times before—they were life, ever changing, ever new, beautiful in movement and at rest; the magpie's nest in the tall acacia in the parsonage garden had secrets to be penetrated every time he stared at it.

Already he looked about him with the eye of a painter, yet despite two painter cousins, despite three art-dealer uncles, despite the collection of paintings at Prinsenhage where his Uncle Vincent often invited him, he showed no particular bent for painting. He was encouraged to draw and to paint as most children are—perhaps more than most since it kept him tolerably quiet—and in quiet moments he enjoyed it as most children do, but when a drawing was praised he would tear it up. He was happier chasing about the countryside after butterflies, beetles and birds' nests, for all of which he had a passion.

If he had thought about the matter at all he would have said proudly and defiantly that he was a Brabant peasant; he felt at home in the village school, he felt at home in the cottages of the boys' parents, he wanted nothing else. But he would have said no more than half the truth; he was happy with them, he looked like them but he was not one of them. They did not walk about the heath revelling in what they saw; they walked with an object, and when they found that object—birds' eggs, say—they seized their find with a whoop of triumph. He paused to admire the delicately coloured egg against its deceptive background, to wonder at the frail home of twigs and moss. Even in their games and exploits he stood out; he was strong, he was masterful, his temper flared alarmingly, he was above all daring; they admired and feared him—he would end on the gallows they all and even

Theo predicted—but he was not one of them; they knew it, he would not.

He was, however, behaving increasingly like a peasant boy, and in 1864 his parents, worried by his roughness and fits of rage and rude speech, decided to send him to a school for the sons of gentry at far-away Zevenbergen. It was raining when they took him off in a carriage on the first day of October, and the dark depressing day symbolised his feelings as he watched them drive back without him. His happiness at home had been intermittent and mingled with much misery and humiliation, but it was home. He was, after all, only eleven years old.

Chapter Two

THE YOUNG MAN
1864-1873

H E spent nearly five years at Mr and Mrs Provily's boarding school at Zevenbergen. He came away with a certain capacity for expressing himself in writing although his grasp of grammar was hazy, and remained so. He had also been encouraged to read widely in European literature. His teachers failed completely to discipline his emotional nature and did not therefore develop a critical sense in him. He left no mark on the school and was remembered only by one peculiarity which was certainly unusual—a refusal to sit at table for meals; he tried always, his fellow-pupils recalled, to go into a corner by himself and eat a piece of bread. This is the first sign of a Vincent later to become familiar—the man who revelled in the mortification of the flesh—and which was illustrated on his return home. His father asked one of his church elders to accompany him on the last stage of the journey from Breda. It was a three-hour walk and the man offered to relieve Vincent of a heavy parcel he was carrying. Vincent refused: "Every man", he told his surprised companion, "must carry his own load."

This is the remark of a prig. His sisters had complained during the holidays that his physical roughness was being replaced by roughness of another kind—a fierce moral arrogance. He was a prig, which at sixteen is not unduly surprising. He was trying in his way to follow his father. But there was another and more important aspect of his remark; it showed that five years of gentlemanly schooling in the Van Gogh tradition had made not the slightest effect on his boyish beliefs; he was convinced that no man should expect others to do for him what he could do for himself; he held that every man was equal in theory and should be so in practice, and he believed fervently that the peasant alone offered the world the example of man as he should be—working on and living by the soil. Such were the elect, and Vincent hoped with passion that he might be counted among them. And indeed he looked like nothing so much as that depressing sight, a peasant

24

out of his element: his clothes seemed not to belong to him, they sat stiffly on his awkward figure; unkempt reddish hair sprawled about the square head; light-blue eyes, set deep behind jutting brows, peered out small and suspicious from a fleshy freckled face; large hands and feet protruded gawkily, a harsh voice spoke in bursts between strange silences as if normal speech were throttled in him by feelings too violent for expression.

But in spite of his aspirations to live the simple life, a very different future was being planned for him. His father lived on the edge of poverty but had little fear for his children, and least of all for Vincent. All the uncles were rich, all benevolently inclined, and one—the richest of all, the childless Vincent—took a special interest in his namesake; he often drove over from Prinsenhage to see him and the pastor, and he took him back to his own grand house filled with rare paintings, at which the boy would stare and wonder. Might he not make Vincent his heir? The parents hoped so. At the very least he would surely place him in the business.

So it proved; and at the end of July 1869 Vincent began work in the Goupil gallery at The Hague. He seemed to be moderately contented in his work, and his longings for peasant life were for the time being forgotten; no more was heard of his ungovernable temper, and he mastered his indifference to appearance sufficiently to make himself presentable. He seemed bound for a prosperous career.

This modification of youthful ideals was not surprising. The change from the quiet parsonage at Zundert, where a stranger was rarely seen, to the bustle of the Goupil gallery was overwhelming, as was the change from the flat fields of Brabant to the busy streets of The Hague—overwhelming and, for a time, far from displeasing. As his uncle's favoured nephew he was flatteringly treated, and he had a port of call in the house of his maternal aunt and, what was more, exciting meetings with the very men whose work he was helping to sell—for two of Aunt Sophy's daughters were in love with painters, one no less a man than Anton Mauve.

Mauve was one of the most popular painters of his day. He painted, photographically, sentimental subjects. He used the dark palette common to Dutch painters to convey, in suitably sombre tones, a suitable moral. Vincent thought him and his

work wonderful; and when the great painter threw a kindly word to his gauche young cousin (who was, no doubt, bound to become a Goupil manager), the youth went into an inward ecstasy of admiration. He loved to admire; he felt an overwhelming need of giving out love. He had somehow to compensate by redoubled worship for his inability to express it. Criticism detracted from the glory of admiration. Criticism as he saw it was the antithesis of love; he didn't care to receive it himself; he would not apply it to others. His life was to be studded with heroes: if they did not possess all the virtues, he supplied them. Mauve was the first of these heroes outside his own home.

All that he learned in the gallery tended to confuse his sense of values. He was in a world of art, a world full of paintings gorgeously framed and temptingly hung, but it was a world in which the picture that fetched a high price was a good picture; if Goupil could get as much for a Mauve as a Rembrandt, was not Mauve as great a painter? Tersteeg, the manager of the gallery, might have his own views, but if he had he kept them to himself; certainly they would not reach the innocent young Vincent busily learning the business. If there was one thing that an assistant must learn, it was never to pit his views against the inclinations of a client; he was encouraged to acquire knowledge but not opinions.

Vincent might have rebelled against this view of art had it not been that the profitable paintings happened to be those which appealed to him or, more correctly, of which he approved. His own critical sense remained amorphous except in the matter of morals. There he was already fiercely strong, and most of the paintings he saw at Goupil's and which as he moved into his late teens he helped to sell attempted in exemplary fashion to mould the spiritual fortunes of those who bought them. There was Mauve, Mesdag, there were the three Maris brothers, there was above all Joseph Israëls, the chief of the Hague school. Their paintings, when they can be found, may appear to the modern eye as dated as an antimacassar, with their farmhouse, cottage and country scenes, their cradles by the hearth, faithful animals and lowly, patiently suffering men and women; but of one crime none of them can be accused, they never confused black and white; with them good was good and evil was evil, and the good triumphed always; and this alone the admiring Vincent saw.

Indeed, the one complaint Tersteeg could find with this willing though inarticulate helper was that he tended at times to overdo the moral aspect. It was an age, in the Netherlands as in England, of moral endeavour, of reform of abuses, of glorification of the lowly and the meek. Nevertheless, certain customers looked for other virtues in art and they must be humoured. Vincent was not, he discovered, very good at humouring.

As time went on, inevitably his chief devotion was given to the master in this kind—Millet. Millet painted peasant after peasant, at his work, at his rest, at prayer, but always close to the soil and for ever proclaiming to those who had eyes to read that only through the humble, the meek, the poor could the lesson of life be learned in its fulness. And Vincent, responding ardently to this marvellous marriage of his own two great beliefs, in the peasant and in the propagation of goodness, spent his precious weekly guelders on prints of the master's work, pinned them to the wall of his litttle room off the Lange Beestenmarkt, and passed evening after evening in rapt contemplation.

"The Angelus," he exclaimed, "that is beauty, that is poetry! The Sower, that is profundity beyond all words!"

When he was not worshipping his prints he would be at the feet of Mauve, listening to the conversation in his aunt's house, or reading in his room. He had begun to read much—Dickens, Carlyle, George Eliot among his treasures, but the Bible most of all. He did not merely read the Bible; he took lessons so that he could understand the better what he read, and because he had a secret hankering to expound the Word. He had a power within himself he dimly felt; but how to express that power, how to direct it? Then he would think that he was helping to sell those worthy pictures, to spread good, and he would go to the gallery the next morning serene once more. But he kept up his Bible lessons and his father sent him devotional tracts—not always to his liking, it would seem; an acquaintance of this time has left a picture of Vincent sitting by the fire in his room throwing on it one by one the pages of a tract from Helvoirt. And he walked a great deal in his spare time—through the narrow streets of the poorer quarters, along the canals, to the nearby sea-coast. He was a tremendous walker, plodding along heavily and untiringly. Occasionally he sent to his parents little sketches of what he had seen during his walks; he sent them to Helvoirt, near 's Hertogen-

bosch, where his father had obtained a new living at the beginning of 1871. The new had no obvious advantage over the old; Helvoirt, like Zundert, was a small village of which only a fraction attended his church; and Theo, now in his teens and still delicate, had to walk ten miles a day to school—an ordeal that may well have helped to shorten his life.

The brothers had seen little of each other in the past few years, but in the summer of 1872 Theo was sent up to The Hague for a few days as a special treat. He was then fifteen, taller already than the nineteen-year-old Vincent. Vincent slipped away from the gallery as early as he could each evening and took Theo to all his haunts, the streets he best liked walking through, his aunt's drawing-room, Mauve's studio and of course his own little room with the prints fixed up on the walls. And on his free day, Sunday, he took Theo for his favourite walk through the meadows and along the canal to Ryswyk. The day was over-clouded and rain fell before they reached Ryswyk. They went into the mill and were each given a glass of milk.

As they walked and while they lingered in the mill waiting for the sky to clear, Vincent suddenly found himself talking, and for the first time in his life talking freely. All inhibitions, all self-consciousness were forgotten; the fifteeen-year-old Theo's admiration, faith and sympathy had overcome his abnormal reticence. The two were amazed to find themselves as one in thought, feeling and beliefs; they pledged themselves to remain as one, to stand together and work for good. Vincent, whose heavy face belied the emotion behind it, became wildly excited. Faith, sympathy, love—these broke down the barrier of nineteen years. To his parents he could not speak freely, he would embarrass his father and his mother would embarrass him, but with Theo he felt liberated. The words poured out.

What he said was of no more importance than the fact that at last he could say it. He spoke of his work at the gallery, of his feeling for certain artists, of his Bible-reading, above all he spoke of his intimations of a certain power within himself. Was he as other men? What was this power—how should it be used? He was only nineteen and his ideas were cloudy. He longed somehow to preach the good life—but who was he to preach?

Theo, always the practical one of the two, suggested hesitantly that Vincent should try to paint; he was for ever sending sketches

home, he was obviously fascinated by all he saw, he had strong connections with painters from whom he could learn and the gallery at which he might sell. Vincent waved aside this diffident prophecy. He to paint, whose scribbles angered himself by their pitiful inadequacy! Besides, was he not a trusted member of the firm, and did he not approve of the business, content to sell his great masters rather than impudently attempt to imitate them? He must wait for the light, the call, and he would wait contentedly now that he and Theo were of one mind, that their life-work must be to spread abroad the seed of the good life.

Theo went back to Helvoirt, and the following January himself began to work for Goupil—but at Brussels, with his Uncle Hein as manager. He was followed home by letters from Vincent, determined not to lose this marvellous chance of self-expression. The correspondence lasted as long as they lived. On Vincent's side (for Theo had neither the gifts nor the dramatic character of his brother) it was one of the most remarkable series of letters ever written.

At first the letters are in no way remarkable: advice to Theo to take up smoking (Vincent was already a heavy pipe-smoker), delight when he gets a rise in salary, congratulations when Theo begins work at the Brussels gallery, pride in his own work, excitement when, in May of 1873, he is transferred to the London branch—these are the subjects of the early letters. Quite ordinary, for the young man who wrote them was, as far as anyone could see, an ordinary young man, well-meaning, hard-working, rather country-bumpkinish, distinctly priggish, inclined to be obstinate, and apparently without a vestige of a sense of humour. Not a great favourite, not an obvious failure, virtually nothing but the son of his father and the nephew of his uncles.

Chapter Three

URSULA

1873-1874

HE travelled to London by way of Brussels (where he had a few excited words with Theo on the station platform) and Paris where the palatial Goupil galleries and the riches of the Louvre and the Luxembourg overwhelmed him. In London, with a salary large enough to live on and a position of some importance, he blossomed out into the city businessman, wearing a black suit and top-hat with as much of an air as he could muster. Life at the Southampton Street gallery (the Goupil business there was with dealers only) was a little easier than at The Hague—he was off at six every evening and four on Saturdays—and he made the most of his leisure. The manager took him to Box Hill one Sunday, and he was soon walking great distances by himself, exploring the centre of the city, the parks, Hampton Court and the sea-coast at Brighton (a walk of close on fifty miles). He went boating on the Thames, he haunted the picture galleries, he lingered at the stalls in Booksellers' Row, buying a book or a print from time to time, he hung about Swain's studio admiring his etchings, he gazed by the hour at the drawings in the *London Illustrated News* and the *Graphic* in their Strand offices, he went to all the churches. He had pangs of homesickness but on the whole he was delighted with the change. London and the country about it seemed more colourful, more genial than Brabant or The Hague and he responded to every new impression. And more than this, parting company with the tourist, he responded with increased ardour when these impressions had lost all apparent novelty. As in Brabant, so in London he saw beauty everywhere. He talks about it ecstatically to Theo (who had been moved to The Hague in his place) and tries to sketch for him some of the outstanding marvels; his letters are happy ones, recounting his wanderings, his discoveries.

He was a very earnest young man, always the evangelist. When his eye caught a street or river scene he was a painter first and foremost; when he looked at a painting he was a moralist

before all else. His generosity of spirit and his need to admire combined with his intense sense of art's moral purpose to make true criticism impossible. "I see that you are beginning to love art greatly," he writes encouragingly to Theo. "That's splendid." He is overjoyed but his helping hand merely hinders. He copies out long lists of his favourite painters so that Theo shall know what to look at. In these lists Millet, Mauve, Israëls, Ziem, Weissenbruch jostle Rembrandt, Corot, Constable. All are rated among the great—all except perhaps Millet the supreme, great artist and great man in one.

Vincent's one trouble was the drain on his money. His room cost him eighteen shillings a week and he could not live up to the habits of the other lodgers. Late in the summer of 1873 he found another and cheaper room in the southern suburbs, in the house of a Frenchwoman, Mrs Loyer. She and her daughter Ursula kept a small school for boys. They made him at home, and he wrote happily to Theo that at last he had the kind of room he had always longed for—without a slanting ceiling and without blue paper with a green border.

But these pleasures soon gave way to a deeper, positive satisfaction. For the first and last time in his life he was received as one of a family; the kindly Loyers, taking pity on the lonely, inarticulate young man, encouraged him to spend his free time with them. The bedroom saw little of him. He would walk back from the office night after night—three-quarters of an hour it took him—eager to be home, to watch the women at their work, to help to correct the boys' lessons or take them for a walk, to help with the meal and to clear up after it; he shared their Christmas with them, he seemed to be one of the small circle. He was blissfully happy—happy and amazed—as he watched the girl and her mother. Never had he seen, never had he even dreamt of such affection between two women. So he told his own mother—a curious observation for him to pass on and a significant one, for it was criticism as well as comment.

When spring came he dug their little garden for them and planted poppies, sweet peas and mignonette. "We must wait to see if they come up," he told Theo lightheartedly. But he never saw them come up. As the lilac, the laburnum, the chestnut trees bloomed, his walk home redoubled in joy; he could not contain his excitement at the sight of so many lovely blossoms. "In every

garden!" he exclaimed to Theo wonderingly. He began to sketch once more, seriously, in an effort to capture the beauty, to share it with Theo and to please his parents by showing them what his room looked like, the house, the street; he stopped evening after evening on the Embankment and at the far side of Westminster Bridge on his way to the Loyers and tried to sketch the buildings, trees, clouds, the ever-changing light. He was ravished by the charm of London, its riverside, its suburban gardens; he could never catch the charm, but he tried again and again even though he lost half an hour of Ursula's company. For of course he had fallen in love—or what he believed was love.

He was attracted by her soon after they met, but he said nothing. He said nothing that autumn, that winter and the following spring. He said nothing because he did not know how to approach her, because she seemed so far above him, because he was happy as he was, happier than ever in his life before, and —perhaps—because some extra sense warned him not to speak. Then, in June 1874, he was given his first holiday; he was to spend it in Helvoirt with his mother and father, and the thought of the approaching weeks away from Ursula drove him to speak.

Ursula and her mother were astonished and pained; they pitied the awkward, tongue-tied young Dutchman because he yearned so plainly for affection and was so unlikely to receive it. But who could love so unlovable a person, so strange and un-civilised for all his glossy top-hat and stiff black clothes? He had a way of looking at one—with a sidelong suspicious blue glance— that with the set of the mouth and the obstinate square head raised alarming hints of violence.

They explained as kindly as they could; Ursula was secretly engaged to the man who had lodged there before him. For days Vincent would not accept the position; he had devoured the Dutch paintings, and the English ones now—Millais, Reynolds, Gainsborough—only too thoroughly: the good, pure woman, the selfless helpmeet—these attributes were transferred easily to the first nice girl he met. Ursula's rôle had been settled in his mind months earlier; she was to release in him all that had been tied up from birth, to exorcise the savagery, to encourage the gentle-ness; through her love he would be born again, no more the caricature of himself that the world saw but the true inner man who put himself into the letters to Theo. Theo was beloved, but

a brother. Given the love and faith of a woman to inspire him, what could he not be, not do?

But there were other reasons why he wanted Ursula: he was lonely, he was longing to sleep with a woman. The harm was not in the wish but in his refusal to admit it, in his insistence on covering it with an almost maudlin idealism and fostering it on to a harmless ordinary woman in the name of love. Many young men deceive themselves in the same way but Vincent was not an ordinary young man, he thrust into every emotion, genuine or not, an abnormal vehemence; he plunged ahead without thought, ready to wreck his own life and the life of any woman who happened to get tangled up with him. For months, on those long walks morning and evening to and from Goupil, in those hours in his bedroom when he knew her to be near, he had dreamed of an Ursula who never existed: was he to deny these dreams, give them up in a moment because he was told of another man—a man he had never even seen? The girl found herself faced by a Vincent who for the first time in his life had had his will thwarted.

She did not love him, she explained again and again. He did not ask for her love, he replied; it was enough that he loved her with a love strong and deep enough for two; he asked simply to be allowed to love her; she need give nothing in return but compliance.

She remained adamant—kindly but adamant. Could such a love not stir her? He would not believe it; he was no ordinary man, his was no ordinary love; it deserved even her. And—he must have his way; refusals from women were to rouse an ugly persistence in him. He pestered her; she, angry at last, spoke plainly: What woman could love such a man? Pity—yes—but love! Besides, did he really love her? She didn't believe it. What he felt was not so much love for her as for his own fine feelings. She was embarrassed by his vehemence, by his sentimental conception of herself, by the outrageous demands she felt behind his humility, by that touchy loneliness which instead of trying to come to terms with the world clings with morbid tenacity to the first person who shows signs of sympathy.

At last he understood—in his own way. His love—that pure and noble thing—was refused because it came in such a guise. An inkling of the future opened before him; there was about

him something that shocked and disgusted and repelled, something that not merely obscured what lay beneath but actively perverted it. Most young people are abnormally sensitive about their appearance and manner; Vincent, more sensitive than most, had greater cause than most for feeling so. He lost all confidence; he hated himself; he could not bear to look in a mirror. And he hated everyone about him. He packed his things and left for Helvoirt.

Chapter Four

END OF AN ART DEALER
1874-1876

His mother and father were alarmed by the change in him, and were soon anxiously discussing the new symptoms. The occasional boisterousness had disappeared and even the bursts of savage temper which they knew well enough and lovingly excused; instead, they watched a much more frightening alternation of pensiveness and despair with an abysmal absence of interest in food, the business, everything. His face had begun to lose its roundness, he talked rarely, even the country attracted him no longer; all he seemed to care about was his drawing; and, as if he could not bear to be parted from the place that had dealt him such a blow, he sketched again and again the suburb in which the Loyers lived. A delightful talent, his mother told the young Theo (already becoming their rock), whom they had at once consulted; but that said, she could find no other consolation.

At last they got the truth from him. All sympathy he rebuffed brusquely. He needed company—that was their remedy; they sent his eldest sister to London with him when his holiday was over; Anna would look for a job and keep an eye on him. For a short time their plan succeeded; he walked about London with Anna in his spare time, taking some pleasure in showing her his discoveries; he even tried to interest her in the paintings he had praised to Theo. But when the novelty wore off and every street, every house, every tree reminded him of that time, so short a while before, when he had looked at them with happiness and hope, he began to spend more and more time alone in the room he had found in Kensington. His letters to his parents dwindled, he abandoned drawing, he read enormously, in medicine and psychology, in the poets, but above all in *L'Amour* of Michelet. This last had been a gospel and a revelation to him, he told Theo, who must at once get it, study it. He himself pored over it and moralised tirelessly on woman and on the relationship of the sexes. He believed in a perfect love in which man and woman were as the two halves of a complete whole. But—and this he

did not tell Theo—the perfect love eluded him, all love eluded him. He had no friends and his abrupt manner offended even his business acquaintances. Reacting violently from his humiliation—for he tortured himself with recollections—he began to externalise self-loathing into a comprehensive hatred of mankind. He had the capacity for love on which Michelet expatiated so nobly; it was wasted and with it his life, because women were deceived by the shell.

But one type of woman there was who dealt in love and who would not reject him; to her, the outcast, despised prostitute, he resorted and of her he spoke much to Theo, quoting Jesus on Mary Magdalene and reminding him of all the pictures with Magdalene themes. He declared that virginity of soul and impurity of body were not incompatible; these "great lovers" proved it; perhaps he too would prove it.

From his anxious parents at home and from his sister in London these attempts at compensation were hidden, but at Helvoirt they read depression in his few short notes, and Anna's reports were discouraging. "Poor boy," said his mother, "he means well, but things are not going well for him just now." She spoke privately with Uncle Vincent, and in October Vincent was transferred to Paris for two months. He was furious when he heard that his mother had interceded for him; he refused to write to Helvoirt, flew at Anna, and sulked his way through the Paris interlude.

Back again in London at the end of the year he felt a final spurt of interest in the business, then relapsed. He got through each day as best he could, doing his work and no more, then hurried home to his Michelet, to Heine (whose lyrics he copied out for Theo to read), and, eventually, in the spring of the new year, to Renan.

From the prostitute and Renan to the Bible was a natural step to one who craved justification. He was soon telling Theo that life was long (he was not quite twenty-two) and that "another shall guide thee and lead thee where thou wouldst not". This was true enough. Reports from the London office disturbed the uncles; Vincent took no interest in his work, he was behaving like an eccentric, he shut himself up after office hours, how he spent his time was a mystery, perhaps not a very savoury one. Uncle Vincent warned him that he must mix with people, be

entertaining—such was the better half of an art dealer's business. Vincent ignored the warning. The reports from London continued unfavourable. In May, Uncle C. M. and Tersteeg arrived but did not come to see him. He complained to Theo that they had given too much of their visit to amusements, commenting darkly, "I hope and trust that I am not what many people think me to be."

To show what he was, he ended his letter with a quotation from Renan: *Pour agir dans le monde il faut mourir à soi-même. Le peuple, qui se fait le missionnaire d'une pensée religieuse, n'a plus d'autre patrie que cette pensée. L'homme n'est pas ici-bas seulement pour être heureux, il y est pour réaliser de grandes choses pour la société, pour arriver à la noblesse et dépasser la vulgarité où se traine l'existence de presque tous les individus.*

A few days later he was again sent to Paris by the persevering Uncle Vincent. His chief in London had talked to him in vain; his silence was stiff with disapproval, his speech even worse, for when he opened his mouth it was to argue with unseemly heat. The second move to Paris pleased him no more than the first, and when it was decided to keep him on at one of the Paris galleries (for none of the London art dealers showed pleasure at the thought of further business meetings with him) he sank into deeper despondency.

He wanted to do good in the world, he wanted to live unselfishly, he believed with Renan and with Carlyle that happiness was not enough, that honesty was not enough, that man's aim must be the noble life devoted to the upraising of humanity. At Ryswyk he and Theo had pledged themselves to that aim. For a few months, after his failure with Ursula, he had lost faith; man had become hateful to him. Now he had been brought back by the despised and rejected of woman and, by way of Michelet, Renan and Carlyle, had come full circle to the feet of the despised and rejected of man, to his father's faith. By the time he had arrived in Paris for the second time he was yearning to spread this faith and, in spreading it, to become himself good.

In fact, he had rebounded from the repulse of his love to a general detestation of all women; then, still by natural progression, as he had lost faith in his power to attract or win love, he reversed this detestation into a general love of humanity; he, the rejected, would, like his greater predecessor, show the world

what true love was and so find revenge and his lost confidence.

Simple and common; but, happening to a Van Gogh who had long felt mystical leanings towards self-immolation, the reaction to Paris was bound to be unique. To wait on the fashionable crowds in the gallery of the rue Chaptal—how could this advance the good life, how could it help but soil the soul? He went to a sale of Millet drawings and entered the salon in a blaze of humility, barely restraining himself from shouting aloud "Take off your shoes! The place where you are standing is Holy Ground." If he were called on to sell work like this for Goupil, how happy and proud he would be! But Millet was one of hundreds hanging in the gallery; the taste of the wealthy Parisians descended often to the worldly in art—nay, to the positively sinful. He was tempted again and again, ever more strongly, to rebuke them.

Fortunately he kept silent, but it was a sulky silence that pleased neither the purchaser nor the manager of the gallery. He tackled Uncle Vincent, but did no more than provoke the retort that he had better keep to the natural and leave the supernatural alone. Vincent quoted Saint-Beuve gloomily to Theo after the interview: "there exists in most men a poet who died young". He lived his real new life in a little room in Montmartre overlooking a garden filled with wild vine and ivy. Soon he was joined in the same house by an English boy of eighteen who had come to Goupil to learn the business. Vincent, with his painter's eye and gift for description, puts him before Theo with a few strokes: "Very uncouth, for instance every morning, afternoon and evening he eats four to six slices of bread and several pounds of apples and pears. Yet he is as thin as a rake, has two rows of strong teeth, full red lips, glittering eyes, a pair of large protruding ears usually red, and close-cropped black hair."

This boy, Gladwell, came like a gift from heaven to a Vincent hungry for converts: he read the Bible aloud to him every evening; they prayed regularly; they went to church after church every Sunday. Vincent described the sermons meticulously to Theo and urged him to follow his example, he destroyed his Michelet, Renan and Heine and commanded the bewildered Theo to do the same. "That will give you rest," he assures him. "It is dangerous stuff. Don't read Michelet, don't read any book except the Bible, and be careful of the words I underlined in

your letter, 'silent melancholy'. There is such a thing, but we can't have it yet. *La jeunesse et l'adolescence ne sont que vanité* is a true and a good saying." Instead of secular poems he now sent Psalms, books of the Bible and the *Imitation of Christ*. The religious poems with which he occasionally ended his letters showed a complete abandonment of any literary standard—they were sheer bathos. And he warned Theo not to give himself completely to art; the religious feeling, he insisted, was other and greater than the feeling for nature. His letters are spattered with Biblical quotations, with hymns, with prayers that he and Theo must make if they are to be saved.

He had not abandoned art—that was beyond even the revivalist in him; his room was a mass of prints, he went often to the Louvre, he was teaching Gladwell to look at art correctly and to collect the right kind of prints. He even sent a sketch or two to Theo. What he had done was to canalise art, taking from it only what bore relevance to his frame of mind; Biblical and obviously moral pictures alone were admitted. When the moral was not obvious enough to his mind, he made quite sure of it by scribbling under a print some apposite quotation from Jesus.

Of the Impressionist pictures which were then beginning to stir Paris he saw nothing and said nothing; if he heard of them— and it is difficult to believe that, working in a famous gallery, he would not hear some rumours, even if unfavourable ones, of this mighty revolution—he paid no attention.

The conversion of Gladwell, the prayers, the Bible-reading, the sermons and services and the exhortations to Theo (who was keeping his own counsel)—not even these could compensate for the days of godless bartering at the gallery. Towards the end of the year he grew unbearably restless, began to lecture prospective customers and finally, although it was the busiest season of the year, went off without permission to spend Christmas and the New Year with his people. His father had moved again, back into the Brabant country they loved, to the little village of Etten.

The reunion was not a joyous one; Vincent announced that he could stay no longer at Goupil; the art dealer's life did not suit him; he thought it ungodly. The news was a blow to his parents; if Vincent persisted in leaving the business he would make trouble in the family and would probably ruin his prospects, for he had no money, his father had none, and Uncle Vincent would

almost certainly do no more for him. Yet his father, though bitterly disappointed, did not try to change his son's mind; he respected scruples of conscience. "There is so much good in him," he told Theo, "and he certainly is not happy."

But what would Vincent do? To that question he had no answer, he did not know. He wanted to lead the good life, to help others. His father suggested that he should try to get a post in a museum, but Vincent would not hear of it; he could not work in a place which showed pictures or exhibits of which he could not approve. He also rejected a plan for him to try to open a small picture-shop where he could sell only the prints and paintings he thought fit for sale. This would mean help from the uncles; they were no more in his good books than he in theirs. His father, looking at the angry, intolerant eyes under their projecting brows, at the cropped red hair exposing the obstinate angular head (for Vincent had cut away his long hair as a protest against vanity), at the cheekbones that seemed to have expanded wider and wider in the past year as the cheeks lost their youthful plumpness, at the ungainly figure, the heavy feet and hands, could only sigh and agree. How indeed could this son of his, so good at heart, so incomprehensible in his feelings and so ruthless in his expression of them, hope to develop a business that called for at least a modicum of the graces of life? It was left to Theo once more to urge his brother to take his drawing seriously, to try to paint. Did he not see as a painter, write like a painter, was he not for ever scribbling little sketches?

But this too would not do: if he could paint, said Vincent, he would paint like Millet—the same subjects, the same treatment. But Millet had said all that there was to say; it would be an outrage as well as an impossibility to try to improve on him.

Back then he went to Paris after his forbidden holiday, with nothing more settled than that if he felt unable to remain at the gallery he should leave it. The head of Goupil, sending for him as soon as he returned, relieved him of the choice: he dismissed him.

Chapter Five

THE REVIVALIST

1876-1877

I N his account of the interview Vincent was disingenuous for
the first and last time in his life. He expressed the hope, he
told Theo, that the chief had no serious complaints against
him. The chief disillusioned him; he had taken French leave of
the business at its busiest season, and his behaviour towards
customers was unhelpful. Vincent, surprised and pained, ad-
mitted that he had behaved badly—but in one sense only, since
he was simply obeying the voice of conscience.

He wrote in this fashion because he wished Theo to show his
letter to his manager at The Hague, Tersteeg. He had dis-
appointed the London manager, he had quarrelled with the Paris
manager and the head of the firm, but Tersteeg had been pleased
with him, Tersteeg represented years of peace and happiness
and, in the main, what he called sound judgment—for the type
of picture sold at The Hague differed greatly from those in
demand at London and still more at Paris. Tersteeg was another
of his heroes; his continued approval was precious and necessary
to self-respect.

Because of his uncles' distinguished record with the firm,
Vincent was given until April to look round for work. He tried
his Uncle Vincent unsuccessfully, then, his inclination fastening
on England, he replied to advertisement after advertisement, also
without success. In his room at night he and Gladwell inter-
mingled their Bible-study with certain secular books, George
Eliot, Longfellow, Hans Andersen, Keats, Bulwer Lytton—all
being passed on to Theo. In the gallery by day he had to remind
himself, he told Theo, to be patient and meek; the reminder was
not always heeded, and his abrupt departure after a violent
scene with the manager relieved everybody.

On this very day he received the first answer to his many
replies to advertisements. A Mr Stokes of Ramsgate offered him
a month's trial without salary as teacher in his boys' school.
Vincent, believing this to be the work of God and an answer to

41

prayer, at once accepted and, after a day or two at home, went back to England. By the middle of the month he was at Ramsgate. He had passed Zevenbergen in the train on Good Friday and the sight of his old school threw him into a reverie that did not avoid the sentimental; in a loving letter to his parents he declared that all were longing for each other—himself in Ramsgate, Anna at Welwyn, Theo at The Hague, the others in Etten —but all were united in God when separated physically.

As for the school, all appeared good to that uncritical eye in such a mood; twenty-four boys, another young teacher, a house overlooking the sea, and although the place was full of bugs, the view from the window made one forget them. Mr Stokes at first appeared rather jolly; he played marbles with the boys and allowed Vincent to take the older ones for exciting walks by the rough sea. Vincent taught elementary French and German, arithmetic, dictation, he bathed the boys, played with them, told them improving stories from *The Wide, Wide World*. Then Mr Stokes' bad temper burst out. He was often bad-tempered it appeared; when the boys were noisy he sent them to bed without supper. Vincent, who was not getting much to eat himself, watched them mournfully. And after his trial month was up there was no talk of a salary: the school was to move to Isleworth on the Thames—at enormous expense, Mr Stokes explained. It moved, and Vincent, going ahead, walked from Ramsgate to his sister at Welwyn, walked throughout the night and gloried in it. He visited Gladwell's parents in London and was pathetically proud because they asked him to stay the night. He refused, but almost happily. At Isleworth, the enormous expense over, he raised the question of salary again. He was becoming very hungry—Mrs Stokes was a thrifty manager. Mr Stokes was blunt; he could get as many teachers as he wanted for board and lodging only; Vincent could take it or leave it.

As soon as he could he left it. During his free days he had gone into the question of becoming a London missionary—that is, a Bible-teacher who visits the poor, the dock labourers, the strays, the foreigners in the poorer quarters. That, he felt, was his work. He wrote to a clergyman he had often heard preach in earlier days. Would he keep a fatherly eye on him ("I have been left very much to myself") and if possible get him a position as missionary? "When I think of my past life and my father's home,

I feel, 'Father, I have sinned against Heaven and before thee and am no more worthy to be called Thy son. Have mercy on me, miserable sinner. Make me one of Thy hired servants.'" "You may think", he told Theo, to whom he had sent a copy of the letter, "that I am not so bad after all. But I am sure I am." His parents he alarmed by vague remarks that he felt himself to be threatened—by what he did not explain.

He did not get the coveted position—he was a year short of the age limit of twenty-four—but he did get away from Mr Stokes. A Mr Jones near by, a Methodist schoolmaster, engaged him to work in his school. Mr Jones was no more free with his money than Mr Stokes had been—indeed, he was soon sending Vincent off on day-long dunning expeditions to recalcitrant parents in the poorer quarters of London—but he was kinder and he dangled an irresistible bait; he would make Vincent, as soon as possible, a Bible-teacher; it might even be that he would call on him to preach in his little wooden church at Turnham Green. Vincent moved, radiant, to his school without delay. He remained hungry but hopeful, now teaching a little, now off on errands to London, always on foot, now telling the boys over-long stories at night after extensive Bible-reading and prayers.

And at last, in autumn, the day came. "Your brother has preached for the first time," he wrote ecstatically to Theo. The sermon was not a good one—his English was imperfect and he spoke badly—but he was beside himself with excitement and joy. He had struck the first blow for God and he knew now what he must do.

But this excitement was bad for a body weakened by tremendous walks on an almost empty stomach. He behaved like one crazed —as in a sense he was—studying the Bible half the night, getting up at dawn to walk off to London, never resting. The little money he had went on new boots and tobacco for his pipe; he had none for food. He slept anywhere that he found himself—once on the steps of a church. His letters to Theo were a strange mixture of descriptions—sensuous yet exact—of all he had seen and of paintings, together with a confused babble of theology. Often enough his letters were sermons pure but not simple—filled with Biblical quotations, with directions to Theo to read selected passages from the Bible, with religious poetry and ending with a

long prayer. Reference to secular matters was ostentatiously avoided. These letters, with their overcurrent of unhealthy excitement, worried Theo—Vincent was so obviously unwell in every sense and revealed a disturbing hint of the family weakness —but did not greatly affect his own mind, young though he was. He was making himself indispensable at the gallery in The Hague and resisted all attempts at conversion without difficulty (they must always think and feel alike, demanded Vincent— meaning simply that Theo must follow him) but with tact. He also, having natural good taste, resisted much of Vincent's advice about paintings and books—advice which his religious fervour had not improved. Vincent related excitedly that he had recognised Millais one day on the street. He had reminded him of the hero of *John Halifax, Gentleman*, then his favourite reading after the Bible. And he praised "The Lost Mite", giving a full and reverent description.

This and much more in the same style Theo could hope Vincent would throw off when he grew up emotionally and when the religious mania left him. He was chiefly worried by the latter and longed to see Vincent exercise in the right direction the genius which he knew was there. But he could do no more than wait, listen, moderate Vincent's frenzy where he could, and warn his parents that they would find a changed son when Vincent returned home.

He did well to warn them: when Vincent came to Etten for Christmas he shocked them profoundly: he looked much older than his age, thin, haggard and ill, the cheekbones standing out in painful prominence: his clothes were tattered, he fell ravenously on the food put before him. His sisters (two of them were still at home) were more bored than worried. In the old days he had at least livened up the parsonage, if not always in the pleasantest way, but now he was unsociable and dreadfully dull, his conversation eternally of the vanities of the flesh. In a country parsonage where news of the great strangeness that was London would have been welcome this was distinctly hard. They complained mildly to Theo, but Theo would not hear a word against his brother; mistaken he might be, but wrong never. He reproached them as sharply as he was able; Vincent was a great man, not amenable to the laws that governed lesser folk—did they not understand? They did not. "You think he is something

more than an ordinary human being. I think it would be better if he thought of himself as an ordinary person."

But his parents, unconcerned by such distinctions, saw simply their loved and difficult son ill and in trouble. He must not go back, declared his mother; she would not permit it. Why, she asked, did he not occupy himself with art and nature? He loved to walk, to observe, to speak and write about the beauties he had seen; he was for ever trying to sketch—she thought, very nicely. To this he would not listen. Art! Nature! when he had found a greater than either! But to stay in his own country—in this he needed little persuasion; once the intoxication of the sermon had worn off he had been mostly miserable. There was no future for him with Mr Jones—he knew it.

But what should he do? And it was after the question had been put that his father was given the greatest shock—greater by far than the tired, prematurely old face, the worn clothes, the hunger. He knew now what he wanted to do, said Vincent; and as he began to explain his father regarded with dismay this son so unlike his other children. In everything he ran to excess; as a child he could not play a game without hurting someone; as a boy he could not discuss anything he cared about without flying into a rage. Now his small light eyes glared with frightening fervour. "Love God!" he cried; "all must be brought to His feet and I, unworthy, must bring them there; I must preach Christ crucified. I must live the Christ life."

The perplexed father pointed to his own life—had he not done his duty, was he not respected and loved in the parish?—but this practical example of the love of God was not enough for the young man walking up and down before him, gesticulating stiffly. Vincent talked of following Christ, but what kind of Christianity was this antithesis of meekness, his father wondered? where was the love of which he was for ever talking? In his heart, no doubt, but not in his voice, his look, his appearance; there one could see only the imperious urge of a strong will who, to save his own soul, was bent on saving others. Who would listen to this fanatic—or, listening, would not shrink from him and his teaching?

The Church would scarcely accept such a man, he feared, he almost hoped, and if it did he could not afford to give Vincent the University training he would need.

PORTRAIT OF VINCENT

At this point Uncle Vincent stepped in again—more for the sake of his worried favourite brother than for the disappointing nephew. Let him try book-selling, he suggested wearily; and forthwith arranged with Braat, the manager, for Vincent to be given a place in the famous old firm of Blussé and van Braam at Dordrecht, between Etten and The Hague.

The selling of books, unless they were Bibles or theological works, could not be considered a large or a logical step towards his goal, but Vincent was very tired, very hungry and very much averse to London again. He was also beginning to feel uncomfortable at home, impatient of what seemed a lukewarm Christianity and resentful of pity real or imagined. At Dordrecht at least he would be near Theo. If he were to prove himself worthy, God might intervene, guide, help. So, having begged Mr Jones and his wife "to wrap recollections of me in the cloak of charity", he went off to Dordrecht in January of the new year, 1877, newly clad in a respectable suit but inwardly unchanged.

Chapter Six

DORDRECHT-AMSTERDAM
1877-1878

THERE was never much chance that he would settle down in a bookshop, and in less than four months he had done with it—and it with him. He kept long hours, from eight in the morning until an hour after midnight, but without complaint; it was his duty, he said, unconsciously echoing his father and grandfather. Nevertheless he was all but useless in the shop and would have been dismissed after the first week or two had it not been for his connections. His heart was not in the job; he spent hours at his desk translating passages from the Bible into English and French, and at odd moments he sketched trees on scraps of paper—trees which, the disapproving Braat noticed, were for ever gathering new branches. And when he did give his mind to his work it often took, in Braat's eyes, an undesirable form; his advice to customers wishing to buy pictures (of which the shop had a good stock) was not to consider such immoral rubbish.

And what a sight he was! Not at all a credit to the famous business with his bristly bullet-red head, his glares of disapproval, his suit which he had somehow managed to turn already into a disreputable ragbag.

However, whatever he did or did not do in the shop, he was there day after day from morning to night and he took a savage pleasure in mortifying the flesh. He wanted to stop feeling, he wanted to stop thinking. But his body was still too strong, his mind too active. He walked ferociously through the town, often coming late to his boarding-house and missing the meals. He haunted churches, moved to tears by the very sight of them and by the sound of common worship. On Sundays he attended services at three Protestant and one Catholic church, and when a fellow-lodger expressed surprise that he should enter the latter, he burst out, "Do you think God can't be found in all churches?" He soon became a laughing-stock in the boarding-house. One lodger, a schoolmaster, who shared a bedroom with him, walked once or twice with him, the rest treated him as a hopeless crank.

He badgered the schoolmaster into attending church, urged him passionately not to marry until he had reached the age of forty, and begged his permission to cover the walls of their room with prints—mostly religious ones. Under each print containing the head of Jesus he wrote, "always sad yet always filled with joy". He looked like a down-and-out, he was for ever reading the Bible, making notes on it and writing sermons, he rarely spoke except to try to convert the lodgers to his way of thinking—then he would talk endlessly—he never visited, he went to bed at fantastic hours, he sketched and scribbled texts on the walls, he always prayed at length before beginning a meal, and his glances —wild, far-away, altogether strange—had for safety's sake to be regarded as a huge joke.

Theo remained as ever his strength and standby. To Theo he wrote again and again of what he had seen and what he had read—the Bible, of course, the *Imitation of Christ*, George Eliot, Carlyle, biographies of Millet and Breton. And he once met Theo.

Their meetings were not so successful as their absences. In Vincent's letters Theo saw the man he loved and worshipped, in his presence doubts rose: Vincent seemed to go out of his way to look uncouth and suspicious: his manner was contentious; why do himself such an injustice? Yet a hint of this would bring him down on Theo with a passion—he was hypersensitive, looking for slights.

Vincent, who would face and indeed anticipate every trouble but this, resolutely refused to regard these rare meetings as anything but a culmination of his correspondence with Theo and a strengthening of the Ryswyk pact; he rhapsodised about them, sentimentalised them. He dared not do otherwise; that one pillar of love and understanding withdrawn, his whole life would collapse.

Yet he was far from happy; he was conscious of sin, of talent wasted, of inability to see his way clear. Why did people not love him—even avoid him? Because they divined the sin in him—he could think of no other explanation. He longed to speak lovingly to them but the words would not come and the loving looks turned despite himself into glares of disapproval. The devil in him was choking the goodness: to feel love and to express hatred —what hell was that! Looking back with longing to the days of Zundert, he saw himself enjoying without struggle, loving and

being loved; now he felt tired of everything, everything he did seemed wrong. Ought he to try to get rid of this feeling, he asked Theo, or was it simply a longing for God that he ought to cherish?

Theo's answer was growing automatic. He was grieved to think of Vincent so wretched—and wretched he believed over nothing. His preoccupation with sin was becoming a morbid obsession; he was misinterpreting his dissatisfaction. Could he not understand, by his perpetual drift to the picture galleries, by his perpetual effort to fix in words the look and feel of what he saw, even more by his efforts to sketch them, that his true bent was towards art? He begged for more sketches.

Vincent sent him not more sketches but verses he had copied from the Psalms and religious poetry. Draw! Paint! How could he, a sinner, even given the ability, put on paper or canvas anything that would edify the world? Let him first purify himself, then try to purify others. The example shone before him, breathed out of every hymn and prayer he heard on Sunday, rose up from the pages he read every day. He had a new hero; before Millet, before Breton, before Mauve, before his father, immeasurably superior even to these—Jesus. He must think of Jesus all the time, everywhere; he yearned after His book, the Bible, he wanted to know it by heart. Then—then! "My life will somehow be changed." Remember that painting *The Light of the World*, he says; "In that great work you see where the peasant and the prostitute get the strength to bear their hard life; and that is where you and I too will find strength, and nowhere else."

Theo could never resist Vincent; he must be right; against all appearances he must be right—that was his creed, and it over-bore conscience, common sense, intuition, everything. He was, besides, only twenty years old. He was old for his age—he had to be—but when word after word poured on him, for Vincent was never at a loss for words with him, he felt a child. Marvellous Vincent! a very giant of wisdom he seemed. Theo was unhappy himself; he had had a disappointment in love, he felt sad and lonely; perhaps Vincent's God would help him too.

Braat, when Vincent spoke to him of his longing to preach the Word, had expressed doubts. Glad as he would be to be rid of him, he wondered how Vincent could possibly become a minister. His father showed no sign of getting a preferment—he seemed destined to stay at Etten with its poor stipend—and could not

afford the fees for the necessary training. Vincent flew into a rage. His father was in the right place, he said; he was a true pastor. And when Theo came over to Dordrecht once more, towards the end of March and just before Vincent's twenty-fourth birthday, he agreed readily to go up to Amsterdam to see Uncle C. M. and Uncle Jan. Theo was spokesman. Of Vincent, "shoe-contemplative, brow-hanging, strange", the uncles thought little enough; he was getting the character of family black sheep. But for his advocate, the handsome, gentle, pleasant-spoken young Theo, they had an affection; they listened, they agreed. After all, if the lad wanted to go into the Church, why not? It ran in the family, and he was fervent enough in his rough unpleasing way. He should be given a chance—one more, one last chance.

Uncle C. M. took Vincent off to the famous Amsterdam preacher, Stricker. Vincent's aunt had married Stricker; he was a power in the land; he could put in a word for Vincent if he would. He agreed: if Vincent's father was willing he would find the right teacher, he would give the boy advice and help. Uncle Jan, now Commandant of the Naval Dockyard, offered Vincent a home while he studied; Uncle C. M. offered him the run of his gallery in his spare moments.

With misgivings his father and mother agreed to the new plan, wondering how a young man of his age, having settled to nothing, could settle to a solid two years of preparatory work—for that was the shortest time in which he could hope to pass the University examination. And what kind of pastor would he make? But he wanted it so desperately; the reliable Theo had spoken for him; and what else could he do? Uneasily they agreed.

Only from Prinsenhage did there come a roar of whole-hearted disapproval: so this was all he thought of his Uncle Vincent's help—to throw up a good job after three months to become a preacher! As if the wastrel could ever pass an examination, let alone preach—he was done with him.

A few days later, a free man, Vincent went back to Etten. He was in an ecstasy; everything and all appeared good to him. He broke into a rhapsody about Anna, with whom he had had little to do since the early days with her in London, and who was engaged to be married. "Don't you think", he asked Theo, "she has something in her of the woman who loved Jesus?" He quoted verses in her praise and harked back fervently to the past: "How

beautifully she behaved with the family at Welwyn, how she consoled them when the child was ill and died. I saw how they loved her. Father and mother are also very fond of her, as we all are. Oh, let us all remain close together!"

In May he went off to Amsterdam. "What is needed is nothing less than the infinite and the miraculous," he told Theo. He was thinking of the higher aspirations of man, but he might well have applied the remark to his present position. The plan was not as he would have had it, but he went fervently praying "that my father's and grandfather's spirit may fall on me". He cries to Theo: "Oh, if I might lose the terrible depression of knowing that I have failed in everything! If I might no longer hear and feel reproach after reproach! If only I might be given the strength to succeed in this!" He worked hard, but all was against the grain. What had he to do with examinations and Universities, with comfortable rooms, smooth talk, fine linen and leisurely meals, whose one thought was to be preaching among the common unprivileged men?

After a few months it became clear to his tutor in classics, Mendes da Costa, that his chances of passing the examination were slender. When he finally learned the rudiments of Latin he used them to stumble through the *Imitation of Christ* in the original. He showed no prospect of being able to master Greek and protested again and again: "Mendes, do you really think such dreadful stuff as Latin and Greek is necessary for a man like me who simply wants to make the poor satisfied with their earthly life?" Was it not true, he asked, that the Bible, the *Imitation of Christ* and the *Pilgrim's Progress* would be more useful to him? "I don't need anything else."

Da Costa felt that there was much in this, but he was being paid to tutor him and he did his best to ram the classics into a head filled with other matters. Vincent, too, tried to force himself to the task, tried by the only way he knew—by punishing the body. Almost all that he read encouraged a natural tendency to self-chastisement. He would be a monk of old groaning happily in his hairshirt, he would be a follower of Carlyle scorning the ephemeral happiness, he would practise the severe and joyless morality of George Eliot. To suffer for his beliefs—that was his joy. So to punish himself for neglect of duty he stayed out so late that Uncle Jan's house was locked up for the night and he

had to lie in the cold on the boards of a garden hut. Morning after morning he came for his lessons with a "Mendes, I got myself locked out again last night", or, his duty laying an even heavier hand on him, "Mendes, I used the cudgel again last night". Da Costa, though half admiring this barbaric stoicism, showed anger; and to appease him Vincent would arrive with a little bunch of snowdrops: "Mendes, don't be angry, I've brought you some flowers because you're so nice to me."

But all was useless—labour, sacrifice, punishment. After a year he gave up. He would never pass the examination, Da Costa agreed. He gave up after a violent scene with Uncle C. M. and went home to Etten. He was twenty-five and seemed to his despairing parents to be good for nothing. His year in Amsterdam was notable for two things: his attraction towards Stricker's daughter (of which he said nothing because she was married); and the fact that he showed himself unmistakably a born painter. Only a poet or a painter could have written the letters he wrote to Theo from Amsterdam: everything fascinated him—the people, the town, the countryside, and particularly the effect of light. There was no commonplace for him and no sordidness: "I prefer old, narrow and rather gloomy streets"; and he preferred the kind of people to be found in those streets; as he had gone to the peasants in Brabant, so he went to the poor and the workers of Amsterdam. Nor was it enough for him to write. "When I write," he apologises, "I seem instinctively to draw a little sketch, I see it all so vividly in front of me."

Theo begged him at least to try to paint, but his year at Amsterdam had taught him nothing; it was a wasted year, he insisted, not because he had mistaken his vocation but because he had gone the wrong way about attaining that vocation. His instinct had been right, to go out and preach forthwith. And he knew where he must go—to the Borinage. He had read about the Borinage in one of his lesson books at Amsterdam: in these coal-fields in the south of Belgium men and women lived even more wretchedly than the peasants of Brabant; they were the lowest of the low. They would not despise him.

He was adamant. The Borinage! he insisted in a frenzy; he was not to be gainsaid; argument only made him madly furious. The girls were frightened of him, his father reproachful—"you are breaking up the family ties"—puzzled and distressed, his

mother by turns angry and sympathetic. In such a state he could not stay at the parsonage. His uncles would help no more. Mr Jones was written to at Isleworth: Vincent was of an age now to be a lay-preacher; could he help to place him? Mr Jones responded nobly—Vincent's few months at Isleworth had left their mark—by coming over to Etten: he knew of a training-college in Brussels; he could recommend Vincent. After three months he could be nominated for mission work.

At the mention of more training Vincent was with difficulty persuaded not to rush off to the Borinage. In July he, his father and Mr Jones visited several colleges, and it was agreed that Vincent should return to one towards the end of the next month, after Anna's marriage. His father, accustomed to accompany Vincent in fear and trembling, was relieved by his manner; he seemed to promise a real attempt at tractability; and he answered questions with gratifying intelligence. England and the year in Amsterdam, the pastor writes, "have not been quite useless after all. When he takes the trouble to exert himself he shows that he has learned and observed much."

Though impatient to begin teaching, Vincent felt less harassed than usual and his parents saw in him a shadow of the boy they had loved. One Sunday his father was to preach at Zundert and Vincent, who associated the village with peace and happiness, offered to go with him. A year earlier, hearing that their old gardener was dying, he had hurried down from Amsterdam, walking the last fifteen miles through the night. Now he called on his old peasant friends and, mellowed and calm, began the drive back with his father across the heath. In the midst of scenes so well known and so much loved father and son felt an accord that had been absent for years. They stopped the horse, got out and walked together. The sun was setting behind the pine trees, the reddened sky was reflected in the pools, the heath and the sandy tracks—white, yellow and grey—spread away into the distance. All was as it had ever been, and over all spread the quiet of evening. How often had they known it so! Life, Vincent told Theo, seemed at that moment no more than a sandy path through the heath, peaceful, harmonious, full of good feeling.

"But", he added, "it isn't always." And soon after that prophetic understatement he went off to Brussels, the short interlude of peace with his family over, and over for ever.

Chapter Seven

THE BORINAGE

1878-1879

BOTH parents felt an omen of worse to come when Vincent went away. "I am so afraid", his mother said, "that wherever he goes and whatever he does he will spoil everything by his peculiar behaviour and queer ideas." His father, remembering the last glimpse of his son, comments sadly: "It grieves us to see absolutely no joy of life in him when we have done everything we could to procure him an honourable position. He always walks with bent head. It seems as if he deliberately chooses the most difficult path."

"He always walks with bent head"—that was Vincent, counting himself as nothing, mortifying the flesh. He would follow Jesus—but in his own way; in his heart deep humility, on his lips a fierce egotism. He would not be taught; he could read; he knew the Bible almost by heart; there was God's word; what need had he of man's guidance? Let him go through the farce of training, then to real life. He was the most advanced of the few students at the college, the most promising, but he would not be taught. "He didn't know the meaning of submission," said one of them. He questioned everything, argued violently, was rude. In the smallest matters he showed an angry indifference to what was considered necessary detail. Bokma, the principal, asked him during a lesson, was a word in the dative or the accusative? "I don't care," said Vincent; and nothing could move him. He insisted always on writing with the paper on his knees. When told to use his desk he answered, "This is good enough for me." In his turn, Bokma refused to let him make a sketch on the blackboard during class. The moment the lesson was finished Vincent jumped up and began to sketch. One of the students pulled at his jacket. Vincent turned savagely and struck him in the face with his fist. His face was ugly with rage.

For their part, the other students looked askance at his clothes, tittered at his lack of manners, criticised his chaotic untidiness, told him to wash more often. What had these things to do with

54

the saving of souls? he wondered contemptuously. He felt like a fish out of water in this namby-pamby training-ground of Christianity where clean, well-groomed young men were taught the externals of God's word with none of its spirit. He didn't come to Brussels to be made a gentleman or to learn rules—he came to fit himself for intercourse with the poor and lowly. But, his teacher pointed out, he could not speak extempore; he had always to read from a paper; what use was that to a lay preacher talking out of doors, in dark cottages, anywhere, at any time? It was true; humiliated, Vincent sulked, stormed; nothing could be done with him.

At the end of three months his nomination was refused. Vincent made light of the failure to Theo, sending him a drawing of a charbonnage in the coalfields near Brussels; he had walked there and had struck up an acquaintance with some of the miners. What grand people they were! His intuition was right; the miner was another peasant of the stock that Millet had painted, that Jesus had chosen—oppressed but truly virtuous, the rock on which humanity was built. He would like, he said again, to make many sketches of the things and people he saw, but "they would keep me from my real work". As soon as he got back, he turned from the sketch to a projected sermon on the barren fig tree.

He spared Theo, but no one else. The principal of the college summoned his father: Vincent had grown weak and thin, he could not sleep, he was in a nervous and excited state; he must be taken away. His father hurried down from Etten. Vincent alarmed him; he showed ominous signs of the family weakness; he looked and spoke wildly. But he knew what he wanted. The Borinage! he demanded again and again—the Borinage!

Could he go? his father asked the principal. If he went as a private person and without salary would there be any hope of an eventual nomination as lay-preacher? The principal looked at the anxious man with the beautiful face, the face so unlike that of the distraught son opposite; he stretched a point—Vincent could go and his work would be watched.

At the beginning of December Vincent was sent off to the village of Paturages near Mons in the Borinage. He boarded with a hawker at thirty francs a month. His father helped him by ordering large maps of Palestine to be drawn at ten francs each,

and Vincent earned a franc or two by teaching the hawker's children every evening. He began at once to visit the sick—many were ill from undernourishment and more from lung trouble due to coal-gas fumes—praying with them and reading the Bible to them. He gave short talks in the village hall, in sheds and stables. He talked in French, forsaking his native Dutch. He wrote to Theo almost with happiness; at last he was being accepted uncritically; no one stared at his shabby clothes—they looked respectable beside the miners' blackened, tattered rags; no one turned away from his harsh, hollow face—the villages were filled with faces hollower, more heavily lined; no one resented his abrupt speech—the local dialect matched it for brevity and lack of grace. It was a hard life and a practical one. It was just what he wanted.

The country under snow fascinated him. Again and again he comes back to this: he was in the Borinage to spread the gospel as he had been in Amsterdam to learn the classics, in Dordrecht to sell books, in London to sell pictures; but here, as there, his first and true thoughts are the thoughts of a painter. Everything reminds him of the paintings he loves: at Christmas he looks about him and sees the very spit of the mediaeval pictures of the peasant Breughel; the combination of red and green, black and white that met him everywhere had been treated just so by one of the Maris brothers; the deep lanes overgrown with thorn, the gnarled old trees with fantastically twisted roots were living Dürers. When the snow melts he describes the Borinage "with its chimneys, heaps of coal, its little cottages, the tiny black figures scurrying about like ants, and in the far distance dark pine woods with small cottages white against them, a church spire or two, an old mill, usually with a haze over all or a weird effect of black and white formed by cloud shadows that reminds me of Rembrandt, Michel . . . and Ruysdael"; and when he sees the cart with its white horse bringing home an injured man from the mines—a frequent sight—he thinks at once of a picture by Israëls.

He is almost happy; he will be completely so, he tells Theo, if he is accepted as an evangelist. In January of the new year, 1879, he was accepted; he had done useful work, he was winning the confidence of the people, he was rewarded by a six months' trial at fifty francs a month. He was given the village of Wasmes as his

centre. There he had to instruct the children, to give Bible talks, to visit the sick.

He had what he wanted, what he had sought frenziedly for the past three years—he was an official servant of God, doing His work amongst the only class of people who aroused his love and charity. For a week or two he was happy; then his conscience smote him: he was being accepted by these people, but was he a part of them, did he lead their life, share their sorrows and their sufferings? In his heart—yes, but that was not enough; true love demanded that he share them literally—who was he to preach at them from the shelter of a comfortable room, with clothes enough, food enough and a salary besides? *"Mourir à soi-même,"* wrote Renan; and did not Jesus say, "He that would follow me must take all that he hath and give unto the poor"?

He no sooner asked himself the question than he acted; he gave up his room and moved into a hut drearier even than the hut of the meanest miner; he gave away all that he had—it was little enough, but he gave it away—his bed, his few francs, all his clothes. He dressed himself in sackcloth, slept on the mud floor of the hut, lived on scraps of bread. He went down the mine, enduring the terrors, the discomforts that made up the miners' daily life; he came up, like them, with his face black with coal dust; he left it so—he was not going to insult them and God with the white face of a man who preached but did no work.

Within a few weeks the district hummed with the extraordinary conduct of this new lay-preacher. The church council at Wasmes protested; what kind of example was this—a man who took pride in looking and living lower than the lowest? The inspector came down late in February, Vincent's father was written to again, Vincent himself was told that he must reform or leave. He was unperturbed. "Jesus also was very calm in the storm. Perhaps it must grow worse before it grows better." His father made the long journey, hid as best he could his distress at sight of the scarecrow who greeted him, and somehow persuaded him back to his lodgings, reclothed him and left him money.

That was in March. For three months no more bad news reached the Etten parsonage; Vincent's letters were normal enough, he stayed at his lodgings, he had had no more trouble with the church council. But there was a difference in his letters nevertheless. His interests were changing; he spoke less of his

Bible classes and preaching, more and more of his attendance on the sick and injured. Practical Christianity—that was his cry. He was becoming a kind of unpaid doctor in the villages round about; the work fascinated him and, awkward though he was in everyday life, he showed a flair for it—a flair and a complete disregard of self; when he needed a bandage he would tear strips from his underclothes.

Less encouraging to those who read his letters were the obvious signs that he was identifying himself increasingly with the miners —not now in appearance and style of living, but even more dangerously by taking their side politically. The *Hard Times* of Dickens, one of Vincent's heroes, inflamed his indignation. He found, devoured, and worshipped *Uncle Tom's Cabin*. Were not the miners also slaves—paid at starvation rate, running terrible risks and unable to change livelihood or neighbourhood? They were there for life whether they liked it or not—and it was usually a short life; injury or disease accounted for most of them before they were beyond the forties. Even the women had to go down the mines, dressed in men's clothes, to keep the family alive. Zola was soon to tell the story of these people in *Germinal*; Vincent discovered it for himself. He loved them; they were being victimised; how could he tell them that God decreed that there should be high and low, that they would meet their reward in another life? The words stuck in his throat. He began to question what he was supposed to teach: love of man as expressed in the life of Jesus—by that he stood firm; the official teaching of the Church was another matter.

By the summer his indignation had reached a pitch and he was all ready for trouble. It came after a great storm followed by an explosion in the mine. Vincent worked like one possessed, rescuing, dressing wounds, bandaging. His mother, anxious to do him justice and justify her love, spoke proudly of his devotion to the poor: "God will not fail to see it." But as his love for the stricken miners and their families blazed high his hatred of the mine owners redoubled. When the miners came out on strike after the explosion he was one of the biggest firebrands, urging them to fight for their rights, heartening and encouraging the strike committee. He was reprimanded by the council, reminded that his concern was primarily with the men's spiritual welfare; his father was appealed to, but Vincent would not listen. "He seems

deaf to all that is said to him," said his mother a week or two after her letter of praise.

In July he was dismissed; he was given three months to look for another job, but although penniless he spurned the gesture. He walked to Brussels, sleeping by the wayside, selling little sketches for a crust of bread. He was on his way to a man named Pietersen to whom he had been introduced by Mr Jones in Brussels. Pietersen was an evangelist but he also dabbled in art; he had a studio; they had talked together about painting. Now Vincent went to him for advice; he did not know why; his heart was still so full of the miners that the obvious reason why he chose Pietersen rather than his parents was not obvious to him, was not even suspected.

He stumbled into the city worn out. Pietersen's daughter, opening the door to him, screamed, ran away and called to her father to deal with the dreadful-looking tramp standing on the doorstep muttering incomprehensibly. Pietersen, recognising him after a moment, asked him in, got him a room for the night, fed him, showed him his studio and calmed him down. They talked of art, discussed Vincent's sketches—he had brought with him a bundle of sketches made since he had gone to the Borinage —and his future. "He gives me the impression", Pietersen wrote to Vincent's parents, "of a man standing in his own light." A profound remark; and as wise was his realisation that only Vincent could remove himself from his own light. What did he want to do? Good. But how? He had no idea. He seemed certain of one thing only: he loved the people of the Borinage; they were his type of people, the true aristocrats, the hope of the world. Pietersen told him to go back and gave him the address of a man in Cuesmes, a fellow-evangelist, who would put him up. He bought one or two of Vincent's sketches so that he would have money for the fare.

Vincent went back, but had no sooner settled in his new room than his parents begged him to come to see them; they sent the fare to Etten. He went in the middle of August: he was a deplorable sight, dirty and in rags, though, said his mother, "he looks well". But that was little comfort even to her, for in all else he was a pain and a sorrow; he sat day after day reading Dickens, he never spoke unless he was spoken to and he would not discuss the future. His father reproached him again for disgracing the

family; Vincent said nothing. His mother wept; he said nothing. They begged him to stay with them rather than go back to uncertainty and hardship: he refused. "You don't trust me, you think me impossible; the best thing I can do is to go away and be as one dead to you." So he thought, but he did not explain himself for another year, and then only to Theo. For the moment he was silent and went away abruptly after a few days, back to the Borinage. He was conscious of failure. He had failed at everything. For the Van Gogh family in general he cared nothing. He loved his parents, he knew that they loved him, but they could not understand him, they were worlds away. What, he felt, was the use of talking when every word widened the distance between them—when in any case he had nothing to say? For he did not know what he could do with his life.

He also did not know, and his parents had not sufficient imagination to realise, how much of his behaviour was the effect of hardship. For this they could scarcely be blamed, but they were unintelligent to expect a man who had gone hungry and lived wretchedly for a year or more to behave like people who had never known a day's want or serious discomfort. He was not the son who had left them for Brussels, still less was he the son who had gone off to his school at Ramsgate; he was a changed man, as all are changed who have experienced poverty, wretchedness and despair. The gentle, comfortable, secure life of the parsonage seemed worldly to him and infuriated him. He even despised their goodness as a mere following of convention by rote, not the goodness that has been purged in the fire of mental torment and physical suffering. That there were other and subtler trials of the spirit and that they might not have escaped them never occurred to him; he saw everything as black and white; they were either for him or they were against him.

He went back to the Borinage but could no longer talk to the miners as an evangelist, not only because he was officially forbidden but because the wish had gone—driven away finally by the atmosphere of his parents' home. But although the frenzy to preach Christ crucified had left him, he was not left empty: he had a message of love—his heart nearly burst with it—but how to deliver it? He had work to do—but what and how?

Even his satisfaction at being with people of his own kind soon proved false; he was with them but not of them; with every week,

every day he felt the distinction; they liked him, accepted him, but as a foreigner; in their homes, their families he had no part. And all about him were homes and families; he only, it seemed to him, was left alone.

His loneliness in the midst of love and companionship forced him to be honest with himself; he was a man before he was an evangelist; the love of God was not enough; he needed the love of woman. He still obscured the simple truth; he was still unable to acknowledge the fact that he needed a woman desperately and very naturally; he talked still of how, fulfilled by a woman's love, he would gloriously redeem the wasted years, the humiliations, all things. But at least he faced his great need, however erroneously he felt bound to justify it.

He pined for love, but there seemed to be no love for him; not only was he without the love of a woman—even the love of Theo showed signs of having been shaken. Theo had been transferred to Paris, he was prospering, he showed taste, acumen, and was not afraid to try to sell the work of coming men. He was busy in his new quarters but that was not the only reason for the dwindling of the correspondence with Vincent; he was deeply distressed by Vincent's treatment of their mother and father; above all he was shocked by Vincent's squandering of his own life. Everyone had tried to give him what he wanted, sacrificing themselves to help him; he no sooner had it than he wanted something else. Now he was loitering in the Borinage, living precariously on the small sums Theo and his parents could spare; he took the money, but did nothing—month after month and nothing to show for it.

And yet what gifts he had! Theo's faith in these never wavered, nor did his affection, but he was angry. In October he came down to try to stir Vincent to action; they walked together to a disused coal-pit, La Sorcière, and Theo reminded Vincent of that other walk, to the mill at Ryswyk. "We agreed in many things then," he said. "Now you have changed so much you are no longer the same person."

This cut Vincent to the quick; he was too hurt to argue and too glad to have Theo (even a dissatisfied Theo) by his side to spoil their rare meeting, but as soon as Theo went back to Paris he snatched up a pen and began to defend himself.

Theo had called him idle and asked, why not do something positive—learn engraving, book-keeping, carpentry, anything to

keep his self-respect? Vincent treated the question ironically: to take such a job, he said, would be as foolish as the man who, reproved for cruelty in riding a donkey, dismounted and carried the donkey on his shoulders. "Don't you think I want to better my life—passionately want it?" he demanded. "But it's just because I want it with such passion that I fear remedies that are worse than the disease." Had they not talked again and again, he asked, of what he should do for the best; and had he not done it again and again with the best intentions, to end up looking more foolish than before?

Then, having ignored the fact that his own will had prevailed every time, he got down to the all-absorbing thought in his mind. With him all his life through there was always to be one outstanding need which, fulfilled, would solve all his problems. He now explained: "When you live with others, united by love, you have a reason for living. I am not made of stone or iron. Like everyone else I feel the need of friendship, affection, love. Without these things I feel a void."

But, Theo asked, why did he not take advantage of the love and kindness awaiting him at Etten? Vincent could find no answer but the fact that he had no wish to see his parents, but, "in spite of my strong repugnance and the fact that it will be a hard road to travel, perhaps I may go for a few days at least".

But he did not go; and Theo, though sending his father a few francs now and again for Vincent, had not the heart to write again; there was silence between them for nine months.

Chapter Eight

PRELUDE TO A PAINTER

1879-1880

THESE nine months were the worst months of Vincent's life; they were so bad that even he shrank from recalling them. Physically he was reduced by exposure and near starvation to a wreck; he never fully recovered. Mentally he suffered tortures that the less passionate, less highly strung can only faintly imagine. It was a time of almost unrelieved despair: he did not know where to go or what to do. The Borinage or Etten—those were his alternatives; he could not bear the thought of Etten; he was in the Borinage, so he stayed where he was. But not happily; the people, kindly though they were, emphasised his loneliness; sometimes he hated the sight of them, their wives and children and laughter and the firelight from their huts. Neither Theo nor his father could understand why he, who worshipped the man who got his bread from the soil, did not do likewise. But a man conscious of a destiny working itself out will follow the slightest hint. Vincent had had such a hint; it was faint, it seemed to lead nowhere, but he was not the man to ignore it. He sought steadfastly and with a passion to unravel the enigma of his existence; he was not as ordinary men, love them though he might; he was in the world for a purpose. He now felt the need to seek the answer in books. He began to read enormously. Occasionally a little money came from Etten; his father could afford only a franc or two, and Theo, feeling that Vincent ought to get a job, restricted what he sent. The money was barely enough to live on—it was not meant to be—but Vincent, caught up by this new passion, spent most of it on books and went without food. How he kept alive is a mystery; but for his little sketches he would surely have died. He had grown into the habit of sketching the miners and their people and from time to time he went on with them. The miners liked them—he had no idea of perspective, knew nothing of anatomy, he drew much like a child with the curving lines and heavy, laboured strokes of the pencil, but to them there was a likeness; they gave him a

meal or a copper for them and pinned them to the wall. They were sorry for him too; he looked wretched with his hollow cheeks and scraggy body and haunted eyes—wretched even in a country where wretchedness was a familiar.

He bought more and more books and borrowed them where he could. He read and read: more George Eliot, more Dickens, Victor Hugo, Shakespeare, Michelet. The monotony of his life was appalling. He was absolutely without diversions; he did not drink, he had no conversation, no friend, not even an enemy; the hours weren't even broken by a meal. He sat day after day, solitary from morning to night, without a fire, with a hunk of bread on the ground beside him, his only company a book over which he strained his eyes in the dim, flickering light; he read hour after hour, sometimes in the fields, sometimes by the coal-pits, but usually in his dark room, his cropped red head bent close to the pages, trying to wrest from them the secret of his failed life. He became light-headed, for days at a time he was too weak to walk far, but he read on.

Among the books he read in the early spring of 1880 were some poems of Jules Breton. Breton was one of his heroes, he knew and loved his paintings of peasant life, he read the poems with admiration. It seemed to him that Breton must feel for the common people as he did. Breton lived in the Pas de Calais, at Courrières—might not he lift the cloud about him, point the path? To think so was to act: he saved up, sold a sketch or two, then set out with ten francs in his pocket. He walked to the nearest station and spent eight of his francs on the fare to Valenciennes. From Valenciennes he began to walk towards Courrières. It was a wet and windy March, and Courrières was a good three days' walk. He walked all day for those three days, wet through and buffeted by the wind, but his remaining francs got him a floor under cover to sleep on and a bowl of soup. He walked with the steady plod of the peasant, shaking the drops from his stubbly hair and broad protruding brow like a shaggy dog; he walked with a good heart because he felt that something lay ahead of him, that the future would declare itself. He saw above him a sky unlike the smoky, foggy sky of the Borinage or the heavy sky of Brabant—the clear, limpid French sky. He saw thatched cottages with moss growing over the thatch, and the round haystacks built about a pole, sometimes about a living

tree with the green shoots rising above the hay. He wondered at the change from the black earth of the Borinage and Brabant to brown earth and coffee-coloured clay, spotted with the white of the marl. He watched flocks of crows fly across the clear sky and he thought of Millet and Daubigny; now he could understand them even better. He met diggers, woodcutters, peasants, miners, women in white caps, and walked through villages of weavers, and his heart went out to these people, to the weaver, the peasant, the miner, the despised and rejected, like himself, like the prostitute, like Jesus. If only he could draw them, give his life to the work, and put them before the world as they really were in their nobility, and not the thieves and rogues and vagabonds they were commonly supposed to be! He did not heed the rain, he breasted and beat the wind. There was a thought! And he was on his way to Courrières.

On the fourth day he walked into Courrières. He had no more money but he had reached Courrières. He asked for Breton's studio, turned a corner and it stared him in the face, a large, pretentious, chilly building newly built of brick, stark, hideously regular, like a Methodist chapel and utterly out of keeping with everything round it. So this was the famous painter's studio, the painter of the humble and meek! He turned away sick and angry. He looked through the town for any sign of paintings. There was none; there was only the Café des Beaux-Arts, newly built of brick, as uninviting as Breton's studio. It was decorated with murals representing the life of Don Quixote. They were very badly painted.

He began to walk back to the Borinage. He had no more money but he managed to exchange a few sketches for bread. It rained and it blew. One night he slept on a pile of faggots. Another night he slept on a haystack; the rain drizzled on him without stopping. Yet another he spent in a farm waggon; it froze during the night, and he and the waggon were white with frost the next morning. He walked on. His feet were coming through his boots, they were sore, they hurt every time he took a step forward. His heart hurt still more; he was in absolute despair.

He reached the Borinage; he was ill and he felt that his misery was past bearing. But his stamina was not yet broken; something in him still wanted to live; he did not die; he even recovered sufficiently to make his way to Etten. He wanted to go back to

England, he told his parents; to him at that moment Mr Jones seemed his one friend and hope. He looked like a convict—his head shaven, his face pallid and drawn, only the light-blue eyes still glittering from their deep sockets: the girls shrank from him, the village people stared, his mother could not conceal her distress at the sight of him. His father said that if he really wanted to go to England he would do his best but asked him, would it not be wiser to live near them so that they could help him? At this Vincent's pride reared up: he was being treated as the prodigal son, he was being forgiven, his father was merely applying his Christian principles; he didn't believe in those principles, he didn't believe he was in need of forgiveness; he was not a prodigal, he was a man who had suffered and was suffering for love. He knew that they could not understand, that they saw in him only a disappointment and a shame to them, a man who wouldn't work, who only read books. He would be better away, out of their sight. And with that he walked out of the house as suddenly as he had entered it.

His visit was reported to Theo in Paris. Theo was shocked by Vincent's treatment of his parents, shocked by the way he had let himself go, but he was also worried. He thought of the vows they had taken on the Ryswyk walk, of Vincent's letters pouring out his very soul, of his faith in Vincent's genius. At last, in the summer, he could bear it no longer; he broke the nine months' spell; he wrote to Vincent. How was he, what was he doing?

The letter roused Vincent for a moment. He had gone back to the Borinage, to the hut of a miner who had put down some sacks for him in the tiny room where the children slept. There he lived. Although Theo did not say so, Vincent read into his letter a belief that he remained an idle waster. His wounded pride overflowed into a tremendous reply, a letter begun in bitterness but ending with a passionate plea for understanding. There are two kinds of idlers, he said. One is idle because he wants to be; the other is idle in spite of himself. This second man is burnt up with a terrible longing for action but can do nothing because he is imprisoned, because he hasn't the incentive he needs to make him work. He knows he is good for something and that his life is not an aimless one; his instinct tells him so. "I know that I could be quite a different man. There is something inside me that could be useful. But what is it?"

66

"I tell you what I'm like," he wrote, "I'm like a caged bird. In spring the bird feels there is something for him to do but he can't do it. What? He tries to remember. Then he remembers. He looks about him and cries to himself, 'Other birds are making their nests and laying eggs and bringing up their children.' He beats his head against the cage, but the cage is all round him, he can't get out. He is maddened by anguish. Another bird flies by. 'Look at that idle bird,' he says, 'living at his ease.' Children peep into the cage. They feed him. 'He has got all he wants,' they say. But he looks through the bars and he cries, 'I am caged, I am caged! And you tell me I have all I want! Fools! I beg you, set me free to be like other birds.'"

"I'm like that bird," wrote Vincent. "I can't do what I was meant to do because I'm imprisoned in a dreadful, dreadful, most dreadful cage. 'My God!' I cry, 'am I to be here for long? Am I to be here for ever, for eternity!' And why am I a prisoner, why am I what you call idle? Because my reputation has been blackened, because I am poor, because circumstances are against me, because adversity has fastened on me—all of these. Yet I could be freed simply, and it is the knowledge of this that maddens me. A deep, serious affection—that opens the doors of the prison cage. Friends, brothers, being loved—this supreme power, this magic force opens the doors."

But Theo, he could not forget, had not only called him an idler—he had said that he was not the same person as that boy who had plighted his troth at Ryswyk with the brother who thought, felt and believed like him. He had changed, he had deteriorated, gone down in the world. Vincent agreed: I have gone down in the world, I have lost the confidence of many people, I dress in rags, I have no money, I might have done better, the future looks dark. All this was true, but nevertheless in himself he had not changed for the worse since the walk to Ryswyk. "If I have changed at all, it is to think and believe and love more deeply and seriously now what I thought and believed and loved then."

Theo had reproached him for wasting his time reading books, for this absurd and useless new passion. "I am a passionate man," he admitted, "capable of doing foolish things that I repent of. I say and do things on the spur of the moment when I should do better to pause and reflect. But don't others do the same? Am I

a dangerous man, incapable of doing anything good, because I am passionate? I don't think so. I now have an almost irresistible passion for books. I want to learn, to understand as fervently as I want to eat my food. Is this wrong? When I was within reach of pictures I had a passion for them. You approved this. Then I went away, I couldn't see pictures any more. What was I to do? Give way to despair? No. If I had to be miserable, I said to myself, let it be an active, inspiring misery. What we call the soul doesn't die in one, it lives for ever and for ever searches. So, denied pictures, I turned to books."

Theo had implied that he was hopelessly unstable, that he took up and dropped one thing after another; he thought this passion for books meant that Vincent had lost his feelings for pictures. "But you would be wrong in thinking that I have lost my enthusiasm for Rembrandt, or Millet or Delacroix or whoever it may be. On the contrary. You forget that we ought to love many things, and that they help each other to complete that love. There is something of Rembrandt in Shakespeare, of Correggio in Michelet, of Delacroix in Victor Hugo, and there is something of Rembrandt in the Bible, or of the Bible in Rembrandt, whichever you please.

"So you must not think that I abandon my passions. Rather am I faithful in my unfaithfulness, and though I have changed outwardly I am inwardly the same, and my one desire as ever is to be of use in the world, to do good. This desire preoccupies me always. That is why I have been drawn to love and study pictures and now books. But I feel a void where there should be friendship and strong, deep affections, and a terrible discouragement rises up, saps my moral strength and chokes the natural instincts of love in me. I am thwarted, I am imprisoned, I cry, 'How long, O God, how long!'"

And so he had come full circle. After he had written and posted this long apologia his first relief at unburdening himself gave way to a dreadful depression; he had unburdened himself but he had also disinterred all that made his life a misery. There it was, inescapable—his failure, his frustration, the vast unending waste; he could not even read, he could do nothing; he sank down, down, until he was back again in the black days of the return from Courrières and the desolate, unhinged weeks that followed.

Then, perhaps because the likeness of his misery to the days of Courrières revived a forgotten memory, perhaps because he could sink no lower, light came to him. Suddenly, at the thought of Ryswyk, the experience of Courrières, Theo's last letters to him, his replies to Theo—all joined in his mind and he was a free man.

In his long letter he had said, "I think that everything truly good and beautiful, every moral, spiritual and sublime beauty in men and their work, comes from God. I think the best way to know God is to love many things—love a friend, a wife, love something and you will know more of the love of God. A man who loves the pictures of Rembrandt will know there is a God. A man who studies the history of the French Revolution will see the love of God made manifest. To try to understand the significance of the masterpieces of the great artists—*that* leads to God. One man has told it in a book, another in a picture."

He had written these words to Theo but his own eyes had remained closed. Now, in a blaze of understanding that lighted up all the darkness of his soul, he saw that of all men the painter speaks to mankind with the most unselfish love; he puts his love of life on to a canvas, it is seen, it speaks to the heart, but he, the artist, is not seen, he is content to send out his message, he asks nothing but to express this selfless love of the world.

And what a man is the artist—greater than his material since he transforms it with his love: he, Vincent, had said so to Theo and still had not seen: *L'art, c'est l'homme ajouté à la nature* he had given as the best definition he could find. "Art", he said, "is nature, reality, truth, but with a significance, a conception and a character which the artist alone can express. He unravels the mystery. A picture by Mauve, Maris or Israëls says more and says it more clearly than nature itself." That mysterious prompting towards paintings and books had not been in vain; there was no need, he now saw, to agonise because he could not stand up in the little shed in the Borinage and, by telling the miners of the love of God, express his own love; there was another and for him a better way. In the height of his enthusiasm he even told himself that there was no need for despair because no woman had joined her life to his.

Even his lack of training was not the obstacle he believed: the walk to Courrières came back to his mind to give reason to the

rest; he had thought then that he must try to draw the miners and weavers at work so that the world should see and admire what it had despised. Even Millet's range had not included the miners of the Borinage, the weavers of Brabant; they were forgotten men. If he could somehow express their lives so that others would understand, his own life would be justified. He could not paint—he had neither the knowledge nor the money for the materials—but to draw he needed only pencil and paper, he had been sketching on and off for years, he could learn what he did not know.

Energy flowed into him. He seized his pencil and began to draw; he began to draw the miners, he began to copy Millet. He scribbled an appeal to Tersteeg in The Hague; would he lend him the *Exercices au Fusain* and the *Cours de Dessin* of Bargue? He wrote off to Theo begging for prints to copy; anything he could spare, but Millet for certain. He wrote like a new man. "Don't fear for me" he cried. "If I can only keep on working I shall be all right again." The letter was short—"I write in the midst of drawing and I can't wait to get back to it."

This was in August 1880. He was a few months past twenty-seven. He had found his vocation.

PART TWO

THE WORKER

Chapter Nine

BRUSSELS

1880-1881

TERSTEEG sent the Bargues, Theo sent the prints, Vincent worked as if possessed. The miner's wife cleared a space for him in the bedroom; he barely had room to move, but he worked on. He went through the Bargues page by page laboriously copying, his head close to the paper in the dim light, his pencil moving slowly in cramped heavy strokes. He drew the miners, their wives, their children, their huts. He copied every print sent to him by Theo of "the masters"—artists most of whom have long since been forgotten, but masters to him because all took working men and women as their subjects. He had not in thought moved one iota from the young worshipper of the Brabant peasant, the mission teacher of Mr Jones, the evangelist of the Borinage; he had merely changed (or found) his medium. He copied the peasants of Millet, Breton, Feyen Perren, Brion, Frère, Daubigny, Ruysdael, Broughton, but especially Millet. He could not have enough of Millet; he saw a mystic significance in his paintings, he quoted him like a god.

Theo was overjoyed. Vincent's long letter had made him ashamed of his criticisms; the next letter, announcing the determination to perfect himself in drawing, came like a burst of sunshine—at last Vincent had taken up his destiny. He had been right, Theo wrong; the step, obvious though it had seemed, could not be hurried; the long and painful preliminaries had to be endured until Vincent found his own way. Theo had never questioned Vincent's gifts, but he had doubted whether he had the clear-sightedness to recognise them. Although nothing had changed except Vincent's mind, he doubted no more. Vincent was perhaps a genius, he was certainly a remarkable man; he must be helped and encouraged at all costs. Theo sent every print he could lay hands on, answered every question of a Vincent desperately eager to know detail after detail of painters and their work; and although, well regarded in Goupil though he was, his salary remained small (he was after all only twenty-three), he stinted

73

himself and sent Vincent every franc he could spare—but, fearing Vincent's touchy pride, sent the money through his father.

His money kept Vincent alive, his prints kept him busy, his encouragement kept him furiously working on the days when the difficulties ahead seemed insurmountable. Would it not be better, he asked, if Vincent came to Paris, where he would be in touch with painters? But Vincent, with the experience of Courrières still sharp in his mind, shied at the thought. He could not afford it, he said—he would need not less than a hundred francs a month and his father was sending him sixty—and the Courrières fiasco might be repeated. If he found courage to speak to painters he might be spurned as a beginner, a nobody; he longed to meet them, but must wait until he had acquired some technique.

But the thought stuck, and when the evenings began to draw in it became irresistible. The tiny room was too dark, the children too noisy, the large pages of the Bargues were unmanageable in so confined a space, and there was no other room even if he had had the money for it. The books on perspective and anatomy sent unasked by the kindly Tersteeg with the Bargues were "very dry and terribly irritating", but master them he must. He longed for advice from a man who knew what he was talking about; in the Borinage no one could help him, he could not even speak of his work. He fretted, could bear it no longer and went off without a word at the beginning of October—but to Brussels, not Paris, where he found a room for fifty francs a month, bread and coffee included. He lived on bread, potatoes and chestnuts.

Theo sent him a couple of introductions. One man, the Dutch painter Roëlofs, advised him to attend the drawing classes in the Academy. Vincent applied, but his application was refused. He went to see the second man, Anton van Rappard, who had studied in Paris, where he had met Theo, and was now at the Brussels Academy. Vincent knocked at the door of his rooms at nine o'clock one morning. His appearance astounded the fastidious Van Rappard as it had astounded others. He thought of the spruce, handsome Theo, so affable, so polite, and he listened with incredulity to the hoarse voice of this creature who looked as though he had just been thrown out of prison or had crept from under a hedge, a creature who spoke antagonistically—for Vincent, noting the signs of wealth in Van Rappard's appearance

and studio, reacted violently against patronage even before it was offered.

The young Dutchman was well bred, he admired Theo, and his breeding prevailed over his distaste; he asked Vincent in, ignored his hostility and for Theo's sake persevered with his difficult guest. Vincent came again and again, won over by Van Rappard's charm. When he tidied himself up, as he was gradually induced to do, Van Rappard could see that the brothers shared the light-blue eyes, the reddish hair, the high slanting forehead, the wide cheekbones, that they were in fact extraordinarily alike—a refined and a coarsened version of the same face and body. And not only alike physically; there was in each of them an unmistakable nervous tension. In Theo it was often no more than a hint, obscured by good manners, of a highly strung man; in Vincent it was no hint but an alarming fact—he seemed to make no effort to control himself, was unbearably touchy, would blaze out on one with a glitter in his eyes that was barely sane.

His gloom could be ferocious. One day, walking with Van Rappard to Roëlofs' studio, they passed men digging in a sand quarry, a farmer sowing, women picking greens. Vincent was suddenly overcome by despair. "How shall I ever manage to paint what I love so much?" he cried, waving his arm towards them. He was inconsolable for hours, a terrifying companion, as though he were encompassed by torments. Again and again Van Rappard had to endure these moods. Yet, he decided, Vincent was worth the trouble. Beyond the scarecrow exterior, beyond the gloom and the rages, there was something, it was not easy to put a name to it, that forced respect from one and more than respect—downright admiration. Vincent had remarkable integrity, made prodigious efforts to overcome his late start, persistently refused to aim at anything but the highest, and proved at heart to be a good fellow. He made Van Rappard, who was doing pleasant little pen-and-ink country scenes, feel a trifler—and indeed it was not long before he was busy telling him so, urging him to leave the sterile Academy and strike out for himself.

So in their way they got on well enough, quarrelling and parting, quarrelling and parting. Van Rappard gritted his teeth and bore as equably as he could the mess Vincent made of his studio;

he tried to explain the mysteries of perspective and anatomy, lent Vincent books and prints and, when his slender stock of knowledge was exhausted, put him in touch with another painter, Madiol. Madiol lent him Cassagne's *Guide* and, being desperately hard up, gave him lessons in perspective. Vincent's sketches began to acquire some depth.

He was feeling his way, but with agonising slowness. He played with the idea of becoming an illustrator of books and magazines —he remembered and revived his admiration for the socially conscious English illustrators—but in clearer moments he saw how far he was from the poorest drawing in print. He suffered the despondency of every beginner—a despondency that with him, older than most and incomparably more earnest, quickly became despair; the more he understood what he had still to learn, the worse his work appeared; the pencil would not obey him, it was one long struggle to force it to move—and then not as he wished. "Technique!" he cries to Theo, "Oh, for technique!" All he did he found clumsy and awkward, like himself. He must draw from the model—he felt it, he was told it—but how, when models must be paid and the free models at the Academy were not available to him?

In January of the new year 1881 Theo was promoted and his salary increased. Soon afterwards Vincent, desperate for money to hire models, begged his father for more: he was working hard, he said, he would live respectably (he enclosed some stuff from a suit he had bought second-hand), but he needed money for his models and the costumes they must wear. He did not ask Theo because he had just written him a spiteful letter. Theo, deep in a staff reorganisation at Goupil, had not written for a few weeks. Vincent, furious with himself for his lack of progress, worked off his anger on Theo; was he afraid of compromising himself with Goupil by writing to the black sheep, or was he afraid that money would be squeezed out of him? If the latter, he might have the decency to wait until Vincent tried.

It was an unhappy jibe, but Theo took it in good part; he had put his hand to the wheel and was not going to take it away; he replied in typical fashion, sending most of his increased salary to his father to pass on to Vincent. In future, he said, he would send a hundred francs a month.

Vincent, whose spleen passed quickly, was able to hire his

models; he did not connect the increase of allowance with Theo, but apologised and wrote enthusiastically, "I love landscapes, but I love studies from life ten times more." He would persevere, he declared, he would become a figure draughtsman come what might. At the end of March his father came down to see him and explained that Theo was paying the allowance. Vincent was overcome: "You will not regret it," he assured Theo.

Then came unpleasantness. Van Rappard was five years younger than Vincent and endured his gaucherie and rudeness; Roëlofs was an established painter and did not. What, he asked, was a Van Gogh doing virtually penniless in Brussels, asking for help here, there and everywhere? Why had he left Goupil—had he quarrelled with his family? He refused to receive him. Vincent, furious, demanded of Theo if his uncles had been talking about him. Instead of gossiping or criticising, his Uncle C. M. would do better to help him as he helped many aspiring artists. True, they had quarrelled when he gave up studying for the University; true, he had said what he now regretted; but surely his uncle could see that he was a new man deserving of help.

He had no sooner expressed the thought to Theo than he dashed off a letter to Tersteeg in the same style. Tersteeg was annoyed: "You can't expect to live off your uncles," he replied; "you have lost your right to help from the family." He advised him to try to get some copying. There was a coolness all round.

Then Van Rappard said that he would be going home in May. "What do I do then?" Vincent asked Theo. He couldn't work satisfactorily in his bedroom, he had begun to long for the country where he could draw from the best models of all, the peasants. He would prefer some place where he and other painters could live and work together; he didn't want to work in isolation; he felt that worthwhile art must come from a community of painters.

Theo again suggested Paris, but again Vincent refused: he was not ready for Paris; he must first perfect his figure drawing and, having been in a city for some months, he needed the country once more, preferably the Netherlands. He seemed unable to dismiss the thought of Uncle C. M. getting work for him on a paper, introducing him to painters: he could not accept the fact that his abandonment of study for the Church and his rudeness afterwards had antagonised all his relatives. As always, he had

written and spoken as he felt, then forgotten it except as a dim, regrettable outburst. The memories of others were longer and clearer.

Perhaps the cheapest and best solution, he suggested, would be to go home to Etten and work. Uncle C. M. might pay a visit and peace be made. Meanwhile he could get plenty of free peasant models. He would "give in about clothes". Of course they would discuss him, judge him, write to Theo about him, but if Theo didn't mind, he did not. He left it to Theo. Theo wrote to Etten, and in the middle of April Vincent was there.

Chapter Ten

K

1881

THEO came up for a few days soon after Vincent had settled
in, and with his help harmony of a sort was established.
The parents eyed the prodigal with doubt and fear, but
with hope also. Theo was convinced that Vincent had found his
vocation, and they trusted his judgment. Certainly Vincent was
working hard, he was out almost every day most of the day,
drawing what he called his Brabant types—the walls of his room
were covered with drawings. He was more approachable than
he had been for years, his temper not often seen, his gloom not
at all; he seemed, not contented—such a word could never be
applied to him—but satisfied in a feverish kind of way, he could
be spoken to without falling into a passion or retiring in upon
himself in a ferocious silence. He was making an effort, that was
plain, and his mother and father responded warmly—sometimes
too warmly. He would glance sideways at his father at such times
with an ominous gleam in the sunken blue eyes, and the ugly
furrows in his forehead would deepen: he suspected Christian
forgiveness. But somehow he held himself in; he loved them, he
reminded himself, and they loved him in their conventional way;
they meant well; and he owed it to Theo to restrain other feelings
than love.

His mother and father were telling each other much the same
thing in the reverse direction. That he was a trying person to
have in a house could not be denied; not only had he no idea of
cleanliness or order, he seemed positively to revel in dirt; he
turned his room and any other part of the parsonage he used into
a pigsty, and his clothes, though no longer rags, did not fit him
and were soon soiled—he slept in them, lay on the ground, lived
in them. His parents trembled when he walked about the village;
their sense of propriety was hurt, and their pride. But he was
making an effort; he kept his disorder to his own room as much
as he was able; and, being summer, he was not seen for hours at
a time. And when Van Rappard came down for ten days and

he and Vincent went out sketching together they began to take real hope; if Vincent could find a friend like this charming young man of good family, then he must surely have turned over a new leaf. Their old faith in him began to revive. Relations were re-established with Prinsenhage, Vincent went over to see his ailing uncle once more, his parents began to speak of him with a cautious pride: he had given up art-dealing, they explained, but only to be an artist. They felt sufficient confidence in his be-haviour to invite their niece, Kee Vos, Stricker's daughter from Amsterdam, to spend a few summer weeks at Etten. She needed a change, they thought. Though not much older than Vincent, she was already a widow; her husband had died suddenly, leaving her with a small son.

She came. They wrote of her as they spoke, as K (the Van Goghs had a weakness for initials); she was good-looking, gentle, cultured, in every way charming; her little boy pleased them all. Vincent behaved irreproachably and his parents drew a breath of relief: if only he could make a living with his drawing, all would be well. Theo came up from Paris again for a few days and the family was complete: he, Vincent, K and the boy walked out together, and the mother and father contentedly watched them disappearing down the sandy paths between the corn. How good for Vincent to have before him this sweet influence and example —his roughness and crudity actually seemed to be lessening before their eyes. He would never perhaps be truly presentable, his ravaged face seemed stamped for life with the years of semi-starvation, exposure, uncontrolled passions, but he had a good heart at bottom.

Theo was his usual bright self in company, but with Vincent he relapsed; he did not believe in worrying others with his troubles, he said, and certainly not his mother and father, who had troubles enough, but he could speak to Vincent because they were now truly of one mind. He was being worked too hard at Goupil, where responsibility after responsibility was being thrust on his shoulders, but that was not the trouble, it merely intensified it. He craved a woman's love; given that, he could work like a horse; without it life lost most of its purpose.

Vincent agreed fervently: as ever, they felt together. Theo's words hung in his mind. When Theo went back to Paris Vincent became increasingly attentive to K and her little boy; he and

the boy played together, became inseparable. At first, like every-one else, K regarded him with distaste—a feeling that she dis-guised for the sake of his parents. She remembered faintly the unsuccessful divinity student of three years past who had looked at her with clumsy admiration when she and her husband came to dinner at the Stricker house. She had been sorry for him then; how he repelled her! But as she watched him play with her fatherless son, giving up hours of precious sketching time to show him the haunts of bird, frog and caterpillar, her heart melted. Could such a man be bad? Her son did not think so, and children were often the best judges. She began to look at Vincent without seeing his ugliness or wincing at his abrupt coarse speech. Her eyes—they were her best feature, soft and clear—began to smile at him. She began to accompany him and her son on their walks. His parents were astonished and pleased: who would have believed that Vincent could be so kind and gentle?

Then the blow fell. The history of Ursula was repeated. One day, without warning, Vincent asked K to marry him. He was a terrifying sight; the man who played and talked with her son had disappeared: his eyes glittered, his arms waved stiffly, he came close. He stood before her trembling, but he spoke abruptly, harshly: he had loved her ever since he saw her; he had not wanted to love her, it had been a shock to him, he had fought it, but uselessly. He loved her with a passion transcending every feeling he had known; they were made for one another: with her he could be a great artist: the child would have a father. Once before he had loved—no (he corrected himself), half loved; he had been content to love without being loved. That was wrong. He had not pressed his suit. That too was wrong. Now he loved with his whole heart, she must love him and together they would spread love through his inspired work. He would hear no denial. A feeling such as his could not be resisted. The love of a woman, of her, he must have if he was to be a whole man and his work great and good.

He became frighteningly emphatic. He was beside himself. "You and no other! K, I love you as myself!"

She was appalled and shrank from him. All her fears and distaste rushed back. "No! Never, never!" she cried, and ran off to his mother for comfort.

He had never heard such a tone from her. She looked and

F 81

sounded angry, insulted, disgusted. He sought out his father, told him what he had done and demanded his support. The old man, shocked and flustered, said that it was against his principles to try to persuade anyone to marry; he began to tell a long story with a moral ending. Vincent broke away in a fury.

The house was turned topsy-turvy. The two women stayed together talking for hours, then K left for Amsterdam with her boy—she refused to see Vincent again. He wrote to her, to her father and mother, to his aunt and uncle at Prinsenhage, to all the Van Goghs. "She and no other!" he declared to them all.

His father and mother reproached him gently: how could he have been so premature and indelicate? She had said "No!", he must resign himself.

He wrote hysterically to Theo—letter after letter filled with abuse of his parents. He castigated their warnings and reproaches: premature and indelicate!—how could he support a wife?—cousins should not marry—the Van Gogh blood was intermingled too much as it was—he should not have abused their hospitality— he should not persist when a woman says a decided "No". This nonsense, he said, showed that they lived in another world. And how could they begin to comprehend his overwhelming need of a woman's love? They accepted K's "past, present and future is all one with me". But that was wrong. She was still a young woman. She ought not to live in the past. He would force her to admit that it was wrong. *Il faut avoir aimé, puis désaimé, puis aimer encore. Aimez encore: ma chère, ma trois fois chère, ma bien aimée* he quoted. That was the truth and he would make her see it, lovingly but firmly. The ugly urge to subdue another to his will preoccupied him again.

All suppressed anger against his parents—those conventional creatures of a past age—burst free. Trying to force him into their respectable dead mould of life! He had not forgiven them for his shortcomings. Putting him in the wrong! And aggravating the offence by doing so with insufferable loving kindness! But now —now they had delivered themselves into his hands! His letters were almost as frantic with them as with K. His mother listening to K without attempting to put in a word for him—actually praying that he might become resigned to his rejection! His father trying to turn the conversation with a parable! Both of them explaining that K had thought of him as a brother, that if

she married again it would be in another, well-to-do family, that she had gone away positively disliking him.

Dislike! he tells Theo contemptuously. How stupidly blind they were. And she spoke to him as she had never spoken to another in her life! All gentleness gone, the real woman startled out of herself. Didn't women always speak harshly when they felt the stirrings of love? Of course she didn't like the thought at first.

Forget her—how could he? "My love is so positive, so powerful, so real that I could no more take it back than I could take my own life." He countered Theo's "But some men do commit suicide" by declaring, "I don't think I am such a man. Life has become very dear to me and I am thankful that I love. My life and my love are one. Theo, I love her, her and no other, for ever her. Though nothing is certain yet, I have a feeling that we have finished being two and that we are united for ever."

Let her go? No, never never! he cried in his turn. He needed her. "In order to work and to become an artist one needs *love*. Without her I am nothing, with her I have a chance. To live, to work and to love are one."

He wrote to her again and again. She did not reply but he wrote on regardless. He had let Ursula go; he was not going to make the same mistake twice.

The letters to Theo became frantic. He was madly excited, up and down: he will have K—how can he lose her? Yet why does she not write? His parents were kind—he knew it; but how lacking in understanding, trying to make up to him for K's refusal and her hurried departure by kind words, pitying looks, tempting food. And how short-sighted! What was the use of talking about God's love if a man was told to hide his earthly love instead of showing it? He turned for comfort to Michelet and read him by the hour. Theo must do the same: "be sure to read *L'Amour et la Femme*". He must also read *My Wife and I* and *Our Neighbours* by Harriet Beecher Stowe, *Jane Eyre* and *Shirley*. Charlotte Brontë, Mrs Beecher Stowe, Carlyle, George Eliot and others were to him the leaders of modern civilisation, they had a message: "Oh man, whoever you may be, who has a heart in his bosom, help us to found a real, eternal, true civilisation. God wants us to reform the world by reforming its morals, by relighting the fire of eternal love. Restrict yourself to one profession and love one woman only."

83

In his excitement he could not confine his discovery to Theo. Read Michelet! he demanded of his father, thrusting the book before him. Then you will understand what I feel. His father waved it away. "I prefer Michelet's advice to yours," retorted Vincent angrily. The inevitable scene followed; it had been brooding over the house for weeks: he was breaking up family ties, said his father, making trouble by behaving like a boor, writing letters to everyone, pestering a woman who didn't want him.

That was the third time he had heard that accusation about the family ties, Vincent shouted. After Amsterdam, after the Borinage and again now. He would show them how it would be if family ties were really broken: from that moment he ignored his father and mother, would not speak to them, would not answer.

They endured his behaviour for a few days, then his father said that he had better leave the house. Vincent appealed post-haste to Theo: write to them, he begged; he had never before drawn so well or with such reality because life had become a reality to him through love. "Wouldn't it be absurd to stop drawing these Brabant types now that I am getting on so well with them, just because father and mother don't like my love for K?"

Theo wrote soothingly, Vincent relaxed his ban of silence, peace of a kind was established in the parsonage. But Vincent was growing worried: time was passing, he could get no answer from K, her father would only ask "what means of subsistence" he had, all others disapproved with one surprising exception—the invalid Uncle Vincent, who secretly sympathised. There was another ally—his youngest sister Willemien. She was the weakest of the family—she had spent much of her life in a home for the feeble-minded—and this perhaps was one reason why as she grew older she lost her fear of Vincent and began to look admiringly at this forceful brother. She was, besides, morbidly inclined and so particularly accessible to the romantic argument. And she was, over all, kind and gentle, wishful to help all in trouble; and Vincent was in trouble. Thus Vincent is soon writing to Theo: "I am corresponding regularly with our little sister Willemien"—she was in Amsterdam at the time—"who is on the look out and will warn me when *she* [Kee] goes to Haarlem and W. will let me know when *she* comes back."

"K is like a block of ice, but I will thaw her with my love," he had told Theo: but how to thaw her if he never saw her, never heard from her, could not even persuade her to read his letters? Time was passing, nothing happened; he must go to her. He wrote again to Theo begging the fare to Amsterdam. Theo sent it with a warning letter against over-optimism.

Early in December he went to Amsterdam; he arrived in the evening, walked to the Stricker house and rang the bell. The maid told him that the family was having dinner. He was asked into the dining-room. There they all sat, all but K. They were in the middle of the meal; Vincent looked at the plates; everybody had a plate before him, there was no sign of an extra plate, K's plate. That she was in the house, that she had left the table as he came in, he felt certain; her plate had been taken away so that he might think her to be out.

"Where is K?" he asked Stricker.

"Mother, where is K?" repeated Stricker across the table.

"K is out," replied his wife.

When the meal was done, he was left alone with his uncle and aunt. "Where is K?" he asked again.

"K left the house the moment she heard you were here," said Stricker.

While Vincent was trying to recover from this blow, his uncle produced a letter: he explained that he had been about to send it to Vincent at Etten but would read it instead.

"You can read it or not," said Vincent, "I don't care."

The letter was read: it asked Vincent to stop writing to K and to make a serious effort to put her out of his mind.

"And afterwards?" asked Vincent.

There would be no afterwards, his uncle replied. The matter was finished.

"No," said Vincent, "it has only begun."

The argument went on, Vincent lost his temper, there were high words. He got up to go, but they asked him to stay the night. He refused; if K left the house when he came in, he could not stay there.

"Where will you sleep?" they asked.

He didn't know; and they confounded him by insisting on accompanying him to a cheap but good inn and seeing that he had a bed there.

The next day he came back to the house; K was again out. The matter was neither finished nor settled, he assured them. "You will learn to understand it better later," they said.

In the evening he was there again. "It is no use," he was told; "when you enter the house, K leaves it. To your 'She and no other!' she answers 'He certainly not!' She thinks your persistence is *disgusting*."

A lamp was standing on the table. Vincent put his hand into it. "Let me see her for as long as I can keep my hand in the flame."

They were horrified, ran forward and put out the light. "You shall not see her," they said.

He came once more, the following morning. It was a Sunday and Stricker was about to leave for his church. "Listen a moment," Vincent said. "If K were an angel she would be too good for me. If she were a devil I shouldn't want to have anything to do with her. But I see her as a woman with the passions of a woman, and as long as she remains a woman the matter is not finished."

But it was finished. Stricker went off to church muttering something about women's passions—he didn't care for the reference—and Vincent was left in the street feeling stunned—feeling, he told Theo, as though he had been standing too long against a cold, hard, whitewashed church wall.

A frightful depression fell on him. He understood why people killed themselves. He was tempted: why not put an end to this useless, humiliating existence?—life it could not be called. But there came into his mind Millet's *il m'a toujours semblé que le suicide était une action de malhonnête homme.* He was not a dishonest man; he put the thought aside.

As evening came on he said to himself, "That damned wall is too cold for me. I can't live without love, I can't live without a woman." He argued with himself. "You have said 'She and no other' and now you think of sleeping with another woman. That isn't logical." And then he said, "Who is master, the logic or I? Is the logic there for me or am I there for the logic? I am a man with passions, I must have a woman or I shall freeze and turn to stone."

He found a woman and slept with her. He rhapsodised to Theo about prostitutes as he had done once before, after Ursula.

"She reminded me of some curious figure by Chardin or Frère, or perhaps Jan Steen. To me there is a wonderful charm in that slight fadedness of a woman over whom life has passed." For years, he said, he had felt as though such women were his sisters.

He said much about that night—too much. He had to do it, he insisted; it was a simple matter of hygiene, of keeping his body healthy and his mind clear so that he could work well. "Is it a *sin* to love?" he asked, "to need love, not to be able to live without love?"

But it was not so simple. He had been humiliated twice. The first time could at a distance just be explained away, he was so young, he didn't know what love was. But he was no longer a boy, he was a grown man. His love had been refused contemptuously. He knew why and he could not bear that knowledge—it had to be driven out of consciousness or he would go to pieces, go mad. Was he, who had in him the capacity for a great love, pure, deep, good, who would do great work inspired by love, to pass unloved through life? The thought was not to be borne, and had to be expunged by a woman, any woman. So he repeated the experience of Ursula precisely.

He was not honest about it because he could not be: he told Theo that he loved K still, that he would win her love, but it was not so and he knew it. Had he ever loved in his life? He loved the idea of a woman—his idea, not the flesh and blood person. It could not be otherwise; he could never see women for the halo he threw around them; his letters to Theo, that painful stream of letters about K, are not the letters of a loving man, they are the letters of a frustrated, obsessed man. K, like Ursula, had the sense to see that his love was not love but a ruthless pursuit of an ideal. Did he suspect this? Certainly he knew that he would not have K, as he did not have Ursula. Would any woman love him—could any woman love him? It was to obliterate the answer that he paid for what no woman would give him.

THE HAGUE

1881-1882

HE went down to The Hague, called in at the Goupil gallery and made his peace with Tersteeg. Tersteeg looked curiously at his blistered hand but said nothing. Vincent was in earnest about his work—there was no doubt of that; Tersteeg had seen some of his enthusiasms and had heard of others, but he let bygones be bygones. Vincent was profuse with thanks for the loan of the Bargues; he copied from them almost every day, they had taught him almost all he knew. Tersteeg told him to keep them; and, when he spoke tentatively of going to Mauve for advice, encouraged him.

Mauve and his wife Jet, Vincent's cousin, received him kindly; he presented a pathetic figure, this old-young man with the lined face and childish eagerness to learn. His obvious worship of Mauve was touching; and when he pulled out of his wallet a bundle of his Brabant types and handed them apologetically to the great man, Mauve decided to be generous. He looked them over with Vincent standing behind him shuffling heavy feet nervously. Vincent was sitting too close to his model, he said at once, but he added after he had been through all the sketches, "I always thought you a dullard, but I see that I was wrong"— at which Vincent was extravagantly pleased.

Might he stay at The Hague for a few weeks? he asked, emboldened by the praise. Mauve answered by putting a pair of wooden shoes, a cabbage, potatoes and a wrap on to a table. "Let's see what you can do."

He was tolerably satisfied with the drawing, but said that a year's work with pencil and pen was more than enough; Vincent should begin to use charcoal, chalk and try his hand at watercolour and oils. Vincent went off radiant to a nearby inn, took a cheap room and began to experiment with the new mediums. Every day he painted in Mauve's studio, every evening he went back there to draw; he had trouble, he stamped on his charcoal in a fury, his patience snapped time after time, but he got on in

bursts. He wrote off with guileless enthusiasm: "Theo, how can anyone represent real life if he has no feeling for tone and colour? How marvellous they are!" "Theo, what a fine thing water-colour is! I can suggest atmosphere and distance with it so that the figure is really surrounded by air and actually seems to be breathing!"

And how kind Mauve was—so helpful, so patient! With reverence Vincent watched him making a study of a fishing-smack: he was a great painter.

The days flew by; his money ran out; he wrote to his father for more. How had he spent so much? his father asked, shocked. Vincent wrote to Theo—the first of a long stream of letters in similar vein: he had spent all his money, he hadn't enough to live on, he hadn't even the fare back to Etten—what should he do? He would like to stay; he had met painters, he was working well, he would much prefer to take a small studio at The Hague. Of course everything was much more expensive than at Etten, but the advantages were so considerable. Anyhow, Theo must decide: what he said, Vincent would do. He would like to stay—except that he had no money. However if Theo would care for a set of water-colours he would be delighted to oblige him—he enclosed sketches of water-colours he had made—but in that case he would need more money. He couldn't ask his father again; his father expected him to account for every penny: his father gossiped about his extravagance—the whole village was given a distorted view of his spending. Of course he had to spend money; Mauve had given him some paints, charcoal, chalk, but he couldn't ask Mauve for everything. Naturally when one began to paint the cost went up, but then consider the advantages. Anyway, it was for Theo to decide. He would only say that he would like to stay; but that would mean more money.

Theo, not yet broken in to this type of letter and not caring for Vincent's criticism of his father, said that he had better go back. He went back with a poor grace. Mauve gave him a good send-off by telling him if he persevered he might make something saleable by the spring—the sun was rising for him, but was still behind the clouds—and followed his encouragement with a practical gift: he sent after the reluctant Vincent a complete painting-outfit, box, colours, brushes, palette, everything. "Come back in March," he said.

But Vincent was back long before March. The snatch of a painter's life had excited him; he wanted to sit at the feet of Mauve; his dream of a brotherhood of painters had revived and solidified; he panted after a studio at The Hague. Etten lost its charm, it was a graveyard, solitary but for the murmurings of a querulous father, the fussings of a mother solicitous about the things which mattered nothing. To be dependant on such people at such a time was intolerable. They could do nothing right: his father gave him a suit—an objectionable hint that he was allowing himself to go to seed again, Vincent thought: why this excessive concern with clothes when there was real goodness to be done in the world? Moreover the suit did not fit and he appeared and felt ridiculous.

He was looking for trouble and he found it. On Christmas Day he refused to go to church. His father protested mildly—what would his congregation think—how could he hope to lead them to God if he was known to have failed with his own son? That settled it, said Vincent, church-going was being made compulsory; so far he had obliged his father out of consideration; he would never go again. He flew into a rage. "Your religion is horrible!" he shouted. "Horrible!" He had believed once in organised religion, but he had learned his lesson, he never wanted to think of it again.

For the second time his father told him that he had better leave the house. If he needed money he would lend it. Vincent would take nothing; he left that day, went to The Hague, saw Mauve, who said "Stay", and rented a garret on the Schenkweg, an ugly new street ten minutes walk from Mauve's studio. Mauve and his wife took him in hand: he must have a bed, furniture, better clothes; they would lend him the money. From his hero he accepted the "better clothes" without a murmur.

He wrote to Paris: Mauve had lent him a hundred francs; what could Theo do? As for his father: "Was I *too* angry, *too* violent? Perhaps; but it is now settled for ever." Theo did not answer. Vincent wrote again. No answer. He wrote a third time: he was in his new studio; why didn't Theo write?; he counted on his usual hundred francs, he was faint with suspense. Theo sent the money, understood the move to The Hague, promised to help as much as he could until Vincent began to sell, but "I can't approve of the way you left father and mother. What made you

so childish, so impertinent, why did you embitter their lives in that thoughtless way? It is easy to fight someone who is old and tired. Don't you understand that father can't live if he quarrels with you? Coûte que coûte *you must* put it right. One day you will deeply regret your heartless behaviour. At the moment Mauve attracts you and you don't care for anyone who isn't like him, you expect everyone to be another Mauve. Don't you think it hard for father to see himself counted as nothing by someone who calls himself a free-thinker? Doesn't *his* life count at all? I don't understand you."

Never before had Theo written such a letter. Vincent began to reply stiffly, returning Theo's letter with the charges listed and replying to each one at excessive length and with much hauteur. "Embitter their lives!" he exclaims. "That's not your expression, it's a typical Jesuitical remark of father's and I've told both of them what I think of it and that I don't care. Father is always saying, when he doesn't know what else to say, 'you'll be the death of me', while he reads the newspaper calmly. He is touchy and full of obstinacy. Sometimes he loses his temper and is astonished when I stand up to him. Those expressions of his— 'you'll be the death of me', 'you're embittering my life', 'I can't stand it'—are all just a trick."

As for fighting the old: "It wasn't fighting, but putting an end to it as common sense wasn't listened to." Regret his heartless behaviour? "I've no regrets so far, in fact I feel much better. When someone says to me 'Leave my house and the sooner the better', it doesn't take me long to be off, and I shan't come back."

Was he a free-thinker? He didn't care for the word, but if it meant telling his father the truth even though he had lost his temper, very well. The clergy and all academic thought were useless to him—that was what he had said and he stuck by it: "I shan't take it back."

On he went, justifying himself in a manner by now only too familiar to Theo, sick to death of the family bickerings. In any case, Vincent said, for the sake of appearances he had sent New Year greetings to his father and his hopes that they would never differ again. He neither could nor need do more. "When they change their minds I'm prepared to apologise. But I doubt whether that will ever happen." But he was much too excited

with his new studio and new life to stay at arm's length; he had to share his hopes and joys with Theo. He was absorbed by his water-colours, he cried; both Mauve and Tersteeg thought they might soon be saleable. He sent sketches of those he had made already, adding the flattering news that Mauve had put him up for the local art club.

There were difficulties too, and Theo must also share them as he would soon share the triumphs: he had had to borrow from Tersteeg as well as Mauve—in fact, with models to pay, he couldn't live on a hundred francs a month. What could be done? "Can I work full speed, half speed or not at all?" He would prefer full speed, but Theo, who would have to pay, must decide.

He added a final ominous note; he had fallen out with one of the painters in the Mauve group. His intolerance, suppressed for a short time by the idolisation of Mauve, had shot up. Mauve might be sacrosanct but not his circle; they were all working together with a common aim and if one of them didn't know his job it was the duty of Vincent, who had been painting for a few weeks, to put him on the right road since the others seemed strangely complaisant. He put him right, but with such a savage lack of tact that there was an explosion: "He doesn't improve on acquaintance" he complained, "he gets angry when one tells him something that is simply A.B.C."

For the moment this weak link in the chain was replaced by a stronger, the young Breitner. Breitner found himself in the company of an eccentric. He introduced Vincent to the public soup-kitchens where he had been discreetly making sketches. Vincent, hungry for free models, followed him the next day. But of tact he had no notion; he arrived with large sheets of paper, began very obviously to make sketches of the paupers waiting in a long queue for their food, caused a great commotion when he was reproached, and was soon driven out. But Breitner, who found something likeable about the difficult man, continued to work with him occasionally, in soup-kitchens, in public waiting-rooms and, in good weather, in the country on the outskirts of the town. One hot day they were walking up a long road shaded by trees on one side, exposed on the other to the blinding sunshine. Breitner moved over to the shady side, but Vincent, laden with his equipment, continued to walk in the heat of the sun. "Why?" asked Breitner after a time. "I want to suffer for art,"

replied Vincent, so busy suffering that he barely recognised his first good living influence in art, from whom he was to get a grasp of the true importance of technique.

But the acquaintance was scarcely made when more trouble threatened; serious trouble this time. Vincent began to complain that Tersteeg, who was coming in often to see his work, was for ever saying, "You must begin to think about earning your own living." A dreadful expression, Vincent thought. Then Tersteeg bought a small drawing from him for ten francs and there was a silence. But not for long: Tersteeg, anxious that Vincent should not be a load on the back of Theo, of whom he was fond, and dubious about the permanence of this latest enthusiasm, criticised his work freely to him (which he endured impatiently) and to Mauve (which he would not endure at all). Furious, he wrote a sharp note, and Tersteeg, visiting Paris, complained to Theo. Theo reproached Vincent: Tersteeg, he reminded him, had been like an elder brother to them both. This pulled Vincent up for the moment, and he reconciled himself with Tersteeg sufficiently to borrow twenty-five francs from him. He borrowed but, he said, would have liked to throw the money in his face; he took it, but only because he must; the very way Tersteeg handed it to him was an insult. After that Tersteeg's criticisms became inexcusable—criticisms of Vincent's work and of him. "You will fail again as you have failed before," he said. "It will be the same old story. Why can't you do something that has charm and will sell?" Vincent lost his temper. "Since when can an artist be forced to change his technique or his aims?" he asked Theo. To Tersteeg he was less coherent; he simply shouted at him. After a final withering—"You have started too late—you are not an artist"—Tersteeg stopped calling on him.

At the same time Mauve's attitude began to change. When Vincent first settled in The Hague Mauve encouraged him during his depressions: true his work was heavy, thick, muddy, black, dull, but wasn't that preferable to a premature transparence that would not last? Better by far work through the inevitable muddy stage; all worthwhile artists went through it, Vincent was no different and could count himself lucky that he wasn't facile. This kind of sensible talk steered him through many a bad patch. Then somehow Mauve was not quite as before. Had Tersteeg reminded him of Vincent's many failures

and predicted another, or told him that Theo was exhausting himself to keep this spendthrift brother, who even so was borrowing from them both in The Hague? Or was Mauve simply growing tired of a too assiduous admirer? Vincent asked himself these questions when Mauve began to show signs of irritation. "That's no use—tear it up," he was told of more than one of his studies; then :"I'm not always in the mood to show you things, I'm too tired," and Mauve would wave him away for the day with a "For goodness sake come at a more suitable time."

Vincent was puzzled and hurt. He described himself as a man of thirty who looked like a man of forty, and complained that his father looked at him through his spectacles as though he were a little boy. But his father had the rights of it; in personal relationships Vincent was a child; his views were not only right, they must be forced on to all; in the name of candid truth he spared no one and sneered at a tact he did not happen to possess. Whoever disagreed with him was an enemy wishing him harm, and whoever incurred one of his devotions had to be something more than human—if he or she slipped from that involuntary eminence, woe betide them! This is an adolescent attitude: in adolescence it is excusable and it is not without charm; in a man of nearly thirty who looked forty it was a menace to peace—to his own peace and the peace of all with whom he had dealings. "One cannot always be friends, one must quarrel sometimes," he told Theo. But he, loving everyone and longing for friends, quarrelled almost incessantly, was heartily disliked and avoided. He never learned to understand other people, did not pause to think that uncritical admiration bores everyone in time, never suspected that everyone shrinks from the man who leans his whole weight on them. The story of Ursula and of K was repeated with Mauve; all Vincent could think of was his need of this man he worshipped; he continued to call with his studies, seeking advice.

Mauve began to mimic him. He was a clever mimic. "This is the way you speak", he would say, adopting a husky impassioned voice; "this is the sort of face you make", screwing his face up into wrinkles and deep furrows; "this is how you look", casting a suspicious look out of the corner of his eyes; and "this is how you behave", stumbling about the room with nervous glances and awkward gestures. Did he hope to cure Vincent of his unpre-

possessing mannerisms or was it merely the malice of a bored man? Vincent took the latter view. "If you had spent night after night in the rain in London like me, if you had spent night after night in the Borinage hungry, homeless and feverish, you would have ugly lines in your face and a husky voice."

He was hurt and angry; Mauve was no longer exempted from criticism; shortcomings stared out in him as they had been plain from the beginning in every other artist Vincent had met. Mauve, he complained to Theo who was being bombarded with letters about Mauve and Tersteeg, Mauve had become narrow-minded; he told him to draw from casts and gave him some plaster hands and feet to practise with. He took them away and did not use them but Mauve went on urging him to draw from casts "in a manner you would not expect to find in the worst academy teacher". He went back in a rage and dashed the casts to pieces in his coal bucket. The next time Mauve mentioned them, he told him what he had done and shouted, "Don't talk to me again about casts. I can't stand it." He was followed home by a note; he had better keep away from Mauve's studio for a couple of months.

The disintegration of yet another relationship was stayed for a few weeks by the arrival of Uncle C. M. in his studio. Vincent had written to him (he had never appeared as hoped at Etten), and his uncle, behaving as generously as his brothers, put Vincent's insolence out of his mind, came down to The Hague and gave him a helping hand by ordering a dozen sketches of the town. Vincent was tremendously excited—"Theo, it is like a miracle!"—but he soon discovered imperfections, as always. Uncle C. M. had the temerity when giving his order to speak of it as helping Vincent to earn his bread. Vincent bristled at once: if a man deserved his bread but could not earn it, that was a misfortune not a crime; to think of him in any other way would be an insult.

His uncle, having determined on a generous gesture, decided to proceed with it and changed the subject. But the hazards were not yet past. Vincent spoke, among other artists, of De Groux, who he thought put much expression into his work; he was a master, like Millet, like Gavarni. He was a man with a very unsavoury reputation, remarked his uncle, who trembled, as did all who knew Vincent, when a hint of some new hero-worship

arose. Vincent flared up: when a man's work was above reproach his private life was his own, he declared. He added ominously that the difficulties of an artist's private life were directly and fatally connected with his difficulties in making a work of art. He spoke with emphasis, but as he rarely spoke otherwise his uncle seems to have suspected nothing, remained tactful, and they parted apparently on good terms.

In his temporary exhilaration—for his uncle's visit coincided with a remittance from Theo—Vincent, still infatuated by water-colours, urged Theo to throw up his job and become a painter: he felt, he said, that Theo would make a good landscape painter and they would be very happy working together.

Theo agreed that the thought was a pleasant one but asked who would then pay for the schooling of their young brother Cor as his father could no longer afford it—who would support their mother if their father died first—who, for that matter, would support him while he was learning? He was too thoughtful to put the last and most pertinent question—"Who would support you?"

Oh, said Vincent airily, "the money will not be wanting—if the idea of becoming a painter took possession of you, you would see that all can be done." He reminded him that if he tied himself up for life with Goupil he was a lost man.

Theo preferred to be a lost man and to remain the pillar of his family. He was still dissatisfied with Vincent's attitude to his parents and asked him: did he know that his mother was ill? Yes, said Vincent, "and many other sad things as well"; and if Theo thought him a man without feeling let him study *Sorrow*, a lithograph he had just made of a nude woman and which he considered his best work. Practically, however, he felt that nothing useful could be done at Etten; the lack of harmony between himself and his parents was "a chronic evil"; they differed so greatly that they would only get in one another's way in the same house; the best thing was to avoid each other. It was sad, he agreed, "but life is full of such sorrows", and at least this one was involuntary on both sides. He could not endure the thought of visiting the parsonage; he had become little more than a half-strange, half-tiresome person to them. As for him, the mere thought of Etten "gives me the creeps, as if I were in church".

Theo would no doubt have taken up the "involuntary"

illusion—he was a persistent man in his unemphatic way—when the exhanges were shattered by a bombshell from Vincent.

Mauve's two-month ban was over and Vincent, unable to resist even a damaged archangel, scribbled a note: could he come? There was no reply and he wrote a frantic letter to Theo. "My grief chokes me. I love Mauve, and it is terribly sad that the happy future he promised me will never come to anything. I shall suffer greatly because of the peculiarities I *can't* alter— the way I look, speak and dress. I shall move in another world from that of most painters because the subjects I want to paint and my whole conception of the purpose of painting differs from theirs."

Having pronounced his fate as a solitary he rushed off to Mauve; he didn't find him, but ran into Tersteeg. "You ought not to be allowed to stay in The Hague" Tersteeg said firmly. "Mauve and I will take care that Theo doesn't send you any more of his hard-earned money."

Vincent hurried away distraught in search of Mauve. He found him painting in the dunes outside the town and asked him to come to see his work and advise him.

"No," said Mauve. "That's all done with. I shan't come to your studio. You are a vicious character."

Vincent turned away, his heart leaden; Mauve, like almost every man in The Hague who called himself a painter, was in truth a philistine disguising himself with a palette and brush. Respectability, money, position, plaudits—these were the things he lived by; he was in essence no better than those self-righteous shopkeepers, the Van Gogh uncles and Tersteeg. But above all his god was respectability. Vincent walked home and wrote hurriedly to Theo. "They suspect me of something. Well, I'll tell you. For the last month or two I've been sleeping with a prostitute. I want to live with her, I'm going to marry her."

Chapter Twelve

SIEN

1882-1883

H E had met her one evening a few weeks after he had settled in at The Hague and was touched by her wretchedness: she was pregnant, she had a daughter of eleven, her own mother—a charwoman—could not keep them so she went on the streets. This, with the conventional account of her first fall, was her story: Vincent, never more the adolescent than when he dealt with a prostitute, accepted everything she told him; he shook with rage at the thought of the vile seducer leaving the innocent girl to her shame; his pity for her rose to a passion: "She walked the streets ill, pregnant, hungry, in winter. I couldn't do other than I did." He paid for her to have baths, he shared his food with her, he took her to the hospital at Leyden for a prenatal operation and promised that he would support her until she had been confined. That, he explained, was why he had not spoken earlier about her—he was afraid that Theo would disapprove and stop his allowance.

Sien's face was pockmarked, she spoke crookedly and with an abominable accent, she had a vile temper, she was a bad mother, she was foul-mouthed, she was riddled with disease, she was in fact an average specimen of the low-class prostitute after ten years or more on the streets—but all this actually recommended her to a Vincent obsessed by the thought of outward ugliness covering inner beauty, his compassion automatically given to the poor and oppressed, his sympathy engaged the moment his eye caught sight of a worn garment, a haggard face, a dirty fingernail, and with an *idée fixe* about all prostitutes.

And he was lonely. Their loneliness, he felt, was their most powerful bond. He chose to see her as deserted, despised, friendless like himself, and like himself pining for love; he ignored the child, the mother, the circle of dubious acquaintances, the whole sordid record of past years; he preferred on no evidence whatsoever—indeed against all the evidence—to credit her with his own feelings—a high-minded but foolish assumption. For he was

98

truly lonely even though he alone was responsible; he was not on speaking terms with Mauve and Tersteeg, he had set by the ears practically every painter in the place, he was as solitary in the bustle of The Hague as in the quiet of Etten and much more conscious of it because of the crowds about him. Then came the meeting. All that followed was inevitable, Vincent being what he was, even to the spiritualising of a relationship that had nothing spiritual about it except in his own mind. As he had done to Ursula and to Kee he now did to Sien and with even less reason. But this he could not see. She began to bring him an occasional dish of potatoes for his dinner, she, her child and her mother sat to him, his little studio was given an illusion of domestic life. The gestures were more effective than she could have dreamed possible: he was conquered; he had thought only of doing good to this poor misused creature and he was offered companionship, mutual affection—those essentials to the painter's life—as well as willing models; his heart had not betrayed him; he could do no less than marry her.

Theo was appalled: what was he thinking of, he demanded, to ruin his prospects by such a connection and in The Hague of all places, where the Van Goghs were so well known and respected—and, not content with that, actually to sink himself by marriage? What of his love for Kee? Not many weeks ago he was assuring him that it was deathless, writing thousands of words to him about it, declaring that it was final, transcendent, that he would never give her up.

It was an awkward question and Vincent blustered his way out of it unconvincingly: "When I stood there in Amsterdam on the third day I cried to myself, 'My God, My God, why hast Thou forsaken me?' My faith died. My love followed. But why should an honest man despair? I am not a criminal—I didn't deserve to be treated like one. I felt that my love, so true, honest and strong, had literally been *killed*. But after death comes the resurrection." He lashed himself into fury, the irrelevant fury of the imprudent sentimentalist with his back to the wall: "Am I free to marry, yes or no? Am I free to dress like a labourer and live like one, yes or no? Whoever wants to stop me can go to the devil!"

This sounded conclusive, but Theo, though alarmed, persisted: What did he know about her; there were hundreds of

prostitutes about—did he propose to tie himself to one blindly? If he must choose such a woman as a partner, why one with a mother, daughter and a second child to come—did he not find life hard enough already, that he must saddle himself with four people?

Vincent was at once on his dignity: "I am thirty (he was twenty-nine in fact), she is thirty-two, we aren't children. She has a child—a child wipes away all stain from its mother. I respect a woman who has become a mother and I don't enquire into her past." As for the old mother, "She works hard and deserves a medal." He continued the preposterous recital in all seriousness.

Christine was her name but he called her Sien, "She is just an ordinary woman of the people, but to me there is something sublime about her." He enclosed sketches: Sien had a good figure, she made an excellent model; she had posed for *Sorrow*; she was something like their old nurse at Zundert, like the woman in Paterson's *Dolorosa* illustrating Hugo's *'93*, and in Frank Holl's *Irish Emigrants* and *The Deserter*, all in the *Graphic*; her profile resembled Landelle's *L'Ange de la Passion*. She had attached herself to him, he assured Theo, "like a tame dove".

Theo was not reassured; he must have wondered whether to laugh or cry. They are all like that to begin with, he replied, and for as long as they can get something out of you. He knew Vincent and loved his impulse to love and to do good; loved and feared it too, for a more quixotic ass about women had surely never drawn breath; he could scarcely take a step, utter a word, without plunging himself and others into trouble; yet—and of this Theo remained resolutely certain—he was a man in a million, intrinsically pure and noble. Yes, Theo understood Vincent; he also understood prostitutes—he had helped them himself discreetly—and he knew something of prostitutes' mothers. Was he sure, he asked Vincent again, that he was not being fooled? And why in any event need he marry the woman? He might, though he did not, have gone further and asked why, if Vincent truly wanted to do practical good, he did not spend his spare money on the little girl, take her away from her mother, send her to school, try to save her from the fate that was certain if she remained with Sien.

Quite sure, answered Vincent. "We are two unhappy people

who want to share our burdens and so change the unbearable
into the bearable, unhappiness into joy." As for marriage, he
thought it wrong not to marry. Surely his father would want
him to marry rather than to live in sin?

Ask him, suggested Theo, but Vincent refused: he would have
no interference. However, if Theo cared to broach the subject
tactfully at Etten, well and good; in any case there would be no
marriage until after the baby was born, in the summer.

These last sounded an unexpected note of reason, and the
explanation soon appeared; despite the dish of potatoes from
Sien his expenses had grown heavier; he ate little, he was some-
times faint with hunger, but the expenditure could not be kept
down: and in short, anything less than a hundred and fifty francs
a month from Theo in future would be useless.

Theo sent him the hundred and fifty francs and the money to
repay the loan from Tersteeg. Vincent could reckon in future on
that amount. "But don't marry until we have had a talk!"

Then, as often, Vincent changed his mind and took Theo's ad-
vice; he wrote to his father and told him about Sien. But this sur-
render drove him to attack its author; he was furious that he had
given way and even more furious that Theo had sent the money
unconditionally. Theo was sometimes too good. Was he bribing
him, then? Even Vincent in anger could not think so. But what
if Theo were acting the traitor unconsciously? "Let me open
your eyes to yourself," he said. "You want to separate me from
Sien, yes, separate absolutely. Right. But I can't do it and don't
want to. And with all your financial power you won't force us
to separate. So I tell you in advance that I'm going to share the
money with her and if I can't consider the money you send as
my own, to do what I like with, then I won't accept it."

That clear to his satisfaction, and Sien blissfully unaware that
she might be enduring him to no purpose, he went on with his
work elated. He had Sien and her family, he was not alone, he
was no longer wholly dependent on one man for love and hope
and life itself.

He was drawing again, perpetually drawing. After the break
with Mauve he abandoned his brushes; he had no heart to use
them, he said, but he also, since he took up with Sien, had no
spare money for paints and canvases. This meant that his one
hope of earning money quickly—by water-colour sketches—

must be given up. He made a virtue of it; he was not a landscape painter, he insisted; he was interested in figure work, which called for incessant practice. He was more than interested, he was absorbed: it was a vocation within a vocation. He explained himself to Van Rappard. They had not met again, but wrote to each other from time to time. On Vincent's side the correspondence was forceful. He was quite a dictator, protested Van Rappard amiably. Vincent was delighted: "I have a *will*, a *direction*, I am following a *definite path*, and I want to take others along with me." He wanted to found a school of painters and his first convert was to be Van Rappard, who must give up all hankering after academical teaching and join him in the fight. He put his creed into capitals. "LOVE WHAT YOU LOVE." Most people loved and lived everything but that; most people bent all their energies to unworthy aims, treating their real love as an unwanted child instead of following the impulse of their heart. And they actually patted themselves on the back for doing it, telling themselves that they were doing their duty, were being strong-minded, conscientious. They had an enormous beam in their eye, Vincent asserted, and confused a false conscience with the real one. He had had such a beam in his eye but at last he had plucked it out and was himself: he loved what he loved.

What did he love? First, the work of the painter; he was making himself a painter with all his strength. But to be a painter was not enough. He looked round about him at The Hague and he saw Mesdag and his wife surrounded by admiring crowds painting a vast panorama of Scheveningen; de Bock sitting down to paint a landscape and leaving out the one thing in that landscape that made it worthy of paint—the man sitting under one of the trees: all choosing the obviously beautiful subjects, the easy, the pleasant; all sitting in their studios, drawing and painting from memory instead of going out to seek what nature alone could teach; and all living in luxurious villas and scheming to get on in the world. To paint panoramas photographically, to paint garden parties, beautiful women sipping tea, beautifully dressed children—this was to paint the lesser part of life. He was not content to be such a painter. To him the painters' job was to depict not the shadow of life but life as it was, a struggle, and to show that in this struggle alone true beauty was to be found. But to discover this life one had to go into the streets, the

fields, the poorhouses, the soup-kitchens, one had to be dirty, work in discomfort, one had to struggle, to be a labourer. He was a labourer, a peasant; he went out day after day in dingy clothes, sat for hours in the mud drawing workmen excavating a road, spent days on a refuse-tip drawing the street-cleaners throwing out their rubbish, stood in the rain sketching women coming out of a factory, sat in the stench and steam of the soup-kitchen making studies, stood about in the chill of the workhouse hour after hour to catch a characteristic group. He particularly revelled in the rubbish-dumps; they were like a fairy story by Hans Andersen, he said—old street-lamps, warped and rusty, broken kettles and chimney pots, empty oilcans, bits of bent wire, twisted baskets, all heaped on top of each other. Ugly perhaps to the passer-by, but "paradise for an artist".

His work did not advance quickly; he drew and drew again, always the figure, but his drawings remained heavy, awkward, they had no depth, the proportions were not right. From time to time a sketch came to life, as with the impression of a man with umbrella, *Old Man from the Almshouse*, but in the main his improvement was infinitesimal.

He knew it, but was helpless; he had quarrelled with almost all who could help him. "I don't want to associate much with other painters," he now told Theo, and meant it in so far as he disliked feeling ill at ease and inwardly disdainful in luxurious studios where he would be expected to tell polite lies about his host's work—and where, he had persuaded himself, they were jealous of the way he painted: "They pretend to be friendly, but really want to throw you out." But to form a community of painters with a common aim—his aim—was still his dearest wish: then his work would grow in strength and maturity, he would be able to keep himself, he would influence the world for good. But the community languished: his chosen lieutenant, Van Rappard, was fascinated but far out of his world; he came to see Vincent in May, was charming but somehow one could get no further with him. Was he hopelessly academically-minded? Vincent asked himself. Breitner was in hospital, all others were hostile or contemptuous. He had to work alone and learn as best he could from the prints he was collecting, the files of illustrated papers, the visits to galleries. He longed once more to follow in the footsteps of those "great draughtsmen of the people",

Renouard, Lançon, Doré, Morin, Gavarni, Du Maurier, Charles Keene, Pyle, Hopkins, Holl, Herkomer, Fildes. The struggle to do so was a difficult one—indeed hopeless. When he looked out some of his drawings and saw how far he had to go, he told himself that the trouble was a weakness of technique—he had but to practise, practise, and he would be the first great Dutch social reformer-illustrator; he played with the idea of producing a series of lithographs of the people to be sold cheaply to the people. That such a crusade appealed to his emotions solely and was in direct contradiction to his genius did not occur to him; he continued to try to force his way up a blind alley.

He worked on. Then came a shock. All about him were up in arms—Mauve, Tersteeg, above all his uncles: he was publicly disgracing the family to a degree undreamt of. In past years he had at least disported himself in decent obscurity except for the shameful business with Kee; now he brandished his degradation in The Hague itself, headquarters of the Van Gogh business, the centre of Dutch painting, a town in which the name of Van Gogh had long been honoured. They put their heads together. He was over age, but . . . And Vincent was startled to have a letter from Theo, chosen by the family as go-between, saying that "witnesses only have to attest that you are incapable of controlling your financial affairs, and that's sufficient for father to have the right to claim that you should be put into a ward." He was startled and at first simply angry. This betrayal, as it seemed, by Theo hurt him intolerably: to threaten him, even to consider so mean an action! And when, on second thoughts, he admitted that Theo would never have conceived such a plot against him, his anger was not greatly appeased; Theo had sanctioned it, had allowed himself to take part in it, to try to frighten him and to separate him from Sien—was that so much better than the plain malevolent dislike of his despised uncles?

He flared up with "I've never done anything criminal and I possess the civil rights of a Dutchman. I won't be molested or put in a ward. Many evil rumours about me have been repeated by the family, but would the authors of them stand up in court and swear to them? I doubt it." But he was worried. After all, he hadn't a friend in the world, he was eccentric, the family history was against him, he might be put in a home for the feeble-minded or some such horror. "There would be no more draw-

ing"—that was his first thought; but although admitting after consideration, "Father could do such a thing", he insisted "He'll think twice before starting it".

The worst of it was, that he had begun to feel ill. "Please," he begged Theo, "let me know if they do take steps and defend me if I'm ill." And he was ill. At first he thought himself merely half-starved, as he was, and worried. But it was not that. Early in June he had to go to hospital. Sien had infected him. He had gonorrhoea, the progress of which he described in detail to Theo. He was in hospital for weeks. His father came to see him, passing Sien in the corridor; they spoke little, but a few days later Sien reported that a parcel had come from Etten to the studio containing clothes, cigars and some money. Vincent was touched but cautious: "They don't know all." As usual, he did his parents less than justice: his father had already guessed not only the fact but the reason behind it, and he concentrated his anxiety where it should be—on the character of Sien. "I hope there is no harm in Vincent's so-called model," he wrote to Theo. "Bad connections often begin when a man feels lonely and dissatisfied."

Vincent sketched in bed when feeling strong enough, read his books on perspective—he was having a lot of trouble with this— more Dickens ("Good God! what an artist! There is no one like him") and his first Zola, *Une Page d'Amour*, and was conquered at a blow: "I am going to read everything Zola has written."

Sien went into the hospital at Leyden before Vincent had been discharged. On the last day of the month he received a nervous letter from her: she was sure, she said, that Vincent would take up with another woman and desert her. His doctor told him that he was not well enough to move; Vincent took no notice, hurried over to Leyden; the child had been born—a boy. Vincent was radiant; he wept over mother and child, looked proudly at the small face in its cradle, and when Sien looked up at him appealingly Theo's warnings and his own misgivings flew away and he said at once that there would be a home for her and the children when she left hospital.

He went back, and although ill and needing hospital treatment threw himself into the alteration of the garret next door. It was tiny, but he made a home of it: he scrubbed the wooden floor of his studio until it shone, he scrubbed his large white deal

working-table, he put white muslin curtains at the windows, pinned up his studies on the greyish-brown papered walls, set up his easels at each end of the room; in the alcove he stacked his collection of woodcuts, his drawing-boards, portfolios, canvases; in the closet he arranged his pots, books, bottles, tubes and brushes. In the next room he grouped the table and kitchen chairs round the oil stove and put the large wicker chair for Sien within sight of the Schenkweg meadows and wharf below. Beside the chair he placed the iron cot with a green cover: there is poetry in a cradle, he told Theo; the old Dutch painters had seen it, Millet and Breton had seen it. He hung on the wall behind the cradle Rembrandt's etching of the two women by a cradle. On the other walls he put up prints of Scheffer's *Christ*, De Groux' *Bench of the Poor* and Ruysdael's *Bush*, a photograph of a painting by Boughton, woodcuts by Herkomer and Holl and a print of the Millet he was never without, the *Sower*. "All very beautiful," he tells Theo; and that done the home was complete with its little kitchen and large attic upstairs like the hold of a ship with its wainscoted walls, its large bed and small bed. On the day that Sien came from hospital he gathered flowers and put them on the windowsill before her wicker chair.

They came home, the woman, child and baby: Vincent fetched them, beside himself with excitement, guarded Sien tenderly, forbade her to stir hand or foot, did all the work of the house. He brought all his small offerings to show her, one by one: he pointed proudly to the fur-lined boots he had bought for the little girl in honour of the day, hung in an ecstasy over the baby. He was a changed man; wildly excited, but gentle too. Perhaps even Sien at that moment felt a certain tenderness towards him, odd, poor and clumsy though he was.

Vincent's letters to Theo shot into rhapsodies: "My God, where is my wife? My God, where is my child?" used to be his cry, he said, "Is the solitary life worth living?" He quoted Michelet radiantly, *"La femme, c'est une religion."*

Tersteeg called and Vincent's satisfaction soared into anger. "He comes in and sees Sien, he looks away from her and says, 'Is that your model or something else?' That's not human, that's not good. I believe he would watch Sien drowning without lifting a finger, saying simply that it would be the best thing that could happen. To purify society! I think he's meddling with my affairs

because he thinks it will please father or the uncles—not to help me." That kind of man spoke of things "between" men and women, meaning some infamous relationship. "What there is betweeen Sien and me is love, the most sacred thing in life."

Theo was to visit him in August and he felt apprehensive: he had made a pilgrimage to the mill at Ryswyk, to find that it had been destroyed. But, he said, though the mill had gone and his youth with it, he felt once more that there was good in life, that one must work for good and that together they would achieve it. He appealed to Theo to let them meet and talk and think together as they did on that day of the walk to the mill. "I would like to talk about marrying Sien when you are here."

Theo came, saw Sien and her mother and was struck with horror: that the mother had herself been a prostitute was obvious and just as obvious was her intention of living as soon as possible on the earnings of Sien and her daughter—for the little girl would clearly go the way of her mother and grandmother. The whole thing became plain to him; Sien, pregnant, could not ply her trade successfully; a mad painter came along in the nick of time, without much money, but what he had was better than nothing—better, certainly, than a regular job. Vincent had offered to share all he had with them; the mother, the ruling spirit, had told Sien to accept; they humoured him, sitting for him, until the breadwinner was fit to resume her lucrative business. Sien was still weak—her confinement had been difficult —but when she recovered, when the poverty and the housework palled, when her mother began to press her to go on the streets again and take her girl with her, Theo could see nothing but suffering and disillusion for Vincent. Yet what could he say to a man revelling in the fantasy of his first home, a man imagining himself into love and his woman into a helpmeet? He tried gently to warn him that prostitution is a difficult life to throw off and urged him again not to marry Sien. In this alone Vincent was amenable for the moment. Sien no longer showed any particular wish for it, he said; perhaps they might live as they were, but live together they would—he had pledged his word, he desired it. When he earned a hundred and fifty francs a month he would marry her. He wrote off straightway to his father repeating the threat.

As they talked together at the end of the visit Theo tried again,

unsuccessfully, to make Vincent see reason. "I can't stand being alone any longer. I would rather have a bad woman than no woman," replied Vincent bluntly and with a desperation that must have struck a chill in his listener. So Sien had already begun to reveal herself! Yet Vincent, retreating step by reluctant step from idealism, remained as stubborn as when he had idolised the prostitute. What could be done with such a man? Theo said shortly that he did not wish to hear more of Sien; when Vincent wrote, let it be of his work. And on that unhappy understanding they parted.

Vincent had plenty to say of his work in the following months. The new home, the family life, Theo's promptings (with extra money from him for materials) and his own true instinct encouraged him to take up his brushes again; he went out every day, painting—to the dunes, to the sea at Scheveningen, to the Ryswyk meadows—from early morning to dusk, continuing in his studio till late at night. He was absorbed by painting, absorbed by colour and describes almost every brushstroke to Theo. For the first time he begins to write like a painter—not just with the painter's eye as he had written for years but with the painter's instinct for essentials and his passion for creating them on canvas. He tells how he sat down in a beech wood one evening as the sun was setting; the ground in front of him sloped and was covered with leaves, some dry, some rotting. "The difficulty was —and how difficult it was!—to reproduce the depth of colour and the enormous force and solidity of the ground." Then, looking again, he saw how much light there was in the gloom under the trees. "How to paint that light and not lose that other light —the deep glow of the turned and turning leaves that shone red-brown from the ground?" Only a painter could have stated the problem so; only a painter could have tackled it as he did. "While painting I told myself that I mustn't leave before I had put on to my canvas that melancholy, mysterious autumnal feeling. But the light was going, the effect wouldn't last. I had to paint quickly. I brushed in the trunks of the trees with a few strong strokes. That wouldn't do. The surface was so wet that the brushstokes, even with a firm brush, were lost in it. So I quickly squeezed in the roots and trunks straight from the tube and modelled them a bit with the brush. Ah! that was it! Now there they are, rising from the ground, strongly rooted in it, growing!"

He was overcome by the mystery of his art. "How I manage to paint a scene *I simply don't know.* I sit down with my blank canvas before the scene I've chosen, I look at the scene, I tell myself that my blank canvas must become that scene. I come home disappointed, put away the canvas for a time, then gingerly take another look at it. I'm still dissatisfied. I can still see that wonderful scene I sat before, and look what I've made of it! And yet, I don't know, I look again at the canvas—perhaps there is an echo of the scene there. Nature has reproduced herself through me in a kind of shorthand."

He did not paint well—his brush was heavy in his hand, his range of colour small, his palette dark, his subjects sentimental and weighed down with moral purpose—but Theo encouraged him. The move to Paris was making a first-rate dealer out of Theo—first-rate in the sense that he was using his experience to enrich painting rather than his directors. He had responded to the stimulus of the greatest art centre of the world, had thrown off provinciality of outlook, was already respected for his good judgment and—as good a tribute in its way—abused for his discreet championship of the moderns. He could see through Vincent's gigantic, infantile faults to one merit: he was an original, he was not (despite all his worship of the "working-class painters") hopelessly derivative—his lack of instruction and his quarrels with other painters had at least done this for him. In these unsaleable canvases there was a new note; crudity in his hands became a virtue. As his technique improved, this crudity showed itself not, as could be imagined, the result of ignorance but the particular manifestation of his genius. He thought strongly about the problem, as he did about everything, long before he had even begun to satisfy himself. "Is the *ne plus ultra* of art an ability to paint a canvas in a particular way, to draw with a multitude of tricks, to have what is called a distinctive technique? My belief is that we must get far beyond technique—so far that people declare we haven't any. Let our work be so *savant* that it *seems* naïve."

He was far indeed from genius in the summer and autumn of 1882, but there was a sufficient hint of original talent to encourage the harassed Theo whose money had now to pay for Cor's education, to be in readiness for his mother, to support, in one way or another, six people. For Theo had followed Vincent: he

met and protected a girl from the Paris streets. The choices were as different as the brothers—Theo's girl was educated, intelligent, conscientious; but the burden on the one man was increased nevertheless. He paid for an expensive operation that she needed late in the year; and although he was determined that she should not live with him if her only motive was gratitude, he had to support her for many months until she had recovered her health and could make up her mind freely. Vincent would almost certainly be a burden on him for years, but he bore it cheerfully when he saw signs, faint though they were, that his faith was being justified.

Theo's main cause for agitation was the rift between Vincent and his parents: he worshipped Vincent but saw his faults; he loved his father and mother but understood their limitations; but he chiefly saw the goodness in parents and child and could not rest until they had been reconciled. In a manner this was also self-protection; he was not a strong man in any sense; his beloved Vincent must not have the slightest slur in his mind; he must somehow be wholly fine as he had appeared on the Ryswyk walk.

For a time Theo's hopes were dashed. His father came up to see Vincent and could not resist reproaching him for continuing to live with Sien. "I never refused to marry her," retorted Vincent. "I hope to marry her as soon as I begin to earn." That would be even more immoral, protested his father: "Why sacrifice your position for a woman who isn't in your class and who will inevitably wreck your life?" They wrangled uselessly until the father turned the conversation, and as soon as he had gone Vincent wrote off to Theo angrily. What was the use of meeting his parents? They didn't understand him. The moment they spoke together all goodwill was blown away. As for his devotion to painting, they thought it only another craze, they would never understand that "the figure of a peasant—furrows in a ploughed field—a stretch of sea, sand and sky are vital things to me, and that to try to express the poetry hidden in them is worth the struggle of a lifetime". Even if they could be made to appreciate this they would still think "he knows nothing about it" when they saw him slaving away but selling nothing.

His rancour was fed for a while by his parents' attitude towards Theo's girl, Mary. He was busy advising Theo at length in letter after letter how to treat Mary, writing with conscious superiority

and a good deal of unconscious humour as one experienced in the ways of women. Then Theo told his mother and father that he wanted to marry the girl. They protested: she was a Catholic; mixed marriages were a mistake; Theo would imperil his soul and his material future. Vincent broke into loud denunciations: "The clergy are the most godless materialists in the world." In his anger he turned a mental somersault. "It's understandable that father and mother object to me marrying Sien, but in your case it's ridiculous—Mary comes from a good family. I'm ashamed of them. It's outrageous father taking up such an attitude with you. Anyway, you've done your duty in telling them—you need not worry about them any longer."

So he argued—with himself as much as with Theo—but events moved against him. In the autumn his father for the last time changed his living; he went to the village of Nuenen in eastern Brabant. Theo, who had not taken Vincent's advice to ignore his parents, came up to help them settle in their new home, talked persuasively to them about Vincent and described the Brabant country so attractively that a cry went up from the garret in The Hague: how he would love to paint the old church! "I'm for ever feeling homesick for heath and pines and peasants—the woman gathering wood, the man digging sand." His parents wrote to him, a pathetic letter showing them anxious to obey the suggestions of Theo and appease the moody genius: how was his painting going on—it was a long and difficult job, they knew—couldn't he some time come to paint at Nuenen?

Vincent was touched; and more than touched when his father soon afterwards sent him another parcel of clothes, including a woman's winter overcoat. This silent acceptance of the situation —for his father made none of the expected reproaches—left Vincent high and dry. What could he say? Only—and he meant it—that he would come to Nuenen as soon as possible.

So the winter opened auspiciously, his parents compliant, Theo helping gladly, the painting making strides, the little home circle grouped about him, giving him strength through love and companionship. He began to write optimistically: one more year would make a painter of him.

Then everything began to collapse about his ears. As the winter set in he had to give up his outdoor work. This did not depress him unduly: he had laid his plans for the winter; Sien,

her mother and little girl would pose for him as they had posed the previous winter; he would once again, without the crippling models' fees, take up the fight to give his figures solidity and motion. But they did not pose; they refused. She was too tired, she had better things to do, said Sien. The better things turned out to be tippling all the gin she could get hold of, smoking cigars and lounging about in the midst of a home that she would not trouble to clean.

Vincent was bewildered, then angry, but he could not out-shout Sien. She would make a wonderful painter's wife, he had exulted to Theo; she at least would not despise him, he had assured himself. He was doubly mistaken. While he had been out all day she had restrained herself; now she abused his work with a flow of filthy oaths, abused him for wasting his time over rubbish, for failing to earn money, for living on his brother, measly pittance though the brother gave him. She screamed at him, would do nothing for him. The house became uninhabit-able. Her mother disclosed herself as a malicious trouble-maker; every time Sien came back from her she behaved like a harridan. Even the little girl showed a shocking depravity, talking like her mother and grandmother, hanging about in the streets. Sien began to run him into debt to satisfy her craving for drink. She began to throw out ominous hints; if he couldn't keep her as she ought to be kept, she knew a better way.

He had to stop painting; he could no longer afford the paints. He tried to eat less to save the drain on their money, became sick and faint and, by the spring of the new year, had not sufficient strength even to draw. He worked on desperately in short bursts whenever he could stand at his easel.

Outside his home was no comfort. He looked so dreadful that even the working people drew away and stared, and children hooted after him. When he went out with Sien he damned him-self still more thoroughly: even on her best behaviour she could not be mistaken for anything but what she was; and she was no longer on her best behaviour—she was tipsy more often than not, ogling the men, exchanging lewd remarks with her friends at street corners, abusing Vincent publicly on the slightest provoca-tion. Tradesmen came to collect debts and when Vincent tried to turn them away they contemptuously pushed him down, threw him on to the floor.

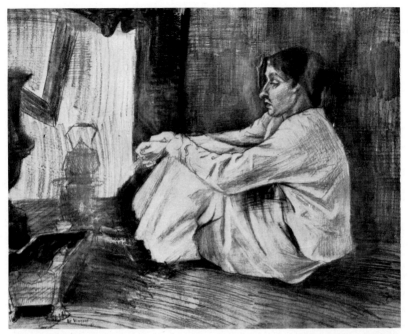

Pencil, chalk and ink drawing.　　　　Rijksmuseum Kröller-Müller, Otterlo
SIEN, 1884

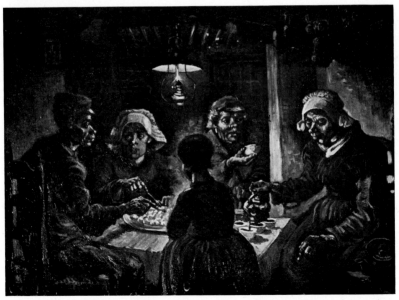

Gemeente Musea, Amsterdam
DE AARDAPPELETERS, 1885

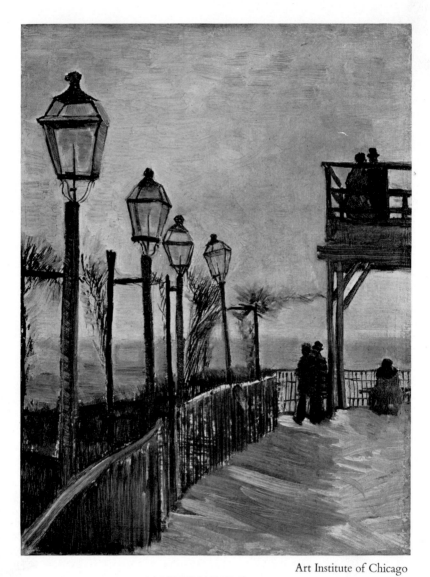

MONTMARTRE, 1886

Tersteeg had visited him in hospital, had called at the garret and begged him to get rid of Sien; he was insane to live with her, he would ruin himself for ever, he said; she was one of the most notorious prostitutes in The Hague. He had driven Tersteeg away and Tersteeg reported to Mauve that he was hopelessly corrupt—nothing could be done for him. He wrote to the parsonage: he was sorry but he could have no more to do with Vincent, who was a disgrace to his profession and should be forced to leave The Hague. Vincent's isolation became complete: Uncle C. M. stopped giving him commissions, the painters shunned him. "Don't think," he told Theo, "that I believe myself faultless because people imagine me to be an unpleasant person. Time after time I become dreadfully sad and bad tempered when I want sympathy and don't get it. Then, trying to appear indifferent, I seem disagreeable, I speak abruptly, I'm rude and make things worse than ever. The result is, I can't bear to be with others although I long for company—it's altogether too painful and difficult for me to speak to people." Alone he had been practically impossible to associate with: now, as if his own manner wasn't enough to put people off, he insulted everybody by taking up with Sien and insisting that, if they wished to know him, they must acknowledge her.

He had only one consolation, but a great one, and to that he attached himself with a frenzy of adoration—the baby. He at least had nothing but love for him. The cradle stood in the studio, the child laughed at him, looked at him with love; when he began to toddle it was to him that he went. Vincent talked to him, played with him, worshipped him. This was Sien's child although she took no notice of it: how grateful he was to her!

Theo came up again in the summer. At first he was annoyed as well as shocked by Vincent's appearance; he not only looked ill but dirty and disreputable, his filthy clothes falling about him, his boots worn through—a revolting sight. Theo protested: how could Vincent expect anyone to associate with him if he persisted in walking about like a beggar straight from the dosshouse? And why not try to be civil when someone did look in? Tersteeg had told him that the very way Vincent shook hands annoyed him. Then Vincent took him home and he forgot about the clothes and the behaviour. He was appalled and reproached him, but in a very different manner: not a word for a year, and this was how

he found him! Vincent reminded him that he had agreed to write only about his work; it was true, but Theo knew that he would have said nothing. He spoke plainly: he was mad to let this good-for-nothing drain his life away and prevent him from developing his gift. Why hadn't he got rid of her long ago? She was evil through and through. He might have added, "she is spending my money and you are wasting it", but he did not; he no longer considered the money as his: it belonged to Vincent by right of talent; if he had had more, if he could have cut his own expenses even closer to the bone, Vincent would have been given it gladly.

"How can she be good when she has never known good?" asked Vincent. He blamed himself; he had taken her from the streets and had tried to offer her the good life, but he wasn't good enough himself to convert her. The fault was his; he couldn't abandon her.

Theo insisted that she must go; he paid all the debts but persisted—she must go. She had made Vincent ill, unable to work, wretched; the situation was intolerable—she must go. She would go anyway—that was obvious, it was only a question of time. Vincent owed it to his art, if he wouldn't take heed of himself, to send her off.

They parted far from the Ryswyk tradition—"I'm beginning to think more and more like Father," said Theo when they said good-bye—but Vincent knew that Theo was right. It was only a question of time; he had failed again; his work was standing still; he must lose the baby, must lose even the likeness of a home. He was surely damned; even a prostitute couldn't stand him.

In the autumn he made up his mind. Sien and her mother were plotting to throw him over and go back to the old life—he could tell it by the way their voices dropped to a whisper when he came into the room, by the way they looked at him. He made one last effort to save Sien: he had failed her, let her get a good steady job; he advertised for her, went around the town asking for jobs for her. He found one. He packed up his things and dismantled the little rooms he had built and decorated with such pride just over a year earlier. He looked at the two women—they were hatching some plan; he knew the signs. Probably Sien would not take the job after all, but he had no heart left to struggle further.

SIEN

He said good-bye to her at the station: he sat in the train, the little boy on his knee, and begged her once more to keep straight, to write to him. Sien, sober for once, looked enigmatically at this man who was leaving her—her!—with tears in his eyes, with protestations of love, with injunctions to tell him how the baby fared, to let him know if she ran short of money. Money! As if he'd ever earn a penny! She had met some queer customers but this was the queerest of the lot. She took the child from him and the train carried him away.

Chapter Thirteen

DRENTHE

1883

HE went to Drenthe in the north Netherlands. He chose Drenthe because Van Rappard had praised it as a painter's paradise: cheap to live in, unlike any other part of the country and—shrewd inducement—where the peasants reminded him of Vincent's Brabant studies.

He also went to Drenthe because it was country. Like most creative people he veered between town and country; each had something to offer, each wearied him after a time. He went heavy-hearted but determined. "Perhaps your duty will make you see things differently," Theo had told him before their last unhappy parting at The Hague. He was right, Vincent now saw, but through a haze of unreality; Sien had faced him, he chose to believe, with a choice between love or duty, a home or his work. There could be only one answer, but he returned the answer reluctantly; he did not wish to leave Sien, he could not bear to leave the child. His conscience tortured him; he had tried to raise Sien and had accentuated her fall. Ought he not to have brought her with him? The question dwelt in his mind uneasily, absurd though it was. Sien in Drenthe! with mile after mile of desolate peat-moor on every side, dingy peat-barges moving sluggishly to the sea along the brown canals, poverty-stricken peat-diggers crowded into miserable huts; no towns, no street lights, no pavements, no crowds, no drinks, nothing—absurd indeed but he agonised on: when he met a woman with a child in her arms the tears started up in his eyes.

Conscience apart, he wanted company; he sought country but he did not seek solitude; yet Drenthe, picturesque though he found it, proved to offer not merely solitude but desolation. The few peasants did not live, they existed. They did not perceive the love in his heart and the kinship in his mind, they saw only a queerly dressed man, red-haired and red-bearded, who lay down and stared at nothing in particular for hours at a time or dabbed furiously with a brush on a board, who wanted them to stand

still in the open, in front of all their people, while he scribbled caricatures of them on his paper. Of course they refused: inside his garret, perhaps, if he paid well enough for the indignity.

Yet it was a beautiful place; the scenery, he told Theo, had the nobility, dignity, gravity of its people. On all sides he saw excellent subjects—the drawbridges over the canal; thatched cottages; the sombre moors; all seen in queer lights and colours. He sketched and painted furiously but unhappily because he was alone. Van Rappard had gone ahead and was beyond Drenthe before he reached it, but, said Vincent confidently, he would join him in the winter. This was the place to found the community of painters; he expected to stay at least a year. But Van Rappard did not join him: an occasional visit to Vincent was stimulating, it was like moving into another world for a few hours; but to live with him was another matter. The community languished. Of all the painters Vincent had met he remained on speaking terms with three—Van Rappard, Breitner, who had seen little of him and was now teaching, and a schoolmaster anxious to pick up hints. But Dutch painters worked in Drenthe. Desperate for company he went to their favourite centre in an open cart before dawn one day—a three-hours' journey—but found no painters: they came only in the summer, he was told. He had left The Hague in September when most painters were settling into their studios for the winter. He walked back despondently.

The weather was deplorable: it rained, blew, snowed. "I can't hide from you that in spite of the beautiful scenery I am weighed down with care, depression, discouragement, despair." Sien had never written to him and he was tormented by fears for her and the child; he did not get on with other painters, with anybody for that matter, yet he could not work successfully in isolation; he had no one to talk to and when he went into the garret he had rented and the dreary light peered through the solitary window-pane on to his empty colour-box, his bundle of brushes with the hairs worn down almost to the wood he felt an intolerable melancholy; he thought of giving the whole thing up and enlisting in the East Indies Force.

Then Theo began writing unhappily. He feared that he would be dismissed because of his sympathy with contemporary painters. He talked of going to America and beginning an art-dealer's

business there. He even dropped hints of suicide. The months of anxiety with Mary, the thought of his loneliness if she left him, the strain of trying to keep the peace between Vincent and his parents and of being just to both sides—all this had broken down a never robust mental and physical constitution. He talked wildly.

At once Vincent was both the stronger and the wiser. He comforted Theo as best he could, dissuaded him from thinking of America—"it will be the same there as in Paris"—urged calmness on him, assured him that all the family he supported understood his position and "will face fate and if necessary will work". Above all he deprecated all talk of self-destruction: "Neither you nor I could ever do such a thing as commit suicide. I also have times of depression, but the thought of doing away with ourselves must—I say it again—be regarded by both of us as out of the question, as quite against our conscience."

Yet Vincent was far from seeing the point—he knew nothing of the Impressionists except Zola's little book on Manet, named Israëls, Mauve and Thijs Maris as the best modern painters, and declared that he was against "a new trend". All he saw and all that he needed to see was that Theo was unhappy and was having trouble with Goupil. The reason was immediately plain to him. He was of those who lean heavily on the idea of Providence; he now fitted his own need to Theo's troubles. Theo had the soul of a painter and could not compromise with the commercialism of an art-dealer's life; he must throw up his job, join him and paint. He would not take no for an answer; he wrote letter after letter.

For a time Theo was tempted (Vincent's emphasis was difficult to resist), but his better sense made him temporise: Vincent was an artist, he was a businessman, he said. "I'm more concerned to understand how arms, legs and head are attached to the body than to worry whether I'm an artist or not," replied Vincent. "I want to make as many drawings and paintings as well as I can, and to die thinking, 'What pictures I might have made!' That's all. Can't you do as much?"

You are the thinker, said Theo. Vincent was sceptical: not more so than man of action and not more of either than Theo: "Look at the Dutchmen who went over to America, the Pilgrim Fathers, look at the proportion who had our square foreheads

and reddish hair. Let us both be the Pilgrim Fathers of art!"

The battle swayed back and forth. City life was degrading, urged Vincent: "To keep up a certain rank one is forced, with one's eyes open, to lie, to commit crimes." The idea that civilisation was to be found in cities was abhorrent to him, as was, increasingly, the idea that the clergy represented a civilising influence. He seemed compelled to attack what his father was and what he had once yearned to become. As always, the slightest hint of compromise maddened him and he saw the grossest example of all compromise in the clerical life as lived about him and in his own home: "Before clergymen have reached the civilisation of pigs they will have to better themselves a great deal. They are still ages away from it." By contrast, look at the men who work on the land, who create life from the soil: "An ordinary farmer who works intelligently is *the* civilised man." And a painter was a farmer, he sowed and reaped; if Theo would be satisfied "with a loaf of bread eaten in a field", they could be together: "Probably we shall have to live like negroes, half starving. At first it will all seem miserable to you, then you'll suddenly make a thing in which there is a *je ne sais quoi*".

As Theo hesitated, Vincent brought every gun to bear: "It's too big a work for me alone. Sometimes I feel I can't stand the loneliness any more. I need someone to talk to, someone who knows what a painting is." And this not deciding the wavering Theo, he went further, he questioned the good faith of Mary: "Is she good or does she hanker after society life, is she using her charms to keep you a businessman? I think of Lady Macbeth." In a cooler moment he withdrew the charge but persisted in another direction: "You are letting me down." He even threatened him in his own way: "If you decide to stay with Goupil, I shall refuse all help from you. I won't develop the artist in me if it means suppressing the artist in you."

He became terribly excited: he saw Theo there, painting with him; they were walking and talking together, two minds directed towards the one end; Theo's presence was transforming his work. In two years, he insisted, he would be selling, and Theo with his help would be well on the way. They could both live, he was sure, for little more than the amount of his present allowance: two years at 200 francs a month, he reckoned, cutting the total by half in his enthusiasm, would be only 2400 francs. That was all they

would need. How would they get it? He didn't know; but surely the obvious security they could give would be their work.

This brought Theo back to reason: their work as security! Vincent might be a painter but he was no businessman and he had the knack of making art-dealing appear more sordid than it was. To Theo it was a necessary and, rightly regarded, a good work: how else would painters exist—even Vincent when he made saleable pictures? To live with Vincent, to create side by side—that was a thought—but one had second thoughts: who could live side by side with Vincent? Theo was neat, particular, precise, he valued standards of living at which Vincent sneered, he had good friends, he loved Paris and in his untroubled moments he loved the life he led, picking out the swans from the geese, encouraging them and educating his public to appreciate them. But he was a modest man and a timid one, bewitched by a powerful personality; from Vincent these suggestions were not hare-brained, he was a potential great man ready to starve for his art—yes, and to make others suffer for it. He could dismiss Theo's questions—who is to keep so-and-so and so-and-so if I stop work?—as irrelevant to the one big issue, the need of the painter to follow his calling. He, Theo reasoned, had the right of the artist to disregard economics; Theo had not that right—he must think for all and especially for Vincent. If he succumbed to Vincent's call, poignant with longing and loneliness though it was, he would ruin all—and all for a talent that might not even exist.

He put his foot down gently; he thought it best to stay with Goupil. As he expected, Vincent was hurt and angry. So he preferred the flesh-pots to his own brother and to art! "You say, 'I want to keep up my standard of life, I want to stay in business, I shan't become a painter.' I say, 'I can see that I shall become even more rough and unlovely, that I shall live in poverty, but *I will be a painter*.'" He was four years older; those four years had given him the knowledge that the duty his father, Tersteeg and the rest had tried to teach him was no more than a shadow of duty: these were men whose virtue was negative, who lived for the outward appearance, the *rayon noir* of Hugo. They told him, "Earn your own living and your life will become useful and virtuous." "When I think of father I know he values things that have no value; he has no knowledge of the intimate life of great

men such as Dupré, Daubigny, Corot, Hugo, Zola and Balzac. He doesn't see the soul of modern civilisation. To me he is *le rayon noir*." But Millet had the *rayon blanc*, Millet told him, "Try to make yourself useful and virtuous, pursue the truth that is in you and the rest will follow—even the earning of money." That was his true duty and he intended to live by it even though Theo forced him to live alone. But "My heart knoweth its own bitterness, as you will understand."

A few days later, unable to bear the loneliness any longer, he started out for Nuenen, walking for six hours through rain and snow to the nearest railway station.

Chapter Fourteen

NUENEN

1883-1884

H E came home at the end of November. His father drove in the carrier's cart to the nearest small town of Eindhoven to fetch him. It was an unfortunate introduction to the new home; Vincent was in such a condition that before driving back his father had to buy him a pair of boots; at Nuenen the carrier had no sooner put father and son down at the door of the parsonage than he hastened to spread the news of his extraordinary passenger—a red-bearded tramp, covered in mud, a famished look on his face and a dangerous light in his eyes, wearing a weird kind of round fur cap, who spoke in husky, impatient whispers and clutched a shabby collection of peculiarly shaped packets. The rumour circulated that this strange creature was actually a son of the gentle, handsome pastor who had come to them so recently—for neither the pastor nor his wife had mentioned his existence.

In the parsonage Vincent was being treated with appropriate care; his letters from Drenthe asking for money and urging his father to make Theo turn painter had warned his parents that they would have a difficult man on their hands. And had he not written, a few weeks before his arrival, that he hoped when he found it necessary to come home that his father "would not spoil things by creating disharmony between them"? Ominous words. "He is evidently melancholy and wrong-headed again," his father told Theo, "and what else can one expect? It must be dreadfully painful to him to remember how he has broken with all his friends and relations. I only wish he had the courage to see that his own behaviour is probably responsible for his troubles but I don't believe he ever reproaches himself—always others, and specially the gentlemen at The Hague. Well, we must be very careful with him."

Their efforts were thrown away. Vincent came back in a savage mood. Two years earlier he had walked out of his parents' house in a passion, he had declared that he would never go back,

he had criticised them, sneered at them, despised them, then he had borrowed money from them, not once but several times. Now he had come back of his own accord, because he was lonely, because he had nowhere else to go—the man who had cried to them that he must and would marry Kee, the man who a few weeks later was living with Sien, the man who had now left Sien and quarrelled with Theo. He had no friend, no home, and he chose to return to them. He could not forgive them for this mountain of humiliation their very presence heaped on his back. If they had reproached him, stormed, shouted at him, he could have dealt with them, but they did not. In their pitying way they loved him, wastrel, failure, disgrace though they thought him, and they forgave him. They said not a word of reproach, they were all consideration. He could not endure this greatest of all burdens: they who are not with me are against me, he told himself; he loved them but he hated them too.

In vain they praised his drawings (genuinely surprised by the improvement), in vain they welcomed him with kindness and cordiality, in vain they took pains to show no surprise at his wild appearance or his curt manner. He would not be mollified: they did not understand him, they showed no awareness of his magnanimity in returning, they did not apologise for having asked him to leave the house at Etten. If he had been the first Vincent, the real Vincent, his welcome would have been different—no question of forgiveness then, but joy and thankfulness—but he was as always the equivocal child; they had never forgotten it, they never would forget. They had kept his very existence a secret, ashamed of their own son.

He worked himself into a frenzy. He had said to his father at The Hague that it was perhaps better for him not to come home, and his father had replied, "You must do as you think best." What kind of reply was that to a tentative advance? he now asked the unhappy Theo to whom he could not resist complaining. "There is no change!" he screamed. "They are not sorry for what they did!" As for his father, "he is of iron, of glass, ice-cold, something like dry sand in spite of his outward softness. He doesn't regret, he believes in his own idea of justice. I think that he and I are implacably opposed to one another."

He behaved with atrocious arrogance. He upbraided his father: "I told him that if he had had any principles he would

have avoided a quarrel. He should never have sent me away two years ago and he should not have quarrelled. He tried to turn the conversation, but I said, 'Father, I have to deal with your idea of justice which is fatal to both of us.' Then he said, 'Do you expect me to kneel before you?'" This, declared Vincent, was intolerable. "Now you can see how narrow-minded he is." He rejected every advance: "Their kind welcome is of no value to me." He sneered at the home offered to him: "This house is too splendid for me, and father and mother and the family are so goody-goody (with no feeling behind it) and—and—he is a clergyman, in spirit they all are." He insisted on complete surrender: "Am I to blame when I want to end the family dissensions? Am I wrong in wanting to make a thorough peace? Am I wrong to be dissatisfied with outward appearance or a feeble reconciliation? I won't compromise. It's the whole thing or nothing at all." He laid down the terms on which he would stay in the house. The whole family must help him by standing as model. "If I say you must pose then you ought to pose." He demanded absolute freedom to draw and paint when and where he pleased. He insulted his father's friends by cutting short their greetings and offering them a single finger. After a few days he refused to talk in the house, scribbling messages on scraps of paper if some communication had to be made. During meals he worked between mouthfuls at a canvas or drawing-board propped on an empty chair beside him.

But anger and suspicion still smouldered in his mind: he could refuse to speak but he couldn't silence them. These smug, self-righteous people were talking about him behind his back—he could imagine their whispered conversations—and setting Theo against him: they were writing to Theo, he knew, and Theo was replying.

In one sense his suspicions were true enough: they were talking about him endlessly: what could they do to satisfy him, to ease this fearful pride? They were also writing to Theo about him, but not as he imagined—they were praising his drawings of the derelict church tower. Only after ten days, when he was making life intolerable, did his father sigh, "It seems hopeless."

Vincent dashed off frantic letters to Theo. "They dread having me in the house as they would dread having a large savage dog. He runs into the room with muddy paws, he is rough, he's in

everybody's way, he barks loudly. In short, he's a dirty beast. He might bite—he might go mad. The dog is only sorry he didn't keep away, for he wasn't as lonely on the heath as here despite all kindness. I tell you I choose a dog's life, I'll remain a dog, I'll be poor, I'll become a painter. I want to stay human— natural."

He threw back Theo's mild reproaches. "So you also think I'm a coward and hurt Father's feelings? I must find a way not to 'bother' you or Father any more. I'll try to keep everything to myself, I won't come here again and I'll stop taking your money after March so that I shan't 'bother' you any longer." He was going off to Van Rappard, he said, as soon as he had the fare. And Theo? "I don't ask you to interfere, I ask something more personal, I ask you frankly how do we stand? Are you also a 'Van Gogh'? I always thought of you as Theo. My character isn't the same as other members of the family. I'm no 'Van Gogh'."

Theo, though distraught by the letters flowing in to him, savage from Vincent, perplexed and hurt from his father and mother, restrained himself, urging patience and pity on the one and suggesting to his parents that Vincent should be given a room to live and work in where he would be left entirely to himself. His pleas were heard: it was true, said Vincent, that he was a living example of Michelet's *le mâle est très sauvage* but he also in calmer moments respected old age; he had spoken to his father, he had chosen a room, the old laundry attached to the house, the furthest removed from the family. His parents thought it a queer choice—why deliberately make yourself uncomfortable?—but they were too relieved to argue, they simply did what they could to make the place habitable, putting in a stove, covering the stone floor with boards and propping the bed on wooden blocks to protect it from damp. They also tried to put in a larger window but were peremptorily forbidden by Vincent to touch the old one. But they had made the room warm and dry; Vincent was working hard, drawing or painting all day; for the rest, "We shall say nothing about the peculiar way he dresses—in any case the villagers have seen him now and it is clear that we can't alter his queer habits. But it is a great pity that he keeps himself so much to himself. . . ." His clothes were unquestionably peculiar, for when at last he shed his rags and his father's old jacket and

trousers he began to walk about the village in a suit of lilac tweed with orange and yellow spots. He declared that he liked the colours very much; certainly he liked every gesture that struck at the philistines' sense of propriety, and he possibly welcomed because he could despise the whispers of madness that began to follow him. Nevertheless it was also true that he ordered the suit because the tailor, unable to sell the ferociously coloured tweed, made it up cheaply.

Late in December he went back to The Hague to fetch his prints, drawings and paintings. He looked out Sien and wrote to Theo in distress: she had been working as a washerwoman, she was ill, he felt sad and guilty: "It is largely my own fault." He took her to a doctor, talked to her, decided that he ought not to live with her again but was unable to resign himself to this decision. He returned just before the end of the year to his self-imposed solitude in the studio, disconsolate, melancholy. He turned his guilty feelings on to Theo, belabouring him in his letters. Theo, like his father, he insisted, was cruel in his worldly wisdom. His father "has a system and conventions to rely on. He doesn't struggle with truth." One part of Theo was no better. He brought up accusation after accusation out of the past as he brooded in his studio. Theo had advised him to leave Sien—he had advised in the wrong spirit; Theo had called her "that person"; Theo had not replied to Vincent's news of her in his letters from Drenthe; Theo had said that Vincent had done himself and Sien a bad service when he took her into his house. "Take that back!" thundered Vincent. Then he made an effort to be just. "I know you did it for my good, but it is impossible to be on good terms with the world and our conscience. I don't like your diplomacy. I think you are too politic at times." All in all, "everything I had built up has been ruined since I left her." And in consequence, as he persisted in regarding Theo as the author of his misfortunes, "I can't speak to you in the same old way."

Why isolate yourself? asked Theo, irritated by the incongruity of Vincent's cries after Sien who didn't care a rap for him and his continued neglect of his parents who loved him. Vincent blustered—"I've never done anything to set myself apart from my fellow-men"—spoke of his preference for the company of the weavers and peasants, and contradicted himself by quoting

Taine: *Il me semble que pour ce qui est du travailleur personellement, il peut garder ça pour soi.* But he was worried; Theo was right; he couldn't live in isolation; it was death to him and his work.

In the middle of January 1885 an event forced him out of introspection; his mother, paying a visit, slipped from the railway carriage, broke her hip and was brought back apparently dying. The family collapsed; her husband could not bear to see her suffering, her daughters were weak and helpless in an emergency, her young son Cor was a schoolboy. Into the panic Vincent marched, taking charge: he calmed his father—he had seen and attended to many a worse injury in the Borinage—this one was not fatal; he gave the girls little tasks that kept them busy; he made himself his mother's nurse, changing her bandages and looking after her wants with an efficiency and gentleness that amazed everyone. The doctor praised him, his father and sisters marvelled, even the neighbours visiting the invalid smiled graciously at the black sheep whom they had so far avoided. So attentive was he and so skilful that his mother was soon pronounced out of danger, then the predicted six months in bed was cut down to three. He brushed aside the praise—"he is tireless and spends every moment of his free time working with tremendous determination"—but the contact with his family did him good despite himself, the need to attend to someone less fortunate than himself took his mind off his own worries, and he felt fierce satisfaction that the despised and rejected could become the support of all.

He attacked his work with new fervour. In the middle of a cornfield at the bottom of the parsonage garden stood the little church he had heard so much about at The Hague. The mere description had intrigued him, but when he saw it, abandoned and soon with only the tower left standing, his curiosity turned to a passion—he drew it, made water-colours of it, painted it untiringly. And in the village were weavers in cottage after cottage: his dream on the walk to Courrières could be realised at last, he thought. But the painter in him was greater than the moralist or the social reformer; he went into the miserable cottages with love in his heart for the poor and oppressed who lived there but, once inside, the painter was ravished by a difficult but congenial subject—how to render the dim light, the hollow faces, the gaunt loom of old greenish-brown oak against

a greyish wall and, when they wove at night under lamplight, how to reproduce the checker of light and shade: "They were arranging the threads when I came in, dark bent figures silhouetted against the light which threw up the colour of the cloth and threw huge shadows of the loom on to the walls—Rembrandtesque!" He remained very much a painter of the north; his paintings must harmonise in colour and tone with other Dutch pictures, he delighted in his dark palette, working largely in browns—no silvery tones, he emphasises, and comments with pointed vagueness, "No doubt some people will disapprove."

Theo was given almost a day-to-day account of Vincent's adventures in this enchanted realm, but the manner of the telling had changed. Theo was in disgrace: he had refused for the second time to become a painter; he was acting as family go-between, trying to smooth out differences; and, final injury, he had not sold a single picture by Vincent.

Vincent's letters grew increasingly bitter: Theo wasn't even trying, he cried; he was still saying "almost saleable"—the very words he used about the Brabant types three years earlier! "Let's be realistic. You told me yourself that you are a dealer. If you don't want to trouble yourself with my work, say so. You seem to me just like the others who told me, yes, your work is very good, but. . . . Tell me frankly, do you show my work to the public or not? I don't believe you do."

"Have patience," repeated Theo.

"No, I won't have patience!" shouted Vincent, his handwriting tumbling over itself in his agitation: "I need my patience for my work, Rereading your letters, I see that you put things in such a way that in the end everything is proved to be my fault. That's a typical Van Gogh trick; it might have come from Father. I'm very angry because of your damned 'have patience' and 'work on' when I believe you aren't lifting a finger to help me. You are neglecting my work." Why didn't Theo help him by introducing him to another painter, by doing something, anything? Have patience! He couldn't live on that. Had Theo thought of his position? Three times in one week he had been asked in the village why he didn't sell his pictures. "The money I get from you is regarded as a gift to a poor bungler who can't sell a picture."

Theo was perhaps flattering himself, Vincent sneered, that his

help would be allowed to degenerate into protection; if so, he could stop deluding himself. "I refuse to become your protégé, Theo. Why? Because I won't."

His rancour rose to a shriek. "You can't give me a wife, you can't give me a child, you can't give me work. Money—yes, but what good is money to me if I can't have the other things? And anyway your money is wasted because it's not doing what I've always wanted it to do—to get me a home of my own. A peasant's hut would be enough, but if I can't have even that my art will suffer."

Theo knew that Vincent's resentment sprang from more than the frustration of the painter, but there was nothing he could do about it: he could not, to please Vincent, stop advising his parents; he could not, to please Vincent, give up his responsibilities and take to painting. There were limits to his love; these were beyond the limits. Somehow Vincent had to accept the fact—but would he ever accept unwelcome facts?

Even the genuine cries of the unacknowledged, hampered painter were beyond Theo's help. "Introduce me to a painter!" demanded Vincent. He forgot what happened when he did meet a painter; Theo remembered. "Sell my pictures!" demanded Vincent: but how sell the pictures of a man, embryo genius though he might be, who insisted on painting in dull yellows and browns, who would take no advice and who refused to come to Paris? How sell the pictures of a man who replied to an attempt by Theo to interest him in the work of the Impressionists with an, "I can't agree that Manet is a founder of modern art. I consider not Manet but *Millet* to be *the* modern painter who has opened up a new world for us"—and whose answer to a further attempt was: "Although from what you say Impressionism is not what I thought, I find the work of Israëls, for instance, so great in conception and execution that I simply can't get up any interest in anything different or new, and don't want to." And Vincent had seen only one or two pictures by Manet (in photographs) and none at all of those who were following him! Theo controlled his impatience and sent Vincent books on painting—in particular one describing Delacroix' theory of colour—and peace of a kind was restored by a compromise with Vincent's pride: from March onwards Theo's monthly allowance would not merely keep him, it would buy his pictures.

Every month Vincent sent off all that he had painted, satisfied that he was being paid for them and not for his food and board. He was a protégé no longer; if Theo did not sell the canvases it was his affair. His letters grew cordial again and by May were expressing much of the old intimacy: he had found a new and better studio, renting two rooms in the house of the sexton of the Catholic church, which removed him from the company of his parents except for certain meals which he still took with them. His landlady, overlooking the mess he made of her rooms, thought him a kindly man and deplored the way that the village boys ran after him when he went out painting. But the villagers, apart from their children, had begun to accept him as an inevitable part of daily life and there were signs that he was winning converts—no fewer than four men sought advice on painting from him.

Van Rappard came down for a few days; they went out sketching and painting, visited the peasants and weavers, sat in the shady parsonage garden and even called on the next-door neighbours. "How I enjoyed it all!" said Van Rappard; Then Theo followed him and the brothers went about as usual. Vincent became almost happy: "I have had a much pleasanter time with the people here lately." But he added a characteristic warning: "One must remember, though, that such times don't always last."

He was not this time thinking of his inability to stay on terms with anyone. One reason for his improvement in spirits, in work and in his relations with Theo, had not been divulged even to Theo.

Chapter Fifteen

LAST LOVE

1884-1885

IN the house next door to the parsonage lived a family named
Begemann. Begemann was an elder in the parson's church, his
three sisters had become close friends of the parson's wife, and
his children played with young Cor. The gardens ran side by side
down to the cornfield surrounding the ruined church beloved by
Vincent, and a gate had been made in the hedge between them
to save the families the trouble of going round by the street.

This free and easy intercourse was brought to an embarrassed
halt when Vincent came to Nuenen with his father in the carrier's
cart. For the first ten days the parsonage became virtually un-
visitable and the Begemanns took the hint; they did not wish to
witness their friends' confusion and unhappiness, nor did they
wish to be insulted by the criminal-looking man who might be
discovered in any part of the house drawing and painting and
who had been incomprehensibly introduced by the Van Goghs
as their eldest son. Vincent, reacting violently to Begemann's
austere greeting, settled the matter by a contemptuous one-
fingered salute. "Is it any loss to me when I annoy such people?
Not a bit—they are hindrances."

When he moved into the old laundry the Begemanns visits re-
commenced, but circumspectly; they kept clear of the garden in
which Vincent painted from time to time; they preferred the
Van Goghs to come to them. Then Mrs Van Gogh broke her hip
and their scruples were put aside; they were obliged to meet her
peculiar son because he was so often in her bedroom. When they
saw his tenderness and skill as her nurse their scruples dis-
appeared; they did not like him—who could?—but he was
certainly showing a most unexpected side of his character. His
friend, Van Rappard, was an unexceptionable young man; his
brother, Theo, was charming. They tolerated him.

But one of them did more than this; the youngest sister,
Margot, began to smile timidly at him, was even friendly in her
shy, withdrawn way. She saw beneath the forbidding surface.

She too was something of an alien in her family; not a rebel as he was—she had neither his courage nor his ruthlessness—but nevertheless not of them. They were both failures, both lonely, both misunderstood.

Vincent, divining the sympathy, dropped his disdain sufficiently to encourage her to speak; he showed her his sketches and was astonished by her reaction; the plain little woman just entering her forties, a country mouse if ever there were one, actually understood something of what he was struggling to do; she stammered, she blushed, she couldn't express herself, her timidity and her efforts to break through old-maidishness were painful, but—she understood.

Helped by Vincent's sister Willemien who was fond of Margot they began to meet outside the parsonage; first, she came hesitantly through the gate into the parsonage garden to watch him when he painted there; then they met in the weavers' cottages, she ostensibly to pay her errands of mercy; finally, abandoning concealment, she joined him on his walks. They walked about the country together, stopping for him to paint or sketch, bringing back to his studio birds' nests and eggs—for this boyhood passion had carried over into the painter. He talked endlessly, talked as he had never talked since the day of the Ryswyk walk, but he talked differently, for she was a woman. She had distressing attacks of primness, and his eyes would gleam with anger when she reverted in fright to the manner of the Begemann drawing-room, but he controlled himself: she was a woman and she understood; she was all he had; she was, he thought, like a Cremona violin spoilt by bungling workmanship, but he had moments when he hoped to conjure the true, glowing tone from it; he had found himself when all seemed lost; perhaps he could do the same for her.

They made an incongruous couple—the dowdy respectable little spinster and the unkempt Bohemian—and the families looked on the growing friendship without enthusiasm. In the Begemanns' house particularly it was felt to be unsuitable; yet how could they hurt the feelings of the worthy pastor and his wife by ending it? Margot was surely too old to arouse gossip and, taking the most charitable view, she might be the means of bringing this lost sheep back to the fold; she had done nothing all her life, she had been a disappointing daughter and sister, a

little queer, not exactly disobedient—she would never dare to be that—but somehow disregarding the finer points of conduct; perhaps she had been reserved for this one great, redeeming work.

But her rôle was a different one. She was nearly ten years Vincent's senior, she had lost any looks she might once have had, she was neither clever nor gifted, she was nothing, but with the sublime unreasonableness of the emotions she offered herself just the same. His attentions—the first she had ever had—and his confidences were irresistible: she fell in love with him: for the first and last time in his life a woman loved him for himself, disregarding outward appearance, manner, reputation, poverty, everything. He was astonished, incredulous, grateful, then more than grateful. He loved her, he said: not with passion but with a pitying, protective affection. Here was someone who needed sympathy and care even more than he did; she had been subdued almost from birth, the poetry in her had been trampled on, the devil respectability had ground her down.

All this he understood. She was older than he, her best years had gone, but he thought nothing of it: he looked older, he felt older, he was convinced that he had not long to live—seven to ten years he gave himself. He had no time to lose—he must work and, if he were to fulfil himself as a painter, he must also love. He could see improvement in his work in the few months since he had known her; it had life, humanity, it was acquiring that *je ne sais quoi* he had sought in vain for years.

She loved him in her faded melancholy way without reserve. He felt a surge of power but it went into his work; he respected her and understood that she had been sheltered too long to survive a relationship outside the conventions—her brain was even more unbalanced than his own. Time after time she exclaimed as they walked quietly together, "I wish I could die now!" He understood: they must live soberly, he must work inspired by her love.

The idyll had a short life and the dramatic ending of all Vincent's relationships. In August they agreed to marry. She spoke to her family and was met with a storm of derisive anger: she was a disgrace, she was insane, she would have to be locked up, she was a traitor, a hussy. "You are too old for that kind of thing," they sneered.

For three days she faced the onslaught; she had never in her life defied her family, but she defied them now. "I too have loved at last!" she cried hysterically again and again. Then she collapsed; she slipped out in the morning to see Vincent and, while they walked in the fields, suddenly fell to the ground. He thought at first that she had fallen from exhaustion. He picked her up and began to carry her home. Then the truth struck him. "Have you taken poison?" he asked. "Yes," she cried. He was horrified. He would tell no one, he said; it might still be possible to keep her secret; she must put a finger down her throat so that she would retch up the poison. She obeyed him in this as in everything. She made herself vomit but remained too ill to walk. He carried her to the door of the house (Begemann would not allow him inside it), hurried off to a doctor in Eindhoven, then wrote a note to the family—the doctor said she would have brain fever if they continued to oppose and persecute her. Begemann replied shortly that if Vincent agreed to wait two years the whole question could be shelved. No, said Vincent; now or never.

Like everything else Margot had done in her life this gesture was ineffectual; she did not die; she was taken away to Utrecht dangerously ill. She recovered slowly and remained a nervous wreck. She wrote to Vincent: not one of her family understood how she was suffering—they treated the whole question as a disgraceful joke. Vincent, furious, stormed into the house: they must write to her admitting that they had been wrong to mistrust her. They refused. From Utrecht, Margot wrote plaintive letters; she tried to think of other things and occupy her mind, but she had no distraction except the books he had sent her; and she was too disturbed to read. He went over to see her, but it was no use; she loved him, but she had no strength to stand with him —she was irrevocably shattered. They had met too late—"ten years too late," exclaims Vincent bitterly.

Six months later she was brought back to Nuenen, but he never saw her again; she was kept inside the house. The Begemanns had broken with the Van Goghs; Begemann gave up his position in the church, his family refused to speak to the pastor and his family, the gate between the two gardens was taken away and a hedge planted across the gap.

In a moment the pastor saw his life's work thrown away. His congregation swelled with the curious then fell away; never had

it been so small. The villagers stared and gossiped. The other church elders carried out their duties but boycotted Vincent and the parsonage. He did not reproach his son but he regarded him with absolute despair: everywhere he had set foot—Etten, Nuenen, The Hague, Brussels, the Borinage, Amsterdam, London, Paris—he had caused trouble: he had angered and estranged his uncles; he had set the entire Van Gogh family at loggerheads; his begging, complaining letters week after week, sometimes day by day for years, had worried Theo to a very shadow barely able to bring himself to open the envelopes for fear of fresh shocks; he had quarrelled with every artist and art-dealer he had met, had embarrassed Kee and her parents, had taken up and left a particularly obnoxious prostitute after driving away on her account every decent person who had dealings with him; he had insulted his parents, spurned their love, disgraced them in the eyes of the village and deprived them of their best friends; and he had made a harmless woman wretched for life.

He did not reproach Vincent, but there was no need for words. Vincent knew his thoughts, knew the thoughts of all and, as was his way, exaggerated them. His sister Elizabeth did not even spare him with silence. "Why did you meddle with her?" she asked; and he could see the question reflected in the faces of the people he passed in the street.

He broke the news to Theo; he had said nothing to him about Margot until then. Theo was horror-struck; to make a scandal in the village—how inconsiderate, how foolish. Would his father be able to stay in his parish? He would, said Vincent, dismissing that subject abruptly. "The B's coming here or not coming is something that matters to Father and Mother and to them, not to me. I have not been impolite." As for scandal, he was ready for it. Foolish? He denied bitterly that he or she had been foolish: they loved one another, they had no regrets. He denied that he had done her harm. He was being accused in the village of disturbing her tranquillity: was it a sin to break the stagnation and melancholy of a woman's existence and to hurl her back into life and love? She might be angry, her love might even turn to hate, but one thing was certain—she would never despise him: had she not cried, "I too have loved"—triumphantly cried it? As for himself, *"je préfère crever de passion que de crever d'ennui."*

He turned from defence to attack: these so-called religious

people, the people of churches and creeds, maddened him. He asked Theo to consider Margot's family: they thought it their duty—their duty!—to suppress everything active and genial in her, to make her passive; and, not content with breaking her spirit when she was young, they had now driven her distracted. "Oh, I'm no friend of Christianity as it's practised now, though its *Founder* was sublime. The bigotry that benumbed her, the damned icy coldness that almost killed her laid hands on me too years ago and bewitched me. But I have had my revenge by worshipping the love that the theologians call *sin*."

He lashed himself into rage: the religion of the respectable, what a madhouse it had made of the world! And wasn't his father numbered among the respectable, wasn't his mother, his sisters, all perhaps but the weak Willemien? Again they dared to criticise him!

He again ignored them; they were back once more as in those terrible first ten days; he would not speak to them, would not look at them. Van Rappard, coming down again in October, broke the ugly spell for a few days, but on his going Vincent relapsed into silence. The days shortened, he could no longer spend all his time out of doors. Letters showered in to Theo: his father cried, "I wish for Vincent's sake that the winter was over. We think he ought to be with other painters, but we can't dictate to him". His mother was not so patient. "How can he behave with such unkindness? He never speaks to anyone. It is almost impossible to bear." Vincent complained, abused, threatened. On the first day of the new year, 1885, he wrote, "I can scarcely remember beginning a year in such a hopeless mood, or with a gloomier prospect ahead of me. I can't see any success in the future, only strife."

Theo tried to console, tried to advise, but what could he say? He was busy (he had been made manager of the Goupil gallery in the Boulevard Montmartre), he was harassed by continual bickering with those who disliked his championship of the Impressionists and their followers, he was worried to death by the impasse at home, he was unwell. He reproached Vincent and brought a storm about his head. Like all solitaries given to brooding, Vincent re-enacted in his imagination again and again all the wrongs he had suffered in the past. The further removed in time, the more unjust and unbearable these wrongs appeared:

he, caring only for goodness, for love, for true justice, to be
treated so! He raged in silent bitterness. As he had dwelt inter-
minably on the quarrel with his father which led to his not
unwilling departure for The Hague more than two years earlier,
so he dwelt now on his last meeting with Theo the previous
summer at The Hague. He could not get this meeting out of his
mind; it was the meeting when Theo had said that he began to
feel more like his father. Vincent did not forget this; indeed, he
did not try; but he did misrepresent Theo's meaning. How far
removed, he told himself—and Theo—was this spectacle of the
once-beloved brother reproving him for his appearance and
urging him to desert the woman he regarded as his wife—how
lamentably far removed from the brother of the Ryswyk walk,
his second self. And—he had left Sien. For this he found it hard
to forgive Theo, and he harped back again and again to that
meeting of brothers which in his eyes had caused all his subse-
quent wretchedness.

There was, of course, another and a more valid reason for his
distress. Margot gone out of his life, Theo once more remained
his only link with the human love he craved. But Theo loved his
parents too and reproached him for not feeling likewise. Theo
was not selling, was not even showing his pictures. Theo thought
that he ought to dress better, to speak like a gentleman and to
behave like one. Theo held him responsible for the tragedy of
Margot Begemann. Theo, in short, had deserted him, left him
loveless and hopeless. "Do you know what made Margot poison
herself?" he demanded. "Her family spoke to her as you spoke
to me last summer." All Theo's sins against him, real and im-
agined, darkened his mind. He read over and over again Theo's
letters. "Your criticism of the last eighteen months reads to me
like a kind of vitriol. You have so many criticisms to make of my
manners, words, clothes that our relationship grows weaker and
weaker. You are the big swell of Goupil, I am the *bête noire*. To
say 'just go on painting' is not very intelligent."

And when Theo wrote "later on, when there is more character
in your work, we shall probably find more in what you have
already done," Vincent threw back a fierce "those are the words
of a Minister of Fine Arts. They won't help me now." Theo, he
declared, was suspicious of him as if he looked at him through a
pair of dark glasses. They must separate. He must go to Antwerp,

perhaps even to Paris, anywhere away from his people. "I don't think you'll agree, but as you do nothing for me I'll have to help myself. I warn you, when I decide to come to Paris I shan't ask for your approval."

Theo, stung, complained: his letters were "extremely unpleasant". "You forget," replied Vincent, "that for fifteen years I've been hearing unpleasant things from you about my relations with the family." In such a mood no good could follow, and nothing but bad news came to Theo from Nuenen: "Vincent seems to become more and more estranged from us," his father wrote in early spring.

Why not talk to him? suggested Theo. His father, seizing the least unfavourable moment, summoned his courage and did so. This was on March 25. Vincent was in a kind mood, he reported, and said that there was no particular reason for his depression. But he remained depressed. "May he meet with success anyway," wrote his father.

Two days later, after one of his long walks across the heath, the pastor, worn out, collapsed and died outside the parsonage door. He was sixty-three.

Chapter Sixteen

THE PAINTER APPEARS

1885-1886

THEO came up for the funeral. He looked ill; his father's sudden death and his fears of Vincent's part in it had grieved him profoundly. His Dutch friend in Paris, a young man named Bonger, had been shocked by the effect of the news on him: "Van Gogh," he told his family in Amsterdam, "is not very strong, and you can imagine how he suffered." But Theo put his feelings aside to deal with Vincent, whom he found restless and at odds with everyone in the house. He urged him to move—to Paris, to Antwerp, to some art centre where he could get fresh impressions, study the picture galleries, see what was being painted by the new men. The advice was a compliment in its way—Theo had noticed in Vincent's monthly parcels that he was getting a grip of his material and beginning at last to paint like a painter and not like a man colouring drawings—but it could also be taken as a criticism, and as a criticism Vincent took it. "My views will not change", he declared. "Nor will my work; it may be better, but it won't be different—'the same apple though riper'." Whether people approved or not, the only way he knew was "to wrestle with nature until she gives up her secrets"; so, forgetting all his recent threats of sudden departure, "I should not be surprised if I stayed here for the rest of my life— I just want to live in the depths of the country and paint country life." And not content with defence, he struck out at the artificiality of painting in cities. What models! What relation to real life had they? Why, when people from the city painted peasants they looked like figures in a Paris suburb! He preferred to go on painting in his own way.

Perhaps Theo had also seen that more trouble would blow up if Vincent stayed on—the Van Gogh relations and he had eyed one another with aversion at the funeral. If so, he was right; at the beginning of May, after stormy scenes, Vincent moved entirely into his studio—lived and ate there.

Theo protested—if Vincent insisted on remaining in Nuenen

he could at least stay with his mother and sisters at such a time
—but he might have spared himself the trouble. It was better so,
Vincent said. No one was to blame—his mother and sisters
wanted to keep up a position in life, he intended to be a peasant-
painter; they thought differently, that was all.

With this Theo had to be satisfied. He was not satisfied, and
in his mild ironic manner returned to the subject from time to
time. This apart, the news from Vincent was hopeful. He had
been painting in fierce bursts ever since he left The Hague
eighteen months earlier. Now, his own master entirely, he painted
without a break, day after day. For a man who ate next to noth-
ing his energy was incredible. When not actually painting he
was still working, sitting by the dim fireside of the weaver's hut
watching the shadowed figure at the loom, standing in the fields
watching the peasants in the sun, the rain, under snow, hoeing,
digging, gathering wood. He had become so absorbed in peasant
life, he told Theo, that he scarcely thought of anything else. He
was no more a peasant in Nuenen than he had been a miner in
the Borinage but the fact grieved him no longer; he was a
painter now, no ordinary painter regarding his subject simply
as a problem of light, shade and colour, but a man with a
mission. If he was not to have a wife and children, his work
must somehow absorb all his love. Painting, he told Theo, "is a
home".

In July Theo again spent his holiday at Nuenen. He brought
with him from Paris his friend Bonger. The two men inspected
Vincent's work, all three walked about the country together and,
in Vincent's studio, talked interminably about art—or would
have done so if Theo had been willing to neglect his mother and
sisters. This, however, he would not do, and Bonger was some-
times left alone with the formidable brother.

Bonger was devoted to Theo; he admired him, in particular,
as the most "spiritual" man he had ever met. Following Theo's
lead, he was anxious to admire Vincent also; and, having no
doubt been prepared for peculiarities, he did up to a point find
this elder brother a remarkable man. He did not think greatly
of his work, but his frightening singlemindedness, his absolute
dedication to painting and disdain of everything—food, clothes,
company and every conceivable creature comfort—that hindered
it, this struck the young Dutchman, as it had struck many and

would strike more, as being quite out of this world. He had never before seen anything like it.

Yet Bonger's final impression was unfavourable; not so much because Vincent was dogmatic (as he often was) or quarrelsome (as he often was) or rude (as he often was) as because of his attitude to Theo—so frequently aggressive, critical, dictatorial. This, to the man who was keeping him, who alone believed in him and tried to interpret him and intercede for him to all, appeared to Bonger as a quite revolting ingratitude. He did not —and one can scarcely blame him—read beneath the surface of word and manner to the respect, the love and the fear (and they were inseparable) that Vincent felt for Theo; he judged by what he saw. He was indignant at this treatment of his hero. He said nothing to Vincent, but his comments to Theo when they went back to Paris joined with Theo's own feelings—mainly on his family's behalf—to produce a reproachful letter.

Vincent leapt to the attack, his pride flaming because Theo— even Theo—had failed to read his heart: "You seem to think that I'm an exacting egoist. Very well, if you can think that of me I should prefer you to stop giving me any help. But I'm not an egoist, though I have other ideas than the family at home."

As usual, his anger roused fear: what if Theo really took him at his word and cut off not only his help but his faith? As so often, he expressed this fear by a pathetically crude attempt to appeal to the businessman in his brother: if Theo made it possible for him to go on painting, he added immediately after his threats, "it may be very important and profitable for you in the future".

Perhaps he was able to write with as much confidence because he had found men who, if not exactly disciples, were at least willing to learn from him. He met them all through the printing office in Eindhoven where he bought his inks. There was, first, young Gestel, the son of the owner of the printing office. The boy was studying at the Academy at Amsterdam; Vincent saw some of his work and at once told his father to take him from the Academy—it would ruin what talent he had. His advice was not accepted—the elder Gestel had more than a little doubt as to Vincent's competence—but he took the boy out sketching and did his best to bend him to his will. By that time he was, thanks to Theo, reading Delacroix and was preoccupied by his theory of colours. He talked a great deal to the young Gestel—without

ridding the boy of incredulity and amusement—of the connection between colour and sound; the last the boy heard of him, he was taking piano lessons so as to work out the connection practically.

The experiment with the piano came to an abrupt end. The teacher—a mild and rather nervous creature—was quickly startled by his pupil's contemptuous rejection of the orthodox scales and exercises and by his violent assertions. Vincent would sit himself down at the piano, strike a chord, listen intently, then shout "Prussian blue!"; and before the bewildered man could recover there would be another chord or perhaps a single note repeated deafeningly, ending with a triumphant cry of "bright cadmium!" or "dark ochre!" or whatever colour Vincent associated with that particular sound. This was surely close to insanity? The teacher recollected that his pupil was known throughout the district as "the madman of Nuenen". There were no more lessons.

The disappointment—if indeed Vincent was not already sickened by what seemed to him as the man's pusillanimous conventionality—was lessened by his interest in his pupils. There were three more of them—a post office clerk, a tanner and a retired goldsmith. The goldsmith, a man of sixty, had just taken up painting and wanted advice. His wish was to paint six wall-panels in his dining-room; he proposed as subjects six saints. Vincent listened impatiently: Why saints? would they improve the appetites of his guests? Why not studies of peasant life illustrating the seasons of the year—studies in keeping with a house in the heart of a peasant country and which would encourage a man to eat well? The goldsmith saw his point and, better still, commissioned Vincent to design the panels so that he could paint from them straight on to the wall. He was not and would never be a painter, but he enjoyed himself and his company gave Vincent much-needed moral support through and beyond the tragedy of Margot Begemann.

The post office clerk was less satisfactory. Vincent gave him lessons in still-life but found him a feeble fellow, too fond of repeating village gossip about the terrible quarrels between Vincent and his father—gossip which Vincent invariably cut short with a "My father was a typical clergyman." The clerk had a gift, however—some of his paintings were later to be confused with early Van Goghs—but to Vincent's mind his heart was not in his work, he was not giving enough time to it. At first as the

clerk, Van de Wakker, excused himself on account of his job, Vincent thought that the fault was in his employer. "I'll deal with that," he said, marched into the post office and demanded that De Wakker be given the afternoon off: "I want him," he said. "So do I," replied the postmaster, trying to cover his apprehension under a jest. Vincent gave him a threatening look: "I expect you to let him go. You understand me?"

He walked out. The postmaster recalled his look, his tone and his bad reputation as a rough man who would stick at nothing. De Wakker was given the afternoon, then and afterwards for some time, but neither he nor Vincent was much the better for the concession; Vincent's desperate keenness appeared to the young man as little short of lunacy and, combined with his violent temper, led to unpleasant scenes; more than once Vincent, disappointed by his pupil's slowness in picking up his instructions, burst into a hoarse stammer of abuse. De Wakker, shocked by the foul language and his master's menacing looks, became flustered and made more mistakes than ever. In vain he tried to mollify Vincent—his mother had prepared a special meal for them both, a luxurious dinner—Vincent was not to be cajoled; he would eat nothing but dry bread, he declared, and left his dinner untouched.

This insistence on dry bread, with at most a scrap of cheese, was noticed by the third and best of the pupils, Anton Kerssemakers, the tanner. Vincent's refusal to eat a good meal was in part, like his insistence on walking in the broiling sunshine during his trip with Breitner, the desire to suffer for what he believed in; a desire that had been pronounced in him since his teens, and which is normally associated with the adolescent and the fanatic —this last the name comfortably coined by those who have learned to compromise with life. But Vincent's attitude also arose from a kind of inverted common sense. "I don't want to spoil myself," he told Kerssemakers when he refused to eat at his house—meaning that as he could only afford to buy meat for himself about once in six weeks, a good meal would merely tempt him to feel dissatisfaction with his everyday existence. And there was a third reason; he had always associated himself with the peasants, and he did so in this; bread was their staple food; in bad times—and times were often bad—they ate little else: "What's good enough for them is good enough for me."

Kerssemakers, a man of forty, showed promise. He had first seen a painting by Vincent, *The Water Mill at Gennep*, and became enthusiastic to learn. Vincent invited him to his studio. Kerssemakers was thunderstruck by the confusion; it could only be attributed to bohemianism (a word then in vogue), he reasoned; certainly he had never seen anything remotely like it. The two rooms were crowded with pictures—pinned on the walls, resting on chairs, lying in heaps on the table, propped against the walls —chalk and water-colour sketches by the dozen, innumerable studies in oils and hundreds of pencil scribbles, of weavers, looms, women driving the shuttle, peasants planting potatoes, digging, harvesting, peasant heads with negroid features (upturned noses, thick lips, prominent jawbones and large projecting ears), peasant hands calloused and wrinkled, still-lives, the old church tower in the cornfield. A large open cupboard was piled to the top with moss and heath plants, stuffed birds, peasant hats and caps, women's bonnets, clogs and birds' nests (Kerssemakers counted thirty of them) collected for Vincent for a few coppers by some of the peasant boys. Between the pictures spread over the floor were shuttles, a spinning-wheel and a bed warmer. The stove was almost hidden by piles of ash—Vincent raked it on to the stone floor each day and let it lie—the rooms were filthy, the chair seats broken, a few crusts of bread were scattered among the pictures on the table.

The acquaintance survived the shock—Kerssemakers relished the chance of seeing how what he thought of as a real artist lived —and it even weathered his dubious comments on some of Vincent's work. At first he thought it distastefully coarse and distressingly unfinished, with the figures out of proportion. He wondered whether Vincent really knew how to draw and at length ventured to suggest his doubts. But all was well; Vincent would take criticism from a man with less knowledge than himself: "You will think differently one day," he said. He spoke with similar authority about Kerssemakers' work; no longer was he dealing with a lazy or half-hearted youth but with a man ten years older than himself; he was able to put himself in his place and, when his pupil felt despondent, he remembered his own fits of depression, recalled his fears that he had begun painting too late. "Remember Mesdag," he said: this being to him the classic example of the man who had made good against all the odds of age.

He spoke confidently. He was confident. His pictures might not sell, he might refuse to sign what he sent to Theo, but he was getting on, he felt it in his bones. He was a painter, faulty and with far to go, but—a painter.

And not even the painter of twelve months ago. His interests had shifted. His attention had moved from the figure at work to the face of that figure. Was it not there that the true story of the peasant lay? So he reasoned as his painter's eye gloried in the possibilities of the rugged, hollow faces, the work-worn hands. He began to sketch and paint them. These were the heads and hands that Kerssemakers saw. At first he painted them in isolation, more than fifty of them, just as he had drawn his Brabant types at Etten three years earlier. Then, after his father's death, he had the idea of painting a cottage interior. It was to be a meal, the kind of meal he had often seen, often eaten. He called it *De Aardappeleters (The Potato Eaters)*—five peasants sitting round a table eating their supper of potatoes by the light of a single lamp. For the five peasants he used five of his study heads. The interior he painted from memory.

From memory! Here was a revolution indeed. He thought of himself as differing from other modern painters, regarding his work with the mind of a moralist, but he was a true painter in his search for knowledge. His letters to Theo were becoming more and more preoccupied with technique. Delacroix had taken him by storm; Delacroix had said that the painter should paint *par cœur*. His theory of colours had a delayed effect on Vincent; he could not see the paintings in which Delacroix had applied it; it turned over in his mind, preparing him for the future; but the call *par cœur* came to him like a command. He threw overboard all his views about realism; he forgot his chastisement of the painters at The Hague for working in their studios; realism, he now told Theo, "that is, *exact* drawing and local colour, leads to a kind of uncertainty and narrowmindedness. There are other and better things than *literal* truth." He abandoned his careful, laboured paintings and struck out at a single comprehensive impression. He knew the peasants by heart, he had painted them dozens of times; he knew their cottages. The voice of Delacroix had sounded at the exact moment.

So he painted his *Aardappeleters* by heart "in the sense of using my imagination". The laboured brushwork fell away into strong,

sweeping strokes. "I want to make it *live*," he said; and he did. The subject is not a pleasing one, the heads have a suspicion of caricature, the monotonous tone ("the colour of a good dusty potato") gives an effect of morbidity, the figures are sometimes preposterous, but the picture, though a failure as a painting, has life. It has also strong individuality; decidedly it had not been painted before.

He sent it to Theo with precise instructions how it must be framed to be seen as he intended. He also sent a lithograph to Van Rappard, and at the sight of it that mild and gentlemanly young man broke into a perfect storm of abuse. Was Vincent mad to paint such a picture? It was hopelessly superficial, the models obviously posing. Why wasn't the man on the right allowed a knee, abdomen or lungs—or perhaps they were in his back? And why should his arm be a yard too short and why is he given only half a nose? And so on. In short, such work couldn't be taken seriously.

But Van Rappard couldn't prevent himself from taking it seriously. Never had he written such a letter in his life. Why did he write it now? He explains: "You dare to paint so and talk in the same breath of Millet and Breton! Art is too great to be played about with like this!" Millet and Breton were his heroes, they were also Vincent's. Vincent had declared it a thousand times. He believed it still. To Van Rappard, looking at the rough, bitter, ugly *De Aardappeleters*, he was a hypocrite and a traitor; there was nothing of Millet in it, nothing of Breton. Vincent returned the letter, then replied at length—"I paint what I feel and feel what I paint"—but the friendship was finished.

Theo also criticised the figures and the muddy tone of the picture. The picture had a moral, replied Vincent; it was meant to show the virtues of manual labour and to portray people who had really earned the food they ate. He wanted to give the impression that the hands reaching out for potatoes in the lamplight had actually dug those potatoes out of the earth. To do that he painted in the colour of soft soap and a worn copper coin. Dull? Those were the colours he saw when he narrowed his eyes and looked through his lashes. As for the so-called luminous painters whom Theo admired so much, it seemed to him that they were interested only in painting in full sunlight or gaslight—shadows or half-lights meant nothing to them.

And the figures? "I should feel absolutely desperate if my figures were academically correct." If you were to photograph a peasant digging, for instance, he wouldn't appear to be digging any more. But look at Michelangelo's figures: "I adore them, though the legs are too long, the hips and backside too large." Why? Because they live and move. For him, people like Michelangelo, Lhermitte and Millet were the real artists: "They don't paint things as they are but as they see them." He wants to follow them, to paint incorrectly, "so that my untruth becomes more truthful than the literal truth".

This made pleasant reading for Theo; and although he criticised the painting he thought enough of it to show it to Portier, the man who had first shown the Impressionists. It wasn't saleable, of course—he knew that—but he thought the time had come to get confirmation of his belief in Vincent's gift. He got it—hedged about with ifs and buts, but all he wanted. And when, that autumn, Elizabeth asked him why on earth he put up with Vincent, who took his money and never did a thing for it but worry him and be rude to the rest of the family, he knew what to say.

Vincent had been a worry to him for years, he admitted. He detested the way he had treated the family, deplored his touchy and quarrelsome nature, and was haunted by the dread that he would get himself and others into more embarrassing situations. All this was true. Once or twice, when Vincent had been particularly impossible and he had particularly felt the pinch of keeping up appearances with this everlasting drain on his salary, he had been tempted to follow his sister's advice and give him up. Why sacrifice his comforts and worry himself to death for a man who couldn't even use properly the precious money he was sent?—for Vincent was a wretched manager. But he had never gone further than a mild reproach. Because, he told his sister, "we must wait and see if he has genius. I think he has. If he succeeds he will be a great man. He may never be appreciated by the general public, but he will be respected and admired by those who know the difference between talent and genius."

That was his position, and he was not to be moved from it. He had worse trials to come, his faith in Vincent as a man was to be tested to breaking point, but he had no more doubt about Vincent as a painter.

His renewed confidence, criticisms notwithstanding, was easy to read in his letters, and Vincent responded with alacrity. The correspondence recovered its cordiality of earlier years. Vincent again wrote expansively; all his hopes, his experiments, his views of the masters were thrown vigorously before his brother. Theo encouraged him, giving in his brief replies a pointer to some book to read, picture to see, method of technique to consider. Vincent soon had need of encouragement. In the autumn his models began to fall off. He waited furious, frustrated. His canvases remained blank. The Catholic priest had forbidden his parishioners—including almost all the peasants—to sit for this godless man; a man doing his impious work in the very house of the sexton within a stone's throw of the Catholic church. And not only godless; a rumour spread that he had got one of the peasant girls with child. He denied it, but without effect; the sexton told him that he must find other rooms, and "I may have to move", he told Theo in despair. He meant, move elsewhere in the village —a difficult task, since none but the peasants would take him, and in their cottages was no room for a studio. The first time that he thought of a complete move out of the district was after Kerssemakers took him to Amsterdam in October. They stayed three days; Vincent would not go into the Van Gogh gallery, waiting outside when his friend bought colours and canvases, but he spent every available moment in the Rijksmuseum. The sight of paintings after two years of nothing but photographs of paintings went to his head; he raved about them; a Frans Hals flag-bearer was "divinely beautiful—unique"; his *Singer* "literally nailed me to the spot". He soon found a greater than Frans Hals, whose paintings "always remain on *earth*—one can talk about them"; but Rembrandt "is so deeply mysterious that there are no words for his paintings".

His judgment was still set askew by old loyalties, and he described two Israëls paintings as masterpieces and named him with Frans Hals and Rembrandt as the three great experiences of his journey. But Rembrandt was the one who bewitched him; Kerssemakers had hard work persuading him to leave *The Jewish Bride*; "I would give ten years of my life to sit in front of this picture for a fortnight with a crust of bread to eat," Vincent declared in a passion of admiration. When the museum closed for the day, as before it opened, he would camp out in the wait-

ing-room in his ulster and fur cap painting impressions of Amsterdam, oblivious of the little crowd staring at the hollow-faced, red-bearded painter rather than at his studies. But, in Nuenen again, Rembrandt and *The Jewish Bride* haunted him; how get that broad sweep of the brush at once soft and strong, how introduce that true luminosity into his work, how persuade his dark browns to give out light? He worked furiously at still-lives—all that he was now able to paint—but remained dissatisfied; he had far, very far to go.

The thought came to him—perhaps he needed more tuition? Certainly, having had a taste of a gallery, he needed to study more pictures. His mind was almost made up after another, shorter trip on which Kerssemakers took him—this time to Antwerp. The city appealed to him, and so did the museum with its Velasquez *Fisher Boy*. He saw little in the limited time, but that little was enough. The continued shortage of models in Neunen —the priest's ban was growing stricter—and the impossibility of finding another studio were decisive. He was not even sorry to be off, he discovered; the country for the moment had had its say; he needed the stimulus of a city. Towards the end of November he moved suddenly to Antwerp, giving a farewell gift to the good Kerssemakers of an unsigned landscape, with a prophetic, "The lack of signature doesn't matter; after I'm dead my work will be famous." He left his rooms in utter confusion, filled with studies. When his mother moved to Breda the next year, the studies were left with a carpenter; he sold them for junk a few years later.

In Antwerp, Vincent was soon declaring it to be much closer in spirit to Paris than the so-called little Paris, Brussels—it was more the big city and had the cosmopolitan air of a world sea-port. He walked about the docks and through the narrow streets, watching the men and women with fascinated eyes. What models —and in what variety! How, he wondered, could he have spent so long away from all that would develop the painter in him? He settled down in a small room over a paint-merchant's shop and began to try to make up for lost time, painting with demonic energy. He discovered new colours: "Carmine! Cobalt!" he cries to Theo, jettisoning his "I expect to become darker rather than lighter" of a few months earlier. And he discovered a new world of painting; he had been reading the Goncourts, he remembered their "Japonaiserie for ever!"; now he ransacked the print shops

and decorated his room with the Japanese prints he found there. What audacity of colour, what gaiety, what delicacy and form! He was too much astounded to do more than look up at these prints that seemed in another world from his own heavy canvases, still dark and still thick with paint; too much astounded and too busy—he was "in a rage of work" to paint Antwerp and its people. He was tormented by the thought of wasted years; he would be thirty-three in a month or two; he had been drawing and painting for six years; he had not sold one picture. He grudged every moment of sleep, grudged the falling of darkness. No time, no time!

Life was dearer in Antwerp and if he wanted models he had to pay for them. He had not eaten much above starvation level for years but even this was too high for him now; when Theo sent his allowance he rushed out and spent the lot on paints, canvases and models. He lived on credit as best he could; it was not well—bread and coffee for breakfast and supper, a crust of bread during the day. In his first six weeks he ate three hot meals with meat. To prevent his hunger from growing unbearable he smoked incessantly. By the end of the year his money ran out, and his credit; for five days he had coffee and bread for breakfast and no more until the next morning; then even smoking would not dull the emptiness and ache. He wrote an urgent note to Theo; he must have more money, he must eat because he must paint. Theo sent more money but when Vincent sat down to a square meal he could not digest it, he felt sick and faint. The symptoms continued day after day; then his teeth began to ache and break off; he had stomach pain continuously.

The money melted; one or two meals, a model or two, colours, canvases, and it was gone. He could not make ends meet. He painted a girl's head; never had he painted with such power, such economy, such certainty. But he could not afford to pay her again; he had to stop just when he was getting his hand in. He felt unbearably frustrated; models everywhere, but none for him who had the greatest need of them. In despair he painted a Rembrandtesque self-portrait—but he could not paint himself for ever. There was one way only for the poor man in a city to paint and draw from the model; Vincent put his pride and his opinions to one side, went to the Academy and showed some of his work. He was accepted; he could have free tuition, free models.

He turned up at the painting class in a butcher's blue smock and his round fur cap and carried as palette a piece of wood torn from a sugar crate. His appearance astonished most of the sixty young men in the class but his method of painting made a sensation; he worked with a ferocity and at a speed that was positively alarming, and he applied his colours so thickly that the paint dripped from his canvas on to the floor. The class was taken by the Director of the Academy, the rigid Verlat. Eventually, going the rounds of the class, he reached Vincent and stared at his canvas frowningly. The subject that day was two wrestlers stripped to the waist; Vincent's version of the wrestlers was far removed from academic principles; had he deliberately set out to defy all that Verlat believed in he could scarcely have succeeded more thoroughly.

"Who are you?" asked Verlat, looking from him to his painting.

"Vincent. Dutchman."

Verlat looked again at the painting. "I don't correct rubbish. Off you go to M. Sieber's drawing-class—quickly."

Vincent, astonishingly, went. It may be that he preferred frankness from the philistines—he was always at home with manners closest to his own—but in any case the unnatural restraint was a measure of his anxiety to profit by what the Academy alone could offer him. And when in the drawing-class he was told that he must spend a year drawing from the nude and plaster casts, he still presented a stoical front—a far cry, it would seem, from the man who had smashed Mauve's casts to pieces.

Yet he was not perhaps so far removed. Sieber was a more lenient man than Verlat, but he found his good nature severely tested in the weeks following Vincent's arrival. On his second day, Vincent discovered that the teaching in the Academy was "all remarkably bad and entirely wrong" and that he alone was drawing with something approximating to correctness in the true sense of the word. With him, to discover was to disclose; he had no idea of discretion and would have despised it if he had—his duty as he saw it was to lead himself and others to the truth and to expose cant and false teachers. He worked on and with a rapidity that staggered every one of his classmates; no retouching for him, he drew with a kind of desperate intensity as if to make up for lost years, copying a drawing a dozen times or more,

pressing so heavily on his pencil that he often drove it right through the paper and throwing each drawing behind him as he finished with a gesture of impatient despair. He did not, however, confine himself to the plaster casts; he sketched the other pupils, the desks, the chairs, the clothes, everything that caught his eye—and all in his own extremely unacademic fashion.

There was in the Academy, as in every such school, a nucleus of rebels against the conventional instruction. At Antwerp only a leader was missing; Vincent, ten years older than most of the pupils, with definite views, infinite moral courage and a fiery personality, was an obvious, inevitable leader. Soon he had a little band of followers—a somewhat scared band indeed, who regarded him and the work he showed them from Nuenen "with a certain stupefaction" but who were too fascinated to resist him. With them he dropped his customary contempt for all who had to do with academic teaching, became approachable and at times so enthusiastic as to become alarming; he knew nothing of moderation, the weakness of the indeterminate. When one of the rebels, a young Englishman, Levens (his particular favourite), made a portrait of him, Vincent promptly spat on it; a little harshly perhaps, since Levens had conveyed with fair truth the angular face, sharp nose, bristly, badly cut beard, carroty hair and the defiant cutty pipe projecting from the large mouth, but with the prompt reaction that was the only kind known to Vincent, whose yea or nay was manifested crudely but always with honesty.

He bore no ill-will—nor, it seems, did Levens—and the rebels were soon following his precepts in class so freely that the patience of the mild but conventional Sieber must have been highly tried. And at last, unable to avoid notice of the growing crop of drawings notable for their demonstration of Vincent's heavy shading and powerful modelling, he haled a rebel before him and forbade him to make a farce of his teaching. He spoke to Vincent also—possibly after some hesitation; there were hot words, but Vincent after a struggle gave way to a certain extent; models he must have, so he confined himself to criticism and left out the abuse; and as if to work off the frustration that this limitation imposed on him, he redoubled his efforts, working morning and afternoon at the Academy, in the evenings at a club, and a great part of the night by himself.

He was driving himself too hard as usual, and he now had the excitements of a city and company and he was eating less than ever. Perhaps no man could have borne the strain for long; Vincent, his nervous energy overtaxed, was approaching collapse by February; his teeth were giving him agonising pain, his fainting fits had increased, he had begun to spit up mucous, he was in a high fever most of the day; he dreaded the end of so many painters, that he would "become crazy or an idiot". He went to a doctor; he was close to a complete breakdown, he was told; all his rotten teeth, ten of them, must be sawn off; he must eat nourishing meals; he must stop worrying.

More imperative letters shot into Theo; he must have more money, the allowance simply was not sufficient for a city.

Why not go back to Nuenen? suggested Theo, beginning to tire of the repeated demands. He pointed out that Vincent had been healthier there, and that living was much cheaper.

These two undeniable facts sent Vincent into a frenzy of impatience. Back? Now? When he had just put his feet on the first rung, when he felt the power within him growing day by day? Never! Theo must find the money.

He was hard up himself, Theo replied; owing many bills, and with the expenses of a move to a new flat on his hands—a move made necessary by his promotion and the entertaining that it demanded.

Theo could have saved himself the trouble of writing. Hard up? replied Vincent. Who was not? Theo owed bills? Let them wait; what were bills to the future of a painter?

Theo held out a day or two longer, trying to reason with the unreasoning. Why stay in Antwerp? he asked. He had heard all about the quarrels at the Academy; he could see no point in Vincent remaining there when he had set against him both the principal teachers and had antagonised most of the pupils. It would be far more sensible to go back for a time to Nuenen, where his health would improve; kind too, for the family was packing to go to the new home at Breda and would be glad of his help. As inducement, Theo gave him a firm invitation to Paris in June, when he would be in the new flat, big enough for two and with a studio for Vincent; he would also pay for a term or two at the Ecole Cormon.

Vincent would not listen; Nuenen would be a backward step;

Nuenen was not on the way to Paris; the gardener could help his mother to pack far better than he. As for Paris, why should he wait until June? He would be company for Theo, he could help to choose the furniture and fit out the new flat. But in any event he must have more money and at once.

Theo was not pleased but he sent more money. Vincent sounded hysterical and ill; Theo could not rest easy under the thought of a collapse in the street or of some desperate action by a half-starved, lightheaded man. He sent the money but again warned Vincent against thoughts of Paris before June; his present flat simply would not hold them both; to come would be an unkindness and would benefit neither. His advice was that Vincent should at least work out the present Academy term ending by April; then they could take stock together about the remaining two months.

But by the time this letter had reached Antwerp the Academy term had ended for Vincent. His class had been given the Venus de Milo to copy. The long suffering Sieber moved along the benches, commenting, correcting. He came at last to Vincent and stood over him appalled by what he saw; Vincent had enormously accentuated the size of the hips: "the beautifully proportioned Greek had become a buxom young Flemish matron". After a horrified pause Sieber got to work with his heavy correcting pencil, slashing in line after line across the page. "You forget," he said severely before moving on, "the unalterable laws of drawing."

This instruction, following the mutilation of his drawing, threw Vincent into a violent rage. "So!" he shouted after the retreating man, "you don't know what a young girl is! Let me tell you that a woman has the right to hips, buttocks and a pelvis in which she can carry her child!" He stormed out and was seen no more in the Academy.

A day or two later, having collected every penny he could lay his hands on and leaving his canvases to pay his rent, he boarded a train. That same day, February 27, a slip of paper was handed to Theo in his gallery. Scrawled in chalk was a message from Vincent. He had just arrived; would Theo meet him in the Louvre, in the Salle Carrée?

PART THREE

THE PAINTER

Chapter Seventeen

VERY HEAVEN

1886-1887

H E was staring at a Rembrandt. Theo was not pleased to see him, but once again his annoyance at Vincent's lack of consideration disappeared at the sight of the haggard face. Vincent looked worn out, ill; his mouth was filled with decayed and broken teeth; he could not keep food down; he was desperately thin. He was also excited; he could not keep still; he was like a boy, stammering, incoherent. This too was impossible for a tender-hearted man to resist, but Theo was worried and wondered again whether he had been right ever to suggest Paris; could Vincent's overstrained nervous system stand the violent change? Yet how could his talent develop without Paris?

The first essential was to make him healthy. Theo took him to a dentist, the decayed stumps were taken out and he was given a set of false teeth. That done, he began to recover, to digest his food and eat normal meals. And when Theo clothed him and tidied him up he was, if one did not look too closely at his face and the light, glittering eyes, quite presentable—rather more so than many of the painters he met with their somewhat self-consciously artistic clothes and attitudes. But his recovery, even a hint of it, made him an impossible companion in the small *appartement* in the rue Laval, and Theo shipped him off hurriedly during the day to the Ecole Cormon.

In those first weeks Vincent moved about feverishly: the Louvre and Luxembourg had been his cry before he reached Paris—there he would study the masters day after day; he felt starved, absolutely starved of pictures and felt ready at last to take advantage of what they offered. In particular Rembrandt and Delacroix fascinated him, especially perhaps the dramatic violets, the prohibited lemon yellow and the Prussian blue of the latter. He felt that he could spend a lifetime before them learning all that they had to teach. But he did not spend even these few free weeks; there were other masters elsewhere; he walked into the Goupil gallery in the Boulevard Montmartre, the Durand-

Ruel gallery along the street, and there he stopped, for there were the Impressionists.

He was astounded; he had talked for years of a community of painters with a single aim, but the last place in which he had expected to find it was a city; yet here it was in the biggest city in France, execrated still but accepted by the progressive dealers and collectors. These men of the *plein air* school had been painting for years, they had transformed the palette, they had overturned at a blow every conception of painting—method, aim, subject, technique—and he had known only the name Impressionism and had rejected it, waving aside Theo's explanations. "In Antwerp I did not even know what the Impressionists were," he wrote to Levens. "Now I have seen them and though *not* being one of the club yet I have much admired certain Impressionist's pictures —Degas nude figure—Claude Monet landscape." This was a revolution, and the self-styled traditionalist welcomed it rapturously; he almost lived in the galleries. What a palette—light itself put on to canvas!

Where to spend his time—at the Louvre, the Luxembourg, the modern galleries? The days were too short, his mind could not assimilate all his discoveries, he was bewildered. He was bewildered in another sense; all this had happened while he was in the wilderness; it was an accomplished fact; no struggling band here to which he could devotedly attach himself to help to rescue painting from the academician, but a group of masters widely acknowledged and praised. "*Not* being one of the club yet," he had written; but would he ever be one—was there a place for him, the latecomer?

In this mood, rapturous and dismayed by turns but always excited, he went to Cormon's. For a few weeks he drew and painted with a fury: at least he would take advantage of Parisian tuition though he had now no notion how to employ whatever technical facility he learned. One of the students, a perky black-haired boy of eighteen, watched him with a blend of amusement and respect: he was a worker; he had a powerful fist—he sometimes went right through the paper—and he handled paint fearlessly, slapping it thickly on the canvas.

Then Vincent's enthusiasm died abruptly; Cormon might be the head of a Paris school, but to him he was like the rest of the academic gang, with nothing to say that was worth hearing and,

not content with being behind the times, actively attempting to hold others back; he advised his students not to waste their time at exhibitions of contemporary, unacademic painters. He and Vincent soon fell out. "I scarcely take any measurements," said Vincent, "and in this I am absolutely and categorically opposed to Cormon who says that if one doesn't measure one draws like a pig."

Vincent's reaction was inevitable, but this time he was not the only rebel and was far from being the leading spirit of revolt. There was a Scotsman, Alexander Reid, who looked extraordinarily like Vincent, whose alternations between extremes of pessimism and optimism were not far short of Vincent's and who talked interminably of Monticelli. There was an Australian, John Russell, a big man and strong, boxing as well and perhaps better than he painted, whose independence and blunt talk forced respect from Vincent and, when they were not in the midst of a quarrel, a warm affection. There was the boy, Emile Bernard, the infant prodigy of the school. There looked in (stories were often told of his penchant for lewd jokes, liquor in large quantities and the more disreputable Montmartre cafes, and of his astonishing gift, strong and satiric, with the pencil and crayon) a strange man with tiny legs—Toulouse-Lautrec. And towering above all was the tall, thick-necked Anquetin with the broken nose and impish sense of humour. Anquetin had a gift; all knew it, even Cormon; and it was Anquetin who led the revolt. Anquetin, explained Bernard, who had taken to Vincent, was the latest follower of Seurat; he, Bernard (whose opinions, he did not explain, veered violently every few months), had a passion for Seurat's chief disciple, Signac, but no matter, they could agree that Seurat was the leader of the new school.

The new school? Vincent huskily demanded details, and young Bernard, eager to instruct a man of nearly twice his age, explained that the new masters were being followed by even newer ones, that the Impressionists, revered though they must be by every right-thinking painter, had merely dented the massive front of ignorance and prejudice. Others must break through and shatter all resistance. A light palette to paint the effect of light— all accepted that essential preliminary; but the actual methods of employing that palette—this was another matter. Manet had been dead three years; Monet, Degas, Renoir, great men though

they were, had eased on their oars, their forward movement was almost imperceptible; they were successful painters, they were not in their first youth, and to be candid, was there not something a shade bourgeois about them? Monet, for instance, was simply coining money, selling for three thousand francs a canvas —how but by pandering to his public?

Bourgeois: this struck a chord: the hint of the respectable could not be denied. But Vincent shied from criticism of his latest heroes; they were great men, they painted great pictures, they had brought painting out of the pit, they deserved all his admiration. But successors they must have; that thought he accepted— accepted it eagerly. A new school stepping on the shoulders of the Impressionists—what hopes leapt in him at the sound of those words!

Bernard enlarged on the subject for the benefit of this curious Dutchman who seemed to have lived in the wilderness all his days, who babbled about Dutch painters that no one had ever heard of, fixed one with a fierce blue stare and stammered hoarse questions in a weird blend of languages and who yet could not be dismissed as a figure of fun: his ceaseless struggle after knowledge was impressive, his manner of attacking everything—a problem, a painting—with ferocious zeal was not only disconcerting but refreshing, and his theories on the painting of the future were many enough and often wild enough to satisfy even this restless and intellectually precocious youth. The masters, he explained, were the painters of the *grand boulevard*, the Boulevard Montmartre; their successors, the painters of the *petit boulevard*, the Boulevard de Clichy. The new school, in keeping with the new freedom of the artist, could not be confined to a single technique —Seurat, Signac and Camille Pissarro were highly individual artists—but Seurat was certainly its leader, Seurat had invented *pointillisme*, the method of employing masses of tiny dots of colour to build up his canvases; he was working on his *Grande Jatte*, the chef-d'œuvre of *pointillisme*; Vincent must see it and meet him (that Bernard had not himself met Seurat—he discussed artists rather as schoolboys discuss county cricketers—was beside the point and unworthy of mention); he was a great man.

Vincent asked about the others, and Bernard sketched them, with his present hero Signac occupying the greater part of the page; Vincent would certainly meet him at Asnières, where

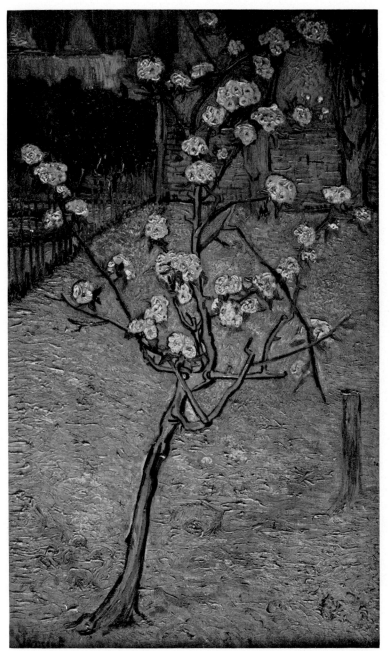

POIRIER EN FLEURS, 1888

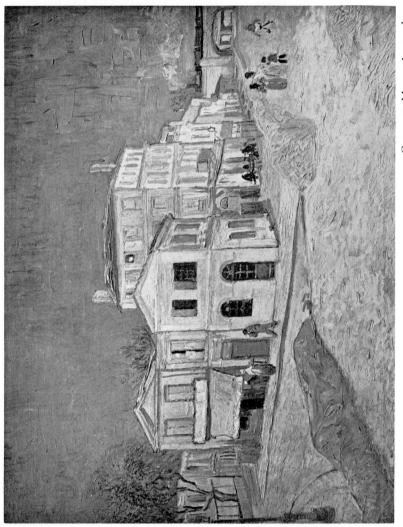

LA PETITE MAISON JAUNE, 1888

Gemeente Musea, Amsterdam

Bernard's parents had a house and where Signac came often to make river studies; he called his canvases symphonies of broad stippling; their colour passed description. Bernard advised Vincent to study the work in the entresol of his brother's gallery, to forget the elders for a moment and look more closely at the less-regarded pictures; there he might see something by Seurat, Signac, the experiments of Lucien Pissarro and the new ventures of his father, Camille, who was turning *pointilliste*; he would perhaps hear about Cézanne, who worked in the south and was painting the very bones of the earth; and in due course he would doubtless be able to see in the entresol canvases by Anquetin, by Bernard and surely by himself too.

Bernard had ardent, expressive brown eyes that could look out of a pretty face (feminine in shape and feature) with such conviction and faith that even stronger men than Vincent were to be charmed into acquiescence. He was elated. To think that he had avoided Paris for years, and that now, only a few months after coming there, he was in the heart of things, talking and listening, accepted and more than accepted, for Bernard seemed not only to look up to him as a painter but to like him as a man; he was free of half a dozen studios—of Reid, Russell, Anquetin and their friends—he was heard and, when he could summon patience, could hear. "It is quite a satisfaction," Bonger was telling Theo on holiday this summer, "that Vincent is acknowledged now. You have always believed in him." The judgment was premature but at least contained a grain of fact; and to Vincent it was not a matter for satisfaction, it was very heaven. And what news he was hearing: a new school in flux still but solidly based on the glorious light palette, and he in time to play his part!

But something had first to be done about Cormon, the man who was laying the dead hand of the Beaux Arts on youthful genius. Vincent felt that he would like to shoot him—he had bought a revolver like the rest of the students. They had no idea of using them, it was a gesture merely, but Vincent was not the man for gestures. Anquetin, openly rebelling at last, began to experiment with *pointillisme*. Cormon had barely rebuked him before he found the entire studio in revolt. Bernard was painting a brown sail—one of the school props—in alternate bands of vermilion and vert veronese. Why? asked Cormon. Because that was how he saw it, replied Bernard. Then he had better go else-

where and see things, said Cormon. But Bernard was popular with all; he at once became the centre of a protesting mob; the class broke up in pandemonium; Vincent, ever the Don Quixote, went home, fetched his revolver and set out to find the tyrant. But Cormon had made himself scarce; the studio was closed down for several months.

Fortunately this coincided, at the end of May, with the better weather, with an Impressionist exhibition in the rue Laffitte and with Theo's move to his new *appartement* in the rue Lepic high up on Montmartre. On the first floor was Portier the dealer; Theo and Vincent were on the third floor. The *appartement* was roomy, it had the promised studio for Vincent, and a girl came in every day to clear up the mess made by him in the studio and anywhere else he chanced to settle himself. The surroundings were not far from ideal for the painter at work and for relaxation; round the corner and up the hill were the Moulin de la Galette, the Sacré Cœur and the cafés of the village; and while giving the satisfactory sense of being a stone's throw from the heart of the city the *appartement* commanded views that gave the brothers the sense, equally satisfactory, of living at the verge of the country. "From our window," said Theo, "we have a beautiful view over Paris." He spoke of the window looking far over the Boulevard de Clichy; from another, looking across the Cimetière Montmartre, he and Vincent obtained a wide view of the gardens of Montmartre and the country beyond.

Vincent was in fine fettle, pleased with his studio, full of the exhibition with its Degas, Pissarros, Berthe Morisots, Seurats, Signacs and the large collection of canvases—nineteen of them —by a man named Gauguin. Now he could paint; nothing would stop him. In the early days after the move, Theo had good news to send home: "You would not recognise Vincent, he makes great progress in his work, he is in better spirits and many people like him." His optimism, so highly tried but so resilient, leapt up: "If we can go on living together like this, I think the most difficult time is over and he will make his own way."

How much of this was fact, how much fancy cannot be said. Theo was unwell—the strain of a new relationship he had formed, the strain of his long fight with Valadon, one of the owners of the Goupil galleries, the strain of the far longer struggle to keep Vincent and the family at peace, the shock of his

father's death, the fears for his own health and sanity, all these had weakened him and made him susceptible to every impression. When Vincent exclaimed jubilantly about the new flat, praised the new studio, worked hard and well and proclaimed Paris to be his salvation, Theo felt that every sacrifice—of money, comfort and (most prized) of privacy—had been justified. But Vincent could be sullen, argumentative, overbearing, dissatisfied with himself and so with all about him ("He is quarrelling with everyone," Bonger reported at this time); then Theo was in despair, felt that he had done wrongly to bring his brother to Paris, felt that he would go mad if they lived together, felt ill and hopeless. Within a few weeks of Theo's glowing report to his mother, Bonger was telling his family furiously, "Theo is still looking very ill. His brother is pestering him and spoils his life with unjust reproaches."

A few weeks later Theo, no better in health, went to the Netherlands for a holiday and Vincent, unconscious or forgetful of his own culpability, busied himself putting his brother's life in order. The girl that Theo had taken up was the cause of his shattered health and nerves—this Vincent saw plainly and told him: "That you and S. don't suit each other is clear, and it goes without saying that the affair must come to an end. But how? You can't just send her away, she would kill herself or go out of her mind and that would give you a terrible blow." He had his solution: "I think you should pass her on to somebody else, for instance to me. I am willing to take her, but I would prefer *not* to marry her, but if it must be I would even do that. Please think the matter over. As she could do the housework and earn her own living, it would be economical too." Anticipating Theo's consent, he dismissed the *femme de ménage*.

Bonger, with whom he had talked the matter over, dismissed his suggestion in a curt postscript "It won't work"; Vincent, in his anxiety to help Theo and to resolve his own loneliness and longing for a woman, had overlooked a vital fact—the girl's view of himself. But although Bonger's views of Vincent as a man had not changed, his respect for him as a painter had risen: "He has made some very good paintings—those with a yellow background are very beautiful. The still-life of the flowers is gay and rich in colours, but some of the colours are cheap, though I can't convince him of it. He keeps on saying 'But I wanted to paint this

and that contrast of colours.' As if I could care less what he *wanted* to do!"

Vincent had begun to paint. He needed two hundred canvases, he told Theo, before he could hope to be anything or do anything. He painted first what he saw around him. He painted his *Moulin de la Galette*, he painted many times his Pissarroesque *Jardinets sur la butte Montmartre* of the gardens and windmills he could see from his studio window, he walked through the Place Blanche and painted his *Boulevard de Clichy*. He walked down to the Seine and painted *La Pêche au Printemps* with Renoir very much in mind. These were Impressionist pictures; he used their palette, and as far as his experience allowed, he used their technique. Although his colours were a little muddy, they were good of their kind—the *Boulevard de Clichy* in particular was painted with a Monet-like delicacy—but they were not Van Goghs, they might have been painted by any one of a dozen painters.

Then he painted his *Montmartre*. This too was intended as an Impressionist picture. But something happened; the line of lamp-posts perhaps struck originality out of him. Whatever it might have been, the picture could have been painted by no other man. The technique was years ahead of its time; into the Impressionist mould Vincent put his own strength and vitality.

But he did not follow this up. He had been seeing a good deal of Reid (in unhappy moments, he short of money, Reid unsuccessful in love, they actually discussed a suicide pact) and he painted his portrait. And, being short of money and so of models, he painted himself—the first of more than twenty self-portraits in Paris. With Reid he had excited discussions about Monticelli. Monticelli had just drunk himself to death at Marseilles, but was that any reason for the neglect of those marvellous still-lives and portraits? Vincent and Reid were the only persistent visitors to the Monticelli exhibition at Delarbeyrette's. Why not buy them up cheaply and sell at a profit to those who would really appreciate them? Vincent's feeling for Monticelli suddenly burst into a series of flower studies. For a time he painted nothing but flowers—"to make the colours of his pictures brighter and clearer", explains Theo. Vincent used the thick paint of Monticelli, and began with the dark background of his Dutch predecessors, but the solidity of his flowers was all his own. The petals curl together with queer force; beneath their delicate surface they

have a powerful bony structure—as powerful though not so crude as the Nuenen still-lives and curiously reminiscent of the treatment of landscape by Cézanne, whom Vincent had met at Père Tanguy's shop in the rue Clauzel.

Père Tanguy, an original from Brittany, had made a name for himself with the Impressionists. He sold them their colours but he also showed their pictures—Cézanne's could be seen nowhere else—and his shop had become one of their chief meeting-places. By the time Vincent came to Paris the younger group had succeeded to the Impressionists; Signac, Anquetin, Toulouse-Lautrec, Bernard were often found lounging over the counter debating the respective merits of the colours, sitting in the back of the shop arguing about a painting propped up against the wall. Père Tanguy gave them credit, listened amiably, threw in his word (he was a revolutionary in politics as well as art), and would have tolerated them there all day but for his shrew of a wife. He took a liking to the newcomer though Cézanne, meeting Vincent in the shop, expressed horror at his pictures—an opinion he never changed. Vincent, always on the look out for free models, was struck by Père Tanguy's broad Breton face and red beard, his blue seaman's jacket and broad low straw hat. The portraits—he painted three in all—were, like all his good portraits, vivid external impressions of the sitter, the kind of portraits that a child would paint if it had the skill. Two of them were painted against the background of Tanguy's trade. It was not an original idea—Manet had painted Zola so, and Degas Tissot—nor was the background all his own; it consisted of Japanese prints and of studies after the Japanese.

That passion also flourished in his new surroundings. The De Goncourts' "Japonaiserie for ever" was no more, he found, than the literary expression of a mode adopted by the Impressionists; his own essay in Japonaiserie in Antwerp was an unconscious echo of this aspect of their work. Now he ransacked Bing's shop in the rue de Provence. Bing was the authority on Japanese art, he had written on it, his attic was filled with prints—"millions of them", cried Vincent deliriously. He brought Anquetin and Bernard along; they spent days looking over the prints. Every franc he could get out of Theo Vincent spent on these prints, he pinned them up on the walls of his room, just to look at them made him feel happy, they were so gay, so carefree, their colours

were crude, cheerful, bright, the kind of colours a child would revel in—and was he not a child? No European painter had dared to use such colours, not even the Impressionists, but Vincent dared; he plunged into a riot of painting after the Japanese, loading his brushes with bright colours, laying his flat tones one beside another, painting their gorgeously gowned women, their great green frogs, voluptuous water lilies, wooden bridges, boats, even their rain, streaking his canvas with it in abandon.

Then he turned back—prompted perhaps by rumours of a Millet exhibition the next year—to the north. He kicked off his boots and there was a subject beloved of Millet. He painted them as they had fallen, but Millet was nowhere to be found on the canvas: these boots had just been kicked off, they belonged to feet, they had walked miles, they were heavy, worn, dirty.

Another day he went into the kitchen; a couple of herrings lay on the table by some potatoes and a milk-jug. He painted them. None of the Impressionists had painted still-lives with so strong a hand; Vincent's *Harengs Saurs* was Dutch in its colours and powerful grasp of the subject but French in its economy, its absence of sentimentality.

Then he remembered Seurat's *Grande Jatte* in the exhibition. How had he ever forgotten it? Bernard had always been talking about it before, succumbing to a fresh enthusiasm, he rushed off on a walking and painting tour of Brittany. Vincent, he said before leaving, must paint with him by the river at Asnières the next spring and summer and follow in Seurat's footsteps. But it was then no more than late summer of 1886; to wait was not a verb in Vincent's vocabulary; he began to experiment with *pointillisme* in his studio; it was slow, exasperating work—not for nothing had it been given an alternative title of Scientific Impressionism—not at all his style and antipathetic to his temperament; there was no rushing at this kind of study, and impasto was out of the question. Yet as he worked he admired Seurat as a master; moreover, Seurat needed workers, he had founded a school—a temptation difficult for Vincent to resist.

He was elated but bewildered; there was a place for him in the *petit boulevard* group but what place—what ought he to paint, and how? Influences tugged at him from all sides—the Japanese colourists, Monticelli, Delacroix, Rembrandt, the Dutch school of his own day—Mauve, Israëls, the Maris brothers—Millet

whom he still regarded as his guiding star, the Impressionists, the Scientific Impressionists, the Post-Impressionists as the *petit boulevard* school was to be known. And, if he followed his contemporaries, which one?—for all were developing a distinctive style, all attracted him, all had virtues of their own. His mind was pitifully confused; how to choose; how to be sure that he took only what he needed to complete the painter in himself? Inevitably he chose nothing and rejected nothing; he painted after this, that and the other as one influence uprooted another: he painted after Millet, Monet, Monticelli, the Japanese, Seurat, Rembrandt, Renoir, Pissarro, especially Pissarro, but only in rare snatches after himself; his particular genius was being throttled by the genius of others.

What was his style—his true "sensation" (as the painter's personal vision was then called)? For the first hectic months in Paris the search had been exciting, the chase too full of incident to allow of reflection; then, abruptly, it grew frustrating, exasperating. He was seeking not blindly but in a mist—seeking what, he tried to express to Levens: "I have lacked money for paying models else I had entirely given myself to figure painting. But I have made a series of colour studies in painting, simply flowers, red poppies, blue cornflowers and myosotys, white and red roses, yellow chrysanthemums—seeking oppositions of blue with orange, red and green, yellow and violet seeking les tons rompus et neutres to harmonise brutal extremes. Trying to render intense *colour* and not a grey harmony. . . . So as we said at the time: in *colour* seeking *life* the true drawing is modelling with colour. . . . And so I am struggling for life and progress in art."

The struggle bore hardly on Theo; coming back refreshed from his holiday, he ran into trouble within a few weeks; Vincent became bad-tempered, noisy, nervy, almost persistently irritable. During the winter he all but drove Theo out of his mind. For years he had lived alone; his mind was bursting with ideas, questions, plans before he ever set foot in Paris; after some months of Paris his mind was chaotic—and on whom should he unload this chaos, to whom should he unburden himself if not his brother? When he could no longer paint out of doors he talked —talked incessantly and bad-temperedly, flying into a passion if contradicted. He had no idea of time, no thought that others also had to work.

Like all good artists coming from a small country to a world famous centre of civilization he had quickly thrown off provinciality of outlook; he had become in many ways more Parisian than the Parisians. But one trait in the Dutch character— a pseudo-philosophical-cum-religious streak—was too deeply rooted even for Paris to destroy; he talked and talked in this strain, and to Theo, a clear-headed man, this woolly-mindedness was particularly exasperating, as much so as the bad temper.

Theo bore with him because he divined the anxiety concealed by the anger; it was hard and thankless work, but if it had been all. . . . But it was not all; to a neat man (and Theo was feminine in his concern for tidiness) Vincent's genius for creating squalor was absolute agony; in a few months he had gone far to wreck the new *appartement*. However, Theo found that he could harden himself to this also; but the manner in which Vincent shattered his home life as well as his home—this stirred him to despair and almost to action. If only Vincent would keep to his own part of the flat! But his canvases sprawled everywhere; he would paint wherever the mood took him or where he spotted a likely subject; and when his companions came in (and young Bernard was there evening after evening, usually with a friend or two) they drifted all over the place, knocked out their pipes on the floor, stubbed their cigarettes on the walls and mantelpiece, put their feet on the sofa, scratched and stained Theo's beautiful cabinet, drank his drinks, ate his food and left the wreckage where it lay, arguing at the tops of their voices. The little crowd was almost always the same—the young painters whose work Theo had begun to show, against strong opposition from Valadon, in the entresol to his gallery. Was it not enough, he asked himself, that he should help them on—one of the few men in Paris who was doing so—and spend hours of his time with them at the gallery without having to entertain them at home? They were not his friends and they did not include women—and Theo, whose wish for a home life was as strong as his brother's, and, unlike his brother's, capable of fulfilment, often longed for feminine companionship. "You have no idea", he wrote to Breda, "how lonely one can be in a city like Paris. Just imagine talking only to people whose one thought is business, and to painters whose one topic is their own hardships. I never meet women and children of my own kind." And he could have added that he had rarely met men of his own

kind since Vincent took up residence with him; Vincent's friends —companions is perhaps the more accurate word—had driven his own friends off; cleanliness and peace and quiet and rational discussions with Theo being a thing of the past they stayed away; except for the faithful Bonger, Theo was deserted. He came home tired—he was for ever battling about his showing of the advanced painters—longing for rest and above all for a change of topic; but there was no change and no rest; evening after evening he had to endure the racket of Vincent and his crew.

And when at last he and Vincent were left together there was still no rest. What did he think of his work? Vincent would ask again and again. Why didn't it sell? What was wrong with it? He was uneasy, he needed guidance, reassurance. But nothing that the weary Theo could say would reassure him; how could it, since he knew that the remedy lay within himself?' But he asked on nevertheless. He would launch out on some new theory he had picked up, then talk for hours about his plan to buy up Monti-cellis. This plan he had taken over from Reid, with whom he had already quarrelled. "I was very much taken in by him during the first six weeks or two months," he was later to explain, "but after that period he was in pecuniary difficulties and in the same acted in a way that made on me the impression that he had lost his wits. Which I still think was the case and consequently he was not responsible even if his doings then were pretty unfair. He is very nervous—as we all are—and can't help being so. He is prompted to act in his crisis of nerves to make money . . . whilst painters would make pictures." But this explanation of the Scotch mentality did not occur to him until he had left the uproar of Paris. In this winter of 1886, walking up and down before Theo, he saw Reid's behaviour and their quarrel as fortunate events; he would continue to paint his pictures while Theo would buy Monticellis and make a fortune. He was not interested in money but he was interested in Theo's health and in his immortal soul; let him buy up Monticellis, he insisted, be freed from all worries on account of the family and—and this was at the heart of the plan—be himself a free man and honourable, abandon Boussod and Valadon and start a gallery of his own, showing only the painters he believed in. Throw up the job, he said; he had it all worked out. He talked on and on about it, following the dog-

tired Theo into his bedroom and sitting on the bed, eyes gleaming, hands gesticulating, hoarse voice declaiming, apparently tireless. When Theo dragged himself up later in the morning to go to the gallery, Vincent was still sleeping amidst the chaos.

Theo was in despair: "My home life is almost unbearable. I wish he would go and live by himself. He talks of it sometimes, but if I were to suggest it he would at once give up the idea. All I ask is that he leaves me alone, but that's the very thing he never does. I can hardly stand it."

Yes, Theo decided, he must get rid of him; they must separate. If not, he would collapse—he felt utterly worn out. Then all who depended on him—his mother, his sisters, his brother Cor, now training as an engineer, and not least Vincent himself, who was spending more money than ever before—would go down with him. Yes, they must separate. Had not Vincent himself written from Antwerp, "I'm not sure whether we shall get on together, though I don't despair of it"? And had he not added, innocent of irony, "it will be much cosier for you to come home in the evening to a studio—depression is our worst enemy"? At home, alarmed by reports of Theo's failing health, they urged him to act. "For God's sake leave him," wrote Elizabeth. Yes, Vincent must go. And then, the decision made, something—a look, an awkward loving gesture by Vincent, a glance at one of his paintings, so uncertain still and yet so full of promise—made nonsense of the decision. "He seems to be two people in one—a wonderfully gifted man, tender and refined, and an egotistic, hard-hearted man. He talks and acts in both ways and actually argues with himself, one part of him against the other. He's his own worst enemy—he not only makes life hard for others but for himself."

Theo couldn't do it. Vincent needed more than his money; he needed him and this home, mockery of a home though it now seemed. He changed his mind. "I've often wondered whether I did rightly to help him all these years. I've often been on the point of telling him that he must fend for himself. Had he been anything but a painter I should have done so long ago. I've thought it all over again but I can't desert him. He's an artist —there's no doubt of that—and even if his paintings aren't always up to much, they are teaching him to make good ones—

yes, perhaps even sublimely good. It would be wrong of me to stop helping him now when he is learning so much. And although he's hopelessly unpractical, I believe he is bound to sell his paintings when he really finds his genius. So I shall go on as before. All I hope is that he will find rooms somewhere else."

Chapter Eighteen

PARIS TURNS HER FACE

1887-1888

VINCENT did not find rooms elsewhere but he found a new
haunt for the evenings—the Café du Tambourin in the
Boulevard de Clichy. The café had been opened a year
before his arrival by the temperamental beauty Agostina Sega-
tori, "aimable et un peu languissante", once the model of Corot
and Gérôme, and soon became the favourite meeting-place of
the progressive writers and painters in Montmartre. Segatori
took to Vincent—he was more of an age with her than the
younger men—and enjoyed drawing him out; he was naïve to a
degree, she soon found, in his dealings with women. A greater
contrast could scarcely be imagined than the voluptuous Italian
and the repressed Dutchman—no doubt that explained the
attraction; the affair, such as it was, proceeded by stormy fits
and starts.

The café lived up to its name—the tables, plates and dishes
were shaped like tambourines, and tambourines were hung on the
walls with stanzas scribbled on their skins by aspiring poets—
and Vincent was soon helping to paint frescoes of tambourines
intermingled with Japanese motifs. He made a study of Segatori,
he and Lautrec each painted a portrait of the waitress with her
hair piled to fantastic heights, he organised an exhibition of
Japanese prints in the café and persuaded Segatori to let him,
Anquetin, Bernard and Lautrec exhibit some of their work there.
The sight of his paintings hanging on the walls caused "irritated
surprise" to many of the habitués who cared little for his work
and still less for the favours shown to this comparative stranger
by the Segatori. But he was once more active, hopeful, excited
and in his intense, heavy way, good company. Exhausting com-
pany too; the first time one of the habitués saw him there he was
sitting at one of the marble-topped tables, wearing the short
jacket of the workman and drinking with a man who had been
plainly worn out by the stream of vehement talk. The man
dozed from time to time, unable to keep his eyes open, but

Vincent, remorseless when airing or developing a theory, only shouted the louder, throwing his opinions literally in his face, so that the wretched fellow was jerked back to consciousness again and again by the hoarse, urgent, imperative voice. The habitué, who saw Vincent often at the Tambourin during the next few months, had the impression of "a man slightly cracked, with an irascible manner and who remained, in truth, rather an outsider."

Theo drew breath again: better days were coming, he told them at home; and it was true, except for the fact that Vincent, trying to live up to the company he found himself in, was beginning to drink more than was good for him and that, having drunk, his temper suffered and so did anyone near him—this apart, the omens seemed favourable.

In the spring of 1887 he went off to Asnières to paint with Bernard by the river where Seurat had worked so recently and Monet, Renoir and Sisley in previous years. At first he was overwhelmed by the colours. "I hope to show," he had told his sister, Wil, to whom he wrote occasionally, "that I am looking for something more than green landscapes and flowers. A year ago I painted nothing but flowers to accustom myself to other colours such as grey. I painted in pink, soft and glaring green, light blue, violet, yellow, orange and a beautiful red." But he had still to work outside Paris. "Then, when I painted at Asnières this summer I saw more colours than ever before." He felt, as on that journey into France from the Borinage years earlier, that he was, thanks to the purity of the atmosphere, given fresh and more powerful eyes, not only seeing more colours but seeing them plainer. He painted with the zest of a boy; he was in love with bright colours.

Signac, who had first seen Vincent at Père Tanguy's, joined them sometimes; he was an energetic young man, rather crisp, with a piercing black eye and a short, neat black beard. He wore a yachting cap, being like so many painters a lover of small boats. He found the antics and enthusiasms of Vincent amusing, but being himself a serious man with a sense of humour, with respect too: "he loved life passionately," he said afterwards. "He was ardent and good. . . . We painted on the banks, lunched at the auberge and walked back to Paris by way of the avenues of Saint-Ouen and Clichy." By the river, at work, "Van Gogh, wearing

the blue jacket of a plumber, had painted tiny dots of colour on his sleeves. Standing close by me he bawled and gesticulated, brandishing his large canvas gleaming with fresh paint and smearing himself and everybody who came near him with all the colours of the rainbow."

To paint with Signac, with Vincent in his present mood of uncertainty, was to paint like Signac; his *Intérieur de Restaurant* is pure *pointillisme* just as his *Sous les Arbres* had been the spit of Monet's *Bords du Seine*; but he also this summer painted pictures foreshadowing the painter of Arles—his first studies of sunflowers whose great masses of yellow fascinated him, and his *Champ de Blé à l'Alouette.*

During these spring and early summer days at Asnières he realised that Parisian life had been losing its charm: too much drinking, too much smoking, too many brothels and too much talk of the wrong kind. Always jokes, jokes, jokes—could no one remain serious? Here was country again, over-civilised though it was, and a sense of soothing leisureliness even in the midst of hard painting. Through Bernard and his parents he had met some charming women: the Comtesse de la Boissière and her daughter for whom he painted two river scenes, and Madame de Laréby Laroquette who delighted him—and more than delighted —by exclaiming "Monticelli. Ah! he should have been the leader of a great painting movement in the south." He painted often in the wooden studio that Bernard's grandmother had persuaded his parents to build for him in the garden; he had an illusion of peace—the Borinage, Etten, Nuenen, Sien in the gloomy garret at The Hague all seemed far away to the man sitting by the Seine sipping absinthe in the sun and revelling in the clear air and pure colours.

Yet the man had not changed. Which was his world—the world he had left or this world of polite conversations, bars, brothels, painters and poets squabbling till the small hours? Or was a third world waiting for him? The words about Monticelli rang in his mind, he had already talked of going south, but he did nothing. Yet though life was easy for him now as it had never been in his life, his work now as ever took first place. He still urged Theo to marry, but for him "*l'amour de l'art fait perdre l'amour vrai*"; he felt sad about it, at times desolated, but there it was—or so he tried to make himself believe. And feeling so, the

questions would recur: "Are you loving what you love? What do you love?" He had no certain answer; one day, he believed, the answers would leap to him and his mind would be made up.

One of his studies painted during this summer, the first of his "yellow" canvases *Romans Parisiens*, won such praise and respect from fellow-painters that for a month or two more the development of his individual talent—his "sensation"—seemed to be proceeding inevitably; the questions remained unasked; indeed at times Paris appeared to have answered them once and for all. Guillaumin, friend and pupil of Camille Pissarro and protégé of Portier, admired this and other of his works—"so expressive"— although the maker of them astounded him by appearing in his studio in such a state of déshabillé that Guillaumin was immediately reminded of Delacroix' *Tasso in the Madhouse*. To explain his work the better, Vincent threw himself on his knees before a canvas, gesticulating wildly. "Nothing would calm him," observed Guillaumin.

Vincent's opinion of the calm and friendly Guillaumin was altogether good and he accepted an invitation to his studio with alacrity and an "I believe that as a man Guillaumin has a better ordered mind than others and that if everyone were like him we should all turn out plenty of good things and spend less of our time envying and squabbling." This to Bernard who had shown by the river distressing signs of another and less charming side of his character; he was quarrelsome and had already fallen out with his so recent god, Signac.

To Vincent this epitomised the Paris that he had begun to see and to fear even more clearly—a Paris that might neutralise its great virtues and prove an absolute menace. He had remonstrated with Bernard to no purpose, leaving "brusquely"; he now wrote and, after an apology, proceeded with his remonstrance. "I persist in believing, not because I want to blackguard you but because I believe it will become your own true conviction, that you will realise that in the studios one doesn't only understand important things about painting but also learns one great good in knowing so much about how to live—and that one is obliged to learn how to live as a painter if one is to avoid the old dodges and deceptions of the schemers. . . . To escape generalities, let me take an example from life. If you are on bad terms with a painter and in consequence you say 'If Signac exposes there, I

withdraw my canvases, and if you run him down it seems to me that you won't succeed as well as you ought. . . .' If, then, you have already reflected that Signac and the others who go in for *pointillisme* often make very good things, instead of running these things down it is especially desirable in case of disagreement to esteem them and think of them with sympathy. Without this one becomes a narrow sectarian, just as those who think nothing of others and believe themselves always to be in the right. And this would be to reduce yourself to the level of the academicians. . . ." But this typical example of wisdom expressed typically was lost on a Bernard who loved the gossip of studio and café almost as much as he loved painting; nor, alas, could Vincent profit from his own advice, as was soon to be seen.

A friend of Russell's, the Englishman A. S. Hartrick, also came to the rue Lepic to see the *Romans Parisiens* and its maker; he had heard much of Vincent, who often dropped into Russell's studio, but was in some ways disappointed—the man, he thought, did not live up to the stories that were being told about him, still less to the legend that was to form in later years. Perhaps his greatest surprise was to find Vincent so small a man—"weedy" is the word he uses to describe him—with pinched features (the result of his years of near starvation) and a light blue eye. He also found him much less the vagabond in appearance than he had been given to expect; he was dressed, on that day at least, "in an ordinary way" and the *appartement* was "quite a comfortable one, even rather cluttered up". But in manner Vincent fully lived up to his reputation and the vigour of his work; Hartrick found him "as simple as a child, expressing pleasure and pain loudly" and his way of showing likes and dislikes "disconcerting" —a truly English understatement. Vincent stood before the easel on which was the *Romans Parisiens* and poured out a string of Dutch, English and French (he was by this time fairly proficient in French and had begun to write his letters to Theo—when the latter was out of Paris—in that language), glancing back from time to time at the Englishman and hissing through his teeth. This also was disconcerting—"when thus excited he looked more than a little mad"—and Hartrick (who was to sketch him doing so) later found him at times "morose as if suspicious"—an attitude that today causes no surprise.

But on that day there was no moroseness, no suspicion; Vin-

cent was glad to have a new listener and showed only excitement and pleasure which, after the first alarms had passed, was engaging until it grew boring. He proudly displayed his Japanese prints —"crêpes" he called them because of the crinkled paper on which they were printed—and Hartrick later believed that in his painting he tried "to get a similar effect of little cast shadows in oil paint from roughness of surface". Then he produced with a different kind of pride some etchings by Matthew Maris and, with diffidence, a bundle of his own lithographs of Dutch peasant women at work in the fields and of Sien as *Sorrow*. The latter Hartrick found "terrible", but he admired the rest and Vincent characteristically offered to give him the lot—he always reacted impulsively in this way to praise of his work.

And Vincent talked—talked interminably, of his theories of colour (he "would roll his eyes and hiss through his teeth with gusto as he brought out the words 'blue', 'orange'—complementary colours of course"), of his aims, of his repudiation of conventional painting. Hartrick felt that there was in his work in particular "a fierce effort to give the effect of brightness, or blackness, or dulness, or whatever was the chief characteristic of the object he wished to depict." Certainly Vincent was already beginning to show signs of an obsession with colour. As he talked, he demonstrated; he had the habit of carrying thick sticks of red and blue chalk, one in each side-pocket, and would illustrate his theories "on the wall or anything that was handy" in lines up to half an inch thick. His main theory of this moment, and the one in which he seemed to take most pleasure, was that the eye "carried a portion of the last sensation it had enjoyed into the next, so that something of both must be included in every picture made". This he demonstrated to Hartrick when he returned the visit; and Hartrick, a cautious man, hastily spread some newspapers on the table of his studio—like Russell's, in the Impasse Hèléne—so that Vincent could slash out his latest "motif" harmlessly.

The visits continued—Vincent had fallen into the way of looking up Russell, who had made a romantic portrait of him at his easel, and began to include the Englishman too. Hartrick seems on the whole to have appreciated the visits—in retrospect in any event—and he at least understood that Vincent was an original and suspected that he might be even more; but his companion,

Henry Ryland, another Englishman, hated and feared them. Ryland, a gentle sentimental soul, was a follower of Burne-Jones; unwisely he hung round the studio walls "a set of weak water-colours of the 'La Belle Dame Sans Merci' type". Vincent, calling, found him alone one day, spotted the water-colours and, not caring for Ryland at the best of times, at once exploded: how dare he face a serious artist with such anaemic rubbish, a useless reflection of the Pre-Raphaelites whose work in any case he despised, as did all right-thinking men. On and on he raged. Some hours later Hartrick, returning, found Ryland (who suffered, even without a Vincent, from sick headaches) looking "a sickly yellow" with his head swathed in a towel soaked in vinegar. "Where have you been?" he wailed. "That terrible man has been here two hours waiting for you and I can't stand it any more."

This was merely funny; but not every man was a Ryland, and Vincent began late that summer to treat everyone alike; he became impossible. Theo, his one restraining influence, was away in the Netherlands trying to recover from the strain of living with him; unsuccessfully it seems, for Wil wrote to Vincent in alarm: they thought that Theo looked very ill. This Vincent took, perhaps correctly, as a reproach—he knew well enough in sober moments what he was doing to Theo—and at once denied it. Theo, he said, was looking better than when he went home the previous year; and for good measure he invented the preposterous theory that Theo's illness was due to the jealousy of the Van Gogh relatives of his success as an art-dealer.

As for himself; "I'm growing rapidly into an old man with a wrinkled face, a tough beard and many false teeth. But what does it matter? Painting is a dirty and difficult job and if I was not myself I would not paint. But being myself I keep on painting with pleasure and I think it possible to make pictures filled with freshness and youth even though I've lost my own youth."

Wil spoke of studying, but this worried him: "No, my dear sister, you had much better learn to dance or to fall in love with one or more solicitor's clerks, officers or suchlike, you had better do a lot of foolish things rather than study in Holland. It's good for nothing, it only makes people thick headed and I don't want to hear another word about it." Like Theo and Vincent she was liable to fits of desperate depression, and to comfort her he ex-

plained "the diseases from which we educated people suffer most are melancholia and pessimism. For instance, I, who can look back at so many years in my life when I forgot how to laugh—whether through my fault or not I won't discuss—I want some cheering up." His remedy was to read books which made him laugh—De Maupassant, Rabelais, Rochefort, Voltaire—and he promised to send her *Bel Ami*: "I often read impossible and rather indecent love stories out of which I get nothing but a little wisdom. But I think I'm right in this, for in earlier years when I ought to have been in love I plunged myself into religious and social affairs and I thought art holier than I think it now." He read seriously also, he assured her—in De Goncourt, Zola, Flaubert, Richepin, Daudet and Huysmans—but added (for she was a pious girl), "We ought to realise that the Bible contains everything we need. I believe that if Jesus was living today he would say to those who are melancholic and downhearted, 'Why do you look for the living among the dead? Joy is not here but risen.' I'm thankful that I have read the Bible more thoroughly than many other people; it gives me a feeling of satisfaction to think that there have been such great ideas in the past."

He was unable to profit by his own advice; neither the humorous nor the serious reading arrested his disintegration. As a painter he was profiting still from Paris and its studios and galleries; as a man he was fast going downhill. To him, the world seemed to be collapsing about his ears; in truth, as always, he was collapsing it: all were in error; to him alone had the truth been revealed; all must listen and learn—he had come to that.

First he quarrelled violently with Bernard's father. Bernard was causing his parents some anxiety; his heroes worried them—a debauched dwarf, a man who had deserted his wife and children and an excellent stock-exchange business to paint; and now a man who had thrown up art-dealing, the Church, one thing after another for painting and who at thirty-four had never painted a picture that anyone would buy. Not a distinguished collection, they felt; when was Emile going to abandon his painting craze and settle down to a respectable, profitable life?

"Never!" shouted Vincent, who was making a portrait of Bernard in the garden studio and who came in for the discussion. He gave the father a piece of his mind; he was worse even than Cormon, trying to get between a genius and his destiny; even his

own parents had not gone so far—not so blatantly, at least. As Monsieur Bernard showed signs of disputing the point, Vincent snatched up the portrait and marched off in a towering rage, the wet paint colouring his clothes and dripping on to the pavements all the way back to Paris.

In Paris he at once fell out with Segatori; not one of their customary violent squabbles but a break. The frank words of Monsieur Bernard rankled: she had not sold a picture for him, he shouted, since he had first shown them in the Tambourin months earlier. Lautrec, who had no need of money, who was not even serious, could live on the sales he had made; Anquetin was keeping himself; even the boy Bernard had sold one or two canvases; what had Segatori done—hung his in a poor light because he was an indifferently good lover? His vanity was hurt, not so much by the unsold pictures—he was used to that—as by her latest lover. He demanded his pictures. He was in debt to the Tambourin, as they all were; the pictures were in a sense pledges, Segatori reminded him. The words grew high; Segatori's new favourite overheard, intervened; the humiliations of The Hague were repeated—Vincent was knocked down, thrown out, his face streaming with blood. "I believe she has had an abortion," he told Theo savagely, taking his revenge where he might. "She was as white as milk."

Matters went from bad to worse. He drank more and more heavily. Models refused to pose for him, he looked so peculiar, his manner was so menacing, his temper so frightful. He tried to paint in the streets to get free models, was forbidden by the police, argued, resisted, was again and again brought home—and even to Theo's gallery—creating a violent scene. Theo quieted him, pacified the gendarmes, the matter was hushed up, but Theo grew thinner and thinner. Vincent's behaviour in the entresol to the gallery grew strange. Every afternoon the *petit boulevard* painters gathered there to smoke, talk and stare at the advanced canvases, theirs included, hung round the walls— Theo's attempt to help the contemporary painter. Vincent would walk in with his latest picture under his arm, put it down against the wall and stare at it with a frown. He half-hoped that others would join him, but that was expecting too much; freakish as he was, talking of his Mauves and his Marises and a string of long-forgotten and best-forgotten Dutchmen, they suffered him

mainly because he was Theo's brother, because Theo was a good
sort, a progressive dealer and might even sell their pictures; but
there was no call on them to go to the length of pretending to
admire every canvas he painted. His audience often consisted of
Bernard. And he was glad, he told himself, and with half his
mind he was truly so—for he usually despised as well as loved
what he put against the wall. Love what you love—yes, but what
did he love? He was not being himself much of the time—that
was all he could be sure of, but it was enough to make him savage
and despondent. Technically he was far ahead of the Nuenen and
Antwerp Vincent, the facility was coming, the range of colour
was growing and the cause for confidence—but confidence in
what? His inability to answer the question made him frantic and
often insupportable. The other painters might not always wish
to look at his work, they might laugh at him and his dark Dutch-
men, but they had to listen to him, and to listen to him was
to quarrel with him.

Then, late in November, Gauguin came back from Martinique.
Vincent had heard much about Gauguin during the past year,
but had seen him scarcely at all. The nineteen canvases in the
exhibition had struck him, as they had struck Theo, by their hint
of power and originality, but he had seen too much in too short
a time to remember a painter in Brittany who was not considered
by anyone to be in the front rank. Then, in the autumn of the
previous year, Bernard had come back to Paris wild with a new
enthusiasm; all his former heroes trembled on their pedestals—
he had met Gauguin. He was making a painting and walking
tour of Brittany, ran into Emile Schuffenecker, Gauguin's friend
and supporter, and wheedled out of him an introduction to
Gauguin who was living at the village of Pont-Aven a few miles
along the coast. Gauguin had not, Vincent gathered, been over
pleased with the introduction; he disliked the curious almost as
much as the conventional; in fact—although Vincent may not
have divined the exact state of affairs—anyone with a hide less
tough than Bernard would have been out of the Auberge Gloanec
and of Pont-Aven that same day—for Gauguin neither wasted
nor minced a word and excelled in sarcasms. But the young
whippersnapper, as Gauguin first thought him, knew a hero
when he saw one; he hung on and insinuated himself, blandly
disregarding the most obvious discouragements, into the little

circle forming about the great man. Gauguin, he told Vincent excitedly and at length, was the coming painter; he called himself an Impressionist but in Bernard's opinion was already moving beyond Impressionism—or carrying it an essential stage further. He had begun to simplify, to paint from memory, flattening his tones, laying complementary colours side by side, pure, in broad flat stripes, he was hardening his contours, abolishing the Impressionist fetish of no bounding line, he might well introduce the black denied by the Impressionists—this last and much else if Bernard's counsels were considered. For Bernard's worship was, as always, inextricably mingled with a stout belief in his own inevitability. He had not wasted his summer, he assured Vincent; at Saint-Brieuc he had studied and copied the cathedral windows; there, he predicted, were lessons not to be missed, in use of colour, childlike simplicity of design and symbolism and in the dramatic effect of the *cloisonnage*. With him at Gauguin's side, inspiring, advising, what might not be done? He placed no limit on the advances that painting might make. That was his view, thrown out at Vincent with infectious enthusiasm.

However, he was not at Gauguin's side and the millennium was unavoidably delayed; he could only talk about it. This he did and with effect, so that Vincent was agog to know the new giant. He saw his work in Theo's entresol, he too could read in it an infinite promise; it pointed the direction that the painting of the future must take, the direction towards which he, following the Japanese prints and infatuated by colour, had already begun uncertainly to take—this he believed implicitly.

But he had to wait to meet the maker of this work. Gauguin had returned to Paris for the winter of 1886-7, but hungry, unsuccessful, embittered, unapproachable; in the three years since he had given up his profitable job on the Bourse he had worked as never before in his life, he had struggled, starved, suffered, he had even been praised, but he did not sell, he remained dependant on others, always on the edge of starvation and—perhaps hardest of all to bear—a standing example to the philistines (which they did not hesitate to use) of the idler who could not keep his wife and children since he had taken up painting. Idler —he! All that Bernard thought of him he thought of himself; he had some way to go but the greatness was there. Theo believed in him and showed his work but could not sell it. By the spring

he was without money or food; he was no stranger to the state, but he was a man of vast pride and a man of action; he left abruptly for Central America.

This gesture made a profound impression on the little group in which Vincent moved; Gauguin had talked of a return to nature, he had insisted that he was a child and a savage (he claimed that the blood of the Incas ran in his veins) and he had declared that the future of painting must rest with the man who went back to the true civilisation of the savage in lands where life was simple and unspoiled, models natural and free, the air transparent and the colours pure and brilliant. The thought was not new—it was indeed a favourite topic in the cafés of Montparnasse and the Boulevard de Clichy—but, like the revolvers so freely owned and carried, all tacitly understood that it was not for use. Then Gauguin fired his revolver—he actually, without money or prospects, went off to one of these fabled, often-discussed lands—and everyone gasped with the mixture of admiration, envy and surprise that such an exploit arouses in the talker.

Now, in November, he was back in Paris. He strode heavily into the entresol of Theo's gallery in his gaily painted Breton sabots, wide fisherman's trousers, blue Breton jersey with its white motifs across the broad chest. In his hand he carried his famous decorated stick, on his head was the green beret pulled down over a scornful blue-green eye. His face with its Peruvian high cheekbones and narrow forehead was deeply tanned; from his mouth projected the inevitable pipe; his manner as always in public was distant, authoritative, faintly contemptuous of the company he was keeping. His sojourn in the south had been by every practical standard a disastrous failure; he had been obliged to join a gang of navvies on the notorious canal diggings in Panama, had gone hungry and had been riddled by fever in Panama and Martinique and had been forced to work his passage back; in Paris he had no money, no home, no obvious future. Nevertheless he was received with a kind of reverence; he was after all the man who had done what he said he would do; and from the point of view of all the painters in the room he had succeeded—for there, hanging on the wall, were some of the paintings he had made in Martinique. None had seen such colours before, such bold draughtsmanship, such courageous use of paint.

At the sight of these canvases and at the sound of Gauguin's voice—he had a delivery of peculiar significance, as though he spoke with a more than human authority—Vincent knew for certain that this man was the painter of the future, the painter who would lead the modern movement and lead it triumphantly forward. *Ramener la peinture à ses sources,* said Gauguin. He described the atmosphere in the tropics, unbelievably light and pure, the consequent startling effects of colour, the free models in the simple coloured people, their kindness and the cheapness of living. Of the fever (from which he was still suffering), the infrequent post, the sense of being cut off from one's fellows, the difficulty, having painted a picture, of selling it, he understandably said next to nothing; and his audience, enthralled, were not so far curious—certainly not Vincent.

But to admire Gauguin was one thing and to get on terms with him was another. Of charm of address, of humour, Vincent had not a grain; and all the qualities in him that Gauguin would appreciate—his singlemindedness, his integrity, his enthusiasm, his record of sacrifice for his beliefs (a record as impressive and longer than Gauguin's)—were hard to get at, hidden by an unfortunate exterior and a still more unfortunate manner. Vincent had an unhappy genius for presenting himself in the worst possible light; he did so now; he felt the need common to the admirer of drawing attention to himself; he chose to assert himself by an hysterical defence of the modern Dutch school and equally hysterical praise of Millet.

Gauguin dealt with the intruder as he deserved, demolishing Vincent's heroes with a few waves of the stick and a few drawled sarcasms that bit deeply. The contrast between the men could scarcely have been more marked: the burly, contemptuously calm Gauguin, the thin, small Vincent quivering with agitation. Yet Vincent's surrender—for surrender he did at last though abating not a jot of his loyalties—was due neither to Gauguin's physical superiority nor even to his invincibility in argument, but to other and worthier considerations: Gauguin, unlike the other men who gathered in the entresol afternoon after afternoon was his senior (by five years); Gauguin, like him, had come late to painting, had abandoned all for it; Gauguin had indisputable genius. He felt them to be spiritual brothers and Gauguin to be the elder, wiser, infinitely more gifted.

From this position was but a step to another. As they talked
night after night through the winter (for Gauguin, appallingly
hard up and anxious to sell to Theo, was less contemptuous than
usual) with Bernard as a voluble, long-haired third between his
two gods, light came to Vincent. Delacroix had painted in the
south, Monticelli and now Gauguin; all their canvases reflected
bright colours under strong light—they were primitive in the
best sense of the word, they had gone back, as Gauguin said, to
the sources. But Delacroix was dead, Monticelli was dead,
Gauguin in Paris and talking of a return to Brittany. The south
was empty, waiting. The community of painters in Paris—alas!
If only one could regard them as painters and not as men. But
one had to listen to Lautrec's lewd jokes, grow fuddled and tipsy
in their company at the cabaret, bored with incessant "bals" at
the Moulin de la Galette, reel off to a brothel, wake ill and re-
morseful, unable to paint. And so short a time to live and so
much to do! "As men," he told Theo, "they disgust me." Even
the Impressionists, those august masters, were falling apart:
Monet, refusing to exhibit with Gauguin, had not shown his
work in the Rue Laffitte; Renoir not there because Seurat and
Signac had been allowed to show their "chemical technique";
Pissarro, having taken up "divisionism" (one of the many words
coined to express the method of Seurat and his followers), being
coldshouldered by old friends. Deplorable! This city, this glorious
Paris with its great artists, defiled and degraded all it produced.
He must shake it off. But not alone.

At last, in the new year of 1888, he put it tentatively to
Gauguin; in a stammering, hoarse voice, abruptly, he expounded
his plan; he wanted to take up the work of Monticelli and found
a school of Impressionism in the south of France, but he alone
could not found such a school—he needed a *copain* and a painter
greater than himself. The south of France was not the true south
of the tropics but it offered light and colours clearer and brighter
than any known in Paris or Brittany, and they could get there at
once if Theo would pay the fare. They could work in health and
comradeship under a clear light that revealed all the colours of
the prism; they could recover the Japanese way of feeling and
painting; they could apply their knowledge of the present great
—the older Impressionists—they could understand and apply
the art of Delacroix, his use of colour with spontaneous drawing

to express the nature of pure country, and of Monticelli. His companion would be undisputed head of the studio; all good young painters would be attracted to the south; painting would come back to nature; they would carry Impressionism to its final, essential conclusion.

Gauguin laughed—that was a tall order—and resisted the compliment without difficulty: if he went south again it would be to the real south, the South Sea Islands for instance, but as he had no money he would go back to Brittany, where he had taken to the sombre people who in feature and even in dress reminded him of the native Peruvians and where the landlady of the Auberge Gloanec was not particular about the settling of bills. He was not to be moved: despite Bernard's commendations, despite the fact that Theo was Vincent's brother, despite the gift that he saw in Vincent's work, he regarded the Dutchman as no more than cracked, an impossible, unthinkable companion.

Vincent was in despair: to know one's course and be unable to follow it—to be trapped in the prison of Paris! He thought of the sun and the colours of the south and looked with loathing on the busy streets, the crowded cafés. A year earlier, at the beginning of his passion for Monticelli and moved perhaps by the experience of Russell who had worked in southern Europe, he had written to Levens: "In spring—say February or even sooner—I may be going to the South of France, the land of the *blue* tones and gay colours. And look here, if I knew you had longings for the same we might combine. I felt sure at the time that you are a thorough colourist and since I saw the Impressionists I assure you that neither your colour nor mine as it is developing itself is *exactly* the same as their theories. But so much dare I say we have a chance and a good one finding friends." But Levens was either unable or unwilling to go; Vincent remained where he was, not unwillingly, for Paris was still showing a bright face to him. Now, a year later, the refusal of Gauguin came as a desperate blow. He could not endure the thought of the loneliness if he went south, but no more could he endure Paris—he had come to hate the life and the people. He drank with Toulouse-Lautrec, who painted his portrait, but could not take his liquor and became madly quarrelsome; he followed him and the rest to the brothels, but could not live up to them there either and became wildly despondent. But what was causing him the most harm

was not so much these excesses as the perpetual state of mental excitement in which he lived; the over indulgence in drink and sex was bad for his body, but at least he was eating more sanely than for years past. To counteract the stimulation of mind he had no kind of antidote: the gadfly Bernard with his nimble brain, persuasive tongue and utter lack of stability stung him into one frenzy of enthusiasm after another; Toulouse-Lautrec baffled him with his skill as draughtsman, infuriated him with his jokes and, when he was sober, disgusted him by his manner of life—with such a gift, to be so little serious! The others were little better; they were not truly of his kind; he suspected mockery; they would encourage his flights of fancy then laugh or change the subject; at best they humoured him, and at such a thought his pride rose into explosions of fierce resentment. He remained, as one of them had said, an outsider. It was true and it was a compliment, thought not intended as such; but he, naturally, saw only the exclusion, became a bundle of nerves, an impossible companion and a misery to himself. He felt ill; he had a dreadful sense of satiety, his brain felt as though it might burst; he was terrified of a stroke or of losing his reason.

He tried to forget himself in work; he painted portraits and still-lives, painted furiously. In all this time, nearly two years, he had sold one picture, a portrait of a friend of Père Tanguy, for twenty francs, and had exchanged another, of the herrings, for a rug. He could find no consolation, no peace. Gauguin might perhaps have provided the rock he needed—he felt it to be so—but Gauguin would not take him seriously. Theo, the one man who truly cared for him, was a busy man and ill; he kept him, uncomplaining, silently cutting down his own expenses when the drain became too heavy, but a companion he could not be—he was not a painter, his tastes in everything but paintings were different, and his conscience was troubling him.

In a moment of devotion Vincent painted one of his yellow still-lives and presented it to his harassed brother, but the gift only accentuated Theo's unhappiness. Paris, he saw, was not the place for Vincent—what had he done to bring him there? The answer was around him, in the pictures on the walls, stacked against the walls, choking the flat. But Theo could no longer see the pictures for the distraught and dissipated man who painted them. Vincent would collapse, he was sure of it; he too perhaps.

But he could say nothing; Vincent would react at once against advice, he would be hurt, flare up, sulk.

Did he even want him to go? When the bedlam in the apartment became past bearing, yes. But often enough when he looked at Vincent's sad face and knew his thoughts, his impulse was to keep him there and somehow protect him. At such times he knew how helpless Vincent was for all his arrogance and touchiness; he was his own worst enemy, he stood in his own light, but was it his fault? Had he not been born in the place of another, and had not this dogged him through life? No, he could not be blamed —pitied rather, though one must never show a sign of it. He had been a painter *malgré lui*; he had struggled and suffered until the truth could be denied no longer. He was a painter and would be a great painter; Theo thought of the boots, the herrings, the flower pieces, the studies of books, the field of wheat, one or two of his river scenes—Vincent and no other! Yes, he would be a great painter, but not in Paris. He must go; not because Theo could bear him no more but because Paris had given him all she had to offer.

But would he have the courage to go after the Gauguin rebuff? Gauguin was the last of his heroes, one could say nothing against him. Would Vincent move without him? Not perhaps so long as Gauguin stayed in Paris. But in February Gauguin returned to Brittany. Theo hurriedly sought a new interest for the desolated Vincent; he took him to Seurat's studio. Vincent was immensely taken with this talented young man; he took life seriously, as seriously as Vincent himself. They had long and earnest conversations, unhelped by liquor, on the future of painting. It could not lie with one man, insisted the grave bespectacled young Seurat, it could not lie with any number of individuals going their own way. The painter had a duty to his fellow-man, to face him inescapably with beauty as the guildworkers had faced him in earlier days with the mighty Cathedral that caught his eye whenever he went outside his house. The painter could influence man in his home by employing a common style. Seurat pointed to his huge canvases; he saw them not as a plaything for the rich but as wall decorations for all; let the artists develop a social conscience, beautify their public buildings and the houses of the people as the Greeks and the men of the Middle Ages did. Every painter who joined in this great work would receive a living

wage from a communal fund, the price of his labour would be fixed, supplies of paint and canvases would be assured; he would no longer be dogged by poverty, the joy of working to a common end would inspire him.

Vincent listened entranced. These were his own sentiments of long ago, the sentiments of Millet translated into modern form. So he had been right after all! There were excited discussions that day with the Pissarros, with Guillaumin. Vincent did not forget the gap left by Gauguin but he now believed once more that it might be filled by Gauguin. Would not Gauguin gather round him a band of painters allied in spirit to Seurat if he showed the way—might not Gauguin agree to lead an established fact even though he had laughed at the idea?

The day after his visit to Seurat's studio he left Paris abruptly for the south; he left after a final gesture of remorse to Theo; he and Bernard spent his last day tidying the flat they had wrecked so often. They hung Vincent's pictures in the best light "so that he will think me here still".

Vincent's gesture was rightly judged; Theo liked to have the pictures about him. Theo grieved that Vincent had gone; in saving his life Vincent had also taken it away: "It seems strange to be without him. He meant so much to me."

ARLES

1888

H E intended to go to Marseilles and the Monticelli inherit-
ance, but he never reached Marseilles. He paused at Arles
—possibly to see the beautiful women praised in the *Max
Havelaar* of Multatuli which he had read—and went no further:
"The people are very handsome here and life seems rather more
agreeable than in any other place I know. . . . Nature is more
colourful here than in the north. The people are picturesque, and
a beggar who looks like a miserable ghost at home is an amusing
grotesque here."

When he reached Arles in the third week of February there
was two feet of snow on the ground—the Midi was having an
exceptionally hard winter—but the snow could not disguise the
vast blue sky, the radiant air. He had seen nothing like them in
his life; the snow had a charm unsuspected under the leaden skies
of the north. Even the solitude seemed a relief for the moment;
he had left Paris, he confessed to Theo, "very miserable, practic-
ally an invalid, practically a drunkard", but he began to feel
better at once. Indeed he was intoxicated in quite another
manner. He could scarcely wait to disentangle canvas and colours
from the motley baggage that comprised his all. Immediately he
began to paint; he painted *Arles sous la neige*, the work of a man
dazzled and uncertain. Eighteen months earlier, in the course of
his first few hectic weeks in Paris, he had responded immediately
and with courage to the brighter light and clearer atmosphere
and to the example of the Impressionists, and had changed his
dark Dutch palette for a light one. Now, looking about him with
wonder, this drastic change, one of the most fundamental pos-
sible for a painter, at once appeared inadequate. For years he had
talked of painting in the south but the south revealed itself as
incomparably beyond the wildest flights of his imagination. The
brilliant light dazzled and hurt the eyes; reflected by the snow it
had a strength and clarity that made his heart leap with excite-
ment and joy. What a challenge to a painter—and what an
opportunity!

He put up at the Restaurant Carrel near the station, stared and stared again. He showed no interest in the Roman remains for which Arles was famed; when, a week or two later, a great bright sun drew off the snow and the mistral began to blow the horizon to unsuspected distances, it was to the country about the town that he turned: to the Camargue, the wide grassy plain between Arles and the sea, sprinkled with the feathery tamarisk with its pink and white flowers and over which white bulls browsed, and half-wild ponies; and to the Crau between the town and the hills, chequered by the *campagnes* of the peasants with their small, red-roofed houses, olive groves, vineyards and tubular haystacks —a Cézanne picture, as he commented.

Then the blossom rushed out and in a moment the countryside was a mass of white and pink: "I feel as if I'm in Japan," he told Theo excitedly; and to Russell: "I remain enraptured with the scenery here." It was certainly "as beautiful as Japan," he assured Bernard, "with its limpid atmosphere and effects of gay colour. The water makes splashes of beautiful emerald and rich blue in the landscape just as we saw it in the crêpes. The pale orange rays of the sun make the earth look blue. . . . The women wear pretty clothes and on Sunday one always sees on the street very unaffected and felicitous arrangements of colour."

He paused for a palpitating moment to paint a drawbridge outside the town—a Dutch subject treated in the Japanese manner—then abandoned everything to paint the blossoming trees. The mistral was still blowing, but at first it seemed no more than an added excitement and a challenge: was a wind to stop him, even though he had never felt or heard such a wind? It threw down his easel, wrenched his canvases away, smeared his paint with fine dust blown from distant regions; he pegged down the easel, lashed his canvas to it, painted over the dust again and again. It shook the canvas so that it trembled incessantly; he held it tight when he could spare a hand and painted as best he could. When even a hand could not hold the canvas against the blast, "I paint with the canvas flat on the ground while I kneel before it." He would not be beaten; he would get the blossom painted—and not just once; Seurat had preached the need for a series; he would follow Seurat: "I am working at a series of blossoming orchards" he informed Russell "and involuntarily I thought often of you because you did the same in Sicily." Hung

round the four walls of a room his canvases would give the illusion, the spirit of a Provençal orchard—an orchard "of remarkable gaiety". It was a pleasure but it was also a duty: he never rested from morning until night; buffeted, blown, hungry, thirsty, he painted, painted, "in a perfect fever" to get this evanescent glory of delicate colour and scent on to canvas. The strain soon began to tell—"My work takes me all day now and I think that it will last. I can't say that it makes me miserable but I imagine that real happiness is quite another thing"—but he worked on.

His light, would-be Impressionist palette had soon revealed itself as unequal to his surroundings, anaemic and virtually colourless. He began to abandon it. One of his early paintings *Printemps premier mai* shows that Vincent had accepted as drastically and decidedly as in Paris the necessity for this second great change in colour and so in style; here already the painter of Arles is visible in embryo and the hint of the real Vincent, tentative and irregular in Paris, began to take visible form; he was discovering his individual vision and the manner in which to express it.

"Nature in the south", he explained to Wil, "can't be painted with the colours of Mauve, for instance, who belongs to the north and is great in his grey colours. Down here the colour scheme at the moment is rich with azure, orange, pink, vermilion, glaring yellow, glaring green, wine-red, violet. But tranquillity and harmony arise out of the use of all these colours just as in the music of Wagner, which, though played with a full orchestra, nevertheless conveys an expression of great intimacy." But the tranquillity and harmony escaped him on his canvases—the effort was too severe for a sick man; as was shown by his reception of news which arrived soon after he had sent off this letter and was in the midst of his battle against time and the mistral. He heard that Mauve was dead. He tried to accept the news philosophically: "I can't think that people like Mauve cease to exist after death. Of course I know that the white worms which later grow into maybugs can't possibly have any sound idea about their future existence—it would be premature for them to investigate the matter, for the gardener who saw them would probably kill them at once. For the same reason I can't believe that our human ideas about our future life can be right—we are as ignorant about our metamorphoses as the white worms are

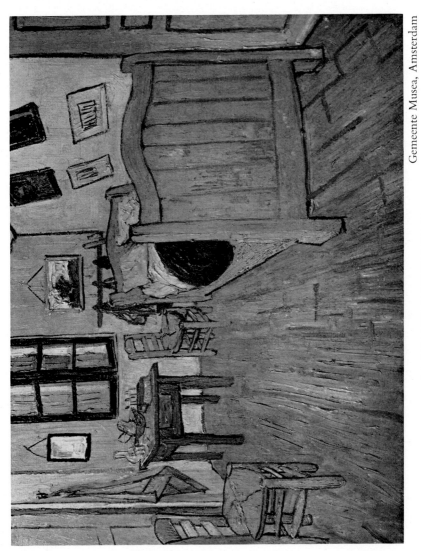

LA CHAMBRE DE VINCENT, 1888–9

Gemeente Musea, Amsterdam

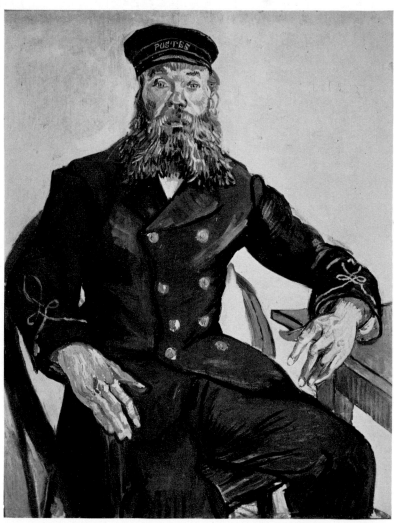

LE FACTEUR ROULIN, 1888

about theirs. A white worm must eat salad roots to attain its transformation and I think that a painter must paint. Perhaps there will be something else after that."

But he was a man of feeling before he was a philosopher. The news was "a terrible shock". He was painting rose-coloured peach trees at the time and he at once scrawled at the foot of the canvas "Souvenir of Mauve from Vincent and Theo." He attacked the work "with a kind of passion": let it be sent to Jet, the widow, he begged Theo. Perhaps Mauve came between him and the finished canvas; perhaps the passion came too late, or, as is more likely, ran riot through excitement and grief; whatever the cause, the peach trees are less successful than another and less regarded painting of this period—his *Poirier en Fleurs*. But all his blossom pictures pleased Theo, pleased him enormously. "I want to express myself," Vincent had written; and that at last was what he was doing: "What an opportunity! Nature here is so *extraordinarily* beautiful. It's the chance of a lifetime. I feel a different man from the one who came here—I let myself go, paint what I see and how I feel and hang the rules!" He took his opportunity; the blossom studies were expressions of an individual painter, dainty but strong and with daring colour combinations—no one but a Dutchman translated abruptly to the south by way of Paris could have painted them.

By the time the blossom had blown he was exhausted and had to stop work. He wanted to save himself for the next attacks on the seasons of the south—the cornfields, the harvest, the vineyards—but the break was forced on him; he was short of money as usual, spending all that he could afford and more on colours and canvases, he had worked for hours, day after day without food, the long struggle against the mistral had been more wearing than he suspected, he felt sick and wretched. The moment he stopped work another kind of sickness preyed on him—his loneliness. He knew no one, spoke to no one, not even to the peasants as in the Netherlands. His only recreation was to take up his stand in the Roman amphitheatre to watch the bullfights. That at least had been his intention but "though there are many bulls no one fights them"; he spent most of the time watching the people—"the one magnificent thing, the many-coloured crowd in tiers"—and by mixing with them to get an illusion of company.

The effort recoiled on him as it recoils on so many lonely men,

merely emphasising his solitude. He told a Dutch acquaintance, "Sometimes a bull runs away and hurts dozens of spectators". But the spectators were fathers, husbands, they had friends, they talked and shouted and applauded because they were together and were happy. He only seemed to be alone, silent perforce, outcast. . . . As so often, he made bad worse; he quarrelled with the *patron* of the Restaurant Carrel; he was being charged extra because his canvases took up so much space and he persuaded himself that the food—instead of, as was the truth, the lack of it was making him ill.

He execrated café life: "How I should love to have a home and settle down in it! And it's the only way to work well—to have a home at your back—a place where you can stay for the rest of your life." He could not rest until he had found a home—then, he assured himself, he would feel well and his nerves would stop their eternal jangle. He walked about the town and at the beginning of May he found on the corner of the Place Lamartine a little two-storeyed house of four rooms to be let for fifteen francs a month. It was just outside the walls, faced the gardens of the square and was close to a good café—"a yellow house with a green door, white walls inside and red tiles on the floor." The colours decided him: his pictures would stand out superbly against the white walls, his ground-floor studio was splendidly lit and above all he accepted the yellow exterior as a sign; yellow was the colour of the Midi dominated by the sun, yellow was more and more becoming his colour, it fascinated him and played an increasing part on his palette to express his excitement; and yellow was the obvious, the essential colour for an Impressionist headquarters in the south—for this was the thought that came to him as soon as he caught sight of the little yellow house. There he would make a guest-room for visiting artists; they would be entranced as he was by the sun, the air, the colours, they would stop to paint and the group of painters of which he had dreamed so often would after all come to pass.

He rented the house but could not live in it; he had no money to buy a bed—he managed to buy a table, two chairs and some crockery for soup and coffee, then his money ran out. He tried to buy a bed by monthly instalments but no one would oblige him; his appearance (for he had once more begun to neglect his clothes, rarely taking them off) and his manner, abrupt and

nervy, were already beginning to give him a bad name in the town. He used the studio by day when the weather was overcast, slept out and ate at the café round the corner when he could afford a meal. He set all his canvases against the white wall—they looked well, very well; he put his two chairs and table in the studio—there was his home. Life returned to him: he would christen the house with a painting. He covered his table with a blue cloth, put on the cloth his blue earthenware coffee-pot, his royal-blue cup with a gold rim, his cup with a blue and orange design against a white ground, his milk jug in pale cobalt and white squares, his blue majolica jug decorated with pink flowers and green-brown leaves, and his grey-yellow earthenware plate, added oranges and lemons and began to paint.

His good spirits were reflected in the work, one of the most satisfactory still-lives he was ever to make. "Six different blues, four or five different yellows and oranges!" he cries. "This canvas simply kills all the others!" But it is not only the colours which make this painting; the composition pleases, the clean lines, the delicacy of the treatment and the solidity of everything on the table. Vincent had the gift of bestowing an individual character on inanimate objects, so much oftener his companions than animate ones; these were his friends—his coffee-pot, his cups, his jugs—and this perhaps explains the particular charm of *Tasse et Cafetière.*

Now that he had found a home even though he could not live in it, the town and its people—"the Zouaves, the brothels, the fascinating little Arlésiennes at their first communion, the priest looking like a dangerous rhinoceros, the absinthe drinkers"—suddenly seemed close and desirable. He wanted to paint them, tried to paint them and at once ran into difficulties; the people looked with unfriendly curiosity on his attempts to paint in the streets; he had persistent trouble in persuading anyone to pose for him—he was not only an impecunious painter but an alarming one, the light in his eyes wild, his speech strange.

But he liked the place, he was tremendously proud of his little house, he spoke of staying indefinitely in the south. He usually passed the entire day in silence, but three visiting painters made themselves known to him—an American, a Dane and a Belgian. None painted well, but their rare visits broke the monotony. The face of the Belgian attracted Vincent; it seemed to him to sym-

bolise the poet; he hoped one day to paint his portrait. There was company of a kind in the brothels, but his desire for it had practically died; he went there often enough, but mainly to talk, having found a girl who took pity on him and would listen. He described the brothel to Bernard, who was taking a lively interest in this subject: "a large room distempered in blue—like a village school. A good fifty red soldiers and black bourgeois, their faces a magnificent yellow or orange, the women in celestial blue, in vermilion . . . a good deal less lugubrious than the same kind of thing in Paris. No spleen in the air here."

Bernard, anxious to play his part from a distance, sent sonnets on the prostitute, on one of which, ending with the line

Those who she had taken away slept with her that night, very late

Vincent pounced with an admonitory "This isn't characteristic, for the women of our boulevard—the petit—are used to sleeping alone at night because they work in five or six bouts during the day or evening and it is that honourable eater of flesh, their pimp, who goes to find them very late and takes them home, but he doesn't sleep with them—or rarely. The woman is so dog tired and done up that she usually sleeps alone and like a log." But when Bernard followed the sonnets with a sketch of himself in uniform (he was due to do his military service) carrying all before him in a brothel, Vincent was filled with admiration and more: "I almost envy you your bad luck that you have to go in in uniform, the good little women dote on it so." And when Bernard asked why don't you sketch there too? he replied sadly, "You know, Bernard, it still seems to me also that if I could make sketches in the brothel I should earn some money, but I'm not young and not good enough meat for the women to get them to pose for me on tick."

For this beyond all, even beyond his longing to talk to a human being, was his primary purpose in haunting the brothels to such an extent that he soon became notorious as a degenerate. No girl, not even the one who pitied him, would sit to him, but at last he found a model among the zouave customers—a lad "with the neck of a bull and the eye of a tiger"; he painted him so, sprawled out in true zouave fashion—"a savage combination of incongruous tones".

But he wanted desperately to live in his yellow house—the first home of his own since the garret he had shared with Sien. A

bed was out of the question; he would go short of food for it, but not short of paints. But a mattress on the floor—why not? He wrote at once to Theo—could he afford extra money for a mattress?

Theo was discouraging; he had bad news; ever since Vincent's departure he had been feeling less and less well. Bonger had persuaded him to go to the doctor; a weak heart was diagnosed following years of serious overstrain; there was some talk of a year away from work or perhaps a trip, part-business, part-pleasure, to America.

Vincent was immediately penitent; this was his doing; let Theo come south and rest while he went to the gallery and earned the money. What was painting to Theo's health? Or would Theo like him to go to America also? He did not forget the family weakness—both he and Theo were neurotic, perhaps he had a weak heart too and that was why he often felt so strange and ill? In any case, let Theo remember that he was not wearing himself out as a mere businessman, he was as much the painter of Vincent's pictures as Vincent himself, and his weak heart could be called "an honourable battle-scar in the greatest war of all."

Theo smiled at the typical suggestions. Vincent at the gallery! But to offer to give up painting, even though he had recently begun to complain that it was a substitute for real life and that he painted to escape from life, even though in fact he never could have given it up—no matter, merely to put such an idea into writing was the greatest sacrifice he could make. There was no cause for worry, Theo replied; he would be all right; he must take life easy, that was all, and have freedom from unessential money worries. He was glad to help Vincent to paint and was repaid by the paintings; but to set him up in a home—he wasn't enthusiastic; the mattress remained unbought. But Theo, for all his mildly stern words, remembered: he still could not sell Vincent's paintings; those sent from Arles were praised by painters dropping into the entresol but the public fought shy of them; but the public, Theo now thought, was wrong and not his judgment. Vincent now that he was finding himself as a painter worried less about the lack of sales; at times he became reconciled to a fate which was not his alone: "People," he told his sister "only buy the paintings of painters who are dead. They don't take any interest in the work of the living artists. I'm afraid

that we can't change this. The only thing one can do is to find a patron or to marry a rich woman or something of the kind or else one can't go on working." Never again was he to complain of being Theo's "protégé".

At the brothel Vincent had found another model and a companion—Second-Lieutenant Milliet, a handsome young man, his face bristling with the imperial still in favour. With Milliet he walked out to Montmajour, that rocky island in the plain. They explored the ruins and sat munching figs from the trees in the old garden and looking across the flat expanse of green. Vincent had made sketches for a painting—his afterwards famous study of the Crau with a train crawling across it in the distance ("the most Japanese thing I have made")—and one of the visiting painters had come up, looked over his shoulder and remarked "That will be difficult to do." This implication that the Crau lacked sufficient contrast to allow for a successful composition infuriated Vincent, whose connexion with other painters was to be short: "I said nothing, for I found it so flabbergasting that I hadn't the strength to argue with the idiot. I went there again and again and again. Fine! I made two drawings of it—of this flat landscape in which he could find nothing but ... infinity ... eternity. Fine! Then while I'm drawing along comes a chap who is no painter but a soldier." This was Milliet, and Vincent, motioning to the sketch and the vista before him, asked "Does it shock you that I find this as beautiful as the sea?" No, said Milliet; he preferred it to the sea, it was as infinite and it was alive as the sea was not. "Which of these two spectators," asked Vincent of Bernard triumphantly, "is the more artistic? I prefer the eye of the soldier."

This conversation sent Vincent to the sea to make sure. After a visit to Tarascon, spoiled by blinding sun and clouds of dust thrown up by the mistral (he made a study of himself, loaded with his materials, trudging along the hot road—"I no longer wear a beard, my hair is cut very short, the colours of my face are no longer green-pink-grey but orange-grey though my eyes are still green, I wear a white suit, have a yellow straw hat and smoke a little black pipe"), he went down to Saintes-Maries, taking the diligence across the Camargue. The Mediterranean convinced him that he had done rightly to come south, lonely though he was, often hungry and unwell, and unable to make his

home his own. "The transparency of the air struck me at once," he wrote to Wil, "and made painting here extremely attractive to me. You *cannot* understand what it is like here, for we don't see such skies in the Netherlands. Here one can distinguish the colour of things an hour's walk away—the grey of the olives, the green of a field, the pink-lilac of ploughed land. In the Netherlands we see only a vague grey horizon; here you can distinguish lines and forms far, far away. It gives one a new idea about air and space." He was beginning to see with the eye of the Japanese, to feel colour as they did, simply, like a child. He had been right to pile on the colour and to exaggerate it, and he must draw as they drew "like a flash of lightning", responding to fine-drawn nerves. A suitable subject stared him in the face. On the sandy shore were drawn up half a dozen boats; they curved delightfully at stern and prow; they were brightly coloured—red, green and blue; they reminded him of flowers. He drew them in an hour and he painted them at rest and afloat—gay, clean paintings that convey with childlike charm the sparkling sea, the brightly coloured boats and the fascinating criss-cross of mast and sail.

He walked at night by the sea. Even at night the sky was blue, a deep, eternal blue and the stars shone and flashed against this infinite background. He was ravished: this marvellous sky must be painted; who had ever done justice to the stars? But he had brought only three canvases with him. He rushed back to Arles, then paused irresolute. Summer was coming on with a great leap that took his breath away; the harvest must be painted as well as the night skies, but so too must more portraits. Portraits, he told Theo, brought out all that was best in him; to paint men and women moved him deeply and seemed to bring him in touch with eternity; he yearned to express the immortal soul of his sitter, not with a symbolic halo but by the radiant vibrations of colour. Two lovers, for instance—couldn't their love be shown by the use of complementary colours, mingling, opposing, vibrating with passion? A thoughtful man—could not his thoughtfulness be implied by the radiance of a light tone against a sombre background? The eternal hope of man—could not this be symbolised by a star above his head; the eager searching soul by a face outlined against the glow of sunset? "I want to paint humanity, humanity and again humanity," he cried to Bernard.

His impulses were dragged this way, that way; the moon,

stars, sun, flowers, harvest, men, women and children all tempted irresistibly. He painted first this, then that; nothing could be sacrificed, all must be put on canvas, and quickly: time was short, the season would change, his reason fail—for this thought came often. He surrendered to every call of colour, every glance of his eye; he painted here, there, everywhere with alarming energy. He could fix his mind on little but colour. "For ever so long," he tells Russell, "I have been wanting to write to you—but then the work has so taken me up. We have harvest time here at present and I am always in the fields. And when I sit down to write I am so abstracted by recollections of what I have seen that I leave the letter. For instance, at the present occasion I was writing to you and going to say something about Arles as it is—and as it was in the old days of Boccaccio. Well, instead of continuing the letter I began to draw on the very paper the head of the dirty little girl I saw this afternoon whilst I was painting a view of the river with a greenish yellow sky. This dirty 'mudlark' I thought yet had a vague Florentine sort of figure like the heads in the Monticelli pictures, and reasoning and drawing thiswise I worked on the letter I was writing to you. I enclose the slip of scribbling, that you may judge of my abstractions and forgive my not writing before as such. Do not, however, imagine that I am painting old Florentine scenery—no, I may dream of such, but I spend my time in painting and drawing landscapes or rather studies of colour." And soon he is writing "I must hurry off this letter for I feel some more abstractions coming on and if I did not quickly fill up my paper I would again set to drawing and you would not have your letter."

When he was writing to his sister this concentration on colour took another form, reminding him of Seurat: "If people reckoned with the laws of colour they would have better colours in their homes, better decorations and everything would be prettier." He had thought about colours for years, he assured her, but Paris and the south had stimulated his colour sense enormously. "It would take too long to explain the whole theory of colours to you," but he gives her an example or two: "Cornflowers with white chrysanthemums and some orange flowers—this makes a motif in blue and orange. Heliotrope and yellow roses—a motif in lilac and yellow. Cock-roses or red geraniums in glaring green leaves—a motif in red and green. These motifs can be divided

into others, but you can see from the combinations I have
mentioned that there are pairs of colours which complete each
other like men and women."

When he turned away from the overwhelming excitement of
nature for a moment to paint the coffee-service, the first of his
Arles sunflower studies, the boats at Saintes-Maries and the
Trinquetaille bridge, his advance as a painter can be seen clearly.
"The colours here are very exceptional," he wrote; and his re-
action to them before they had carried him away completely can
best be seen in the joyful still-lives, the sunflowers glowing with
colour applied firmly and with courage. The boats on the danc-
ing sea are brushed in with a sure quick hand following an eye
for bright colour and pleasing design. The Trinquetaille bridge,
a greater painting, shows a new mastery of composition, and his
colours are bold and successful: he painted sky and river the
colour of absinthe, the quays lilac, the figures black, the iron
bridge an intense blue, and into the blue background he worked
vivid orange and malachite green. But when he forced a moral
on his painting the result was always unfortunate. Not content
with his array of subjects on every hand, he painted versions of
Millet's *Sower* again and again, imposing on them a mystic
symbolism which ruins them as paintings; they are an unhappy
blend of emotionalism (which came naturally) and intellectual-
ism (which did not); the figure of the sower still shows Vincent at
his weakest as a painter; it shows too the morbidity from which
the south had so nearly rescued him.

He painted more portraits. At first they were outward im-
pressions, dashed off quickly: to the zouave boy and Milliet he
added his mousmé, a small girl, and the postman. He painted
this man at a sitting. His name was Roulin: he looked like
Socrates, Vincent thought, with a great spade beard depending
from his pleasantly ugly face, and, like Socrates and Père Tanguy,
he was a revolutionary—"No doubt he is rated a good republican
because he takes no pains to hide his dislike of the republic and
even questions the entire republican theory"—but like them too
he was, under his gruffness and tub-thumping manner, a good
man and kind. He was shrewd in his simple way; he discerned in
the mad painter, as the townsfolk were beginning to call him, a
man frantic for company. There was not much that he could do
but he did it; he stayed to chat in the morning when he brought

Vincent letters from Theo, Bernard or Wil; he offered his family as models; he sat with him occasionally at the café of his friend Joseph Ginoux, the Café de la Gare, listening with amiable and, usually, rather fuddled incomprehension to Vincent talking passionately about his work—all there was to do, the impossibility, the necessity of doing it. He also advised him about the house, helped him to get it cleaned, and joined him for a walk when he was free and Vincent was to be found.

But he was not often free and Vincent was not often to be found. Roulin, the only friend he was ever to know, had come into his life too late, as the south, as everything had come too late. The strain was becoming too great to be borne: portraits, stars, moon, sun, harvest painted at such a rate, with such intensity and in an unrelenting heat the like of which he had never known nor even faintly imagined—it was too much. He cut down the number of his letters to Wil, who had taken his advice and was reading "that scoundrel Voltaire" while Vincent warned her that when in *Candide* "Voltaire dared to laugh at the serious life which we ought to use for noble purposes, I don't need to tell you that this is a dreadful crime". She was, however, no better for her "humorous" reading than he had been in Paris, and her letters became so depressing that he asked her to write less: "Letters from either of us won't cheer the other up when we feel melancholy as nervous people like you and me so often do." Roulin had told him that *"le meilleur traitement pour toutes les maladies c'est de les traiter avec le plus profond mépris,"* but neither he nor his sister was able to take the advice; she put her faith in a medicinal herb, he in drinking "lots of bad coffee when I am in such a mood—not because this will improve my already bad teeth but because my strong imagination builds in me a firm belief—worthy of an idolator, a Christian or an anthropophagist —in the cheering influence of this liquid."

But he did not confine himself to coffee; when he had the money or could get the credit he began to drink cognac and absinthe again to keep himself going: "When one overstrains the brain as Delacroix did, and Monticelli, as Wagner, and now as I am doing, the only remedy is to drink hard and smoke heavily and bemuse oneself. If the tempest in my brain gets too violent I take a glass too much."

Yet that was not the only reason for his drinking. To keep

going—that alone was useless, not worth living for. What he lived by were his moments of exaltation: "When I can't have the company of other people I have to get all my satisfaction from these—and when I'm in that mood I run to extravagance."

The extravagance began to show itself in his work—in his next portraits, for instance. He painted a peasant, a "dreadful" portrait, he intended to make it, of a man exposed to "the furnace of the full harvest time". To do this, transposing to the peasant his own reactions to high summer, he set the simple unworried face incongruously against "stormy shades of orange vivid as red-hot iron". He said to Bernard, perhaps too hopefully, "I dare to believe that you and Gauguin would understand it."

The portrait of the Belgian painter Boch, done at last, was even stranger. Boch was a young man with a distinctive face "like a razor blade with green eyes". Vincent chose to see in him the ideal poet; he had met him only two or three times but he believed him to be "a man who dreams great dreams, who works as the nightingale sings, because he must". "I want," said Vincent, "to put into this portrait the love I feel for him." He painted the head against "the richest, most intense blue I can manage" dotted with stars "to suggest infinity". But the head made a caricature of his intentions; he exaggerated the razor-blade effect of the face, he turned the fair hair into a blend of orange, chrome and lemon yellow, and his passion for the sun colours drove him to throw them into the face and eyes in such a way that his ideal poet is made shifty and as though reflected in the very flames of hell itself. The background of stars is cheap.

A few days later he painted a true version of hell, his *Café de Nuit*. He spent three nights painting without stopping in this café round the corner from his house, where down-and-outs could get a few hours' rest on the tables. The atmosphere was too much for Vincent; he painted a place "where one could ruin oneself, go mad, kill". He felt it to be a home of evil passions. The room he made "blood red and dark yellow", the four lamps he painted lemon yellow with a surrounding aura of green and orange, the sleeping tramps he painted "incongruous reds and greens, with violet and blue", the *patron's* white coat became a blend of lemon yellow and pale green. He gave the whole "an atmosphere of pale sulphur like the devil's furnace".

Furnace: the thought ran in his mind; his mind was a furnace,

like the days; his mind, like the land under the furnace, was astonishingly productive; never had he worked so fast—faster than ever, yet never fast enough. It was full summer and serenity disappeared from his landscapes. The rapidity and luxuriance of growth in the south staggered him—great thick sheaves of corn shooting up almost overnight, clusters of grapes hanging heavily on the vines, orchard trees bowed down with ripe fruit, orange groves heavy with yellow, the orange kaki swelling in every garden. He was seized again, as in spring, with an irrepressible urge to paint this riot of life thrusting out on every side. But this second excitement followed too closely on the first to be bearable; he had no longer the shadows and delicate shades; all was intolerably bright, bursting with colour under a breathless sky. He painted from morning to night. The peasants rested in the afternoon when the sun was hottest, but not he—he painted, painted, painted, sweating, parched, his eyes aching his head dizzy. His paintings grew wilder and wilder as the summer moved into hot dry autumn. He was no longer painting what he saw before him; the landscapes, the night skies, the harvests of corn, fruit and vine had become an excuse for him to express his passion for colour. By day the sun was a great staring yellow ball, the stars by night were enormous and glittered across the sky. He painted them so; they dominate picture after picture—the sun, the corn and the ranks of vine by day; the moon, stars and cypresses by night. He painted the sun full in the face, huge, hot. He fastened candles to the brim of his hat and painted by night, painted the solid silver disc of the moon and the stars shimmering into shining silver arrows. He could not rest; he was absorbed by the "high yellow note" of day and the silver and black of night. He felt "a terrible lucidity so that I lose myself and paint as in a dream".

He quoted with approval the elder Pissarro's dictum that the painter must exaggerate the effects of harmony or discord produced by colours; he too was deliberately exaggerating the essential and leaving the obvious vague. But he could have spared the explanation; he did not think of Pissarro or of anyone else when he was under the Midi sun with a subject blazing before him; he did not think at all; his pictures were sensuous orgies depicting with an almost fearful realism an awareness of the power of life, life that moves the stars and bends the trees and pulls the corn up from its seed and pushes the feet of a man along

a road. As the creative power left his sexual organs it moved into his hands; the less he was able to reproduce his kind the greater became his awareness of reproductiveness wherever his eye fell and the greater his frenzy to put it on to canvas.

In his room at night he would explain to Theo at length what he would do next—how he would carry on the work of Monticelli, bring the work of the Impressionists to a finality, use the Delacroix colours and technique. He explained endlessly. He wrote so because he felt that he had a mission and because he was conscious of his debt to Theo: that mission must be fulfilled, that debt repaid. He wrote as he felt, as he had been writing for years, but the gap between what he proposed to do and what he actually did was prodigious. For years he had been telling Theo of his heroes—Millet, Mauve, Israëls, Rembrandt, Delacroix, the Impressionists, the men who were developing Impressionism. They had shown him the way to go, but whenever he tried consciously to go their way he failed. Now he wrote in the same strain but the conscious effort at work had disappeared. Influences could be traced, of course—no painter has been without them—but they had been merged in his own individuality as painter. He was himself at last; the sun, the sky, the air of the Midi had liberated him from the last of his masters even though he still spoke of them as such when he had moved beyond them. "Surely," he said to Russell, "Monticelli gives us not, neither pretends to give us, local colour or even local truth. But gives us something passionate and eternal—the rich colour and rich sun of the glorious south in a true colourist way parallel with Delacroix' conception of the south, viz. that the south be represented now by *contraste simultané* of colours and their derivations and harmonies and not by forms or lines in themselves as the ancient artists did formerly."

At times, unable to restrain himself, he would sit down to write, hot, dusty, his eyes burning, while under the spell of the scene he had just left. Then—and only then—was the painter as he painted reflected in words. The value and the uniqueness of his work lies in this emotional approach; never had a man reckoned as sane portrayed the pulse beats of life by such colour and movement; in his reactions to nature he is of no place or time; in his renderings of those reactions he was a phenomenon, a Dutchman in the south painting with tremendous solidity. He

obeyed the Impressionist laws to obtain a luminous canvas, he used a palette never seen in the north, but his brushstrokes were of the north—strong, powerful, brutal. He gave this driving force to the most delicate of objects. His pear tree is slender—not much more than a sapling—but it shoots from and into the ground with an overwhelming sensation of growth. Life, inescapable, unstoppable floods up that slender stem, bursts into blossom, plumps out the fruit, but also moves downward into the spreading roots clasping the ground with tenacious grip, at once holding the little tree and feeding it with moisture sucked from hidden depths. This double sense of growth—the growth seen and the growth unseen—is the particular triumph of this picture and the general triumph of Vincent as mature painter. Slender his pear tree may be, but it is, like an iceberg, only the outward manifestation of a vast, hidden power—the power of life itself.

But how could any man sustain such pressure of feeling? He was out at five in the morning, he was painting until nine in the evening. Heavy drinking, heavy smoking, cup after cup of black coffee kept an illusion of vitality in him, but the vitality was in his mind alone and there precariously. For years he had demanded from his body more than any body could bear, he had forced on it privation after privation. He was virtually impotent, he told Theo: a wife and children were not for him, even the brothel couldn't offer much relief. All the more reason, then, to reproduce himself in the only way he could. He was under no illusion: it was the lesser way, he insisted, it was not life but a shadow of life, but it was the only thing he could do.

At first, for a month or two, he had been exultant, even light-hearted, writing of Arles "surrounded by immense fields covered by the blossoms of innumerable buttercups—a sea of yellow . . . with a belt of violet iris and in the background the coquettish little town with its pretty women!" His work in such surroundings appeared all joy: "I work at noon in the cornfields under the full sun without shade and I'm as cheerful as a cricket." Then he begins to excuse himself for his incomprehensible letters: "My eyes are tired even when my brain isn't. . . . I write hurriedly, very exhausted and at a moment when I'm not capable of working any more, the morning in the fields having completely fagged me out." Then it becomes, "The fact is, I'm so knocked up by my work that when I sit down quietly in the evening to write I'm

like a run down machine, the day in the open air tires me in every limb." And this led to excuses of another kind—for his work. His landscapes, he said, "were made quickly, quickly, quickly and hurried like the reaper who works under the hot sun." And "I'm entirely incapable of judging my work, I can't see whether my studies are good or bad."

For it was not only his body that showed the strain. He had lived for years in a state of violent excitement. He felt inspired, while he painted—delirious with passion—but away from his work he felt weak and sick, and his mind began to lose its grasp of reality. He began to talk more and more of insanity; he had, he said, "a body that's good for nothing and a mind near enough crazy to make no matter".

There was madness in nature too: "The row of bushes in the background are oleanders raving mad—the damned things are flowering so violently that they'll get locomotor ataxia if they don't look out." And there was madness in the mistral: "Shall I ever paint peaceful pictures, carefully worked out?" he asks. "I think the mistral must have something to do with the haggard look of my canvases." And not only the canvases; he looked haggard too, and more than haggard. As he stared at himself in the mirror, contemplating another self-portrait, he was reminded of the *Hugo van der Goes* by the mad painter Emil Wauters. When he caught that look on his face reflecting the chaos in his mind he sees ahead and warns Theo, "There's no blinking the fact that things may come to a crisis one day."

"That devil mistral!" he called it. To a brain on fire it was the last unbearable torment; it blew and blew with unearthly ferocity—fearful culmination of that force of life he was painting. It blew, it shrieked day after day. No escape! As it drove the flames of the forest fires ever higher on the hills, so it fanned the fires in his head; there was no escape from it; indoors, outdoors alike it howled with its high and ominous shriek. Outside he was blown, buffeted, breathless; inside he lay on the bed with his face vainly pressed to the mattress—the mistral tore at the tiles, beat on the panes, shook the very house so that it quaked and trembled. Depression, forebodings, the voice of doom itself sounded in that wind. His nerves rose to a frightful pitch of excitement and dread, the blood pounded in his veins. Was he sane? Was he mad? He no longer knew.

LA PETITE MAISON JAUNE

1888

ARLY in the summer Gauguin had begun to fly distress signals from Brittany. His liver—a legacy from the fever in Martinique—was worrying him, the weather was dreadful, he could not paint outside the auberge, he had no money, he was smothered by unpaid bills, he was being dunned. "My God!" he cried. "How terrible these money questions are for an artist!" Towards the end of May he appealed to Theo for help. Theo sent him fifty francs and told Vincent. To Vincent, desperate for companionship, the news appeared as a godsend; he leapt at the chance to help Gauguin, to put an end to his own loneliness and to found the studio of the south with the man he would prefer above all others.

He replied at once: "I thought of Gauguin, and look here, if Gauguin wants to come here there is his journey and there are two beds or mattresses which we absolutely must buy. But afterwards, as Gauguin is a sailor, it's probable that we can eat at home. Two of us could live on the money that I spend alone. You know it's always seemed idiotic to me that painters should live alone, one always loses when one is isolated. Anyway, it's in reply to your wish to get him away from there. You can't send him enough to live on in Brittany and me enough to live on in Provence, but you may think it a good idea if we share and fix a sum of, say, 250 francs a month if each month, over and above my work, you have a Gauguin. Isn't it true that provided this sum isn't exceeded it would even be an advantage?"

As his fashion was when excited, he followed his letter with another long before Theo could reply; his feelings insisted on expressing themselves; an audience he must have; he could not talk, therefore he must write. The essence of his second letter was, as so often, haste; he could not wait: "If Gauguin accepts and if there's no greater difficulty to be got over than his removal, it would be better not to leave the matter hanging on." He scribbled a postscript: "I believe in the victory of Gauguin and

other artists, but between then and today may be a long time . . .
it's bad that he doesn't work, but at last we can do something
about it."

He had said already that he would write immediately to
Gauguin, "but *without a word* of all this, simply to talk of our
work." However, when he took pen in hand his eagerness would
not stop short at his work, would not even begin with it—he out-
lined his whole plan right away, confident now as he was not in
his tentative advances in Paris. He had thought of Gauguin often
and warmly, he said, but did not want to write until he had
something to say. And now he had something to say; he had
rented a house "and it seems to me that if I find another painter
who wants to take advantage of the Midi and who, like me,
would be sufficiently absorbed by his work to resign himself to
living like a monk who goes once a fortnight to the brothel and
for the rest would be tied to his job and little inclined to waste
time, it would be a fine chance. I suffer a bit from the isolation
all alone here and have often thought of speaking frankly to you
about it. . . . I was ill when I came here but have recovered and
now find myself decidedly attracted by the Midi where one can
work in the open air almost the whole year round. Life here
seems to me to be dearer but the chances of making pictures are
greater." And for the future, he could see more than one possi-
bility; to rust in Arles was quite unnecessary: "We could immedi-
ately begin to show in Marseilles, opening out a road for the other
Impressionists as well as for ourselves."

He wrote at length; he was wildly excited, and his occasional
attempts at caution (for he had intimations that Gauguin was
not exactly wholehearted) were swept aside by thoughts of the
master with him in the yellow house, painting, talking, a second
self, founding the studio in the south. He plied Theo with letters:
let Gauguin do as he had done in Antwerp, leave his canvases as
security for his debts. What could Theo do to help them to come
together?

Theo, concerned by Vincent's loneliness—"for days I don't
speak to a soul"—fearful of its effect on him, and moved by his
pathetic eagerness to have Gauguin with him, soon gave way:
he would try to do as Vincent suggested, keep them both at
Arles, take their work in exchange, although he could not afford
at the moment to furnish the yellow house. He told Gauguin

who, the weather having improved, had put his troubles behind him and was painting outside and well, his immediate needs satisfied by the fifty francs. He struggled uneasily in the net; like every painter and with better cause than most he complained from time to time, complained bitterly—he had a reputation but could not sell enough to live on, he was always on the edge of starvation, having to cadge, humiliate himself; but although he complained, he had no wish to leave Pont-Aven unless he could scrape together enough money to go back to the tropics; to join Vincent at Arles was about the last resort in his mind—Arles perhaps, but not Vincent; yet he could not afford to antagonise Theo, the one dealer in Paris who believed in him. There was only one thing to do: he accepted the offer gratefully but provisionally; he would come to Arles but could not say precisely when—at that moment he had not the fare and owed a large bill at the Auberge Gloanec. And, having written, he busied himself with plan after plan to raise money so that he might escape the obligation.

Vincent, disregarding the reservations, was overjoyed; he could see them eating together in the yellow house, saving money, feeling healthier, painting better: "It would make an enormous difference to me if Gauguin comes here. Left to oneself for too long in the country one gets stupid. It's not so bad in the summer, when I'm out all day, but I was afraid I'd dry up completely this winter. But if he comes there'll be plenty of talk, plenty of ideas. And if we make up our minds not to quarrel we shall help each other to increase our reputations."

He wrote to Gauguin, he wrote to Bernard: "I become more and more certain that if painting is ever to reach the severe heights of Greek sculpture, German music and French fiction, a group of painters will have to collaborate and carry out a common aim." Gauguin would lead the way in the south; he an admiring follower. "Everything that comes from his brush has something charming, heartrending and remarkable about it. People don't understand his work yet and he suffers cruelly, like other great poet-painters, from an inability to sell it." But that would surely be put right after they had worked together; Gauguin would come into his own. And why not Bernard too? "How glad I should be to have you here with Gauguin this winter. Couldn't we risk the expense of the journey and try to

recover it by our painting? If you want to help in the cause all you have to do is to work alongside Gauguin and me. The affair has now begun." He was premature, as so often, his longings translated into facts; Gauguin remained at Pont-Aven where he had been joined by Bernard and his sister and by Charles Laval, the disciple who had accompanied him to Martinique. Laval had a little money which was automatically put at Gauguin's disposal. Bernard, recommended powerfully by the young, pretty and soulful Madeleine, who reminded Gauguin nostalgically of the daughter at Copenhagen whom he never saw, was received into the little group forming once more about Gauguin as the weather attracted painters to Brittany. Bernard handsomely repaid the gesture: inspired by the windows at Saint-Brieuc, by his study of the Symbolist poets and by Gauguin's work, he painted his *Bretonnes Dans La Prairie*—a canvas that opened Gauguin's eyes fully to the method of expression he had been seeking for so long. That same day Gauguin painted his *Vision Après Le Sermon*. The Post-Impressionist movement and all that has followed it has been traced back to this canvas of Gauguin; but in the summer of 1888 at Pont-Aven the group of rebels that he headed were content to call themselves the Ecole de Pont-Aven, to paint enthusiastically, fish, swim, box, fence, argue together, abuse the philistines and the academic painters, and in general to enjoy life; they talked of the future, indeed believed that Gauguin was the greatest and most original painter of his day and that they were one and all striking lusty blows for freedom from the teaching of the Beaux Arts; but the struggle was the thing—that and the pleasures of corporate life.

To Gauguin, active, adulated by his followers and reviled by the academic painters (the one as exhilarating as the other), conscious that he had at last discovered his true "sensation" and was making pictures of genius, the thought of closeting himself with Vincent at Arles, cloudy though the future remained, was obnoxious, absurd and, although he could not say why, unwise. He kept as silent as Vincent allowed; and when pressed, repeated his hopes of coming but pointed to his debts at Pont-Aven and to the cost of the journey to Arles. Bernard wrote enthusiastically— if Gauguin made the trip he would not be far behind—but sounded distinctly less so about Arles than about Brittany and Gauguin in Brittany; they were painting together, he said, "as

children paint"; for his part he thought Gauguin so great an artist that he was positively terrified: could such a genius exist and live—was he not too far above them all? He could not understand why Vincent did not join them.

Vincent listened with some impatience; anxiety too. Yes, Gauguin was wonderful, he really didn't need young Bernard to tell him so, but why didn't he come? What was he to do about the house? he asked Theo late in July; he had taken it until the end of September; he wanted Gauguin to see it before he decided whether or not to renew the lease, but Gauguin didn't appear, showed not the slightest sign of appearing. Now he hadn't even the rent for the next month—he had spent it on a model—and the landlord was talking about another tenant.

Theo sent him the money for the rent but could do no more. Then relief came from an unexpected quarter. Uncle Vincent had just died at Prinsenhage. When his will was read Vincent, once his heir, was not mentioned but Theo came in for a small legacy. Theo wrote at once to Vincent; he would send him the whole sum as soon as it was paid over. Take the house for as long as you like, he said, furnish it as well as you can. But he warned Vincent, don't depend too much on Gauguin—he may not come after all and he may be a difficult customer if he does come. And he asked, was Vincent sure that he would not be wiser to join Gauguin and Bernard in Brittany?

Vincent's reply struggled comically between gratitude and hauteur. How could he ever repay Theo for his kindness? But why suggest Brittany? "I'm not going to stay at the inn at Pont-Aven with that crowd of English and men from the Ecole des Beaux-Arts and spend every evening arguing with them about nothing. I'm going to dig in my heels on this point. I intend to found a permanent studio, and sleep and eat there and not at an inn."

As for Gauguin, he did not care whether he came to Arles or not. Gauguin wrote, "I am at the height of my powers", and suggested—to Vincent's imagination at least—that he thought himself perhaps on the grand side to bury himself in a backwater with an unknown painter. But Vincent too considered himself at the height of his powers, and if he thought that the yellow house in Arles was good enough in which to found the Impressionist group of the south, he had a right to think so. He also

knew—Theo need not bother to warn him—that Gauguin was not altogether to be trusted: let him enjoy himself "fooling away in the north with his friends, painting, arguing and fighting the English"; let him sponge on his friends, try to make money in Paris, let him go back to his wife and children. He, Vincent, would regard his movements with equanimity; if he chose to join him in Arles, good; if not, also good.

All this to Theo; to Gauguin nothing but pleasantness. A day or two later Theo received a letter bursting with enthusiasm. "I'm now painting with all the élan of a Marseillais eating soup —which won't astonish you when I tell you that I'm painting large sunflowers. And the idea? To decorate the studio now that there's a hope of living in it with Gauguin. I aim at a dozen panels of sunflowers in the room that will be Gauguin's. The whole thing will be a symphony in blue and yellow. I work at it every morning from sunrise for the flowers fade quickly and the ensemble must be done at one go."

Within a few days the total number of canvases needed to decorate the house had risen to thirty. He was exultant: a home at last, and the principles of Seurat actually being carried out in the home. He asked Theo to tell Seurat what he was doing and that all was due to his example. He could see the house blazing with colour to greet Gauguin and all the painters who would follow him; he painted furiously, the sunflowers glowed from canvas after canvas. The more he painted, the less he was able to consider the home without Gauguin; he began to talk and to write of it as a settled fact. When his sister Wil came to Paris to stay with Theo he told her, after advice about the right painters to see—Breton, Daubigny, Corot, Delacroix—and the news that he intended to paint a child in its cradle if he could get the parents' consent, that she must try to come to Arles the following year when he would be living with Gauguin—that was, he added, unless he and Gauguin had by that time gone off to the mountains, for which he was developing a feeling.

Then the legacy arrived, and he hurried round to the Roulin house between the railway bridges and asked for their help— what should he buy and where? Madame Roulin had recently borne her third child, and Vincent, after listening to her advice, admiring the baby in its cradle and perhaps getting permission to paint a study of it, went off to the Café de la Gare with Roulin,

sat down before a drink and thrashed the matter out with the occasional word of help from the *patron* and his wife. The Ginouxes were the only people in Arles, the Roulins excepted, who had a good word to say for Vincent; they were a middle-aged couple, simple and kindly; Madame Ginoux suffered from nerves—which formed a bond between Vincent and herself—and was in consequence always ailing; Ginoux accepted Vincent as a friend of Roulin who was both a friend and good customer; both disapproved of the feeling against Vincent in the town and of the persecution from which he was beginning to suffer from some of the children in the streets; both welcomed the news that he would soon live in his own house with a painter friend. He was warned that he would not get a good bed for less than three hundred and fifty francs, and it was so—he paid seven hundred for the two; but they were of solid wood, "Country beds, big double ones". Then he bought twelve chairs and a mirror, some things for the kitchen, and the legacy was nearly done. He painted away at the sunflowers until the next month's allowance came from Theo. Then off he rushed, after more advice from the Roulins, and came proudly back with a small dressing-table. "I want to make it a true *artist's house*—not precious but with real character in everything from the chairs to the pictures."

His bedroom—the less-attractive room upstairs—was complete: "very simple but with solid furniture"—the white-wood bed and table, three chairs and the dressing-table. He thought of decorating his bed with three panels, including a nude woman and a child in a cradle, but that could wait; Gauguin's room (and Theo's when he could get away for a few days) must be finished first. This was the better room upstairs, looking out on the gardens across the road and facing the early-morning sun. He wanted, he said, to make it like the boudoir of an artistic woman; the sunflowers would glow from the white walls, twelve or fourteen of them to each bunch.

He spent his first night in the house and could scarcely sleep for excitement; he wandered from one bedroom to the other, down the short stairs to the studio and kitchen and back again. He had made, he realised, what amounted to a Dutch interior set down in the south of France—he had seen the like a hundred times in The Hague and Amsterdam—and corresponding to his own work as a home should do. Everywhere was pure Millet, he

told Theo, except the studio, which could only be Daumier with
its red-tiled floor, rustic chairs, white-wood table and (he hoped)
portraits on all walls; and outside, surrounding the house, were
Daumier and Zola in atmosphere, appearance and people.

One thing only troubled him; the guest-room, Gauguin's room,
was not fully furnished; a dressing-table and chest of drawers
were still needed, and a table and large frying-pan for the
kitchen. Yes, and an armchair he had set his heart on—a brown
wood armchair that would take Gauguin's bulk easily. Could he
ask Gauguin to sit on an armless white-wood chair like himself?
He wrote off to Theo again: could he lend him three hundred
francs and deduct it bit by bit? Theo "lent" him three hundred
francs; he had fallen in love with one of Bonger's sisters, Joanna,
wanted to marry, wanted to save every franc he could, but he
sent the three hundred francs.

All was going well except that Gauguin did not appear.
Vincent made spasmodic efforts to induce him to take the step;
for instance he recommended Russell—who had money—to buy
one of the Martinique canvases. Russell was painting in Brittany
and, says Vincent, "Gauguin is in Brittany too but has again
suffered an attack of his liver complaint. I wish I were in the
same place with him or he here with me." But Russell, though
thinking it very good of Vincent "to give Mr Goguin a leg up",
failed to see the recommended picture, and those he did see "that
big one of yours unfortunately swamps in my *opinion*".

The compliment meant nothing to a Vincent who had worked
himself into a state of singlemindedness rare even with him. He
persisted—one satisfactory sale would provide Gauguin with the
fare and would settle his debts—and continued a stream of
letters, exhortatory and supplicating by turns, to Gauguin and
Bernard, and a not far from daily note to Theo—sounding some-
times a note of pride, of criticism, darkly suspicious of Gauguin's
intentions, of high independence from Gauguin or any other
painter, but almost always coming round to an excited appeal to
Theo to do his utmost to get Gauguin to Arles. Vincent had
always been a man in love with an idea, whether personified or
not, but never more so than now.

At Pont-Aven Gauguin continued to keep open his escape road
but with no lessening of reluctance. Vincent's letters did nothing to
reconcile him to the joint household plan; to his robust common

sense they read hysterically, unhealthily, even ominously; the writer was clearly unbalanced, and was, it seemed, expecting Gauguin to act as some sort of nurse and housekeeper. That Gauguin understood fully what drove Vincent to make the guest-room of the yellow house like the boudoir of an artistic woman was as unlikely as that Vincent himself had an inkling of his motive—but the bare idea appeared both comic and repugnant to a particularly masculine man. Nor was there much sign that Gauguin appreciated fully what drove Vincent to agonise after him, the boudoir aspect apart; he knew, as a man who had suffered for his art, that poverty and loneliness were crippling, affecting the body, the character and the work; but he knew also that Vincent had, as he had not, a regular income from Theo, small though it might be; and he suspected, not without reason, that if he had been favoured with a similar allowance instead of being permanently insolvent, he would have managed it so that he could eat and keep his self-respect and his health and so work well. But he had nothing; and this must have made him regard Vincent's pleas with a certain inevitable lack of justice; he could not forget from any point of view that Vincent was the brother of a successful art-dealer.

Yet no practical alternative appeared; August and September passed, the Auberge Gloanec began to empty, the Bernards left for Asnières, the other painters for their studios, the evenings were chilly, the days closed in. He had painted through the summer as never before, but without a sale; he was not appreciated, not understood; his liver worried him, he was in debt, he was cold, uncomfortable and was facing a long winter of work indoors without even the convenience of a studio. His mind moved uneasily towards Arles and the south, where he would have warmth, could work outside and would not pay for rooms or keep. He hesitated.

From Paris young Bernard, who had no intention of being left out of anything, suggested to Vincent that he, Laval and two more Gauguin disciples, Moret and De Chamaillard, should join him in the Midi as soon as possible and recreate Pont-Aven in Arles, but the inflexible Vincent merely expressed general pleasure—Bernard, he reminded Theo "is sometimes *fou et méchant*"—and commented, "I don't ask anything better, but when he discusses a communal life with many painters I stipulate

before all that an abbé is necessary to keep order and that natur-
ally would be Gauguin. That's why I want Gauguin to come
here before them (besides, Bernard and Laval can't come before
February)." The mere act of writing about Gauguin made his
continued absence intolerable: "*Gauguin's journey before every-
thing,*" he cried, "to the detriment of your pocket and mine.
Before everything."

Gauguin was also talking—with an eye no doubt to safety in
numbers—of forming a party, and tried to soothe Vincent's im-
patience with a picture of himself, Bernard, Laval and Vincent
occupying the dark winter evenings profitably and convivially
by making lithographs for publication in a book. But again
Vincent was not to be distracted: "Make lithographs in the even-
ing, you, me, Bernard, Laval? Fine—I'm sure of it, but as for
publishing, that I'm *not* so sure of." But the real point was that
Gauguin should join him—all other plans could await that fact,
as he emphasised in a couple of postscripts: "Come then as
quickly as you can!" followed by "If you aren't too ill, come at
once, if you are too ill please send me a letter." In a third post-
script to Theo with a copy of his letter he excused himself:
"You'll perhaps find my postscript too stiff, but whether he says
yes or *no, he is* ill, but he'd recover much better here."

Gauguin did not come at once but he wrote that the moment
he managed to sell something he would join Vincent; it would be
a struggle because the people at the auberge had been so good
to him that to leave them would appear outrageous ingratitude;
nevertheless he hoped to come; to suggest that he had any other
thought was to twist a knife in his heart.

"Ah well," said Vincent in a short attempt at resignation,
"It's his own business." But longing for Gauguin and distracted
by jealousy—chiefly of Laval whom he had not met—he was
complaining to Theo in the next breath and continuing to try to
tempt Gauguin. He explained at length how, since the talk with
Seurat, he and Theo had determined to "take steps to safeguard
the livelihood of the painter and his means of production (paints,
canvases, etc.) and to make sure that he got a reasonable share
of the price paid for his pictures by the public."

This was highly hypothetical, but Gauguin, like Vincent, was
a child in many things; he read and approved; except for the
mention of Seurat, whom he could not abide, he looked forward

to a secure livelihood with materials supplied free, and he rejoiced at the thought of the dealers being mulcted of their huge profits. But he discovered that one had to pay in other ways: Vincent described Arles as pure Daumier; Gauguin disliked Daumier. Vincent spoke of a self-portrait he had sent off in exchange for self-portraits of Gauguin and Bernard: "I have tried to render the character of a good and simple admirer of the eternal Buddha"; he wrote, "I still have the coarse appetites of a beast. I forget everything but the exterior beauty of things, but can't reproduce it—I make it ugly and vulgar"; he wrote on and on, not always to Gauguin's taste. And Vincent's lack of humour was quite alarming. Gauguin, possibly a little tired of hearing rhapsodies on the sun of the Midi, had sent him the previous month a caricature showing Vincent perched on the top of a steep cliff overlooking the sea and facing an excessively oversized sun which he was frantically painting. This brought from Vincent merely a half plaintive, half reproachful "The artist in your letter who looks like me, is it me or someone else? It has the air of being me as far as the face goes, but for the rest I always smoke a pipe and I also have a horror of sitting like that, becoming giddy on steep cliffs at the edge of the sea. I protest, then, if that is supposed to be my portrait, against the untruths mentioned above." To Gauguin, whose sense of humour was broad but very much alive, this inability to relax for a moment boded ill.

Yet Gauguin agreed unhesitatingly, "I'm rather of Vincent's mind, that the future is with the painters in tropical countries which haven't been painted yet." Arles was not the tropics, Martinique was, but he could not go to Martinique—he had not the money—and he could go to Arles with Theo's help. And when Vincent's self-portrait arrived, he was impressed and said so. Vincent had slanted the eyes after the Japanese, had violently accentuated and changed the colours, but, as he explained, "I have tried to exaggerate my own personality into a portrait not of any one painter in particular but of an Impressionist in general." Gauguin approved; he was astounded by the advance Vincent had made, he said; he knew that he had talent but the new canvas surprised him; nor had he forgotten Vincent's emphatic championship of the Japanese from which he had benefited. The sight of the canvas, he assured Vincent, had made him wish to come to Arles at once, but he had again been ill and

could not face the thought of the long journey.

His praise did not cover Vincent's disappointment; some of the worst consumptive cases made the journey, he commented to Theo; could not Gauguin, who was not so ill, do as much? "And he pretends that he must stay where he is to get well. What stupidity!" But to Gauguin he offered as usual no reproaches, only appeals, and he was soon asking Theo to make a special effort to bring them together.

Theo, in love and loved for the first time in his life and within sight of the domestic happiness he craved, moved heaven and earth to pass on some of his joy and to relieve his conscience—for he could not suppress a sense of disloyalty to Vincent. At the beginning of October he manged to sell some of Gauguin's pottery for three hundred francs and Gauguin's resistance began to crumble; he liked the prospect no better but could see no more reason for refusing; he went so far as to tell his friend Schuffenecker in Paris that he would go to Arles at the end of the month and "stay for some time because I can work there without having to worry about money".

In Arles, Vincent paused exhausted and looked at his handiwork with transcendent pride—his home, the permanent studio he had dreamed of; he had repainted it yellow outside, had whitewashed every inside wall, he had had gas put in, he had decorated it with glowing southern canvases. "Oh," he cried to Theo, "the joy I feel in my house and my work! And I dare to hope that the joy will be shared!" His mind went back to another famous collaboration: "What a fine thing this would be, like that time when Corot, seeing Daumier in a fix, assured him of a living." All was ready: "a studio complete and in such a way that it offers a setting worthy of the artist Gauguin who is to be its head". He had finished off the house, French fashion, with a couple of tubs of oleanders by the door. "I only want two things," he told Theo. "I want my paintings to bring in all the money I have had from you so that I can give it back to you in full; and I want Gauguin to be able to paint in peace and quiet so that he can have a fair chance to stretch his legs as an artist."

But he was not only exhausted, he was lightheaded; for months on end, through summer and into autumn, he had worked all day and well into the night at one thing after another, and often several together—the cornfields, olives, vineyards, portraits, the

town gardens and the house; one thing after another and all on the scantiest of food and sleep. The work for the house alone seemed interminable, for when he had painted the walls and the canvases for the walls he could not resist painting every aspect of the house—the view of the *Place* from the house, the view of the house from the *Place*, his bedroom, even the chairs—all and more demanded to be put on to canvas. And, the house completed, he could not bear to see his canvases on the floor and the walls of his studio bare; he ordered frames that he could not afford, his money ran out, he lived for four days on twenty-three cups of black coffee and some dry bread, he had six francs only left for the next week and still he lacked colours and canvases— for he could not rest, he must be for ever at work to show Gauguin a fit house to live in and an artist of a calibre fit to live with.

He appealed to the town librarian—one of the few people in Arles who would speak to him. This man was not interested in painting but he felt pity for Vincent, he said, as one would feel pity for a sickly, wretched, undernourished child; and Vincent presented such a sorry sight deprived, as he thought, of materials, Theo's allowance exhausted and an unavoidable gap of days of frustration between a fresh application to Theo and a fresh supply from him, that the librarian's heart went out to him. In fact Vincent often spent Theo's allowance and went short of food in consequence, on materials he already possessed; but he had no notion of it, nor had the librarian who sent him off to his friend the chemist with a message that ensured him a free supply.

But this occasional act of kindness did not counterbalance the increasing hostility shown towards him in the town. Although he was pestered only by children and youths, these reflected the opinions of the parents. This was made clear by one of the children, later to become assistant to the librarian; the townsfolk, he explained, did not care to associate with Vincent because he was so often to be seen hanging round the brothels; and the children thought him fair game, a weird creature wearing dirty, strangely coloured, ragged clothes and altogether bizarre in appearance and manner—particularly in his habit of coming to a dead stop in the street to stare at some possible subject that had just caught his eye. These were invitations to the conventional and the cruel in children: "We liked to mock at him."

While there was work to be done to the house, while he faced

the disgrace (for he felt it so) of Gauguin arriving suddenly to find anything undone, neither lack of food nor sleep, neither heat nor mistral, neither mockery nor disapproval could touch Vincent; but everything done, the effect of all fell on him and crushed him—he felt "absolutely all in". His one relief from this intolerable reaction was to talk and drink with Roulin. Roulin was willing—too readily perhaps for Vincent's good. Roulin, he told Theo, made him think of Monticelli who had died of drink "but not in the sense of one who stupefies himself with liquor but who drank because he knew that his life was spent to better advantage in the open air and the cafés than in the north". Roulin, perhaps because he was a disappointed man with thoughts above his station, perhaps because he had a shrewish wife, in his way too "lives much in the cafés and is certainly more or less of a drunkard and has been for most of his life. But he is the reverse of stupid, and his excitement is so natural, so intelligent and he reasons at such moments so much in the style of Garibaldi that I willingly reduce the legend of Monticelli, absinthe-drunkard, to exactly the proportions of the case of my postman."

There was much in what he said; and those who condemn him for drinking heavily lack, as well as the charity, the imagination to put themselves in the place of a man desperately lonely, starved of every kind of food, and with one object beyond the companionship of Gauguin—to paint, paint and paint again the ravishing colours that gave him his one emotional relief. In his drinking he was merely echoing the experience of innumerable artists, and, like them, some of his best work was done under the influence of drink. His misfortune was that his body needed food as urgently as his mind craved for the support and stimulation of drink, but did not get it; he would humour the one but not the other. The disparity was to be the ruin of a man mentally unstable from his early years; of this he had many a foreboding but always he put his work first; if to drink would enable him, as it did, to go on with it, to paint as otherwise he could not have painted, then he preferred to take the consequences.

He now appealed again to Theo, who once more sent him extra money with no more than a mild "What a financier you are! What troubles me is that with your house and everything you are still unhappy because you will always be doing things for

others. I should much like to see you more egotistic until you are *en equilibre*."

But Vincent was not to be *en equilibre* in any sense. "I have been working at a mad rate," he told Bernard. "I painted my *Summer Evening*, a canvas three feet square, at one go. And my cornfields, seven of them, were done at a frantic speed, in harmony with the reaper working like me in the sweltering sun with a single thought in his mind, to cut as much as possible." It was probably unwise, but he simply couldn't help it: "Ah! the beautiful sun here in full summer—it strikes at the head and I don't doubt that one becomes crazy. Well, as this is nothing new I simply rejoice in it. Ah, my dear chaps, we loons enjoy ourselves through our eyes all the same, don't we? Alas, nature takes it out of the beast in us and our bodies become despicable and a heavy burden at times. But since Giotto, that suffering soul, it has always been so. Ah! nevertheless what joy we get from our eyes and what laughter is like the toothless laughter of that old lion Rembrandt!"

And still there was nothing definite from Gauguin. Vincent wrote for news to Bernard in Paris, he could scarcely lift the pen for weariness, the page danced before him, he could not command his thoughts—he was often like that then—but he wrote on; he must know: "My head isn't in a fit state for writing, but I feel so cut off and out of it all. I've no idea what you and Gauguin are up to. I try to be patient, but it's difficult."

He despatched another frantic note to Theo; could he not sell a Gauguin picture so that Gauguin would have the incentive to move? Theo had his doubts about the direction Gauguin would take if he did move but he kept them to himself and assured Vincent that he would do his best.

Then Roulin brought a parcel to the door of the yellow house —self-portraits of Gauguin and Bernard each with the other self-portrait shown on the wall behind the sitter. "My heart was overjoyed," Vincent told Bernard, "my heart glowed when I saw your faces. My house seems more lived in now. I have always been touched by the habit of Japanese artists of exchanging pictures with one another; it shows that they loved each other, that harmony reigned among them and that they lived in brotherly concord. So must we."

Studying the canvases, he felt another kind of satisfaction:

"My portrait holds its own, I'm sure." But this satisfaction was followed quickly by sadness. His own self-portrait, said Gauguin, was "one of the best things I have done, absolutely incomprehensible, totally abstract, like the head of a bandit chief". But Vincent, whose sense of humour was negligible, saw only a work inferior to the Bernard; "more studied, less power"—"very dark, very sad" with "not a shade of gaiety" and seeming "as though he wanted to make a melancholy thing, the flesh in the shadows is lugubriously blue". These were obvious signs to Vincent that Gauguin was tiring as a painter, was in need of the peace and harmony that the yellow house alone could give. And not only the painter, for to him the face was the face of a prisoner, of a man looking ill and tormented. "Don't think I exaggerate," he insisted to Theo. "He needs to eat, to walk with me in this beautiful countryside, to have a shot or two at sketches, see what the house is like and how we get on, then begin seriously to divert himself." "He must not go on like this," he exclaimed; "he must once more become the rich painter of *The Negresses*!"

Those negresses! He was for ever talking about them and their maker—he even read a book on the Marquesas and anathematised the white invaders who had wiped out whole tribes: "The frightful whites with their hypocrisy, their avarice and their sterility! And those savages so sweet and loving!" In Gauguin's *Negresses* he found the whole tragic history of the coloured islanders. "Ah," he told Bernard, "you do awfully well to think of Gauguin. His negresses are the height of poetry."

His admiration, which he flung at Bernard in almost every letter, merely began with the expression of it; he not only revered Gauguin as the modern master, he was inspired by his work, and the sight of a Gauguin canvas actually in his house—for he promptly hung both self-portraits in his bedroom—drove him to a fresh burst, tired though he was. "I can't," he told Theo, "allow Gauguin to influence me before I have shown him that I have some individuality of my own. He will change me as a painter and I shall welcome it, but I'm vain enough to want to impress him with what I've done already—including the decorations of the house which fascinate me. I want him to feel that the decorations and the house are one, in perfect accord."

But "I want to do as much as I can before he comes"—that was the gist of his feelings. He decorated in a frenzy: he had had

another and better idea for the decoration of Gauguin's room and more in keeping with the feminine atmosphere he imagined for it—a series of romantic garden scenes. "I have tried to express the essential character of the country," he told Gauguin. "And I have tried to paint this garden in such a way that one will think at the same time of the ancient poet of this place (or, precisely, of Avignon) Petrarch and of the new poet—Paul Gauguin." These had to be done and done quickly, and there were other subjects that he could not bear to leave unfinished: in a week he painted five canvases—*The Trinquetaille Bridge*, *The Tarascon Diligence*, *Autumn Garden*, the fourth painting of *The Poet's Garden* for Gauguin's room, and the railway bridge near his house. "I am nearly dead," he tells Theo. "There's a violent mistral hurling the leaves away in a rage, and I'm once more pretty nearly as mad as Hugo van der Goes. A good thing I'm a blend between monk and painter or I'd have been quite mad long ago. But I must take care of my nerves." But his chief sensation was triumph: Gauguin would have something to see when he came.

At Pont-Aven in the middle of October Gauguin remained in two minds; he had paid some of his debts but Theo's three hundred francs had gone. However, Brittany was becoming uncommonly cold, the auberge more and more uncomfortable, the skies outside were dismal and lowering. His spirits drooped; no last-minute rescue had arrived from Paris; he felt forsaken and aggrieved. His view of close companionship with Vincent had not changed but the sun and blue skies of the Midi began to tempt him in earnest, and the thought of free board and lodging for the winter and no new debts piling up was decisive. He dismissed his misgivings, wrote to Schuffenecker to ask Theo to wire fifty francs for the fare. Theo sent the money and Gauguin took the plunge: he had sent off his baggage, he told Vincent, and would be with him about the twentieth.

Theo did more than send the fifty francs; he sold a picture, *Les Bretonnes*, for five hundred francs. "He will therefore be solvent for the moment," he warned Vincent, "but will he come to you! Don't lose heart even if he doesn't. I'm sure you will succeed in making your house a place where artists will feel at home."

But Gauguin was not put to the test; he was actually on his way and did not get the five hundred francs until he arrived at Arles.

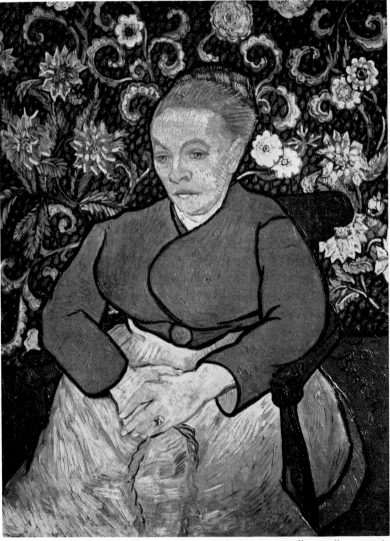

LA BERCEUSE (Madame Roulin), 1889

NUIT ETOILEE, 1889

LA PETITE MAISON JAUNE

Vincent was beside himself when he got Gauguin's letter. He wrote to Theo: "My whole mind is set on Gauguin now." To Gauguin he replied half hysterically, his mind veering from one thought to another. First he imagined his hero on his journey—ill, yes, but "I almost envy you a trip that will take you through league after league of varying countryside in all its autumnal glory. I've never forgotten how I felt during my journey from Paris to Arles that winter. As if I were already on the look out for Japan. Childishness, eh?"

He remembered his last, almost incomprehensible letter: "When I wrote to you the other day my eyes were curiously tired. Now I'm going to rest two and a half days before going on with my work, but I shan't dare even then to work out of doors." As for his work indoors, he had been making the study of his bedroom: "It amuses me enormously to make this interior out of nothing, with a Seurat-like simplicity." Then, perhaps looking at the study before writing further, he was taken with doubts—what would Gauguin think of it? "However, you'll see this with the others and we'll talk about it because I often don't know what I'm doing, working almost like a somnambulist."

Then the sound of the mistral, or perhaps the chill of the house, sent him on another tack—"It begins to feel cold, specially during the days of mistral." What would Gauguin think of it—he who had complained so bitterly of the Brittany autumn? "I've had gas put in the studio so that we shall have a fine light this winter." But even so? "You won't find the house as comfortable yet as we shall make it bit by bit. But you can't do it at one blow—it costs such a lot!"

However, the mistral had to be faced; Gauguin should be warned. "Perhaps you'll be disenchanted with Arles if you arrive here during a mistral. But in the long run the poetry of the place will penetrate. . . . I believe that after a time, during the intervals between mistrals, you'll be seized as I was with a perfect fever for painting the autumnal effects and that you'll understand why I have insisted on your coming now. . . ."

The letter went off—no more letters, but face to face!—and the promised rest of two and a half days was abandoned incontinently, forgotten. Rest, with Gauguin on the way! He rushed round to the Roulins, to the Ginouxes, with a photograph of Gauguin: his chum was coming, a fine man and a great

painter. He was wildly excited and attacked his paintings with fury; all must be finished. He tidied up Gauguin's room once more, hung his *Poet's Garden* sequence on the walls, gave the brown armchair a final polish. Then, worn out, he slept.

Gauguin arrived at Arles in the small hours and went to the night café. He found himself known; Vincent had shown the photograph there too, had talked and talked: "That's my *copain*." He sat on, looking about him disapprovingly, until sunrise, then walked heavily round to the Place Lamartine and hammered at the door of the yellow house.

Chapter Twenty-one

GAUGUIN

1888

ALTHOUGH Vincent had slept and Gauguin had not, Gauguin was the fresher of the two; he did not look ill, he did not even look tired. Vincent looked like death. Gauguin marched into the house and took it over. He approved the top floor silently ("I don't know yet what Gauguin thinks of my decorations," said Vincent, on tenterhooks), but the ground floor shocked him; the studio was in an appalling mess—canvases everywhere and anyhow, brushes scattered all over the place, tubes of paint rammed into an overfull colour-box which would not shut, the tiles of the floor spattered with paint. The kitchen was beyond words; at the sight of it Gauguin took off his jacket and got to work. In a few hours the studio and kitchen gleamed.

Vincent watched him in awe; he was beginning to feel better already—"I felt I was going to be ill, but Gauguin's turning up has taken my mind off it." Gauguin, clearing the studio, had noticed that Vincent's colours were often duplicated; plainly he was unfitted to handle money; Gauguin took it from him and put it into boxes, one for their recreations, one for the rent, one for the food; whenever any money was taken out of a box, he explained, a note must be made on a piece of paper kept on top of it; he even put a pencil on the paper—the kind of methodical touch that Vincent, who could not endure it in his father or Tersteeg, now found wonderful in this quietly masterful man.

For that matter, he found everything wonderful in Gauguin for the first few weeks; Gauguin took everything in hand, and to Vincent everything he did was good: he strode majestically through the shops accompanied by the admiring Vincent and bought furniture, kitchen utensils, food and "heaps of things we need" and, home again, cooked the food—cooked it *"perfectly"*. In future, he said, brushing aside praise, that was how they would live, eating sensible meals at home and drinking on a filled stomach; no more painting until the small hours, no more foodless days in the full sun, but a regulated régime, working

reasonably and hard for reasonable hours and enjoying themselves, also reasonably, in the evening. And his word was obeyed.

Vincent wrote ecstatically to Bernard "Gauguin interests me much as a man—much. It has seemed to me for a long time that in our dirty job as painters we have the greatest need of people with the hands and stomachs of workmen and with more natural tastes—and temperaments more loving and charitable—than the decadent and dandified men of the Paris boulevards. Now here without the slightest doubt one finds oneself in the presence of a virgin being with the instincts of a savage. In Gauguin blood and sex prevail over ambition." He could have praised on and on, Gauguin appeared so much more even than he had dared to hope, but an unusual instinct of tact stopped him short. "But enough, I only wanted to give you my first impressions in a few words—you have seen much more of him than I."

Gauguin added a postscript; they had lost no time in discussing Vincent's theory of a new generation of painters working in the tropics, and "I intend to go there as soon as I get a chance." Words of warning if Vincent had been able to think for more than a moment of anything but Gauguin in the flesh beside him; but he could not, and any spare attention was given delightedly to the master's closing words to Bernard about the Poet's Garden studies: "Vincent's two paintings with the falling leaves are hanging in my bedroom. You would think them very fine."

To Vincent, looking about him after a day or two, the transformation must have seemed like a miracle; he had dreamed of the yellow house as a centre for the Impressionists of the south and as a home for himself, and all of a sudden it was a studio and it was a home, no longer a place in which, solitary, he camped uncomfortably; within a few hours of Gauguin's coming it began to take on the atmosphere and the serenity of the lived-in house —something that he had never known in his life—whilst he, the lonely, the man who had always failed with men, was sitting, talking, working in this home with the painter whom of all painters he most admired and would most have wished as companion—a painter who not only presented him with a magnificent example in his work but who, unasked, took over the rôle of protector, brother, wife and mother in one. At first he could not believe that Gauguin would really stay: "Gauguin is an astonishing man, he's not packing, he's waiting here very calmly and

working hard for the right moment to take an immense step forward." Then, as Gauguin settled in, "I'm thankful not to be alone. . . . It does me an enormous amount of good to have a companion as intelligent as Gauguin and to watch him at work." He might have added, a companion as cool, and as steady—for these were precisely the qualities that he lacked.

But Gauguin had not yet done with him; having put his hand to the plough, he decided, for his own satisfaction and peace of mind, the house being in order, to turn his attention to Vincent's work. Indeed, decided is scarcely the word; no painter, and certainly not Gauguin accustomed to dominate the Pont-Aven group, could have resisted comment on the work of a man with whom he was to live at such close quarters—and Vincent would have been surprised and hurt if no comment had been made; so much so that one doubts whether he could have restrained himself from seeking Gauguin's opinion. But whether he did so or Gauguin volunteered comment, the comment when it came must have given him very great pleasure; for when his canvases had been disentangled from the mess and Gauguin had examined them, he was clearly impressed; he did not expect the originality or the power and he said so.

Vincent, immensely gratified, explained that when he had found himself under the strong sun of the south he had realised the truth of Pissarro's dictum—Gauguin had actually reminded him of it in a letter from Brittany—that painters in the north could not comprehend the effect of southern sunlight—the simplicity, the gravity it bestowed on every object. He had tried in the spirit of Monticelli to profit by the discovery, to express what he had to say by colour instead of using the northern emphasis on technique and the picturesque; he had no system, he simply lashed the canvas with irregular brush-strokes and let them be, he used impasto, he left bare patches when he felt like it, he did not finish other patches, and others he overpainted. The result was often coarse and brutal—he was not satisfied with it—but that was what happened when he had a canvas in front of him and a brush in his hand. The essential form he took care of by line, and for the rest he used simple flat tones, intensifying blues and yellows to avoid photographic realism.

This was a clear invitation to Gauguin of which in time he availed himself; for a man to say that he was not satisfied and

that he had no system was a challenge, an irresistible challenge. He had many reservations about Vincent's use of colour, he saw him as influenced out of his element by Seurat and Monticelli, he found his work far too emotional, indeed full of faults, yet so promising that he was worthy of much effort. There was vanity in this, of course, but there was right too—and none was so ready to agree with it as Vincent at that time. Gauguin began his tuition easily and with a compliment; he found the sunflower studies remarkably good, better than Monet's; and Vincent, perhaps forgetting in his delight that Monet could not endure Gauguin, hurriedly began to paint more and turned with renewed hope to his figure work: "If by the time I'm forty I can make a picture with figures as good as the flowers Gauguin has spoken about, I shall have a standing as artist worthy of comparison with anyone."

Gauguin then opened his campaign in earnest by urging Vincent to paint away from the scene, to use his imagination; and Vincent, who had not long since told Bernard, "You have the gift for abstract painting, so has Gauguin, but I can't work without models. . . . I am too frightened of losing accuracy of form", began to follow them and was soon writing to Theo, "Gauguin has brought me to see that it's about time I varied my work. . . . Now I work from memory. Gauguin gives me courage to use my imagination, and it's true enough that paintings of this kind have something mysterious about them. . . . Gauguin and Bernard don't ask what the exact shape of a tree is, but they do insist that one should be clear whether the shape is round or square, and they're right. They are fed up with the photographic but empty perfection of certain painters. They don't ask what the exact shade of the mountains is—they say, 'By God, the mountains were blue, weren't they? All right, then chuck on some blue and don't bother to tell me that the blue was rather like this or that. Make the mountains blue and that's enough.' " He added, and the addition indicates how greatly he was influenced by a strong character and by worship, "When he's explaining this kind of thing Gauguin is often like a genius, but he's afraid of showing his genius. It's touching to see how he takes the trouble to say things that will really help the young painters."

Gauguin's coming seemed, then, to be all benefit, his own

doubts to be proved without foundation and Vincent's optimistic imaginings proved true; here at last was the companion he had sought for years past, and in a country where the opportunities for the painter seemed endless. Life inside and outside the yellow house was regularised, work and pleasure alternating. The pleasure, however, led to work; Vincent had explained his difficulty in persuading women to sit for him; to that, Gauguin replied that all the women he wanted were to be found in the brothels, which were thick in the town because the Zouaves were quartered there. Vincent had been little more successful in the brothels than in the town, but when he accompanied Gauguin his friend quickly demonstrated how business and pleasure could be combined. Poor Vincent's pleasure was limited—"I begin to resemble in physique," he told Theo, "the man in Maupassant who was so exhausted by hunting that when he married he found himself useless"—but, still in the first stages of hero-worship and the delight of companionship, he watched with no more than a faint sadness Gauguin carrying everything before him with contemptuous ease night after night. "Gauguin", he reported a day or two after Gauguin's arrival, "has practically found his Arlésienne already"; and a few days later: "Gauguin is having lots of luck with the Arlésiennes." His portion after eight months in Arles remained the girl in the brothel who pitied him; but he accepted his portion—Gauguin was wonderful there, he thought, as he found him wonderful cooking their meals and composing masterly pictures. And it was true that Gauguin's coming had done wonders for him; his indigestion vanished, he had no more hallucinations through overstrain and undereating, he slept well and worked soundly. "I find your brother somewhat nervy," Gauguin had told Theo on his arrival, "but I hope to calm him down." This he had done; and it did seem in the first few weeks that he would succeed in making a healthy man of him.

Vincent expressed his good health and the stimulating effect of companionship in two of his most satisfactory paintings—Gauguin's chair and his own. As with the coffee-service, he gave life to the inanimate and more than this; he made a chair as such, without any special distinction, an object of interest and beauty fit to occupy an entire canvas, and he gave to each chair not only its own chair-like distinction but something of the personality of the man who usually sat on it. Gauguin's chair has his

bulk, his virility, his strength, something of his tendency to flashiness yet also his calm; Vincent's chair reflects his worship of plainness and also his egotism—Gauguin's chair might have arms, colour, polish, but his was white-wood perfection, simple and beautiful in its simplicity, good enough for a cottage, for a peasant, for him. And, final good stroke, his chair is painted in daylight, Gauguin's by night.

Gauguin too was satisfied—more so than he would have believed possible; Vincent's nerves had gone, he was astonishingly docile and companionable, eager to learn, gratifyingly grateful for all that was done for him. Besides, there was a "something that shone out of" his talk; "Daudet, Goncourt and the Bible inspired his Dutch brain." He had also, Gauguin discovered, "a noble nature" that one must respect however much it was wrapped about by oddities; he was not, as he could appear on short acquaintance, a contentious eccentric, but a questing, earnest man who tried to lead the good life—and Gauguin understood in Vincent what was fundamental in himself. As for the surroundings, Arles was not the tropics but neither was it Daumier as Vincent had insisted before he came; to Gauguin it was Puvis with a tinge of the Japanese. He did not see it as a final home but he appreciated the clear light and good colours; he was painting good pictures, he had paid his debts at Pont-Aven, had sent money to his wife, had money in the boxes and his self-respect was higher than it had been for some time; and he found the Arlésiennes all that Vincent had claimed if not more: *"leur coiffure élégante, leur beauté grecque"*.

However, the Arlésienne that both men were to leave to posterity was not one of these that Gauguin won so easily and Vincent had agonised after for months, it was Vincent's friend —or perhaps confidante would be a better description—Madame Ginoux. Madame Ginoux suffered from the vapours, she fidgeted, she could not keep still, was an impossible sitter; Vincent painted her portrait in forty-five minutes while Gauguin made a sketch. The portrait made Gauguin raise his eyebrows, and Vincent, though insisting that Gauguin's sketch had caught the essence of the subject, was vastly encouraged and worked steadily through the Roulin family—his one unfailing source of models— making portraits of the grown-up son, the schoolboy and the child and mother.

Gauguin's admiration dwindled when they moved to landscapes: "influenced by the experiments of the Neo-Impressionists, he always used strong oppositions of tone on a complementary yellow, a violet, etc., whilst later, after my advice and my example, he worked quite differently—he made yellow suns on a yellow ground, etc., learned the orchestration of a pure tone by all the derivatives of that tone. Then in landscape all the usual trash of still-life objects, at one time a necessity, were replaced by a great accord of solid colour resulting in a complete harmony. . . . His drawing began to suit itself to the subject." He advised, demonstrated and, if Vincent is to be believed, not without effect: "Gauguin has made me see that it's about time I varied my work"—"I owe much to Gauguin"—the grateful tributes are many both at this time and afterwards. And if Gauguin's actions are to be believed, he too thought that Vincent was benefitting from his advice and—what was more important, since he would not otherwise have troubled himself—had his own "ardent, impetuous nature, intelligence and originality" and was in short so much better a painter than he had dreamed possible that he must be included in the exhibition of the work of "a little group of pals" that Gauguin was anxious to hold in Paris. The pals would consist of Gauguin, Schuffenecker, Bernard, Laval, Guillaumin, one or two lesser lights and now Vincent too: "I refuse to exhibit with *les autres*—Pissarro, Seurat, Signac, etc. This is our group!" They looked out suitable canvases—Gauguin ten, Vincent six; Vincent was divided between pleasure at the honour and distress at the snub of Seurat—but on the whole the pleasure had its way.

This, early in December, was the peak of an unnatural relationship Theo, deceived by the unexpected signs of harmony from Arles and believing that Vincent had against all probability found his fellow, had broken the news that he had fallen in love with Joanna Bonger. He had had good fortune since Vincent had left him; Monet had come over to him from Durand-Ruel and he could afford, he calculated, to marry without altering his payments to Vincent. He was still unable to sell Vincent's pictures, good though he thought them, and he prepared himself to continue to support him. This, of course, he kept to himself; he told Vincent merely that he would visit the Bonger family in Amsterdam at Christmas.

Vincent rejoiced for Theo wholeheartedly; he felt no fear or envy because he was no longer alone. His letters were all of Gauguin: how he had painted women in a vineyard, women washing clothes, the night café, a nude reclining with pigs in the hay—"very original, oh very fine, of enormous distinction"—had made a pot—"magnificent"—and was making a portrait of Vincent which, commented the sitter, "I don't consider likely to be thought one of his less successful projects." Gauguin, he declared, was "a very great artist and a friend in a million . . . a very, very interesting man, and I'm sure that with him about we shall do heaps of good things", leading to the prophecy, "I dare to predict that in six months Gauguin and you and I will see that a studio has been founded that will endure—a useful, maybe even essential outpost for all who want to paint in the south."

None so optimistic as Vincent in the grip of hero worship, none so blind; he spoke of six months when after six weeks the enterprise—one of the most hopeless ever attempted—was beginning to founder before his eyes. There can be no surprise for anyone but Vincent—the surprise must be all for the fact that the concord lasted as long as six weeks—a fact that can only be explained by Gauguin's relief at finding a winter haven, warm and without worry and with excellent opportunities for painting, and by Vincent's ecstatic appreciation of a companion (and such a companion) who had delivered him from loneliness and lovelessness. But Vincent had never lived with anyone without differing violently from them, and never would, and Gauguin, easy-going though he was, was not the man to accept irrationality at his very fireside, hysteria and a perceptible diminution of admiration, not to speak of attempts at correction. Only the occasion was wanting to uncover the weaknesses of this *ménage à deux*, and there were to be plenty of occasions. And it soon became plain from Vincent's letters that a certain disillusionment was setting in—that is to say, Gauguin, like all of Vincent's heroes, began to fall from his impossibly high pedestal.

Ostensibly at least the trouble opened with their discussions. Those humiliating and infuriating afternoons in Theo's gallery, when Vincent's early heroes were torn to shreds and which he had forgotten for the moment, began again, but in the yellow house, in the studio, with Gauguin sitting back in his armchair eyeing Vincent disdainfully whilst Vincent leaned forward on

his plain yellow chair, his pipe belching smoke, stammering hoarsely, deepset eyes furious and pleading by turns. On bad days when they couldn't get out to paint the talks went on for hour after futile hour.

Gauguin began to grow bored and impatient. "He admires Daumier, Daubigny, Ziem and the great Rousseau," he told Bernard—and one can see the shrug of the huge shoulder—"all people whom I can't stand. And he dislikes Ingres, Raphael, Degas, whom I admire. He's a romantic, I'm a primitive. He's always raving about Monticelli's colour, I detest it. But to keep the peace I say, all right Brigadier, have it your own way."

But Gauguin did not always say "All right, Brigadier, have it your own way," The question was not simply that one preferred this painter, the other that. Gauguin had been struck, immediately he looked at Vincent's work, by the disparity between Vincent's principles and his painting. They didn't agree at any point. Vincent talked, as he had talked for years, of Millet, the Dutch school of Mauve and Israëls, as well as of Rembrandt, Delacroix, Monticelli and the later Frenchmen. In a sense he had not moved forward one inch; he had added enthusiasms, he had discarded none; and his professed attitude to painting was still a moral and sentimental one. But his best work showed no sentimentality and no moral purpose; except for choice of subject and strength of touch his Dutch years seemed to have left no trace on his paintings. But Gauguin was no man and was in no mood to pass over discrepancies. Vincent's untidiness of attitude worried him just as much as his untidiness of person. He had tidied Vincent up physically; he would finish the job and tidy up his mind; he would "disentangle from his disordered brain a reasoned logic in his critical opinions".

But Vincent wouldn't be disentangled; he denied that he was entangled; he refused to budge an inch; he grew angry at the reflections on his heroes and Gauguin grew cutting; there were scenes.

Gauguin has been criticised severely for this attempt to mould Vincent's mind, and it is true that it proved both hopeless and harmful, but the admirers—idolaters would perhaps be the correct term—of Vincent overlook the fact that even had Gauguin remained silent Vincent would not; he had always tried to browbeat men into acceptance of his theories, and when his

hero worship of Gauguin began to wear thin he attempted it again. They also underestimate Gauguin's motives—Vincent when clear-minded did not; his admiration for Gauguin, which was to persist until the end of his life, was given largely because he penetrated beneath the calm and even lazy talk and manner to the passion—the equal of his own—of a man for his art and discerned in him what he was to describe as a "sense of moral responsibility" towards his art—and it was this, more than his dislike of the irrational, that drove Gauguin to correct and try to convert.

Gauguin was, besides, becoming increasingly bored and irritated. His sense of humour and his considerable vanity had carried him through the first weeks of unadulterated worship, but he was tiring rapidly of a man who "had a boundless admiration for Meissonier and a profound hatred of Ingres, whose *bête noire* was Degas, who thought Cézanne nothing but a faker and burst into tears when he spoke of Monticelli," who had the audacity to dispute his judgments and to criticise his work—"he always loves my paintings, but when I've done them he always finds something wrong"—and who even (turning the tables with a vengeance) questioned his competence to discuss a subject rationally because he had "a low forehead". If only he could paint in the sun and enjoy the Arlésiennes, Gauguin would have relaxed contentedly enough through the winter months—but no, he had the antagonistically worshipping Vincent always at his heels, and sooner or later he had to return to the yellow house where Vincent seemed to take a self-destructive pleasure in re-opening discussions leading night after night to an angry scrape of the white-wood chair and a tension that one could cut with a knife. The storm had not broken, but such an atmosphere was bad for the nerves and bad for work. Had he come all the way from Pont-Aven for this? He was annoyed with himself for having given way to Vincent's importunities and his own discomforts, he disliked the position into which Vincent was thrusting him of being forced to leave snug winter quarters for a probable foodless garret in Paris. He grew spiteful; those lazily hidden eyes missed none of Vincent's weaknesses; his tongue rasped.

Vincent began to look at his hero with loathing, then worshipped again when he watched Gauguin at work, then after more argument loathed again. Did he love or hate? His mind

was inextricably confused. He would spend a whole day without speaking a word, then would turn rough and noisy, banging about the house like a maddened creature, like a dangerous version of the boy of thirty years earlier.

But the discussions, serious though both men were, covered on Vincent's side another and absolutely fundamental cause for his behaviour. Gauguin in his boredom with incessant and unrewarding argument was talking of leaving Arles. His talk, like that of most penniless artists, was often no more than talk, but Vincent took it in deadly earnest. First came the threat to the studio of the south: on a rainy day Gauguin would dilate on the superior climate of Martinique, and Vincent, seeing his plans collapsing, would write, "Gauguin, though he works hard here, is still longing for the tropics"; followed by a more concrete threat, an invitation to Gauguin to exhibit at Brussels, which produced Vincent's comment, "His imagination already begins to draw a picture of himself settled in Brussels." Brussels was close to Copenhagen: "That would probably lead to a meeting with his Danish wife"; and that in turn would lead to a reunion with his children of whom he had talked often and with affection. Once reunited, how could Vincent hope to see him again? The thought of the children was in every way intolerable—"*We* aren't so dangerous in that department"—and linked up in Vincent's mind with Gauguin's nightly triumphs at the brothel, which suddenly became offensive. He had explained to Bernard not long before that his own lack of success at the brothel was due to his age. But Gauguin was five years older, and look at him! "No one would think him a married man, the way he goes on," Vincent now remarked sourly.

The result of Gauguin's hints and of his behaviour on Vincent is not difficult to imagine; of all men he needed love and security; he had accepted calmly the prospect of sharing Theo's love and interest with Jo because he thought that in Gauguin he had found a greater substitute; he now appeared to be in danger of losing everything, of being utterly abandoned and lonelier than ever in his life before. The thought was fearful and not to be borne— a thrust at his life, no less—and was sufficient to account for all that followed.

His behaviour reflected his feelings; at one moment threatening, at the next abasing himself. Once or twice Gauguin wakened

to find him coming towards his bed. "What's the matter, Vincent?" he asked loudly; and Vincent would go back to his bed as if in a trance. He began to scrawl religious texts and symbols on the wall—Gauguin's jibes at his Dutch heroes had stirred the Vincent of the Borinage and the years that led to it. Their quarrels grew loud and serious: "We talk," Vincent told Theo excitedly, "until our nerves are so stretched that we can scarcely raise a spark."

Gauguin wrote to Theo: he respected Vincent's intelligence, but their temperaments were incompatible, they could not live together in peace; he would be grateful if Theo would send him the fare to Paris.

Vincent protested, pleaded, promised amendment. In a weak moment Gauguin changed his mind, wrote again to Theo asking him to ignore the first letter. In an effort to get back on to a friendly footing they went to the Fabre gallery at Montpellier. At first the excursion seemed to have been successful: "We talked a lot about Delacroix and Rembrandt," wrote Vincent, and while the conversation kept to them all was well. But there were other works at Montpellier on which the two men did not see eye to eye; Vincent's devotion to Th. Rousseau irked Gauguin, and his blistering comments on him and others irritated Vincent. When they got home the argument raced into high pitch: "Our discussions became *excessively electric*."

But the excitement was one sided; Gauguin kept cool—too cool—and poured his annoyance and uneasiness into the portrait that he was still making of Vincent at his easel painting another sunflower study. He also prepared himself: "Between the two of us, he like a volcano, I boiling inwardly, a struggle of some sort was inevitable."

The portrait brought the struggle into the open; it was a cruel piece of work, clever, like yet unlike, a half truth. Vincent watched it fascinated; Gauguin had caught a likeness, no doubt of that. "At times" he told Bernard "I looked exactly like that, absolutely exhausted yet charged with electricity." But was this all that Gauguin could find in him?

When Gauguin finished the portrait Vincent stood before it for a long time. "Yes," he said at last in a queer voice, "it's me all right, but me mad."

They went over to the café as usual for their evening drink.

Vincent asked for an absinthe. When it was brought he threw it at Gauguin. It missed him.

Gauguin got up without a word, took Vincent in his arms, walked home and laid him on the bed; he seemed to fall immediately into a kind of coma.

The next morning Vincent apologised. He hadn't known what he was doing, he said.

Perhaps, replied Gauguin; but once was enough; if the absinthe had hit him he would have hit Vincent; it was better for both of them that he should go to Paris before worse trouble blew up.

Vincent dashed off a letter to Theo—the shortest he had ever written. "I'm afraid Gauguin is a bit tired of the good town of Arles, of the little yellow house, and particularly of me.

"It's true enough that both of us still have serious troubles to get over—but these troubles are more in ouselves than outside.

"I believe he'll make a clean break or an equally definite decision to stay.

"I have urged him to reflect again and consider his own best interests before acting.

"Gauguin is very strong, very creative, but precisely because of that he must have peace.

"Will he find it elsewhere if he can't find it here?

"I wait with absolute serenity for him to make up his mind."

Absolute serenity! And the fate of his house, his plan for a studio, perhaps his very life—for how could he now rely wholly on Theo whose love was no longer his alone?—all resting on the decision of that man, that greatly hated, greatly loved man who hummed his way almost too unconcernedly about the house, sorting out his things! The tormented Vincent, his mind in a fever, could settle to nothing. Would he really go? Dare he go? Vincent watched him, watched every movement.

That evening—two days before Christmas—Gauguin was crossing the Place Lamartine when he heard familiar footsteps, short, quick, uneven, behind him. He looked back. Vincent was coming for him with an open razor in his hand. Gauguin spoke to him sharply, as he had spoken when Vincent approached his bed. Vincent turned away without a struggle. He ran back into the yellow house, stood before the mirror as he had stood so often when painting a self-portrait, and hacked off part of his left ear

with the razor. He tied a scarf tightly round his head, dragged down his round fur cap over it, wrapped the ear in paper, put it in an envelope, put the envelope in his pocket and walked out of the house.

He walked to the brothel. He gave the envelope—his phallic symbol—to the girl who had preferred him to Gauguin. When she opened the envelope the girl fainted. Within a few minutes the brothel was in an uproar. In the centre of it stood Vincent, a ghastly figure, glassy-eyed, dead white, swaying on his feet, blood pouring down his cheek from the soaked bandage—for he had severed an artery.

Into the confusion—women screaming, Zouaves angrily playing with their daggers, everyone talking at the top of their voices except the trance-like Vincent—came Roulin. For weeks Roulin had been growing concerned about Vincent; he thought that Gauguin was having a bad effect on Vincent who was clearly not himself and acting very strangely. He kept an eye on him and now, hearing the babel of voices, he hurried into the brothel and managed to half-lead, half-carry Vincent back to the yellow house before the police arrived. There he put Vincent on the bed and stayed with him through the night, trying to stop the flow of blood.

Early the next morning Gauguin, who had slept for safety on the far side of the town, came back to fetch his things; he intended to leave for Paris at once. He was astounded to see a large crowd and several gendarmes before the yellow house. Inside he found the ground floor a mass of blood. Upstairs Vincent lay unconscious. The police were questioning everyone. Gauguin satisfied them that Vincent had mutilated himself; he was allowed to go. He wired to Theo: come at once.

The telegram reached Theo just as he and Jo were about to leave Paris for the Netherlands. Theo hurried to the other side of Paris and caught the next train south while Jo went north alone.

In Arles Gauguin told Theo that Vincent was in hospital critcially ill. How was he? Gauguin couldn't say: he had refused to go near Vincent since he had been threatened by the razor.

Theo found Vincent conscious but wretched, utterly and inconsolably wretched. Sometimes he agonised about his religious beliefs: he had deserted God—would God forgive him? This Theo found incomprehensible. What could he say? But Vincent's

LE RAVIN, 1889

L'ESCALIER A AUVERS, 1890

City Art Museum, St. Louis

most frequent and most heartbreaking sorrow was his inability to express himself. He saw his life ruined, his last hopes gone, and he could do nothing about it. He could not even weep. He had to lie there living over a life of suffering and despair crowned by this final ignominy at the very moment when he had found a home and himself as artist; he had to live it over in silence because he had not found the person who would have broken the silence and released him.

Theo, never taking his eyes from him, guessed his thought. "If he could have found someone to whom he could have opened his heart, perhaps his sufferings would never have reached such a pitch." When Vincent had sent him his *Café de Nuit* he said he felt it had something of Dostoevsky about it. It had; and Vincent himself had much of the Russian about him—too much, thought Theo unhappily, looking at the contorted face on the pillow. Perhaps only a Russian could understand and love him: Mashûrina of *Virgin Soil*—if he could meet such a woman, "one who has experienced life's wretchedness to the full", then even so late he might find peace.

But he had not; he had only Theo—Theo who had fallen in love with Jo Bonger. Was that it? wondered Theo; was that why he did not speak freely? How little Vincent knew his true feelings if so! Yet what could he say? He said nothing but, watching his struggles with helpless compassion, laid his head beside him on the pillow. For a time that relieved Vincent. "Like Zundert" he murmured. His mind went back to childhood. He saw Zundert with astonishing clarity. He could see every room in the parsonage, every path in the garden, every tree and bush and flower. He could see the views from every window across the flat fields and the heath to the large horizon. He could see the faces of all their friends and neighbours, the look in their eyes, the wrinkles on their faces. He could see the church, he could see the tall acacia with the nest on which flickered, if one stared hard, the magpie's black and white. He was a child again, seeing, hearing, smelling with the intensity of childhood. What blessed relief, to pass to this from those unspeakable hallucinations!

Yet even Zundert, that refuge of thought for so many years, could not protect him for long. He was good then, though not without trouble—he had never been without trouble—but he was good and he had hope. Such hopes! And then. . . . His mind

travelled over and over past time—failure, strife, humiliation and no love. Where there should have been love, where in his heart there was love, appeared its opposite—differences, estrangements, disappointments, hate. Again and again. Love—never. And now no hope. And he could not even weep!

And when night fell—that terrible time when fears were thickest and resistance at lowest ebb—what thoughts came to him then! of failure, disgrace, inescapable madness. He dreaded sleep for the nightmares that made him scream in helpless agony, but even more he dreaded lying awake. He forced himself desperately to think of pleasant, good things. Again and again, he didn't know why, his mind settled on Degas, the one Impressionist whom everyone respected: Degas who had said, "I'm saving myself up for the Arlésiennes." He had talked to Gauguin about Degas. Gauguin listened readily; Degas thought well of his work, Gauguin had plenty to say about Degas—Gauguin liked to think that he was defending Degas. Vincent, he said, couldn't understand the greatness of Degas; and Vincent time after time had found his admiration passing into annoyance. But now he thought clearly and calmly and with relief, Degas would succeed where they had failed.

But Gauguin—where was he? Vincent called repeatedly for him. He did not come. He would not come: "I should excite him again."

At the end of the Christmas holiday Theo had to go back to Paris. Vincent was still in danger, he had lost an appalling quantity of blood. Theo could barely tear himself away. But for once he left Vincent in good and friendly hands. Dr Rey at the hospital was sympathetic and hopeful; he would keep Theo informed. Roulin came day after day to see his friend; he would send Theo the latest news every day. And the Protestant pastor, Dr Salles, had visited Vincent and seemed to understand and want to help him.

Theo went back to Paris trying to weigh these consolations against the threatened desolation: "He has suffered and struggled more than most. If he dies my heart will break."

In the compartment with him sat Gauguin; he was storing up for himself reproach and calumny which have continued to this day. But if emotion is controlled and the matter is regarded objectively, it is possible to see just cause for reproach in two

details only: why did Gauguin not follow Vincent back to the yellow house instead of going to an hotel for the night; and why would he not visit him in hospital? He has given his answer to the last: "I should excite him again." This seems over cautious and cruel, but it has to be remembered that Gauguin had lived with Vincent and had been threatened by Vincent and that his critics have not. Gauguin also answered the first charge—with a question: "What would you have done?" It is a difficult question to anyone who faces it honestly.

But the best answer to all criticism lies in Gauguin's companion; he not only travelled to Paris with Theo, he did so amicably; not one word of disparagement by Theo has ever been recorded, and his actions during the rest of his life suggest anything but anger and contempt for Gauguin. Why? The answer to this question, which may be left to the reader, is also the answer to Gauguin's critics.

STRUGGLE FOR SANITY

1888-1889

FOR the next few months Vincent struggled against the new enemy. Before the end of the year he had rallied; Madame Roulin reported excitedly that he had asked after the baby Marcelle—the first interest he had shown in the world outside himself. A day or two after the new year, 1889, Roulin, who being no penman dictated his daily letter to his elder sons, told Theo that Vincent was not only out of danger but better than before "the unfortunate accident". He longed to get back to his house and painting, and Roulin would see that he did so. He was chiefly concerned by the trouble and anxiety he had caused.

Vincent, scribbling a line himself, repeated the apology. "I hope I have been the victim of nothing worse than an artist's prank." This was how he intended to regard that extraordinary fit; he dared not look at it in any other way—a freak, a folly, the kind of thing that might happen to any highly strung man. He hoped to be at work on the blossom again in a few weeks.

In this spirit too he wrote to Gauguin. Why hadn't he come to see him? he asked Theo. Was he scared? How absurd! He had much to say on this subject during the next week or two; he was puzzled, he was hurt. At first he could not realise that Gauguin had gone. "Why doesn't he give me a sign of life?" he demanded. Then, knowing that he had gone, he became sarcastic: "Supposing that I was all that he said in the way of aberration, why wasn't our illustrious friend calmer?" He spoke of him as "the little Bonaparte tiger of Impressionism who abandons his armies in Arles as in Egypt", accused him of causing all the trouble by spending too much money and, when Gauguin asked for his fencing-mask and gloves to be sent on from the yellow house, exploded with an "I am eager to send him these infantile toys, hoping that he will never have to fight more serious things." But it was not long before he was reassured and in a manner reproved by Theo, who continued to befriend Gauguin, introducing him to the Dutch painters De Haan and Isaacson and pushing his

work. The significance of Theo's attitude was not lost on Vincent; Theo, the only other man who had lived with him, did not blame Gauguin, quite the contrary. And at heart Vincent did not blame him—in reflective moments he knew himself too well. He was soon begging Theo to ask Gauguin to write to him: "Tell him that I think of him always"; exclaiming with joy when he heard good reports of him, "I love to believe that he has found his way"; and, when Theo told him that Gauguin was still determined to go to the tropics, "this gives me enormous pleasure. That is the right road for him. I believe that I see his plan clearly and approve with all my heart. Naturally I regret it, but you'll agree that for him to be able to go on well is all that matters." In his letters to Gauguin he confined his reproaches to a mild, "My friend, was it really necessary to have brought my brother down from Paris?" and a request "not to say anything bad about our poor little yellow house." He assured him "there is no evil, all is for the best in this best of worlds," and wished him well; he didn't believe they had worked together for the last time; he would hope still to see him in the south again.

The next day he and Roulin visited the yellow house. The Roulins had cleaned it up; all was as it had been, as if nothing had happened. Vincent was pathetically happy. Roulin, a satisfied smile on his face, watched him wandering about, picking up a brush, fingering a tube of colour, putting one canvas after another on the easel, twisting it this way and that, stepping back from it, peering close at it, sitting on his own chair, in Gauguin's, looking out of the windows across the gardens and down to the all-night café and the railway bridge. Roulin did not know much about painting, but he knew a likeness when he saw one; this man had painted him, his wife and children more than once, and there they were. Besides, Vincent was a good-hearted fellow who meant no harm to anyone; the townsfolk were a silly lot of sheep to be taken in by his rough manner and hot temper, they made no allowances for the inevitable eccentricities of a man who had the gift for making such pictures.

They were away four hours. So much brighter was Vincent for his excursion that Dr Rey gave way to Roulin's persuasions and let him go altogether a day or two later; he had only to come back regularly for inspection and to have the wound dressed. That day, January 7, was a day of rejoicing; he was in his house

again and free to paint and he was conscious only of friends about him—the Roulins to a man, and the Ginouxes. That evening he spent all but his last franc or two on a celebration dinner with Roulin at the Café de la Gare; the Ginouxes welcomed him back and paid special attention to his table. "My dread of another attack has gone," he told Theo.

But before they parted for the night Roulin had bad news for him; he was being transferred to Marseilles; he would have to go alone because he could not afford to move his family; they were all utterly wretched.

This was not the only blow. Roulin had to tell him that the landlord of the yellow house had let it over his head to a tobacconist from the end of his tenancy in May.

And there was the solitary house to be lived and slept in. He was terrified that he would not be able to sleep there; it seemed empty and forsaken without Gauguin's heavy footsteps and authoritative voice. The nights in hospital were appalling, but at least he had had others near him. He grieved about Roulin—what would he do without him? He paced up and down indignant with his landlord: how dare he let the house without a word after all that he had done for it! He sprinkled camphor thickly on pillow and mattress and lay down at last, burying his face.

He managed to sleep; he had unspeakable nightmares—he had never been without them since he mutilated himself—but he slept. In the light of morning his confidence returned. Roulin brought a letter in a new hand, from Jo Bonger: she and Theo were officially engaged; she sent her love and hoped that they would meet soon; she knew and loved his pictures.

At this another fear disappeared. Vincent had brooded over Theo's forced visit to Arles instead of to Jo's family: would her family feel insulted, set their face against the marriage, and all through him? Immensely relieved, he sent congratulations to both: he owed it to himself to get married, he told Theo, he would avoid loneliness, perhaps obtain peace and certainly please his mother. As for himself, freed of this last anxiety, "I feel absolutely normal."

Then, his money gone and Theo's next remittance a week away, he grew nervous and uneasy. Dr Rey had told him that his attack was due to years of undernourishment and too much drink: the drink he might manage to avoid, but already he would

have to go without food. He told the doctor: "It may be that for certain reasons I shall fast for a week. If this happens to affect me don't think I've gone mad again." He used the word "mad", but still would not accept its implications. "I've had brain fever," he explained to a Dutch acquaintance. "I don't know whether I'm mad or not, but as this is a matter that the Dutch catechists will discuss eagerly I'll leave it to them to decide."

Somehow he got through that week without food and remained sane. He began to paint again: he painted two still-lives, not among his best work, then he painted a portrait of Rey marred only by his tendency to slant the eyes after the Japanese. To him the portrait showed "that I'm not yet off my balance as a painter". He presented it to Rey who managed to simulate pleasure until he had gone, then hastily thrust it into the attic as "too ugly" to have about the house. Rey was not interested in painters or painting—he saw Vincent as a very badly dressed man who had brought all his troubles on himself by neglecting to eat sufficient food—but, being young and keen and Vincent being an unusual case, he had been forbearing, sitting to him and allowing him, in and out of hospital, to relieve his mind. He disguised his boredom while Vincent talked by the hour about his theories of colour, his work and the work he hoped to do, and was rewarded by seeing the patient make a substantial recovery; the uses to which Vincent put his new-found strength and sanity were perplexing, but Rey was chiefly anxious to get him off his hands.

Vincent, unconscious of Rey's views or of the fate of his portrait, was painting with increasing confidence, and took up an unfinished portrait of Madame Roulin. He had painted her with the baby more than once, but this was a solo portrait, he had spoken much to Gauguin about it; he intended to call it *La Berceuse*. It was not so much a portrait as a design and a symbol; a well-composed, richly coloured picture with a smooth clean treatment unlike anything else he had painted or was to paint again—the one obvious sign of Gauguin's influence. It fascinated him; he painted it again and again, five times in all. And he began another self-portrait. These *Portrait à l'Oreille Coupée* (he painted two, one with and one without a pipe) with the fur cap and the bandage have become popular. They are certainly the only benign self-portraits he ever painted, but unfortunately are

not in the least like him—he romanticises himself, from necessity no doubt, just as Russell with less reason had done in Paris two years earlier.

He painted self-portraits because as always he could get no models. "Several people would ask me for portraits if they dared, but everyone is afraid of me." How, he wondered, unable to see himself or hear himself, could they think him mad when he had been discharged from hospital, walked about freely, painted with the utmost sanity? If they had simply refused and let him be— but he was treated as some kind of pariah. Why wouldn't they give him a chance, trust him to behave himself instead of driving him mad by looking at him askance, by whispers and sniggers?

The girl at the brothel reassured him. He called to apologise, but she waved his awkward words away: "Everybody's a bit off their rocker in this place." Perhaps she was right. The hot sun, the mistral—weren't they enough to turn the head of anyone? He had written months earlier, "the people here are rather decadent", and decadence was on the way to insanity. He spoke to one or two people in the street; they looked and sounded rather queer. Or was he the queer one? It was safer to think them all slightly touched.

He tried to reason the matter out with Theo. He had had moods of "indescribable mental anguish when the veil of time and inevitability seemed for the twinkling of an eye to be parted". Then all was chaos. But these hallucinations had stopped; he took bromide of potassium and they dwindled to nightmares. He could at least claim control of his brain except when the nightmares whirled it away. But he had realised at last that by ordinary standards he was sometimes strange in his manner and excited in his speech; that, he understood, was why the people stared at him. But they did not understand that he felt everything so deeply—everything. To feel strongly was not to be mad. How could he be mad? He knew that people stared because he spoke excitedly—that knowledge was a proof of sanity—of a kind. "It's useless for us to think of me as completely sane," but was there such a thing as complete sanity? "I'm well or I'm ill"— that was his explanation—and when he was ill and seemed insane he was in good company: "If Gauguin and I are a bit mad, what of it? Can't we justify our madness on the canvas?" Besides, look at them all—Delacroix, Berlioz, Wagner—mad, if

one cared to put the matter that way, but gloriously so. "Perhaps some day everyone will have neurosis, St Vitus' dance or some such." Then, he hoped, all would be artists.

As long as he could discuss his state openly in this way he felt reassured. With Theo as sounding-board and with Roulin at hand he had a sense of security. But Theo was getting married, he would have other things to think of—a wife, a home, a family —and Roulin was leaving him. He had appealed in vain against the order of transference, and on January 23 Vincent, the Roulin boys, Madame Roulin and baby were at the station tearfully watching the bearded face drawn inexorably away. When the Roulins went home Vincent wandered about disconsolate and frightened. Roulin had become an elder brother to him, protector, adviser, a true friend; with him at his back the fear of madness had grown insubstantial, a night-time wraith; merely to sit with him at the café and listen to his tirades against government had been to live in sanity. Roulin gone, the chain of security was broken.

Madame Roulin continued to sit for him; he had tried to prepare himself for a refusal but she seemed anxious to relieve her unhappiness by discussing her husband. She provided occasional company but no consolation. Nor was confidence to be found with his other friends, the Ginouxes. Madame Ginoux was herself practically a mental case; she was as disturbing as she was kind, with her ailments, her fidgetings, her restless frightened eyes.

He struggled on, his dread closing in on him, for a week or two, then the hallucinations returned. They took a new form; he believed that everyone was in league to poison him; he couldn't sleep for fear that someone should enter the house and doctor his food; he lay awake listening, he padded up and down to the kitchen. In the street he accused passers-by to their face. At the cafés he made scenes—even the faithful Ginouxes became suspect.

Early in February he was taken back to the hospital.

This second attack was short—by the middle of the month he was allowed to return provisionally to his house—but he knew now that the first attack had not been an isolated incident. Somehow he must find a reason for both or he would lose all confidence and collapse. He found it in the words of the girl at the brothel. He clung to them: he had at times a touch of a local

malady—that was all. He asked himself and he asked Theo—was there any sign of insanity in him as he worked in his studio at yet another portrait of Madame Roulin, or in his chats with her or in that calm face he was painting on the canvas?

If more proof were wanted (and he sought feverishly for it) that he suffered only from a local aberration, he had merely to look at the people of the town to see his own state reflected there. But worse, much worse; even since he had been in hospital—only a few days—his neighbours had grown distinctly crazier—so crazy that they hated painters. They were actually afraid of painting—that was his explanation for their dark looks when he set up his easel in the street; now not only the urchins who had always pestered him but grown people who should know better, crowding round. And not merely curious, but actively hostile, murmuring, glaring, as if they would smash the canvas to pieces.

Their madness grew alarmingly as the days passed. They were no longer content to gather about him in the street, to jeer, to make foolish asides; they clustered about his very house; they peered in at the windows. They watched him painting the postman's wife. Was that mad? They seemed to think so. When Madame Roulin didn't come for a sitting, they saw him painting a self-portrait; they stared at him with his fur cap on indoors, looking at himself in the mirror, then painting, then looking again. Was that mad? They seemed to think so. The heads at the window increased; youths climbed up to get a better view; not a room in the house was free from insane eyes. The onlookers were not silent; they mocked, they cat-called, they would not leave him in peace.

Suddenly, just before the end of the month, his resistance snapped. He threw open the windows and screamed at them.

He was taken, protesting, back to the hospital, shut in a separate room and the door locked. The shock of the forcible removal from his house brought on another attack; once more he screamed and shouted at the top of his voice; he tried to outshout the voices he heard, to frighten away the figures he saw; he tried to hold himself rigid to counterbalance the flux before his eyes. The whole world was moving, disintegrating; the slightest movement was agony; he longed for death.

Again he recovered quickly, but he was not released this time, he was kept in a locked room. Nothing was the matter with him;

they were mad, not he—he wanted to scream it aloud, but he dared not; if he so much as raised his voice they would lock him up for ever as a dangerous lunatic.

He lay for days, for weeks, motionless, saying nothing. Silence was his one hope; not to express by a sound the bitterness that filled his heart—that was the task he set himself. He succeeded; he kept silent; but he could not keep his mind quiet. They had locked him up although nothing was the matter with him. He had been pestered, he had lost his temper, he had had a sort of brainstorm. Was that a crime? Was that madness? But no one would believe him: he was locked up; he could not go to the yellow house, he was not allowed to paint, he was not even allowed to smoke. To lie and think, think—that was his sole resource.

Theo, making preparations for his wedding, wrote frantic letters: what had happened, why didn't he write? Vincent did not reply: he was ashamed to write. After all that Theo had done for him, to end in this fashion! He would never trouble him again.

Dr Salles, the Protestant pastor, explained. Salles, visiting the hospital, had kept an eye on Vincent; he was sorry for him; he disliked injustice and Vincent had been treated unjustly; he had been the victim of mob hysteria. He wrote to Theo: soon after Vincent's second return to the yellow house most of his neighbours—eighty-one of them—had sent a petition to the mayor: he was a public nuisance and a danger, he ought to be confined. The mayor ordered him to be taken back to the hospital. "The neighbours," said Salles, "have roused a tumult about nothing. His first foolish act has made them interpret unfavourably every singularity of the poor young man."

At last Salles persuaded Vincent to speak: "If the police had prevented the children and grown-ups from crowding round my house and climbing the windows as if I were a curious animal," Vincent said, "I should have controlled myself and done no harm to anyone."

Salles advised Vincent to write to Theo instead of grieving him by silence. In the third week of March, moved by the anguish in Theo's letters, Vincent at last wrote "as your brother, not as a madman". All he asked was that people should not meddle with him when he painted, ate and tried to sleep—"but they are meddling with everything". He was terrified lest these agitations

drove him hopelessly mad. If he had occasional epileptic fits—well, so did thousands of men and women in France: to drive him insane on this account, so that he could not paint, could only suffer tortures—what wickedness! If he were allowed to smoke and paint he would be content. From his window he could see spring blossom, white and pink; he yearned to paint it. As it was: "to endure without complaints, that's the lesson I have to learn". That was the lesson he had been forcing on himself during his month of imprisonment, and despite a sense of cruel injustice and a disposition that rebelled instinctively against any form of control he had learned the lesson. He was calm, he told Theo, though sad; he was resigned; his one hope was for Theo to marry and to found a healthy family which would carry on the principles by which they both lived, the principles of the walk to Ryswyk.

Theo was horrified: to be taken forcibly from the home made with such love, to be deprived of his painting! And resignation—from Vincent—how could that be true? Vincent was trying to shield him. He and Jo had arranged to be married in mid-April, but he had no heart for it while Vincent was wretched: he wrote at once to Rey, insisting that Vincent should be given his freedom; he begged Vincent to come back to Paris; he asked Signac, who was going to the Midi, to call on Vincent and report.

Vincent's door was unlocked, he was allowed to smoke, to walk about the hospital garden and paint. Signac came down, found him looking well and speaking normally; he asked to see the yellow house, and Vincent, cheerful at once, agreed eagerly. Signac, a determined young man, forthwith carried him off to the Place Lamartine; the house had been locked by the police, but Signac forced his way in and the happy Vincent showed him every room: Gauguin's with its sunflowers and "Poet's Garden" studies; his own with its severe white-wood furniture; the kitchen and the studio. Then they looked through the paintings still to be sent off to Theo—his *Nuit Etoilée*, *La Berceuse*, *Les Alyscamps*, *Café de Nuit*, portraits of Roulin, the baby, the chair, himself and studies of sunflowers. Signac "didn't seem at all afraid of them" he noted with immense pleasure, and when his guest admired his study of smoked herrings—a companion piece to the canvas he had exchanged in Paris for a rug—he promptly gave it to him. His liking, he explained, was not shared by the local

gendarmerie; they were nicknamed the herrings and, looking for an excuse to persecute him, insisted that he had painted the picture simply to insult them.

All through the day he talked on and on, rapturous at having a painter to listen: talked of painting, books, politics and again painting. By evening he was growing tired—the frightening bursts of the mistral had unnerved him, he confessed—and seeing a bottle of turps on the table in the studio he was about to drain it when Signac restrained him. Signac seems to have decided to suppress this incident, for he went off to Cassis to paint and sail after dropping a reassuring—too reassuring—note to Theo. He had perhaps become accustomed in Paris to Vincent and others behaving madly without being mad; he now reported emphatically that he had found Vincent physically and mentally "perfect" and that Rey had told him that if Vincent led "a very methodical life, eating and drinking normally and at regular hours, he will have every chance of avoiding a repetition of these terrible crises". And although the likelihood of Vincent doing so would seem to have appeared slender to anyone who met him, Signac held by what he had said. "He never gave me the impression of being mad," he said later. "Eating practically nothing, he always drank too much. After days spent entirely in the open in frightful heat . . . he sat himself down on the terrace of a café. Absinthes and cognacs followed one another. How could he stand up against such a life?"

Vincent took away all the paints and canvases he and Signac could carry and, back at the hospital, began to paint. He painted the hospital garden, including one study of particular delicacy and charm, the spring colours seeming to impose restraint on his colour and brushwork. Then, gaining confidence and lured by the blossom, he ventured as far as the public garden opposite his house: he sat painting and looking across to the house he was not allowed to live in, and to his relief was not molested; people walking and sitting in the gardens looked curiously at him but said nothing.

Sitting there in the sunshine, palette on one hand, brush in the other and the canvas before him, so safe and normal did everything appear that he wondered whether after all he might not escape his terrors—madness, confinement—and return to the yellow house; it was his still: somewhere he must go—the hospital

did not take mental cases and would not accept a lodger. But Salles, when he spoke of his hopes, urged him not to try to return there but to make up his mind to abandon the yellow house for ever; if he went back his neighbours would protest again and his illness might return. Rey also advised him and Theo that he would do well to leave the house, "his neighbours being hostile"; and Roulin reluctantly agreed when Vincent sounded him. Roulin had come back on leave and spent one of his precious days at the hospital. He could not escape from the post at Marseilles, he explained; his pleas had not been heard; he would move his family as soon as he had the money: without him near by to be called upon in case of need, Vincent would be wise to start afresh in another part of the town.

Roulin was an object lesson and Vincent tried to profit by it: "He has a heavy load to bear, but he always looks cheerful and he isn't stupidly optimistic—life, he makes clear, gets no easier with time, but it can be borne." His attitude to Vincent that day was touching—a silent tenderness and concern: he was not sad, he was not happy, he was not embittered, simply wise and good and loving and completely to be trusted. "No one knows what will happen tomorrow, but whatever it is, think of me—I shall be thinking of you"—that was his attitude and, said Vincent, who had known so little of friendship, it did him immeasurable good.

To Theo this was small comfort; he did not see how he could leave Vincent alone to face such an existence. He talked it over with Jo who asked why Vincent could not come back to Paris or go to his mother and sisters at Breda. But Vincent had already refused to return to Paris—"One day perhaps, but I couldn't stand the life of a big city at present"—would not be moved from his decision, and rightly, Theo believed. Jo had not seen him, she had only read the letters that gave so little indication of his impossibility as a person: "There's something in the very way he speaks," explained Theo, "that forces people either to like or dislike him violently. And even when people like him it's the most difficult thing in the world to stay on good terms with him. He can't be indifferent to anything or anybody—it's love or hate all the time. Whenever he sees anything he thinks is wrong, he says so—he spares no one's feelings—and that causes trouble. All the same, if he wanted to come back, I shouldn't hesitate a moment."

But he did not want to come back and Rey thought he would be unwise to go to Paris: he wants, Rey explained, simply "to be able to work quietly"; he could best do that in Arles, but not in the yellow house. To live with his mother was out of the question —she would not have it, for, said Theo, "You see, he has long since broken with convention. The way he dresses and his queer manners mark him out as a strange man, and people who see and hear him say 'He is mad!' To me that doesn't matter, but to mother it would be impossible."

The one temporary solution Theo could think of was a spell with another painter; not living together—that seemed beyond hope—but taking perhaps a long walking and painting tour. Even if he postponed his marriage, Theo could not spare the time from his gallery, but if a painter could be found. . . . But not one could be found: "Those he would like to go with were always a bit afraid of him—and the affair with Gauguin has made them even more so. They wouldn't risk it."

"I'm afraid I must let him do as he wants." That was Theo's conclusion, though it made him miserable. "A quiet life is only possible for him in the country or with simple people like the Roulins. It grieves me not to be able to help him, but for un- common people uncommon remedies are necessary."

But what did Vincent want? Rey and Salles tried to settle his mind so that Theo could marry in reasonable peace. Rey offered him two rooms in a house at a distance from the Place Lamartine; Vincent finally agreed to rent them and prepared to move in.

Heartened by the news, Theo and Jo married. For a fortnight Vincent heard nothing from Theo, who was, he told Signac, in the Netherlands undergoing the "pompes funèbres" of the wed- ding reception, the congratulations, the lamentations of both families, the ceremonies religious and civil, the signing of papers, "all carried out with a ferocity unequalled by the cruellest cannibals". Vincent went with Salles to the yellow house, he took the pictures from the walls, he packed up as many canvases as possible for Theo, he watched his precious things being taken away to the Ginouxes, who had offered to keep them for him: the sturdy wooden beds, the two chairs, his and Gauguin's, that he had painted with such love and understanding, the coffee- service, all that he had collected with such pride—all gone out of the place that had given them their life. He looked round at

the bare white walls, the red-tiled floor, dusty and deserted, and his heart died in him: "I thought how you had given me all these things with such brotherly love, and how you had kept me all these years, and then for me to have to tell you this wretched ending to it all—oh, I can't tell you what I felt!"

"Our fraternity, our love for each other," replied Theo with passion, "is worth more than all the money I shall ever possess." It wasn't the end, he insisted, but a new beginning.

But Vincent knew better. "At times it isn't at all easy to begin life again, for a lot of despair remains inside me." At the last moment he refused to move. He had put his life into the yellow house; if he could not live there he had not the heart to live anywhere—neither the heart nor the confidence. After the first attack he had felt optimistic, after the second he had had hope, but after the third all hope, all will disappeared; a gleam of light no sooner entered his head than it was chased out by fear; the attacks would return, they might grow worse, more violent, he might do—what madness to himself or others? Then they would lock him up for good, and his last resource, his only remaining purpose in living, his painting, would be taken away. "I've tried to found a studio in the south. My satisfaction must be in that. I can't face the isolation any more." He was humble, contrite: "I'm terribly sorry to trouble you like this, but my head is not steady enough to work at stretch by myself as I did before. And I dare not risk making any more public scenes." To Salles he said simply, "I'm not fit to govern myself and my affairs."

Salles looked round. Not far from Arles, near the village of St Rémy, was the old monastery of St Paul which had been turned into an asylum. The director, Dr Peyron, said that he would take Vincent for a hundred francs a month. Vincent wrote to Theo: "I should like to be shut up for a while as much for my peace of mind as for others."

Theo, in the middle of his honeymoon, was terribly distressed: Vincent, he felt convinced, was sacrificing himself to be out of the way—come to Paris, he begged, or go to Pont-Aven where Gauguin was thinking of settling once more. But even this last temptation could not alter Vincent's determination to remove himself from the world; he was not fit to associate with normal men—that was his attitude. He urged Theo to transfer as much of his love as he could to his wife and to regard the move to the

Musée du Louvre

PORTRAIT DU DR GACHET, 1890

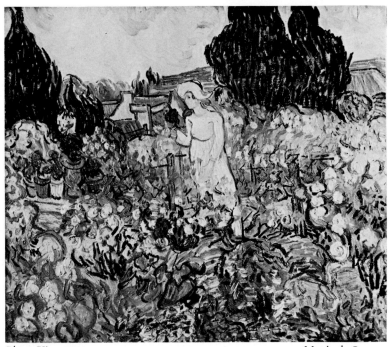

Photo: Vizzavona Musée du Louvre

MLLE GACHET AU JARDIN, 1890

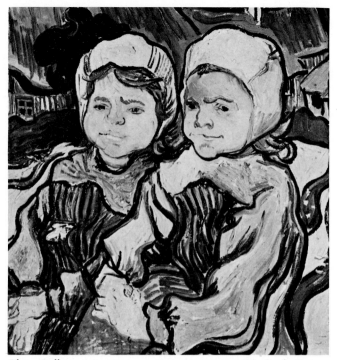

Musée du Louvre

LES DEUX FILLETTES, 1890

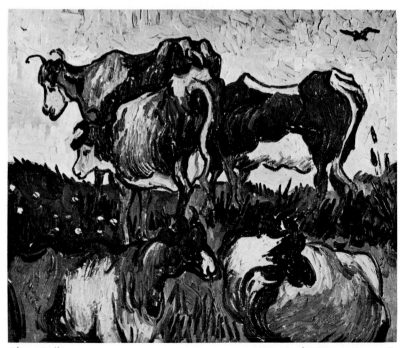

Musée des Beaux Arts, Lille

LES VACHES, 1890

asylum as a formality—he himself thought of St Rémy as a refuge. With this Theo had to be satisfied. He wrote encouragingly and his wife Jo sent her first letter to Vincent, telling him how happy they were together and how much he was in their thoughts: "I found many beautiful little things in the flat—vases and pictures—which remind me of the paintings of the brother-in-law I have never seen."

At the last moment two calamities fell on him: Dr Peyron refused to allow him to paint outside the asylum; and, far worse, spring tides in Arles flooded the cellar in which his remaining canvases from the yellow house were stored. Vincent's calm, enforced and superficial, collapsed: "Not only my plan for a studio wrecked, but even the souvenirs of my attempt, the studies, ruined!" And he would have no chance of repainting the spoilt canvases in the asylum if he could only work indoors. He talked despairingly of joining the Foreign Legion (he could paint as well in barracks as in an asylum cell, he said, and for nothing), but was dubious whether they would take him if they heard of his medical history. He did not know what to do: "If I hadn't your love they would drive me to kill myself."

Theo wrote hurriedly: "Take courage, your disasters are surely coming to an end." As for the Foreign Legion: "*C'est un pis aller n'est-ce pas?*" And St Rémy—was Vincent certain that he wasn't thinking of it as a plan to save himself and Jo? If so, he was on no account to go, but if he insisted he should go for a short time and Theo would write to Dr Peyron and arrange that painting should be allowed out of doors. But a short time it must be, say three months: Theo refused to accept Vincent's view of St Rémy as a place of retreat; it could be a temporary rest cure, no more.

At this Vincent's last reluctance vanished. He would go to St Rémy—to find peace and to paint what he could as well as he could. But farewell to grandiose ideas: "We shall always have a sort of passion for Impressionism, but I'm going back more and more to the views I had before Paris. Let's try to live for small ideas, that's enough to be going on with."

As for his madness: "If I can throw myself into my work again, fine, but we may as well face it, I shall always be a bit cracked."

Early in May Salles took him to St Rémy.

ST RÉMY

1889-1890

S ALLES left Vincent "somewhat moved" by the thought of
the new life he was beginning. It differed greatly from the
life of the hospital at Arles. As a privileged patient he had
two cells to himself: through the barred windows of the cell in
which he slept he could see a field of corn over which the sun rose
every morning and, beyond the wall surrounding the field, a
cottage or two, and beyond them again the foothills of the Alp-
illes. With the two cells and the view his privileges ended: the
walls were of thick stone but not thick enough to muffle the
noise from neighbouring cells; his companions, though not con-
sidered sufficiently dangerous to be locked up, could be heard
howling and raving all day and most of the night—one man, an
epileptic, shouted incessantly for two weeks soon after Vincent
arrived—and they flew into fearful rages and attacked each
other without warning or provocation. They were left to prevent
or stop these fights as best they could; there was practically no
attempt at discipline: the keepers were too few to keep order,
and did not try to do so; the sisters who looked after the food,
the hospital and the spiritual welfare of the patients contented
themselves with telling the unfortunate creatures that each must
bear with the others and remember that when his turn came he
was as great a trial to his companions as they to him. There was
not a book in the asylum; the only distractions were bowls and
draughts. For the most part the patients did nothing but eat bad
food and wait for the next attack to come on; on wet days they
were confined to a dreary stone room with a solitary stove and a
few upright chairs—like a third-class waiting room in some for-
saken village, Vincent thought, an illusion strengthened by the
appearance there of the most "distinguished lunatics" in their
hats and cloaks, brandishing canes and flourishing eyeglasses.
The noise was deafening.

It is only necessary to imagine the Vincent of a few months
earlier in such a position—to anticipate his fierce reproaches, his

rages and the stream of bitter complaints that would descend on Theo—to realise that this final trial which would have been unendurable to most people had brought out all the greatness in him. For the first time he was consistently what injudicious admirers persist in seeing in him from the cradle—quiet, resigned, gentle, thoughtful for others, above all filled with that most touching and noble form of dignity, the dignity of the man who has gone into the pit and grappled with hell itself. This change after his self-mutilation presents a sight at once mysterious and almost alarming, as though one had witnessed the taming of the untameable; but it is also and pre-eminently inspiring—he had won his fight and he was at last, though he seems to have been unaware of it, leading the life that for nearly twenty years he had yearned after, the life of the good man.

For when he had overcome the first shock of finding himself in this bedlam, Vincent actually got some comfort from it. When one was in the midst of madness, he discovered, it lost most of its terrors, it was plainly an illness like any other illness, it came and went, one sickened and recovered. In their sane periods the patients were approachable; he talked to one who could only gibber, but the poor thing somehow signified comprehension and pleasure. "Though there are some seriously ill here," he told his sister, "the fear of madness that I felt has already largely disappeared. Although one is always hearing howls and cries like beasts in a zoo, the people here understand each other very well and help each other when they fall into a fit." He told himself that he was much more fortunate than most; he remained rational for weeks, for months, he had his own rooms, he was free to paint. Put down in the society of the so-called sane he was at once conscious of his oddity (a single visit to the village of St Rémy made him feel queer in the head) but in the asylum he was the sanest of all.

He counted his blessings and tried to resign himself: "The effect of my terrible attacks is that there seems to be very little desire or hope left in my mind, and I wonder whether this is what happens to one—that the passions die down and one begins to descend the mountain instead of climbing it." In this mood, so far from the Vincent of past years, he announced, "It is very probable that I shall stay here for a long time. I've never been so quiet as here and in the hospital at Arles, and at last I can

paint a little. The small mountains, grey or blue, are very near here with very, very green fields and pines at their feet. I shall count myself very fortunate if I can work enough to earn my living—I'm very worried when I think that I've made so many drawings and paintings without a sale." He warned Wil to profit by his example, fearful that Paris (where she was still staying) would affect her as it had affected him—the likeness between their mentalities was always before him and the slightest sign of interest in painting from her alarmed him. "Don't become fond of painting," he urged, "and don't try to paint." But as for himself: "What would you? There are people who love nature so much that they become ill or crazy—they are the painters; and there are people who love what men make—they are those who love pictures."

For he had begun to paint at once: "The idea of work as a duty is coming back to me." At first he was not allowed to go beyond the garden—a large, walled, neglected field of grass under pines—but he found plenty of subjects. He put up his easel and began to paint. His companions, roaming aimlessly about the garden, came to see what he was doing, but, said Vincent, "they leave me in peace and are more discreet and polite than, for instance, the good folk of Arles." He painted four studies of the scruffy garden with its tall weeds—not beautiful, but redeemed by the sky above, a startling flawless blue, and by the sun that rode in that sky day after day, hot, yellow, magnificent; he painted it, huge, from his windows shining on the field of corn, and again when the reaper had begun to cut the corn. He painted iris in the garden and a lilac bush. Then, a month passing without ill effect, he was allowed to paint round about the village, the head warder going with him, and there he painted olive groves and cypresses and another *Nuit Etoilée*—the village of St Rémy under the hills in moon and starlight.

Theo was charmed by the canvas of iris when it reached him— "a beautiful study, full of air and life"—but the *Nuit Etoilée* worried him: "I find that the choice of style detracts from the true sentiment of the subject." When Vincent went outside the protecting walls of the asylum (for protecting was the predominant sense in which he regarded them) he was faced once more by nature, uncontrolled, rampant; everything was larger than life in this hot and fertile country—flowers, vegetables,

trees, fields of grass and corn, vines, all grew twice as quickly and twice as big; everywhere he saw growth, fertility, a riotous exuberance of life—huge purple figs, enormous pumpkins, grapes bursting out of their skins, sheaves bending under the weight of the corn. He had watched this work of the sun before, in the previous year, and his senses had reeled under it. Now he saw it again, even less well fitted to withstand the emotional assault. He no longer saw an immobile earth from which the sun drew movement; he saw the earth itself heaving with life as the bosom of a woman rises and falls. Was not earth the great mother and the sun her fructifying spouse? Driven by emotion as before, he reacted violently yet not as before: in the past months he had lived with Gauguin and he had looked madness in the face; the artist, like the man, was no more the same. The structure of his studies in oils was no longer built on colour—for the first time he began to paint in the more obvious and less dramatic colours of the Midi, the greys and greens and blues—but on line. Yet not on line as commonly used; he remained as individual and original at St Rémy as in his Arles period: his brush moved in a series of curves; his earth writhed in an orgy of reproduction, his cypresses speared up like living tongues of black flame flickering ever higher, his olives were locked in silent struggle, his clouds, spiralling across the sky, reflected the movement below, the sun glared down, a vast hot disc, moon and stars disturbed the darkness with silvery lusts and longings. He had not only moved far from literal presentation of a scene; the very spirit of it as commonly and even uncommonly seen had disappeared; the peaceful cypress, the serene olive, the virginal moonlight are not here: how could they be to a man, impotent himself, who saw life begetting life in every rustle of the wind through leaves, every sway of the ranked corn, every green shoot and every warm colour?

But he was not mad: extravagant, his imagination stretched unbearably, but not mad; nature as he saw it exists, as it exists afresh in every eye, every imagination. He was not mad; in July, Dr Peyron was so satisfied with him that he gave him permission to visit Arles.

Theo, reading with incredulity his complaisant letters, suspected that Vincent was glossing over unspeakable torments and humiliations and reminded him that his three months had nearly

passed. Theo was happily married, he was to become a father in the new year, his reputation as an art-dealer had never stood so high, but with Vincent wretched his blessings withered; he could not live with Vincent without misery, perhaps without being brought to his grave, but no more could he live apart from him happily if he suffered. "There is no one in the world he loves so much," Jo told Vincent; it was so, and she accepted the fact gladly—these two were not as ordinary brothers. Now Theo was being harrowed by Vincent's letters; as in the hospital at Arles, but worse. Indifference from Vincent—in that place! Theo could not accept it: let him come away, he urged; let him say where he wanted to go, it would be arranged.

But Vincent would not move: he had neither will nor wish to go, he said; he was neither happy nor unhappy; he was nothing except when he painted, then he fulfilled his duty, he left on record his conception of absolute truth—he wasn't satisfied, but it was all he could do. And what was absolute truth—was it to be found in the earth, in man or in God? He could not say; if one led the good life the truth might reveal itself. He believed that Millet intended his sower to stand as a symbol of the good life. He had tried to lead the good life; the love he sowed as a man had fallen on stony ground, it had not reached a single human heart, he would die without reproducing his kind, but he sowed on in his work, and who was to say that this would not bring forth tenfold, an hundredfold? He could do this work where he was. Theo talked of his moving, but he could think of no other place where he would not be a burden; he could not foist himself on a newly married couple with a first child coming along; he would not in his present state inflict himself on Gauguin, who had returned to Brittany with a new disciple introduced by Theo; he was fit for neither Theo nor Gauguin. "Don't worry about me," he insisted.

He went off to Arles accompanied by the keeper, Trabu; he wanted to collect some studies still in store, but even more he wanted to see his friends whose kindness and forbearance stood brightly against the hostility of the town and the officialdom of the asylum. At St Rémy was peace of a kind, but no hope and no love. Trabu and his wife were kind in their way, Peyron too, but had little time for him and no patience to listen; the sisters with one exception were cold and disapproving—they came to

look at his canvases in the garden, were alarmed by the speed with which he slapped the paint on and by its thickness (*"de pâtes d'hirondelles et pompons de couleurs,"* they said)—and treated him as a particularly abnormal case. One only, the head sister, Epiphane, was attracted by his paintings, but her suggestion that one of them should be hung in the sisters' sitting-room was rejected with horror. The liberties allowed to Vincent appeared to the other sisters as a lamentable departure from essential rules, and the result as a debased and horrible art.

Nowhere in the asylum was comradeship or understanding, and without it he could not live. Was painting enough—could one exist in it? When he had a brush in his hand he could believe it, but alone in his cell at night or on rainy days, listening to noises that were barely human, he craved a sign that as a human being he existed in the minds of men and women. Security of a kind he must have and the only security he knew or cared about was the love of others. Theo's love was now a shared love and Theo was far away. He longed for Arles—Arles that had put him where he was, but Arles in which he could find a smile, a sympathetic and sane word, even perhaps a look of affection. He missed both Rey and Salles but he saw the Ginouxes, he saw Madame Roulin and her family soon due to join Roulin in Marseilles; he made them a present of a canvas apiece. Then he went on to the girl in the brothel and the old woman whom the Roulins had found to clean the yellow house for him a year earlier. Not a long list but to him a precious one. To pass the yellow house was difficult but he did it. He came back warmed at heart but excited and exhausted by the long day walking and talking in the heat of full summer.

But at the heart of his excitement was another feeling—a mixture of despair and a terrible eagerness. From the moment just before Christmas when Gauguin prepared to leave the yellow house, Theo's engagement to Jo had taken on a new light—as a severance of the Ryswyk pact; friends he and Vincent would always be, but lovers in the best sense of the word, but two minds without a secret, an unshared thought, never again. Hence Vincent's stony heart-broken silence when Theo sat by his bedside in the hospital at Arles, hence the long gaps between Vincents' letters, his seeming reluctance to write, hence the insistence that Theo should not visit St Rémy and the refusal to

go to Paris—for, humbled by disaster, Vincent had tried to put
Theo into the background of his life, to live for art alone and to
justify himself through his work. He fought hard and was still to
fight, but he fought the unconquerable—his longing for love. He
went back to Arles because he could not endure a life without
love. But in Arles he met not love but at most a pitying affection;
it was something, but to a Vincent yearning inexpressibly for a
kind of blood brotherhood it was not nearly enough. When he
came back to St Rémy it was with the frustration of a man long-
ing for strong liquor who has been offered a glass of milk. But—
and this was at the bottom of his excitement and what resulted
from it—there had been hints of that strong liquor, hints which
inflamed his imagination and his desire. What did they talk
about, he and the Ginouxes, he and Madame Roulin and the
Roulin boys, he and the *femme de ménage*? Of the old life, of course,
when he and Roulin used to sit together at the Café de la Gare,
when he had made studies of them all, one after another. But
an integral part of that old life—the one outstanding fact to
a desolate Vincent—was the man whose photograph he had
carried round excitedly that day in October nearly a year earlier.
Whom did they talk about—whom did Vincent encourage them
to talk about? Not about Theo whom they had seen only for a
moment or two, but about "Monsieur Paul" that unforgettable
man who walked, talked and looked at one with such authority,
that big man with the slightly rolling gait, the lazy blue eye, the
high commanding head and the cutting, blistering flow of
language when roused. Gauguin, Gauguin—Vincent could never
hear enough of him: how he did this, said that, looked the other.
And so it was that, back at St Rémy, he re-lived the life with
Gauguin, not as it had truly been lived (except when he agon-
ised over his failings) but with a brotherliness, a Ryswyk he and
Theo relationship plus the bond of a common passion for the
making of pictures—all this imposed by dreams of himself and
Gauguin together again in mutual love (he having learned his
lesson) and in one artistic triumph after another. Here was the
true, the only escape not only from St Rémy but from the death
in life of his soul of which St Rémy was to become the symbol.
His mind burned with hopes, fears, plans.

A few days later he had an attack. He was some way from the
asylum, in the foothills, painting his *Carrière près de St Rémy*. The

subject had "a beautiful melancholy" in keeping with mood and day. He was painting in greens, reds and rusty ochres, almost a Dutch palette, painting strongly and with effect. His mind was disturbed by his journey and, the subject being what it was—desolate, deserted, dramatic—his exaggerations suit the theme: he had rarely painted so well. Then the mistral blew up, as was its way, from nothing. In a few minutes the place was an inferno; his easel was thrown down, the canvas whirled away; he set up the easel, wedged it upright with blocks of stone, recovered the canvas and, gripping it hard, went on painting, but the mistral tore at him insistently, howled through the quarry, whirled up and out carrying clouds of earth and stones; the cavernous din was unearthly with its high ominous whine. Were those the shrieks of the eighty-one neighbours who had signed the petition against him? His head began to wheel, quarry, hills, earth, sky revolved and advanced on him to crush him; he added a few despairing strokes to the canvas—it was all but done—then collapsed.

The attack was the worst he had yet had; when he at last came out of it his throat was so swollen with shouting that he could swallow nothing for four days. He tried to kill himself by swallowing his paints; and although Peyron was able later to tell Theo that "his ideas of suicide have disappeared", his nightmares had returned more terrifying than ever and his hallucinations, which came and vanished inexplicably, flung him back to the time of the Borinage when he had agonised ceaselessly about religious truth. Not until August could he lift a brush; not until September —and then only on the insistence of Theo—was he allowed out of the building.

The attack shattered every hope that had been gathering slowly in his mind. For five months he had been sane; it had seemed that, forced into a regular life, unable to drink or smoke too much, he might even yet elude the horror. Rey had told him that his attacks were due to his irregular life—that was one reason why he had agreed to go to St Rémy. But Rey had been mistaken. He had led the regular life, he was physically better than he had been for years—hale and hearty, putting on weight, with a good healthy colour in his cheeks—but in vain; ill or well, the attacks would come; he was a marked man; he never knew when the blow would fall—all he could see now was that sooner or

later it would fall, again and again and again until he died.

The attempt at suicide and Vincent's long silence threw Theo into panic; he re-lived Vincent's thoughts at night—the dreadful incoherence, the frantic grasps after reality, the despair—and as the fond and the imaginative will, he perhaps even exaggerated his sufferings. He implored him to leave St Rémy, to go to Paris or Brittany, assuring him that he would be welcome, but Vincent would not move and for a time could not even bring himself to reply—when he did at last write a line or two it was to his brother Cor, who was visiting Theo in Paris before going to England for training.

Jo, shocked by Theo's pain, sent off a tactful little note that same day: "Theo was a little disappointed that you did not write a word to him. Please write to him soon—if only a few words— we are longing so much to hear from you how you are and we hope with all our hearts that you will recover soon. You don't know how often we think and talk about you. Mother too wrote to us that she was longing to have a letter from you." She predicted that her child would be a boy, "even if you laugh at me", and she ended with another appeal, "Do write something to Theo if you can—he is longing for it so much."

Vincent, touched, roused himself to write, but hopelessly; what was the use of moving? he asked; in another month or two he expected another attack. When that was over he might think of leaving. His hopelessness struck Theo to the heart, but he could do nothing; he could not carry Vincent away against his will; Peyron did not think that he ought to go; there was nothing to be done but to try to hide his mind from Jo. Their child was to be born in a few months but he could not rejoice. In an effort to express his feelings he assured Vincent that the child if a boy should be named after him. Vincent returned a definite No; he was to do nothing of the kind; the child must be given his father's and grandfather's name. He had been thinking during those intolerable, interminable nights of his mother and father—how good they had been to him and how abominably he had behaved to them; thinking too of Theo, sacrificing himself to them and to him, and of his reward at his hands—a mad brother, a useless painter, a drag on him for the rest of his life. He could not bear the thoughts, but he thought on, back and back. He protested with extraordinary emphasis: do not name the child Vincent;

it was an accursed name, ill-omened. He was more disturbed than he could understand; somehow—he could not think why—a threat to him seemed to lurk in that loving gesture; it was absurd but he could not drive the fear from his mind. He tried to joke it away: to talk of naming the child before they knew whether it would be boy or girl! But he repeated—don't call him Vincent.

Since his last attack and the realisation that St Rémy could not cure him, his attitude towards the asylum had changed; he looked about him with loathing and could no longer bear to meet his fellow-inmates. He had prided himself on being saner than they, but what if they dragged him down to their level, sitting about day after day, hopeless, waiting for the next onrush of insanity and the next until death! He shut himself in his cell, painted with all the strength that was in him, painted with "dumb fury": to justify this wasted, wrecked life, to extract from it something good—that was now his one thought, his one hope: "If one could resign oneself to suffering and death, surrender one's will and love of self! But I love to paint, to meet people, to see nature." If he could complete his series of "Impressions of Provence", he felt that his life would not wholly have been wasted; even if he did not succeed completely "I believe that my work will be carried on. Not directly perhaps, but after all I'm not the only one to have faith in the truth. And if someone carries on the work, what do I matter? People are like the corn; both are ground between millstones to make bread. Happiness or unhappiness, what is the difference if one looks to the result? Both are necessary, both useful. Death, life, all is relative."

His mind rushed back and forth. What did he believe? At one time this, at another that. But the canvas, the brush, the paints —there was solidity, there was truth; idleness, the empty moment —there were his enemies; never to have a spare minute—that was his refuge. He went to Peyron, he begged to be allowed to paint; Peyron, moved by the anguished face, agreed. Vincent painted day after day. Through the bars of his cell that summer he had seen the reaper cutting his corn and had begun to paint the scene: now he finished it: "In this reaper fighting like mad under the blazing sun to finish his job I see the image of death. But I don't feel any sadness in this death doing its work in broad day under a golden sun."

He was preoccupied by death, and worked on feverishly. His subjects were limited. He painted more self-portraits. He painted once more his bedroom in the yellow house—the first canvas had been spoiled by the floods. It was agonising work to recreate that bedroom but he did it, brushing in steadily the bed, the chairs, the table, the pictures on the bright white walls. He could not have the bedroom, he could not have the house, but at least a record should remain of the home he had made. He painted after Delacroix and Millet. He persuaded Trabu to sit for him; his face, he said, would be like a bird of prey but for its intelligence and kindness. The portrait was one of his best. He urged Trabu to permit his wife to sit for him; she was nothing, absolutely nothing, he said, but had not one of his admired Japanese painted a solitary blade of grass? "I want to paint this blade of dusty grass." He went downstairs and painted the entrance hall; he went out into the courtyard and painted the doorway with Peyron standing by a contorted tree (painting "*à la vapeur*", said Peyron's son, watching his rapid brushstrokes with amazement); he ventured further, into the village, and painted workmen laying a path. He painted fantastic olive groves, he painted a ravine in the hills—one of his most mature landscapes. He painted, painted, packed up the canvases and sent them off to Theo.

Winter closed in. He was forced to paint from prints sent to him by Theo—of Millet mostly; he was cold, he was fearful of the atmosphere about him—in summer one could get out but the long dark days, with madness confined, concentrated, evil, on every side, ringing in the head, beating at the brain were not to be borne. His resistance to Theo's importunities dwindled.

Would he consider a private mental home in Paris? Theo now suggested; or should he ask Camille Pissarro, who lived just outside Paris, if he would take him as lodger?

Vincent liked Pissarro and agreed that he might go there, anywhere out of St Rémy before an attack disabled him again. Theo sounded Pissarro, who, kindly as ever, consented, but his wife raised horrified hands: was it not enough to have an unsuccessful husband and five failures of sons spending their lives on useless daubs without a Vincent van Gogh who had neither wits nor money?

Pissarro spoke to an old friend, a Dr Gachet, one of the earliest followers of the Impressionists. Gachet lived an hour from Paris,

at Auvers-sur-Oise, he was sympathetic with unusual mental cases, he was in a sense a case himself; he was interested.

Vincent, intolerably restless, had gone off again to Arles: he could not believe that he had done with it or it with him, he dared not believe it. He preferred to think that he had suffered his last attack because he was cooped up with madmen and that intercourse with the friendly and sane might preserve him from future attacks; grasping at any explanation that might offer a hope of relief, he thrust the responsibility for his state on to his way of life: never to speak a word day after day except the rare exchange with the saturnine Trabu, the uncommunicative Peyron who refused to commit himself to a definite statement of his patient's progress—how could a loving man endure it, was it not enough to drive him insane? "It is a good thing to show yourself there from time to time," he insisted.

But as before his predominant thought was, if he kept in touch with those in Arles who would talk to him, he would be reserving a place for Gauguin, for "I still believe that Gauguin and I will one day work together. I know that he is capable of greater things than he has yet given us." He thought no doubt that he would prove a better influence than Bernard and fiercely criticised some of the work being done in Brittany. Bernard had sent him photographs of some recent canvases which he found "a kind of nightmarish dream. . . . I have worked in olive orchards and it maddens me to see their Christs au Jardin where nothing is observed. . . . I have written to Bernard and also to Gauguin that our duty is to think, not to dream."

"The Annunciation!" he demands of Bernard. "Annunciation of what? . . . I adore the true and the possible and I don't find this healthy . . . the gross, froglike priests kneeling as if in an epileptic fit, God knows how or why! I see the figures of angels—elegant, my word! . . . and when the first impression has passed I ask myself if it is all a mystification and if these figures in fact tell me nothing. . . . Truly, does this express a sincere conviction? No! you know better than this." And as for the *Christ au Jardin*, "Gauguin spoke to me when we were together about another motif . . . and when I compare that to this nightmare of a Christ au Jardin, my word, I feel sad and with this thing in front of me I again beg of you, with shrill cries and giving you absolute hell with all the strength of my lungs, that you'll become a little more

yourself again. The Christ carrying the cross is atrocious. Are they harmonious, those blobs of colour? And I won't thank you for the *banality*—yes, banality—of the composition." This abstract painting, he assured Bernard, trying to recover his temper, "is enchanted ground, my dear chap! and one soon finds oneself up against a brick wall."

For in his mind the villain of the piece was the too-persuasive and too little serious Bernard who, he commented in disgust, "has probably never seen an olive tree, he fails to get hold of such a thing, either its reality or its potentiality." Certainly his criticisms only made him the more desperate to have Gauguin with him, and he continued to try to interest Russell in his work, hoping as he had hoped more than a year earlier that a substantial sale would induce Gauguin to repeat the journey south: "He struggles always and alone or nearly always alone. He and I are still friends . . . but I have had several attacks of grave nervous crises and delirium—that's why we have had to separate and walk different paths. But only for the time."

If he had needed an incentive to long after Gauguin, De Haan would have supplied it, writing to Theo about Gauguin's sufferings in Brittany—"if I had not supported him for the last three months he would have starved"—praising his genius—"he is a very great painter"—and demanding, "My God, can't we do something for him?" Gauguin wrote, talking vaguely of founding a studio in the tropics, but his "gloomy" letters did not deceive Vincent: "I can see clearly that something is wrong with him. . . . he writes vaguely of having quite decided on Madagascar, but so vaguely that I can see he's only thinking of it because he doesn't know what else to think of."

How, in any case, could Gauguin get to the tropics when he had not enough money even to live where he was? He would be forced to settle nearer home; that thought was enough to raise the hopes of Vincent who learned his lessons slowly and whose enthusiasm and generosity and loneliness combined to drive all realism out of his mind: "What a pity he didn't stay on here. We could have done better work together. If he chose and if he doesn't find anything else we might still work together down here."

He had, then, a double mission in Arles, and set off too eagerly. He stayed two days. A week or two later, at Christmas, he had

another attack short but violent. He recovered in time to wish
Theo and Jo a happy new year but he could not disguise his
distress: "I can't see any way out. I can't stay here indefinitely—
I see that—but I should like to finish the pictures I have in
mind." He did not, in fact, wish to leave the Midi—not, at least,
until it was absolutely certain that Gauguin would not return.
Gauguin there, and he could see a home in Arles, the yellow
house over again, but successful this time because he was not the
same man. From his barred window even in winter the colours
were superb, the light translucent, the temptation to paint irre-
sistible. How could he leave such a country? Yet he felt, with a
strange and significant choice of words, that "business is busi-
ness, duty is duty, and it's therefore only just that I should return
soon to see my brother, but it will be painful for me to leave the
Midi".

He recovered quickly—too quickly—and at the end of January
was off to Arles once more "to see my friends again—they always
revive me". He looked over his furniture in the Ginoux basement
and suggested to Theo that if he came north he might give it to
Gauguin so that it would at least benefit a painter who intended
to work in the country. He could not get Gauguin out of his
mind, thinking of his sufferings and his greatness and dreaming
of a *ménage à deux* once more. For weeks he had been working on
a version in oils of Gauguin's drawing of Madame Ginoux. He
remembered that drawing exactly, he remembered the day on
which it was made, he could see Gauguin looking up at the
touchy model with cool, hooded eyes, he could see the huge fist
moving with superb assurance over the paper. He worked with
fanatic intensity to do justice to the master drawing: "I try to be
religiously faithful to it," he explained to Gauguin, "and to
present the essence of the Arlésiennes." It was also to express the
essence of their work together: "You will understand it as I do,
but very few others will." He worked feverishly to make it the
perfect offering of friendship—feverishly but also with a kind of
despair. To Wil, who had been taken by Theo to see Degas before
she went home, he explained, "I'm trying to find an expression
other than that of the Parisiennes." But, looking back, he felt
hopeless: "Ah, Millet, Millet! how he painted humanity and
that something higher, familiar yet solemn. One reminds oneself
nowadays that he set to work to paint weeping, that Giotto and

Angelico painted on their knees, Delacroix so broken-hearted, so touched . . . *almost* smiling. Who are we Impressionists, soiled in the struggle for life, to do as they did?"

The excitement of the work, of the new visit to Arles, the talk there and the sight of the furniture that might soon be in use again—all were too much for him; he was struck down again. He attributed the attack to his emotions during the painting, but when Gauguin saw it and approved all was forgotten: "I feel enormous pleasure that it pleases you. It is a synthesis of the Arlésiennes if you choose. The doing of it cost me a month of illness but I knew that you would understand."

He wrote quickly to the Ginouxes as soon as he had recovered, to thank them for their kindnesses and to sympathise with Madame Ginoux, whom he had found unwell once more with symptoms mildly resembling his own intense depressions. She had once told him, "when one makes friends it is for a long time" —a saying that he hugged to himself in his loneliness and never tired of repeating. He tried to comfort her out of his own experience; such words, he said, "encourage us, the illness over, to rouse ourselves, get up and want to be cured at once. I assure you that last year the fear of suffering a relapse almost prevented me from being cured so little did I wish to begin again. I very often said to myself that I'd rather there was no more of it and that it should all be over. However, we are not the masters of our fate and it seems to be a question of learning to want to live again even while suffering. Ah, I feel myself to be so cowardly about this. Even with my health coming back, I still fear. So who am I to encourage others, you'll say, and it's true that the rôle doesn't sit very well on me. Anyway, this is only to tell you, my dear friends, how ardently I hope and believe that Madame Ginoux's illness will pass and that she'll come out of it quite cheerful again and that she knows how much we all need her and want to see her well. Illness did me good—it would be ungrateful not to admit it—it calmed me and, very differently from what I had imagined, I had better luck than I had dared to hope. But if I had not been so well looked after and if people had not been so good to me I believe that I should have kicked the bucket or lost my reason completely."

He had no sooner sent off this letter than he heard from Theo and Jo that a son had been born to them; he was to be named

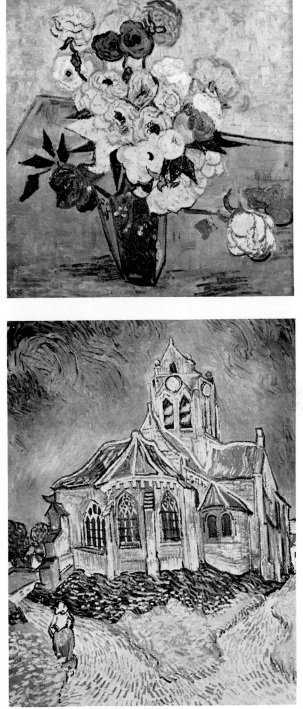

ROSES ET
ANEMONES
1890

Musée du Louvre
Photo: Vizzavona

L'EGLISE
D'AUVERS
1890

Musée du Louvre

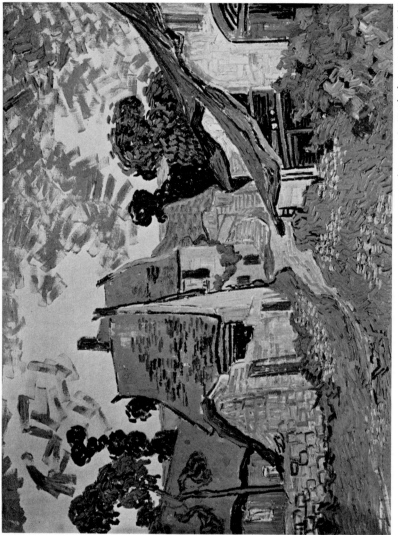

RUE A AUVERS, 1890

Ateneumin Taideakatemia, Helsinki

Vincent—they insisted. His feelings—of pleasure and of inexplicable apprehension—had scarcely subsided before he was reading an article on his work in the *Mercure de France*: the writer, the young symbolist critic Albert Aurier, hailed him as one of the coming painters. He was tremendously pleased and proud—he promptly sent Aurier one of his canvases—but being a truly modest man he deprecated this first public attention he had ever received; the article, he told Aurier, would have been juster and stronger if, "when discussing the future 'paintings of the tropics' and the question of colour, you had done justice to Gauguin and Monticelli before speaking of me. *The part I have played or will play remains, I assure you, very secondary.*"

To write of Gauguin was to bring him closer and to relieve his own conscience; the days of reproach were long over. "I owe much to Paul Gauguin," he insisted, " . . . this curious artist, this stranger who in manner and appearance vaguely resembles Rembrandt's portrait of a man at the Lacaze gallery—this friend loves to make one feel that a good picture is the equivalent of a good action—not that he says so, but it's difficult to be with him without becoming aware of a certain sense of moral responsibility." To Isaäcson he wrote enthusiastically: "In Gauguin there is a genius unsuspected by most people, who judge him by outward appearance." And to Russell: "I assure you that I owe much to the things Gauguin told me about drawing, and I hold in high estimation his way of loving nature. But in my opinion he is even better as a man than an artist."

More exciting news followed: Gauguin was back in Paris and he, Vincent, had sold a picture—*Le Vigne Rouge*—in Brussels for four hundred francs; the purchaser was the sister of the Belgian painter Boch, who, persuaded by Vincent, was then working in the Borinage. At last he had made a genuine sale, after ten years of work and on the eve of his thirty-seventh birthday: he could afford to move; he could see Gauguin; he need be beholden to none. He rushed off to tell his friends at Arles of his good fortune, but he did not see the Ginouxes; the journey, strung up as he was, proved quite beyond him; he collapsed in the town and was brought back in a carriage the next morning; no one knew where he had spent the night.

He managed to drop a note to the Ginouxes: "I had news of M. Paul the other day and it is possible that I shall soon hurry

off to see him since I also have a great wish to make the acquaintance of my brother's little son." Then he plunged from one nervous crisis to another; he did not recover for two months; his head was never clear enough even to write to Theo; all he could do in lucid moments was to make little sketches, all from memory and all of the north—the potato eaters, the old church tower of Nuenen, women gleaning, one Dutch subject after another.

Towards the end of April he at last scribbled a coherent letter to the despairing Theo: he no longer believed that he could escape from the dark threat of insanity, but the atmosphere of the asylum was more than he could endure—"the society of the other invalids influenced me so badly that finally I could think of nothing"—Peyron had forbidden him to visit Arles again, so that the last reason for staying at St Rémy had been taken away. He agreed, though without hope, to try Auvers after a few days in Paris.

He grieved bitterly because he had missed the blossom—the trees had lost it all before he recovered sufficiently even to look out of the window—and he had not finished his studies of Provence, but the roses were out, the new green grass sprinkled with white and yellow flowers was already high in the garden, the iris stood up tall, white, violet. These, he said, he must paint before he went away. "When I was ill," he told his mother and sister, "I painted a picture of Brabant, now I'm painting a field of grass with dandelions in full sunlight. Please send me some of my studies and drawings of peasants for me to use as models."

The studies were too late for him, but he painted the spring flowers, left them to be sent off by Trabu and prepared to go. But at the last minute there was a flash of the old Vincent: Theo was terrified that he would be taken ill on the train and suggested that he should come down to fetch him or at least arrange for him to be accompanied. "I am not dangerous," replied Vincent, hurt and angry. "I've been patient for a year or more, I've never done harm to anyone—is it just that I should be accompanied like a wild beast? Anyway, I'm so cut up to be leaving in this way that I shall be far too upset to go mad in the train."

Theo said no more and Vincent packed his few things. To lose that atmosphere, those colours! "I can scarcely bear to leave the Midi," he told Theo. "This morning I saw the country again

after the rain—it was so fresh, and the flowers . . .!'' He wrote a sad note to the Ginouxes: "One can't do as one wishes in this life; it was necessary to leave the place to which I was the most attached, but the memories remain and one remembers—dimly, as in a mirror—one's absent friends."

But resignation—even though resignation had been his predominant mood at St Rémy—came hardly when he looked about him. "Oh!" was his final cry, "if I could have worked without this accursed malady, what things I could have done!"

AUVERS

1890

H E could not be persuaded to say when he would go. Not until May 16 did he wrench himself away, and then only after the sun had fallen and night had hidden the colours. In Paris, Theo, waiting anxiously day by day, suddenly received a telegram; Vincent was on the night train. Theo could not rest, imagining him having had an attack during the long journey, running amok, injuring himself or others. By the time he left for the Gare de Lyon the next morning Theo was a white-faced bundle of nerves.

To Jo at the window of their *appartement* (they were in the Cité Pigalle) he seemed gone an age; then an open fiacre drove into the courtyard below and two men waved up at her—Theo and the brother-in-law she had never seen. When they walked into the sitting-room she was astounded; the red-bearded man who came forward to greet her looked far healthier and stronger than Theo, his face was ruddy, his bearing confident and he was smiling cheerfully; he showed none of the signs of insanity she had feared—he did not even appear nervous. She could scarcely believe that he had come straight from an asylum where he had had fit after fit in the last few months.

They looked at his namesake asleep in his cradle, then Theo fetched out Vincent's paintings. Theo's favourites had been framed and hung—*De Aardappeleters* over the dining-room mantelpiece, *L'Arbre Fleuri* in his bedroom, the *Vue d'Arles* and the first *Nuit Etoilée* in the sitting-room—but piles of unframed canvases were stored in every available corner, under the bed, under the sofa, in the cupboard, and almost filled the little spare room. They were all taken out and spread one by one on the sitting-room floor; Vincent in his shirtsleeves, pipe puffing hard, knelt down staring hard at them with Theo bending over him; the place was in chaos but they talked happily and earnestly. The next morning Vincent was up early, examining his work again; he had never before seen it gathered together; he and Theo

discussed it by the hour. Other painters dropped in—Bernard, Lautrec, Guillaumin. St Rémy was never mentioned.

For a day or two Vincent seemed contented. In the morning he went out to buy olives—he had developed a passion for them in the south; all must eat them, he insisted—and he began a new self-portrait—his best. Jo marvelled at his normality; Theo, she began to think, had exaggerated his condition. Then all at once Paris, the visitors, the talk, the noise of the traffic, the lack of country air and colour—and perhaps something else that he could not acknowledge—affected him, and Jo detected unmistakable signs of abnormality—a sort of excessive form of the nerviness displayed by Theo from time to time; he became irritable, touchy, unbearably restless: he must go, he said; time was passing, he had much to do. He did not even try to discover if Gauguin were still in Paris—he dared not face this longed-for companion showing the slightest hint of nerviness. He left that day for Auvers, promising that he would return soon and make their portraits, and urging them to visit him when he had settled in.

At Auvers he called on Dr Gachet; he walked up the hill overlooking the Oise and climbed the terraced garden to the house, a massive building dimly lighted by tiny windows and in hopeless confusion, stuffed with antiques—"black, black, black!"—and looking and smelling like a museum. He found his host etching in a room rather like a dungeon. Gachet was in his early sixties, a widower, thin, nervous, emphatic. He specialised in diseases of the heart and travelled to Paris once or twice a week to give consultations, but his mind seemed to Vincent to be more on art than medicine; he was for ever painting or etching, he had been a friend of Courbet, Daumier, Daubigny and Manet; Cézanne, Pissarro and Guillaumin had all stayed with him in Auvers, and his house was filled with Impressionist canvases, most of them unframed and unhung.

He took Vincent into a large yard at the back of the house where ducks, chickens, turkeys, peacocks, cats and a goat, Henrietta, roamed amicably and he introduced him to his children, a girl of nineteen and a boy of sixteen. The boy, Vincent noticed with a sense of reassurance, had a distinct look of Theo.

On the whole Vincent felt that he would get on well with Gachet. The man was mad, of course, as mad as he, but that was

no handicap, a bond rather. They even looked alike—sufficiently so for Jo to comment on it when she saw them together; there seemed generally to be a curious family resemblance between the Gachets and Van Goghs. Gachet had a passion for painting, oddly expressed though it was, and he had done much for it; when he settled in Auvers nearly twenty years earlier he had found Daubigny painting there, and after Daubigny's death six years later he had tried hard and successfully to maintain Auvers as an art centre—had tried, in fact, to do what Vincent had wished to do at Arles, to tempt men into the country to paint from nature and under a clear light. He had thought in particular of the Paris painters and he had chosen well; Vincent was enraptured the moment he saw the little town—barely more than a village—stretched along one of the rolling hills, green and fertile, forming the Oise valley with the clear water running under the willows far below. It was a queer blend of styles; the eighteenth-century centre about the Mairie, the clusters of rickety thatched cottages bordering the fields, and the newer outlying villas built by Parisians since the railway had been made, but Vincent liked them all—the thatch best of the lot, but the villas too, for they were set in flowery gardens and looked bright and cheerful in the sunshine. He could not wait to paint the place and, having resisted Gachet's recommendation to an expensive inn, he settled at the cheapest he could find, the Café Ravoux in the Place de la Mairie. From his window he could see the Mairie opposite, and that pleased him too, for the little building was very much like the town hall at Zundert.

He began at once with the first of his many views of Auvers, a study of thatched roofs with a foreground of corn and a background of green hills. It differed from his landscapes at St Rémy and the later ones at Arles; all morbidity, all exaggeration of colour and form disappeared, the colours were bright and gay, the study had the charm of a Japanese print, of a child's painting, yet it was a mature and individual work and accurately reflected the state of his mind in the early days at Auvers. The mental disturbance of the last day or two at Paris was wearing off. He discussed his case with Gachet when he went up to the house again on Sunday (he was to spend every Sunday there, Gachet insisted), and his host was reassuring. If Vincent felt too depressed, something could be done to drive the depression away;

but he thought that the change to Auvers might work its own cure.

Gachet was a deplorable advertisement for his skill as mental healer; on closer acquaintance his nerviness, his eccentricity and spells of low spiritedness were quite frightful—"there's no doubt that old Gachet is very—yes, very much like you and me" Vincent told Theo—but he was kind, helpful and almost too ready to admire. And as at St Rémy in the first weeks, the idea of a man afflicted like himself seemed to Vincent to be a positive comfort; he was not alone, he was actually companioned (perhaps exceeded) in peculiarity by, of all men, a doctor. Gachet ought to know the right treatment; Vincent was certainly feeling better, and was soon writing hopefully to Theo: "I begin to think I caught a disease peculiar to the south and that my coming here will be sufficient to get rid of the whole business."

Such a thought was enough to change his whole attitude—a change best shown by his forbearance towards Gachet. In a sense those Sundays were absolute torture; he and Gachet struggled through two full meals of four and five courses because Gachet had old-fashioned notions of the manner in which to treat a distinguished guest; but Vincent not only perceived this, he endured it without a word. He had many kindnesses from Gachet; he was promised models beginning with the Gachet family, he was free to paint in the garden and immediately did so, making a study of Gachet's daughter among the flowers and painting his *Dans le jardin du Dr Gachet*, a work of particular interest in which the cypresses are treated as in the St Rémy studies and the startlingly brilliant colours remind one of the Arles canvases, but which nevertheless conveys a sense of calm and order absent from both earlier periods as if—as was indeed the case—he has absorbed all the benefits of Provence while throwing aside the excessive emotionalism that Provence had raised in him. But these favours from Gachet would have been as nothing not so long ago to a Vincent asked to sit still for an hour or more, to stuff himself, and to listen to interminable reminiscences and rhapsodies. Now, chastened by his experiences and elated by the prospect of permanent release from them, he found a patience and a charity unknown in him before.

The first week he painted Gachet's portrait—the portrait in which he wanted to portray "the heartbroken expression of our

age". Gachet, like Madame Ginoux, was an impatient sitter, and Vincent painted him as he had painted her, rapidly and with a masterly unity of design. Gachet was delighted—"he is absolutely *fanatical* about it", Vincent told Theo—demanded another, and became from that moment a fervent admirer. He had seen Vincent's studies in the café bedroom and prophesied a great future for him. This Vincent found embarrassing—he regarded himself still as in his infancy as a painter—but after years of neglect it was also undeniably gratifying. After all, Gachet was not an ignoramus, he had known, admired and collected the work of the Impressionists—if collection was the word for that haphazard assortment in odd corners. Vincent began to take heart, his premonitions to fade; he painted, lightheartedly for him, one confident picture after another, including *Les Vaches* after the engraving that Gachet had made with the study of Jordaens in mind but with a strength and mastery of colour unsuspected in the original. This picture he made with a speed unusual even for him; his *L'Eglise d'Auvers*, taken more slowly, was more impressive still—a remarkable example of his power to bestow individuality on the inanimate. He says of it—he wrote as usual though with a noticeable increase of confidence about all his work—"It is much the same as the studies I made of the old tower at Nuenen except that the colour is probably more expressive, more sumptuous" but as usual he did himself less than justice; colours and conception alike are inimitable.

Elated by the progress he was making he was soon suggesting to Gauguin, who was back in Brittany, "It is very probable that —if you agree—I may join you for a month to make one or two seascapes, but specially to see you. Then we will try to do something serious and studied—the kind of thing we should probably have done if we had been able to stay together in the south." He had said out of the despair of St Rémy, "I believe we shall work together again", and that unlikely prophecy now seemed possible.

The thought of Gauguin, never long out of his mind, and the joy of imagining himself at work with him once again plainly influenced his vision. He painted two studies of village children of which in particular *Les Deux Fillettes* is with one important exception the spit of Gauguin's child studies in Brittany—the exception being that his children have not the appeal of Gauguin's, being formidable rather than touching.

Gauguin's reply was noncommittal—the inn was full, he said —for he had no wish to have his "assassin" at close quarters again. Vincent was distracted momentarily from dismay by a visit from Theo and his family. Gachet invited them for the day and early in June Vincent met them at the station with a bird's nest for his nephew, he carried the child to the Gachet house and took him round the yard, introducing him to all the animals. Theo had never seen him in such spirits and he too became bright and cheerful: Vincent had not exaggerated; the move to Auvers seemed to have cured him.

They lunched out in the garden where Vincent had made his portrait of Gachet, and in the afternoon Vincent took Theo and Jo round Auvers, pointing out what he had painted and what he must paint as soon as possible—Daubigny's garden (his widow still lived in the village), the queer staircases from one street to another, the Mairie, the fields and cottages, his landlord's young daughter. Theo looked at the work in Vincent's room: it was good and he felt pleased and proud: the Gachet portrait and *L'Arlésienne* alone justified all the help so gladly given through the years. Surely Vincent's hardships must be over: he was a very good painter, he would be a great painter, it was even possible that Gachet had not spoken wildly when, in a confidential whisper, he declared that Vincent was a giant among painters. "Every time I look at his pictures I find something new. He's not only a great painter, he's a philosopher."

Theo expressed his pride and pleasure to Vincent; he was charming, full of understanding—so much so that Vincent must have had the illusion that the Ryswyk accord had again been established.

Theo and Jo sat back relievedly in the Paris train that evening: a day with Vincent and not one jarring note! Theo said that he felt as if a new life was beginning for them all. Vincent, left by himself, felt his loneliness all the more for the company he had had, but he also felt the strength to face it. When his mother said how lonely she was in her old age, he replied: "I understand how you feel. I shall always be lonely too. My work is the only thing that keeps me contented." In the next few weeks he tried to live up to his words: he worked hard: he painted another portrait of Gachet, he painted his son, he made a study of Marguerite Gachet at the piano that brought a cry of "admirable!" from

Theo, he painted three portraits of the sixteen-year-old daughter of his landlord, one of them a notable example of psychological realism, he painted Daubigny's garden and one landscape after another, culminating in the great *Champ de blé sous un ciel bleu*, and made his charming *Paysage à Auvers* as a companion picture to his painting of the Crau at Arles.

The pictures poured out as though he had been freed from fear, as though he at last felt that the years of struggle were to have a triumphant end. His *L'Escalier d'Auvers* is a study in sinuosity years ahead of its time—a fascinating example of the curved line technique he had adopted at St Rémy but used now without strain; he painted in his *Jeune Fille Debout* a study, not of the usual field of corn, but of a "close-up" of the sheaf as ostensible background to the figure: he made in his *Bouquet des Champs* (unhappily impossible to reproduce satisfactorily in black and white) the finest of all his still-lives: "some thistles, corn, leaves of several grasses. One is almost red, the other very green and another yellowish." What he did not say was that he had picked these things, grass, dockleaves, corn stalk, poppy, as he passed through the fields, had stuck them anyhow into an ochre jar and had painted rapidly a study of such beauty of colour, composition, such mastery of technique that the onlooker finds himself wordless. And finally he produced what is possibly his most striking canvas, the *Rue à Auvers*, the work not only of a great painter but—and the one contributes to the other—of a man at last unhaunted and free; the clear, bright colours and the irregular line of roofs with their hint of the fantastic leading him back to the cottages he had loved and had tried again and again to paint in the Netherlands. Always at this time he is talking of past times, at Etten in particular, as if the final flowering of his genius allowed his mind to return in happiness to those much loved scenes.

He worked fast but not exhaustively. There was much to do, but there also seemed for the first time in his life no need for hurry except the natural eagerness of the painter surrounded by subjects. He was, after all, only thirty-seven; the brush at last "slips between my fingers like a bow on the violin"; perhaps the future was his. He had never felt so well nor so hopeful. His contentment was expressed in a letter to Wil—his first from Auvers because, he explained, he had been so busy. He wrote enthusi-

astically about Gachet: "I have found in Dr Gachet an absolute friend and something like another brother, so much do we resemble each other physically and morally. He is very nervous and very queer. . . . We made friends practically right away and I spend a day or two every week at his house, working in his garden."

Gachet was in truth a tower of strength, praising, encouraging; he was, said Vincent, "*decidedly enthusiastic*" about the last version of the *Arlésienne* and the last self-portrait, "and this pleases me because he urged me to figure work and will I hope find me some interesting models". He repeated his affirmation to Bernard two years earlier: "What excites me most—more than anything else in my calling—is the portrait, the modern portrait." He explained what he was trying to do: to convey likeness—true likeness—by the use of colour; "I want to make portraits which to people a century later will look like apparitions. I'm not aiming at a photographic likeness but, by using our modern knowledge and taste in colour, to convey exaltation of character by the passionate expression of the face."

Then, at the end of June, a fatal blow was struck at his serenity by the one person in the world who would have died rather than hurt him. In Paris the baby had fallen ill and at the height of his anxiety Theo became embroiled once again with Boussod and Valadon. In vain Tersteeg wrote, "Show Valadon that you have a tongue of your own and that you aren't afraid of him"; Theo was not a strong man and took his troubles to heart. For a long time he had managed with a struggle to keep news of this recurring strife from Vincent, but he had never been the same since the years with Vincent in Paris, the shock of the self-mutilation and the long agony of St Rémy. Now, his nerves on edge after nights by the child's bedside, he wrote to Vincent telling him of the child's condition and warning him that he might have to leave Goupil and set up on his own. He wrote because he could not help himself but also to reassure Vincent, who might hear rumours from Gachet or the other artists in Auvers. "You are not to worry," he said, "my chief consolation is that you are well and that you have found your way."

The attempt at reassurance was useless. Vincent's newfound calm vanished in a moment. For years he had urged Theo to open his own gallery; the news that he might be forced to do so

was wholly welcome though it threatened to destroy his own future. But Vincent's thought was of Theo suffering and he not there to help, without even the power to help. Thrown off balance by the thought of an abrupt end to his security, he wrote in terrible distress: "What can I do? I shall only make matters worse if I come."

Theo obviously agreed; he was too harassed to write again; he said nothing. But this also was intolerable to Vincent; he could not keep away, and after two or three days of indecision, unable to paint, his mind grappling with horrors, he took the train to Paris and arrived unexpectedly at the Cité Pigalle.

His visit was a tragic mistake. There were one or two moments of normality: he met Aurier, he saw and found "wonderful" the *Mlle Dihau au Piano*, on which Lautrec, unknown to him, had been working while he was making his study of Gachet's daughter; but the background to the days was discord and wretchedness. For once Theo was not glad to see him, and could not disguise it. Vincent made no allowance for his feelings and, if he attempted to be considerate, did not succeed; he was the old Vincent of Paris days—on edge, difficult, quarrelsome, "Leave Goupil," he insisted, regardless of every practical difficulty; he repeated his old cry—let Theo open his own gallery selling only good pictures.

But this thought led to another—if Theo opened a gallery of his own he could move to an *appartement* over the gallery, a larger one than the rather cramped flat in the Cité Pigalle—and to yet another: Theo and Jo were suddenly shocked out of weariness; Vincent, all at once aflame with rage, was shouting and gesturing about the room with an angry arm—was that the way to treat a man's life-work, to huddle it under sofas, beds, cupboards; let them get a bigger *appartement* and store his canvases decently.

Normally Theo would have understood that this outrageous outburst when the child was ill was made precisely because the child was ill; he, who knew Vincent better than Vincent knew himself, would have realised that he could not bear the slightest sign of neglect and demanded his full and ordinary attention— not so much because he was jealous of others as because he needed the assurance of Theo's love, the one human feeling that bound him to life and hope. He had love elsewhere but it carried with it none of the assurance he craved: his mother, aging, lonely and perhaps remorseful, seemed to feel more

tenderly towards him than for many years, but could offer him no support, only sad thoughts; Wil, affectionate, proud of him and longing to help, was timid, morbid, easily unbalanced, someone to be protected—and who was he to protect? his request to her two years earlier not to write so often to him was a measure of their relationship—a touching one, but so far as practical value went, a fair weather relationship only.

No; it was Theo or nothing for him; on Theo his life and his reason depended. But the child was ill, Theo was preoccupied, miserable, tired out. In his wretchedness he thought, when he thought at all, that Vincent would realise that lack of attention at such a time was natural, was even a sign of confidence and love. After all, he had come to Paris unasked. But Vincent could not realise any such thing; he was a child himself, a frightened child insisting on tangible proof of love. When he did not get it he flew into a panic. Theo was deserting him, was tired of him, had transferred all his love to Jo and the little Vincent—especially the little Vincent! As ever when he felt insecure he became truculent: as a child, uncertain of his mother's love, he had rampaged about the house at Zundert; as a man he had written furious letters to Theo when loyalty to Goupil seemed to come between them. He could and did attack Goupil's successors still. Leave them! he shouted again and again. But Theo's business was now the lesser threat; the greater threat was lying ill in the cradle, his own namesake, the child he loved. The love prevented Vincent from complaining directly of neglect to himself, but the fear demanded action. A symbol was not far to seek: his canvases lay out of sight, dusty and dirty; they were not brought out, examined, discussed, they were not even mentioned, they were neglected, forgotten, unwanted—Theo had no time for them because he had no time for him. At this unbearable thought he fell into a fury, he raged, he turned the sad household into pandemonium.

Theo unharassed could have calmed Vincent—he was familiar with the symptoms—but, worn and worried, he was almost as frantic as Vincent and could see only selfishness in this mad talk of the canvases at such a time; he reproached him and they came as near to an open quarrel as they had ever been in their lives. In the early days of July Vincent rushed back to Auvers without a word.

By the middle of the month the child was out of danger and the breach with Valadon had been made up, but the news came too late to save Vincent—indeed, perhaps nothing could have saved him after the visit to Paris. He had no sooner reached Auvers than he was overcome by guilt; he apologised, but hopelessly; he painted on, but in despair—his mind was clouding and the pictures he made were the work of a lost man; one only—the fantastic *La Mairie à Auvers le 14 Juillet* showed a gleam of feverish brightness; the few others were landscapes heavy with doom.

In the third week of July Theo took Jo and the child to the Netherlands to recuperate and returned to Paris for a week before rejoining them for his summer holiday. The letters waiting for him were disturbing, deeply melancholy: "I feel done for," wrote Vincent, "my soul is foundering." A few days later he described a landscape he was making, a field of corn driven by the wind and over which flew a cluster of crows—a wild and ominous subject painted with terrifying power: "It wasn't difficult for me to express sadness and extreme solitude," he said. This letter made Theo even more anxious: "Will life never be peaceful and happy for him?" he wrote to his wife. "He's such a good man."

There was no relief for Vincent at the Gachet house. As he had shrunk from the inmates at St Rémy during the later months, fearful that they would contaminate him, so the nerviness and instability of the doctor began, after the Paris visit, to appear as a threat—he was being driven mad by the company he kept: "He's worse than I am," he told Theo. "Can the blind lead the blind?" Everything Gachet said and did became intolerable, but Vincent's wrath and fear soon centred on one peculiarity which seemed to sum up the menace awaiting him in the Gachet house —the manner in which its owner kept his Impressionist canvases, unhung most of them, unframed, dusty in corners, an insult to the great artists who painted them. But there were canvases unhung, unframed, dusty, in the Cité Pigalle: Vincent began to look at Gachet with furtive hatred; he could only reproach Theo, and he suffered for that, but this fellow was another matter. One day towards the end of the month, looking from Gachet to the disorder in his study, his mind blurred—Gachet, Theo, Gachet, Theo, canvases on the floor at Auvers, canvases on the floor in

Paris—and suddenly he drew a revolver from his pocket and pointed it at the doctor.

Like Gauguin, Gachet looked at him sternly and spoke sharply: "Vincent!" Vincent turned as he had turned in the Place Lamartine and rushed away horror-struck and ashamed: for the second time he had tried to kill his love.

He went back to the café, met Ravoux and muttered, "I can feel my life slipping away. I can't hold on any longer." Ravoux was startled for a moment, then remembered that Vincent had been saying quite a few queer things since he had come back from Paris. He was a queer fellow—all painters were queer it seemed to him. He did nothing.

Vincent went upstairs and sat down. He was back again in those terrible days of the hospital at Arles when he first returned to consciousness—back, but worse, far worse. He had no more hope of Gauguin; Theo was lost to him; he knew now that, alone, he could not fight his fate. He took a sheet of paper and began to write to Theo. He wrote a page. "You are more than a dealer in Corots." he said. "Through me you have helped to produce paintings which won't lose their meaning even if the world becomes chaos."

"As for me," he went on, "I'm risking my life for my work and my brain is beginning to give way. No matter. But you're not a tradesman. You can take the part of humanity."

He added four words. "*Mais que veux-tu?*" and then stopped writing, stuffed the unfinished letter in his pocket, walked out of the house, up the road and into the field behind the château. "*Mais que veux-tu?*" Auvers could not save him, no place could save him; the madness in him was not bred by the sun of the Midi, it was in his blood; wherever he went it would follow; it would be on him again soon—he knew the signs—and he would again be the beast, unaccountable for his actions. He could not escape; it was with him for the rest of his life. He could not endure it.

Yet even with that dreadful shadow hanging over him he could have found strength to endure and to work on. One thing would have saved him—the whole love of another human being —but that thing he could not have; Theo, that other and better half of him, had no more need of him, he had a wife and son, the family was united in love, complete in itself. The first Vincent,

that dead Vincent into whose shoes he had stepped, had blasted his childhood, destroyed his confidence in his power to win love. Theo had saved him by years of selfless love, he had been man and woman to him. Now Theo had begotten a third Vincent who had taken from him the last, the only reason for his existence.

Theo had no more need of him? That was an understatement: he was a drag on Theo, a drag on his family; for more than ten years he had lived on him, he had drained him of money—twenty, thirty thousand francs in all. In return he had given him pictures that he could not sell and a life of one anxiety after another.

"*Que veux-tu?*" He had seen the effect of his coming amongst them—the unhappiness, Theo white with worry, Jo puzzled and hurt. Wherever he went, misery followed; he was not wanted; he would be better dead.

"*Que veux-tu?*" Life had finally defeated him. Many times during his short life he had faced the temptation of suicide but always, save in that one moment of madness at St Rémy, he had put the temptation behind him; he had disdained the tendency in himself and he had fought it in Theo; it was a cowardly way out, dishonest, not a thing that a Van Gogh would do—he had an answer again and again. He made only a single condition; he said to Theo more than a year earlier what he had felt all his adult life: "If I hadn't your love they would drive me to kill myself." And now he no longer had that love—not as he must have it to survive—and "they" could have their way.

He took his revolver—that revolver bought in the days of Cormon—out of his pocket and shot himself. He pulled the trigger too soon; he shot himself in the stomach; he did not die, did not even lose consciousness, he remained a failure to the end.

He shuffled back slowly, down the hill, along the street and through the café, his shoulders hunched, one hand holding his belly. Ravoux and his daughter commented on his lateness and his looks but he brushed them aside with a muttered, "*Pas du tout,*" climbed the stairs to his room and did not come down again.

A few minutes later Ravoux heard moans from upstairs, remembered his strange words earlier that evening and ran up to his room; Vincent was lying on the bed smoking his pipe, his face screwed up in pain, his clothes bloodstained.

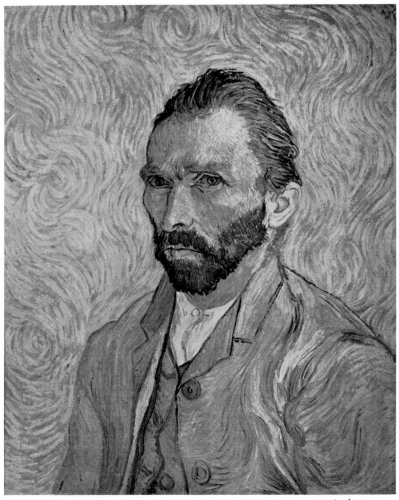

THE LAST SELF-PORTRAIT, 1890

Drawing by Dr. Gachet. Musée du Louvre

VINCENT A SON LIT DE MORT, 1890

Ravoux sent for Gachet who fussed in aghast, dressed the wound and said that he must send for Theo. Vincent refused to disclose the address: Theo was not to be disturbed, he said.

Gachet rushed home, wrote a note to Theo and gave it to one of the painters in Auvers to take to the gallery in the Boulevard Montmartre. Theo got the note the next morning just when he was about to leave for the Netherlands to join Jo and the child. He hurried to Auvers; Vincent was lying on his bed smoking his pipe.

Why, asked Theo again and again—why?

Vincent tried to tell him why: "Who would imagine that life could be so sad?" The burden of living, he said, was too heavy to bear alone and he was alone.

Theo protested but vainly; he could not convince his brother that the marriage and the child—especially the child—had left their relationship where it was in the days of the Ryswyk walk and the years that followed it. He scribbled a few words to Jo: "Don't be too worried. His condition has seemed hopeless before, but he has pulled through. The doctors don't know the strength of his constitution." But he did not deceive himself: "Oh, if only we could give him some new reason to live!" This was beyond the power even of his love; Vincent had lost the will to live and nothing could revive it. In the early morning of the next day, July 29, he said, "I wish I could die." A few minutes later he died.

He was buried in the churchyard at Auvers.

The tragedy of Vincent's life overwhelmed Theo: a good and a great man had lived in misery, unacknowledged and unloved although his heart had been filled with love. The tragedy of Vincent's death killed him: Vincent had shot himself because he believed himself to be alone, because he could not face life, with its recurring threat of insanity, alone—and he was not alone. All came back to him with inescapable clarity: Vincent's self-mutilation after the news that he had fallen in love with Jo and the loss of the substitute figure Gauguin, Vincent's agonisings in the hospital at Arles and his inability to comfort him because he was engaged to Jo, Vincent's behaviour during the child's illness —all ran together and accused him. He had failed him; he loved him more than wife, more than child, Vincent was and would always be first with him, but he had failed to convince him, he had killed him.

Theo collapsed at the graveside, but managed to get back to Paris. There he had a stroke, he became paralysed, his brain gave way; the doctors could do nothing for him; he had lost Vincent and was no more himself. In the autumn Jo took him back to the Netherlands, sane again but broken. He did not recover; he died in January and was buried beside Vincent at Auvers.

Jo returned to the Netherlands to live. She took with her Theo's collection of pictures. Chief among this were two hundred canvases by Vincent valued at about one hundred and fifty francs apiece. Why not sell them? she was asked time and again; she needed money—Theo, with a perpetual drain on his income, had never been able to save. She would not sell; one day, she believed, Vincent's genius would be acknowledged and Theo's faith would be justified.

She lived to see that day.

THE LETTERS AND THE MAN

T HE new edition of the Van Gogh letters (Wereldbiblio-
theek, Amsterdam) contains every known letter of Vincent.
The first three volumes correspond in plan to the earlier
editions, including Madame Gogh-Bonger's introduction, the
letters to Theo and extracts from reminiscences of those who had
met Vincent; but the reminiscences are greatly extended, and
some twenty new letters are printed together with dozens of
passages suppressed in previous editions. The fourth and extra
volume prints the letters to Van Rappard, Emile Bernard and
his sister Willemien, the letters of Theo to Vincent, several
miscellaneous letters concerning Vincent, and more reminisc-
ences and details of the Van Gogh family.

Vincent van Gogh is generally regarded, in his own country at
least, as one of the world's great letter-writers. It is certainly true
that he revealed himself in his letters as few have done, and the
additional letters and parts of letters now available help to
present a more rounded portrait of an extraordinary man; it is
also true that the letters contain in imperfect form a philosophy
of life that is fascinating and within limits helpful; but when
judging the merits of the letters a distinction must be made
between form and matter. In form Vincent must be considered
as one of the worst letter-writers ever to become famous: he is
repetitive to a degree difficult to parallel, going back again and
again to a thought or an argument in a single letter, sometimes
repeating the very words a paragraph later (an example, in
précis, had been given in this book); his writing is so elliptical
that his meaning is often hard to guess; his grasp of grammar and
of logic is hazy, he confuses cause and effect, falls often into what
is known in his country as the Tante Betje Stijl, and, to make
matters worse, often uses English construction when writing in
Dutch. A Dutch translator has put the matter succinctly: "To
translate Van Gogh into another language, one has first to trans-
late him into Dutch." As much can be said for the letters in
French and English; Vincent wrote bad Dutch, bad French, bad
English.

The problem of the translator is difficult; if he translates Vincent literally his work will often be unreadable, yet if he departs from Vincent's manner he will lose much of the man—for his faults as letter-writer reflect much of himself as a man. He sat down at the end of a day of painting or drawing, tired, hungry and possessed almost always by one outstanding thought—his need for money, for love, for a home, his theory of colours, his work, his feeling for Sien, Kee and so on; he could not write quickly enough to express himself, his thoughts ran ahead of him —that led to compression; he could not write himself out of his obsession of the moment, nor could he believe that the reader of his letter would understand or act on a single statement—that led to the interminable repetitions. The result of this passionate impatience of a weary man who would rather be painting than writing and of this excessive singlemindedness, combined with a rudimentary grasp of grammar and syntax, are letters often difficult and sometimes practically impossible to read without a struggle.

The struggle is of course very much worth while and is soon forgotten. Few men have written such revealing letters; nothing, one thinks, is hidden of the workings of his mind and heart. Yet the impression given by the letters is far from the impression given by Vincent in the flesh and remains in some respects most misleading. The suppressed passages and letters show, as one might expect, his less favourable side, particularly in his relations with Theo and his father, yet the picture left in the reader's mind remains that of an honest, passionate and even reasonable man; he has the habit of setting out a case with such simplicity and directness ("Tersteeg has only to come to me and I shall greet him with outstretched hand and love in my heart") that one is led to think of him as maligned. The truth, however, is usually otherwise; Vincent was one of the most unreasonable men who ever lived, governed entirely by emotion—or, if that statement is too strong, he was of all men perhaps the least able to express his feelings face to face. He believed implicitly in what he wrote and at the time of writing he felt it with a passion, but he could not live it; on canvas he could do so—that is one reason why he is a great painter; in life he failed. To pursue the example given: when he wrote of Tersteeg, he had a vision of the frank and friendly handshake, of the heart-to-heart talk, good fellow-

ship on both sides, of harmony, love, progress; nothing, it seemed, could be simpler or more inevitable. In the event, this never happened; Tersteeg would call (and for Tersteeg one can freely substitute anyone who had dealings with Vincent), Vincent's very greeting would rouse resentment—"he shakes hands as though he hates you"—his repellent appearance would rouse distaste and his manner offend—a chance word by the visitor (almost any word that did not agree unreservedly with Vincent's theory or mood of the moment) would expunge every good intention in him; he would see himself immediately the victimised and the despised, would at best react fiercely, uncompromisingly and at worst almost to the point of insanity, insulting, shouting, overmastered by sudden rage.

At moments all this was known to him: "Don't imagine . . . that I don't blame myself because many people take me to be an unpleasant character. I am often terribly melancholy, moody and irritable; I long for sympathy, and when I don't get it I try to behave as though I don't want it, I speak harshly and generally make matters much worse. I'm not easy in company and I often find it difficult and even painful to mingle with people and talk to them." Unhappily, for him to analyse himself correctly was not a sign that he would try to correct his behaviour—quite the contrary; he will write such a passage, then behave as though it had never been written. He could not, in fact, realise that he had pronounced his own life-sentence—how could he when, alone, he felt so often in his heart nothing but love for his fellows? But he could not translate his good intentions into action; almost invariably he expressed the direct opposite; there was in him— in person, looks and manner—that which damned him whenever he appeared or opened his mouth to speak.

Vincent has unfortunately become the centre of a cult, just as Emily Brontë has; he is freely spoken of as a profound philosopher, as one of the best men who has ever lived, even as a second Jesus —and at one period of his life he encouraged this delusion by speaking in the words of Jesus and by regarding himself as suffering in the same way and for the same cause. How far removed he was even from the good men who have tried to follow Jesus can be seen quite simply; for their characteristics are charm, tact, a true humility and a genuine and practical love for mankind— all conspicuously lacking in Vincent, the most egoistic of men.

The feelings of the present writers towards him have varied much in the last thirty years. They began with an idolatrous regard for a misunderstood saint. Later, as they grew older, certain facts —his behaviour to his family and his attitude towards women in particular—made them wonder uneasily whether he were not in truth a positive menace; they asked themselves how a man could be described as good who caused anger, strife, embarrassment wherever he went—whether a single person who met him could be described as the better for his having lived. These questions, honestly but perhaps narrowly faced, were disastrous to youthful worship. And it is a fact that judged by the world's standard Vincent was not a good man; he is acclaimed as such by many, partly because the social conscience is uneasy when it regards the misfortunes of a man afterwards discovered to be a great artist partly no doubt because we all wish to identify ourselves with one who had the courage to stand by his principles against the world, but also because his life appeals to the romantic instinct in the young and mentally immature. The fact remains, however, that not one of these admirers at a distance could have endured him for ten minutes together in the flesh, nor he them; they would react precisely as everyone reacted in his own day and for the same good reasons. The fact also remains that the world's standard of behaviour is essential in the world and that a man who will not conform to it, for whatever reason, must be adjudged anti-social and a danger. Good intentions are not enough, are indeed nothing in themselves; actions, as far as the world is concerned, are everything.

Many learned people have addressed themselves to this problem; Vincent has been explained often, at length, and in widely differing terms. We who are neither psychoanalyists nor theologians can only suggest that he remained a child to the end of his life, that the virtues of the child are reversed when he takes on the shape and responsibilities of a man, and that the adult child is a notorious misfit in an adult world. But although Vincent was in many things a child, in a few things he was more adult than most men—in his faith, his absolute honesty of mind, his perseverance, his unshakable moral courage. And it is here and not in a supposed mystical saintliness that he is truly great and it is here that the source of his work is to be found—for these are the attributes of a great man who painted great pictures. A

distinction must obviously be made between the world's good and another, presumably higher good. The tragedy of Vincent was that he could not express this good in any other way than by his pictures, which he steadfastly regarded as second best. But it may be that neither Vincent nor those who write, talk and think about him are able to consider the matter apart from a man's life; it may be that man is a means to an end and that by his end he triumphs. If so, Vincent has triumphed greatly. It may also be that he was once again a true prophet when he said: "A white worm must eat lettuce roots to attain its transformation and I think that a painter must paint. Perhaps there will be something else after that."

SHORT BIBLIOGRAPHY

The titles below are restricted to those essential in our opinion to a study of the subject. Editions and translations which we consider unsatisfactory have been omitted. Interested readers should also consult the fuller bibliography in our biography of Gauguin.

Verzamelde Brieven van Vincent van Gogh, Ed. Mme J. van Gogh-Bonger and Ir. V. W. van Gogh. 4 vols. Amsterdam 1952-4.
Lettres à son frère Vincent. Amsterdam 1932.
Brieven aan A. G. A. Ridder van Rappard. Amsterdam 1937.
Briefe en Emile Bernard, Paul Gauguin, Paul Signac und andere, Ed. H. Gruber. Bale 1938.
Letters to Emile Bernard, Ed. Douglas Lord. London 1938.
Van Gogh et John Russell. L'Amour de l'Art and Burlington Magazine, Sept. 1938.
Lettres à sa mère. Paris 1952.
Beer, J. P., and Leroy, E., *Du Démon de Van Gogh.* Nice 1945.
Bernard, Charles, *Vincent van Gogh.* Le Matin, Antwerp, Nov. 1927.
Bernard, Emile, *Souvenirs sur Van Gogh.* L'Amour de l'Art, Dec. 1924. Preface to "Lettres de Vincent van Gogh à Emile Bernard." Paris 1911.
Bom, E. de, *Victor Hageman en Herinneringen van Vincent van Gogh.* Nieuwe Rotterdamsche Courant, Nov. 1938.
Braumann, M., *Vincent van Gogh: Kunst und Künstler*, 1926.
Bredius, A., *Herinneringen aan Vincent van Gogh.* Oud Holland 1934.
Bremmer, H. P., *Vincent van Gogh, inleidende beschouwingen.* Amsterdam, 1911.
Brusse, M. J., *Vincent van Gogh als boekverkopersbediende.* Nieuwe Rotterdamsche Courant, May 1914.
Coquiot, G., *Vincent van Gogh.* Paris 1923.
Doiteau, V., and Leroy, E., *La Folie de Vincent van Gogh.* Paris 1928.
Du Quesne van Gogh, E. H., *Vincent van Gogh. Persoonlijke herinneringen aangaande een Kunstenaar.* Baarn 1910, 1923; Eng. trans 1913. (But see comment by J. de Meester in De Gids, May 1911.)
Gestel, D., *Vincent van Gogh.* Eindhovensch Dagblad, Oct. 1930.
Hartrick, A. S., *Post-impressionism, with some personal recollections of Vincent van Gogh and Gauguin.* London 1916. Printed in *A Painter's Pilgrimage through fifty years*, Cambridge 1939.
Havelaar, J., *Vincent van Gogh.* Amsterdam 1915, 1929.
Honeyman, T. J., *Van Gogh; a link with Glasgow.* Scottish Art Review, 1948.
Kerssemakers, A., *Herinneringen aan van Gogh.* De Amsterdammer, April 1912.
Keizer, F., *Vincent van Gogh.* De Nederlandsche Spectator, May 1892.
Leymarie, J., *Van Gogh.* Paris 1951.

SHORT BIBLIOGRAPHY

Maks, C. J., *In Breitner's Atelier*. Elsevier's Weekblad, Oct. 1947.

Mendes da Costa, N. B., *Persoonlijke herinneringen aan Vincent van Gogh tijdens zijn verblijf te Amsterdam*. Algemeen Handelsblad, Dec. 1910.

Nordenfalk, C., *Van Gogh and Literature*. Journal of the Warburg and Courtauld Institute, 1948.

Pierard, L., *Van Gogh au pays noir*. Mercure de France, July 1911.

La Vie Tragique de Vincent van Gogh. Paris 1924, 1939; Eng. trans. 1925.

Ravoux, Mlle, *Vincent van Gogh: personal memories*. R.D.F., March 1953.

Stokvis, B. J., *Nasporingen omtrent Vincent van Gogh in Brabant*. Amsterdam 1926.

Nieuwe nasporingen omtrent Vincent van Gogh in Brabant. Opgang, Jan. 1927.

Tralbaut, M. E., *Vincent van Gogh in zijn Antwerpsche Periode*. Amsterdam 1948.

Vanbeselaere, W., *De Hollandsche Periode (1880-1885) in het Werk van Vincent van Gogh*. Amsterdam 1938.

Vermeylen, A., *Vincent van Gogh*. Van Nu en Straks, 1895.

Van Eeden, F., *Vincent van Gogh*. De Nieuwe Gids, Dec. 1890. (See also letter of P. C. Görlitz to Van Eeden in *Verzamelde Brieven*.)

Van Hoensbroek, B., *Vincent van Gogh*. De Nederlandsche Spectator, Aug. 1893.

Westerman-Holstijn, A. J., *Chapters on Psycho-analysis*. Utrecht 1950.

Weisbach, W., *Vincent van Gogh: Kunst und Schicksal*. 2 vols. Bale 1949-52.

La Faille, J. B. de, *L'œuvre de Vincent van Gogh*. 4 vols. Paris, Brussels 1928.

Brooks, C. M., Jr., *Vincent van Gogh: A bibliography*. New York 1942.

REFERENCES

No references are given for quotations and incidents commonly known; these are taken mainly from Mme Gogh-Bonger's introduction to the Letters and from Vincent's letters to Theo as originally published by her. The references below are confined to new material and to material which although previously printed—often many years ago—remains little known.

PAGE

15	The Carbentus family	*Letters* 4.366-8
15-6	*Stokvis*	
16	The Van Gogh Family	*L.* 4.347-69
16	V. W. van Gogh	
17-8	*Stokvis*	
18-9	V. W. van Gogh	*L.* 4.323
19-21	*Stokvis*	
22	*Du Quesne*	
22-3	Mr De Jonge van Zwijnsbergen	*L.* 4.327
23	*Stokvis*	
24	*Westerman-Holstijn*	
24	*Stokvis*	
27	*Van Hoensbroek*	
28	*Stokvis*	
30	Vincent to Van Rappard Jan., early Feb. 83	
30	Vincent to W. J. van Stockum-Haanebeek 2.7.73	*L.* 1.8-10
31	Vincent to C. & W. van Stockum-Haanebeek Oct. 73	*L.* 1.14-5
35	Vincent to C. & W. van Stockum-Hannebeek 3.3.74	*L.* 1.19
38-9	Theo to Vincent 7.9.75	*L.* 1.34-5
	Vincent to Theo 8.9.75	*L.* 1.37-8
39	Vincent to Theo 29.9.75, 30.9.75	*L.* 1.37-8
42	Vincent to Theo, Anna to Theo 17.6.76	*L.* 1.60-1
43	Vincent's sermon	*L.* 1.88-91
43-4	Vincent to Theo Nov.-Dec. 76	*L.* 1.80-6
47	Vincent to Theo 4.6.77	*L.* 1.122-3
47	*Brusse*	
47-8	*Van Eeden* and *Görlitz*	
48	Vincent to Theo 23.4.77	*L.* 1.104-5
49	Vincent to Theo 31.5.77, 7.9.77, 18.9.77, 21.10.77, 30.10.77	*L.* 1.120-2, 139-49
49	*Brusse*	
50-1	Vincent to Theo 3.4.77	*L.* 1.101-2
51	Vincent to Theo 3.4.78	*L.* 1.164-7
51-2	*Da Costa*	
53	Vincent to Theo 9.7.77	*L.* 1.126-7
54-5	*Vincent van Gogh en Meester Bokma* by Fr G., Brussels 12.4.12	
82-3	Vincent to Theo Nov. 81, 18.11.81	*L.* 1.255-9, 265-7
84	Vincent to Van Rappard 17.1.84	

REFERENCES

PAGE

89-91	Vincent to Van Rappard 15.10.81	
90	Vincent to Van Rappard 23.11.81, 3.12.81	
90-1	Theo to Vincent 5.1.82; Vincent to Theo 7.1.82	*L.* 1.298-303
92	*Maks*	
93	Vincent to Theo May 82	*L.* 1.341-8
95-6	Vincent to Van Rappard May 82; to Theo May 82	*L.* 1.352-8
101	Vincent to Theo May 82	*L.* 1.358-9
102	Vincent to Van Rappard 21.11.81, 23.11.81, early Mch. 83	
103-4	Vincent to Van Rappard end Feb. 83, mid Sept. 82	
104-5	Vincent to Theo end May 82, 1.6.82	*L.* 1.375-8, 380-3
105	Vincent to Theo end June 82, 1.7.82	*L.* 1.386-8, 392-3
105	Vincent to Theo Mch. 83	*L.* 2.125-9
105-6	Vincent to Van Rappard early Feb., mid Feb. 83	
106-7	Vincent to Theo July 82	*L.* 1.410-5
107	Vincent to Theo end July 82	*L.* 1.415-8
109	Vincent to Van Rappard Apl. 84	
110	Vincent to Theo Apl., May 83	*L.* 2.175-80, 182-6
110-1	Vincent to Theo Jan., Feb., Apl.-July 83	*L.* 2.103-5, 106-9, 116-22, 125-9, 156-65, 170-2, 175-80, 182-6, 200-3, 205-11
111	Vincent to Theo June 83	*L.* 2.175-80
113	Vincent to Van Rappard Sept., Oct. 82	
114	Vincent to Theo late Aug., Sept. 83	*L.* 2.252-5, 257-67
118-20	Vincent to Theo Oct.-Nov. 83	*L.* 2.292-304, 305-31, 337-344
120-1	Vincent to Theo late Sept. 83	*L.* 2.274-9
122	*Stokvis*	
123	Vincent to Theo Dec. 83	*L.* 2.349-51
123-4	Vincent to Theo Dec. 83	*L.* 2.351-3
124	Vincent to Theo Dec. 83	*L.* 2.353-5
124	Vincent to Van Rappard Apl. 84	
124	*Stokvis*	
125	Vincent to Theo Dec. 83	*L.* 2.353-5, 355-61
126	Vincent to Theo Dec. 83	*L.* 2.355-65, 366-70
127	Vincent to Van Rappard 17.1.84, 25.2.84, end Feb. 84	
127-8	Vincent to Van Rappard Apl. 84	
128	Vincent to Van Rappard end Feb. 84	
128-9	Vincent to Theo Jan., Feb., Mch. 84	*L.* 2.381-3, 386-93, 394-404
130	Mrs Schafrat	*L.* 4.334
131	Vincent to Van Rappard Apl. 84	
131-2	*Stokvis*	
134	Vincent to Theo Aug. 84	*L.* 2.420-3
135	Vincent to Theo Nov. 84	*L.* 2.452-5
137	Vincent to Theo Oct. 84	*L.* 2.423-5, 434-6

REFERENCES

REFERENCES

PAGE

193	Vincent to Emile Bernard Apl. 88	
194	Vincent to Koning spring 88	*De Telegraaf* 29.11.33
194	Vincent to Wil June-July 88	L. 4.148-55
196	Vincent to Emile Bernard 20.4.88, May 88, Oct. 88	
197-8	Vincent to Wil June-July 88	L. 4.148-55
198	Vincent to Emile Bernard mid July 88	
198-9	Vincent to Wil June-July 88	L. 4.148-55
200	Vincent to Russell July 88	
200-1	Vincent to Wil June-July 88	L. 4.148-55
201	Vincent to Koning Spring 88	
201	Vincent to Wil July-Aug. 88	L. 4.155-7
202	Vincent to Wil Mch.-Apl. 88, June-July 88	L. 4.146-7, 148-55
203	Vincent to Emile Bernard late Aug. 88	
205	Vincent to Russell Apl. 88	
206	Vincent to Emile Bernard May, June, end June 88	
207	Vincent to Emile Bernard end June 88	
208	Vincent to Theo early June 88, 6.6.88	L. 3.225-6
209	Vincent to Wil July-Aug. 88	L. 4.155-7
209	Vincent to Gauguin June 88	L. 3.227
210	Vincent to Emile Bernard June, May 88	
212-3	Vincent to Theo Aug. 88	L. 3.306-10
213	Vincent to Wil Aug. 88	L. 4.157-8
215	Vincent to Russell July 88, Russell to Vincent 22.7.88	
216-7	Vincent to Theo Sept. 88	L. 3.324-7
217	Vincent to Gauguin Sept. 88	L. 3.334-5
217	Vincent to Theo Sept. 88	L. 3.333-4
217	Vincent to Gauguin Sept. 88	L. 3.334-5
217-8	Vincent to Gauguin early Oct. 88	
218	Vincent to Emile Bernard Sept. 88	
219	Vincent to Theo Sept. 88	L. 3.333-4
220	*Braumann*	
221-2	Theo to Vincent 23.10.88	L. 4.257-8
222	Vincent to Emile Bernard late Aug., end July, early Oct., mid Oct., Sept. 88	
223	Vincent to Theo Oct. 88	L. 3.329-31
223	Vincent to Emile Bernard May 88	
224	Vincent to Gauguin early Oct. 88	
225	Vincent to Gauguin mid Oct. 88	
226	Gauguin to Emile Bernard Dec. 88	
227	Vincent to Theo 22.10.88	L. 3.252-4
227	Vincent to Theo 20.10.88	L. 3.351-2
228	Vincent to Emile Bernard end Oct. 88	L. 4.230-1
228	Gauguin to Emile Bernard	L. 4.231
228-9	Vincent to Theo 22.10.88	L. 3.352-4
229	cf. Vincent to Theo Nov. 88	L. 3.358-9
230	Vincent to Theo Dec. 88	L. 3.360-2
230	Vincent to Emile Bernard Oct. 88	
232	*Avant et Après*	
233	Gauguin to Fontainas Sept. 02	

REFERENCES

REFERENCES

PAGE

279-80 Vincent to Gauguin June 90 *L.* 3.527-9
280 Vincent to Wil June 90 *L.* 4.184-5
280 Vincent to Wil June 90 *L.* 4.182-4
280 Vincent to Gauguin June 90 *L.* 3.527-9
281 Vincent to his mother June 90 *L.* 3.525
283 Vincent to Wil June 90 *L.* 4.182-5
283 Tersteeg to Theo 7.4.90 *L.* 4.304-5

INDEX

INDEX

INDEX

INDEX

INDEX

INDEX

Printed in Great Britain
at Hopetoun Street, Edinburgh,
by T. and A. CONSTABLE LTD.
Printers to the University of Edinburgh